Drawing Essentials

San Diego Christian College 2100 Greenfield Drive El Cajon, CA 92019

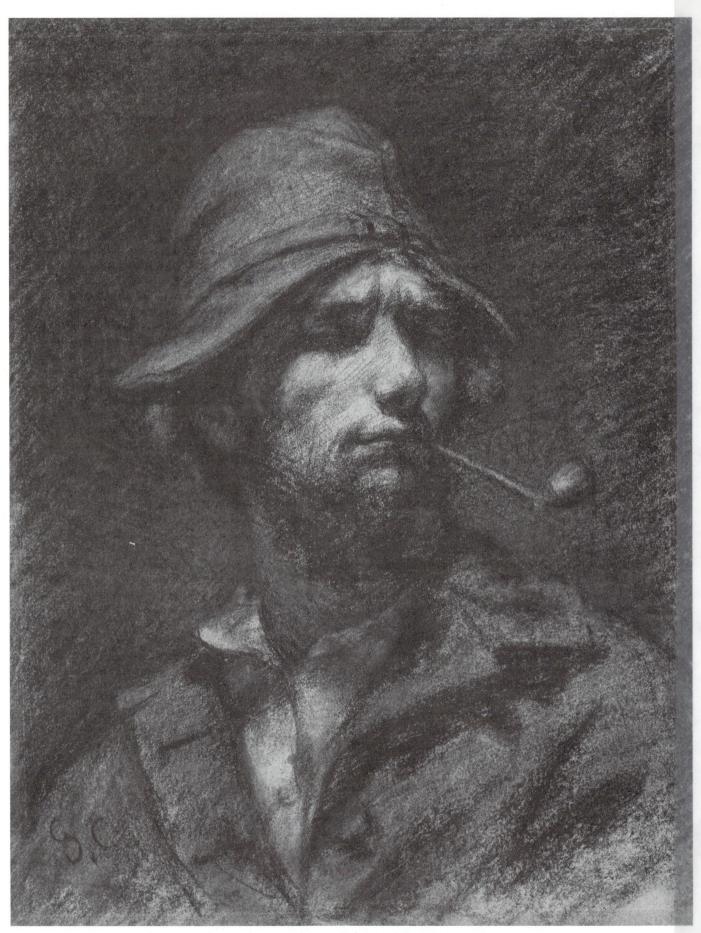

Gustave Courbet, French, 1819–1877, Self Portrait, c. 1849. Black chalk, $11\frac{1}{2} \times 8\frac{3}{4}$ inches. Wadsworth Atheneum Museum of Art, Hartford, CT. Purchased through the gift of James Junius Goodwin. 1950.605.

Drawing Essentials

A Guide to Drawing from Observation

Deborah Rockman
Kendall College of Art and Design

New York Oxford OXFORD UNIVERSITY PRESS 2009 Oxford University Press, Inc., publishes works that further Oxford University's objective of excellence in research, scholarship, and education.

Oxford New York Auckland Cape Town Dar es Salaam Hong Kong Karachi Kuala Lumpur Madrid Melbourne Mexico City Nairobi New Delhi Shanghai Taipei Toronto

With offices in Argentina Austria Brazil Chile Czech Republic France Greece Guatemala Hungary Italy Japan Poland Portugal Singapore South Korea Switzerland Thailand Turkey Ukraine Vietnam

Copyright © 2009 by Oxford University Press, Inc.

Published by Oxford University Press, Inc. 198 Madison Avenue, New York, New York 10016 http://www.oup.com

Oxford is a registered trademark of Oxford University Press

All rights reserved. No part of this publication may be reproduced, stored in a retrieval system, or transmitted, in any form or by any means, electronic, mechanical, photocopying, recording, or otherwise, without the prior permission of Oxford University Press.

Library of Congress Cataloging-in-Publication Data

Rockman, Deborah A. 1954-

Drawing essentials: a guide to drawing from observation/Deborah Rockman.

p. cm.

Includes bibliographical reference and index.

ISBN-13: 978-0-19-531432-8 (pbk.)

1. Drawing-Technique. I. Title.

NC735 R624 2009

741.2-dc22

2007035097

Printing number: 987654

Printed in the United States of America on acid-free paper

Contents

CHAPTER 1

Preface

xiii

Acknowledgments xv Introduction 1
Essential Skills and Information 4 What Every Student Should Know About Drawing
Sighting and the Use of a Sighting Stick 4 Why Use Sighting? 4 Guidelines for Sighting 5 Applications of Sighting 6 Transferring Sighting Observations to a Drawing Surface 13
The Technique of Scaling to Determine Accurate Size Relationships Establishing Scale Successfully 15 The Process of Scaling 16 General Guidelines for Scaling 18
The Principles of Composition: Theory Versus Application Review of Some Simple Definitions 24 Visual Principles of Composition 24 Variable Compositional Elements to Consider 26 Using a Viewfinder: What Does It Do for You? 28 General Guidelines Concerning Composition 34 Thumbnail Studies as a Method for Exploring Composition 37
The Golden Section 39 What Is the Golden Section? 41 Constructing a Golden Rectangle 42 The Fibonacci Series 44
The Illusion of Space and Depth on a Two-Dimensional Surface Methods for Indicating Space and Depth 46 Different Kinds of Space 50 The Volumetric and Spatial Effects of Color 50
Line Variation and Sensitivity 52 Working from General to Specific 52 The Medium and Surface 52 What Is Meant by "Sensitive" Line? 52 Achieving Line Variation and Line Sensitivity 53 Different Kinds and Functions of Line 59
Working with Value Structure 66 A General-to-Specific Approach to Building Value Structure 67 Using Value to Establish an Effect or a Mood 68

	Value and Texture 69 Four Things to Look for When Identifying Value Structure on a Form 73 Various Methods for Applying Value 74 Exercises for Promoting a General-to-Specific Approach 79 Controlling Some Variables of Value Structure 81
	Creating an Effective Still Life 81 What Kinds of Objects Should Be Included? 81 Additional Considerations for Still Lifes 83 The Meaning of Still-Life Objects 84 Using Photographic References 86
CHAPTER 2	Essential Drawing Principles in Relation to the Human Figure 88
	The Human Figure 88 Why Study the Human Figure? 88 Classroom Etiquette When Drawing from a Model 90 The Process of Sighting in Relation to the Human Form 91 Comparative Proportions in the Male and Female Figure 94
	Gesture Drawing or Rapid Contour Drawing Seeing Is the Key 99 Using Axis Lines 99 Keeping It Simple 100 Setting the Pace 100 Working from the Inside Out 101
	Enhancing the Illusion of Volume and Space in the Human Form Line Variation in Figure Drawing 101 Scaling Techniques in Figure Drawing 101 A General-to-Specific Approach to Form and Value in Figure Drawing 103
	An Introduction to Portraiture 104 Common Errors 105 General Guidelines for Locating Facial Features and Other Landmarks 106 The Features and Other Significant Aspects of Portraiture 109 An Alternative Viewpoint in Portraiture 118
	Mapping the Figure in Space 120 Drawing the Figure in an Observed Environment 120 Using Straight-Line Construction 121 Creating Visual Paths of Movement 122
	The Figure and Anatomy 123 Artistic Anatomy Versus Medical Anatomy 123 Anatomy Reveals Itself 124 Major Bones of the Human Skeletal Structure 132 Bony and Other Landmarks in the Figure 135

Superficial Muscles of the	Human Figure	135
Anatomical Terminology	139	

	2
CHAPTER	\cdot

Spatial Thinking and Visualization The Essential Principles of Perspective Drawing

Δn Ir	troduction	to	Perspective	140
All II	ıtıvuuctivii	ιυ	reispective	140

What Is Perspective? 140
Different Types of Perspective 140
Basic Principles of Linear Perspective 141
Perspective and Sighting 142
Limitations of Linear Perspective 142
Recommended Sequencing for Maximum Comprehension 143
Suggestions for Effective Perspective Drawing 144
Perspective Materials List 146

The Terminology of Perspective 147

Primary Working Terminology
Related Terminology 148
Additional Useful Terminology 148

Perspective and Cubes 149

Constructing a Cube in One-Point Perspective 149
Constructing a Cube in Two-Point Perspective Based on Estimation of
Cube Depth in Relation to Cube Height 151
Estimating Cube Depth in Two-Point Perspective 152

Using Perspective Grids 153

Constructing a Gridded Ground Plane in One-Point Perspective
Constructing a Gridded Ground Plane in Two-Point Perspective
154

Increasing Complexity in the Perspective Environment 158

Multiple or Sliding Vanishing Points 158
Cube Multiplication 158
Cube Division 161

Mathematically Precise Cubes in Two-Point Perspective 162

Constructing a 30°/60° Cube Based on Initial Determination of the Height of the Leading Edge 162
Constructing a 45°/45° Cube Based on Initial Determination of the Size of the Base Square 164
First Alternative Method for Constructing a 45°/45° Cube Based on Initial Determination of the Height of the Leading Edge 165
Second Alternative Method for Constructing a 45°/45° Cube Based on Initial Determination of the Height of the Leading Edge 166

Constructing Ellipses in One-Point and Two-Point Perspective 166

The Eight-Point Tangent System for Ellipse Construction 166
Major and Minor Axes, Distortion, and Fullness of Ellipses 167

Using Measuring Lines	for Regula	r (Equal) and	Irregular	(Unequal)
Divisions of an Area	169	-		•

Setting Up the Measuring Line 169 The Process of Dividing a Form 169

Applications for the Use of Regular (Equal) and Irregular (Unequal) Divisions

171

Inclined Planes in Perspective 171

Auxiliary Vanishing Points and the Vertical Trace 172

Geometric Solids and Transparent Construction 174

What Is Transparent Construction? 174
Establishing the Cubic Connection 175

Three-Point Perspective 178

Constructing a Form in Three-Point Perspective
Suggestions for Perspective Exercises 181

CHAPTER 4

Developing Ideas, Resolving Problems, and Evaluating Results 188

Ideation: Generating Ideas 188

Imaginative Thinking and the Brain 188
Imagination, Creativity, and Brainstorming

Diagnosing Problems in Your Work 190

Inaccurate Proportional, Scale, or Shape Relationships 190 Multiple Perspective Eye Levels 191

Foreshortening Inaccuracies or a Lack of Foreshortening 191

Flat and Restricted Line Work 192

Detail or Specifics at the Expense of the Larger and More General Underlying Forms

192

189

Scaling Inaccuracies in Relation to Perspective Principles 192

Lack of Volume or Timid Value Structure in Three-Dimensional Forms 193

Overly Generalized Drawing 193

Substituting Recipes or Formulas for Careful Observation 194

Unintentionally Ambiguous Space 194

Rigid or Pristine Drawings Lacking a Sense of Process 194

Disregard for or Poor Composition 194

Intentions Versus Results 194

Discovering Disparity 194
Descriptive Feedback 195
Interpretive Feedback 195

The Importance of Critiques 196

Group Critiques 197 Individual Critiques 197

Key Questions for Critiquing Work 198

Questions Regarding Composition 198

Questions Regarding Drawing 199
Questions Regarding Figure Drawing 199
Questions Regarding Perspective 200

CHAPTER 5

Drawing Materials and Processes

Media and Materials for Drawing 202

Traditional and Nontraditional Drawing Surfaces and Substrates
Traditional and Nontraditional Drawing Media
211
Additional Materials for Drawing and Related Processes
225

Transfer Techniques Combined with Drawing 225

Photocopy and Laser Print Transfers 228
Acrylic Medium Transfers 229
Lazertran Transfers 230

Appendix

Contemporary Art 234

A Gallery of Drawings

Joe Biel 235 Mary Borgman 238 Dustan Creech 241 Susan D'Amato 243 244 Bailey Doogan 247 Rob Evans Dan Fischer 251 Leah Gregoire Prucka 254 Sol Kjøk 256 Sangram Majumdar 259 262 Antony Micallef Chloe Piene 265 Ben Polsky 267 269 Jennifer Purdum 272 Jon Rappleye 276 Robert Schultz 280 Jenny Scobel 282 Joseph Stashkevetch Richard Talbot 284

Bibliography 287 Index 289 202

Preface

As a practice that has been a significant aspect of art making for centuries, the definition of drawing has grown increasingly fluid in postmodern culture, embracing traditional practices of drawing as well as more experimental and pluralistic contemporary practices. Drawing, along with other disciplines, is responding to the increasing dissolution of discipline-based boundaries, as evidenced in the work of many contemporary artists and in the structure of many B.F.A. and M.F.A. programs around the country. Consequently, drawing continues to stand in both tradition and innovation, depending upon the artist's desire.

This duality of tradition (based on historical notions of drawing) and innovation (based on contemporary notions of drawing) is, in my experience, one of the hallmarks of a successful drawing program, and it forms the basis for the drawing program at Kendall College of Art and Design. Drawing is offered as a concentration in both the B.F.A. and M.F.A. programs and provides support courses to both fine arts and applied arts programs throughout the college. Initial course work in the undergraduate fine art program provides students with strong fundamental skills and experiences rooted in tradition, while intermediate and advanced course work progresses toward a broad working definition of drawing that supports students whose technical emphasis is more traditional as well as students who wish to expand upon or work outside of a traditional definition of drawing.

Regarding the definition of drawing, it is increasingly difficult to clarify what is or is not a drawing in artworks that do not fit cleanly within narrow definitions or clearly defined discipline-based boundaries. In fact, it is often easier to determine what is *not* a drawing. Although the definition of drawing as a material practice is fluid, embracing both traditional definitions and revised contemporary definitions of drawing, obvious instances remain when work is *not* a drawing—for example, oil paint on canvas is generally not considered a drawing.

But still we grapple with definition. Drawing is sometimes defined as any work on paper that is not specifically photography or printmaking. But consider the work of Whitfield Lovell, who draws with charcoal on reconstructed plank walls from slave-era dwellings; or Leah Gregoire's soft graphite drawings on glass; or Sol Lewitt's wall drawings that

are executed by others based on his instructions; or the work of Jennifer Pastor, Mary Borgman, and Wangechi Mutu, all of whom draw on mylar; or Jenny Scobel's graphite drawings on gessoed panels that are sealed in wax, a substrate and material typically associated with painting.

Drawing is sometimes defined in terms of materials or media so that drawing material on any surface, paper or not, is defined as a drawing. But how do we define drawing material? There is no question that charcoal, graphite, conte, and ink are drawing materials, although they often show up as elements in work from other disciplines. What about ink washes? On paper, they are considered drawings. Does this mean that watercolor on paper is also a drawing medium? If not, then the notion of paper as a drawing substrate is negated.

Drawing has historically been thought of as intimate or small in scale, although we know that this limited definition is no longer valid. Drawings have exploded in scale, in part because they have been liberated from the traditional paper substrate and in part because paper manufacturers are producing larger sheets and oversized rolls of high-quality paper that allow for large-scale works. Some examples of drawings that move outside of the frame and emerge from beneath protective glass include Toba Khedoori's wall-size graphite drawings, Julie Mehretu's explosive mixed-media drawings, the large-scale drawings of Los Carpinteros (a Cuban collaborative group), Ben Polsky's oversized carbon transfer drawings on paper, and Robert Longo's ongoing series of wall-size charcoal and ink drawings on paper. In some cases large paper pieces hang freely on the wall, while in other instances the paper is mounted on wood or a stretched canvas backing for additional support.

Drawing is sometimes defined as achromatic, lacking any significant use of color. This particular definition of drawing discounts the primary role that color can play in drawing and does not take into account the use of colored pencil, chalk pastel, oil pastel, and other color media that are often used in the context of drawing. Consider the work of Julie Mehretu that explodes with color; Elizabeth Peyton's colored pencil and watercolor drawings; the mixed-media color drawings of Jockum Nordstrom, Shahzia Sikander, and Rob Evans; Steve DiBenedetto's vibrant colored pencil works

on paper; or Amy Cutler's gouache on paper drawings. It should be noted here that a number of works reproduced in *Drawing Essentials* include color in the original work. My decision to publish all illustrations in black and white was based on the affordability of this text, as any color printing drives the cost up excessively and places the book outside the financial reach of many students.

Many contemporary art organizations, exhibitions, and publications, such as the Drawing Center in New York City, Drawing Now: Eight Propositions (Museum of Modern Art, 2002), and Vitamin D: New Perspectives in Drawing (Phaidon Press, 2005), increasingly interpret drawing as broadly as possible, encompassing both draftsmanship and experimental art to emphasize the complexity, variety, innovation, and relevance of the practice of drawing in contemporary art. Some of the materials and supports that comprise this expanded definition of contemporary drawing include graphite, charcoal, ink, watercolor, gouache, pencil, crayon, conte, acrylic, felt-tip pen, colored pencil, marker, gunpowder, ballpoint pen, oil, latex paint, carbon paper, chalk, chalk pastel, correction fluid, cut paper, wax, gesso, silverpoint, carbon, paper of all kinds (including gessoed paper, tracing paper, vellum, mylar, newspaper pages, craft paper, and found paper), photographs, photocopies, raw wood, painted or prepared wood, acetate, blackboard, cardboard, walls, and canvas.

In an essay by Claudine Ise, co-curator of *International Paper: Drawings by Emerging Artists*, an exhibition held at UCLA's Hammer Museum in 2003, she writes,

[D]rawing is an age-old practice that nevertheless continues to inspire innovation and experimentation among artists today. This exhibit explores the broad range of techniques and approaches that one finds in drawings today—including the use of watercolors, gouache, graphite, and colored pencil, along with paper cut-outs, mixed-media collage, and scored and folded vellum—and includes both representational and abstract works and large- and small-scale drawings.

In 2005, The Museum of Modern Art in New York announced the addition of nearly 2600 drawings by more than 640 major and emerging artists toward the achievement of its goal to assemble "the widest possible cross section of contemporary drawing made primarily within the past 20 years. These new works demonstrate the richness and complexity of the medium of drawing and its central position in the artistic process, and catapults the Museum's collection into an unequaled position for contemporary drawing."

The cover of the January 2006 issue of *Artnews* featured a drawing by Artura Herrera with the caption *The Big Draw*.

Written by Hilarie M. Sheets, a writer for the *New York Times* and contributing editor for *Artnews*, the feature story addressed the changing nature of drawing.

From fractured fairy tales to abstract geometries to observations of the night sky, drawing is becoming many artists' primary medium.... [D]rawing's informality and immediacy have long made it an essential part of the creative process of most artists. Since the time of the Renaissance guilds, it has been used as a preparatory tool for painting or sculpture, yet artists from Leonardo to Watteau to Ensor have prized their drawings as finished works. More recently, drawing flourished among conceptual artists of the 1960's and 1970's, who found that its notational quality suited their process-oriented art. What is striking today, however, is that a growing number of artists are choosing drawing as their primary medium.

It is clear that contemporary drawing is alive and well and receiving considerable critical attention as a force to be reckoned with in contemporary art, particularly in the hands of the upcoming generation of younger artists. Although many institutions that prepare students to be working artists are grappling with how to structure or restructure their drawing program, there is no mandate requiring that visual art programs choose either tradition or innovation, choose one at the expense of the other. They are not mutually exclusive. There is in fact a continuum between the most traditional of approaches to drawing and a drawing practice that is inspired by experimentation and innovation.

Within my own practice as an artist and a teacher, I believe in the significance of introductory experiences that acknowledge and embrace the technical and formal traditions of drawing, ultimately providing the context for a broader scope of contemporary drawing practices. Students benefit from exploring both objective observation and subjective interpretation with emphasis on the interdependence of process and product. At more advanced levels a broadened exploration of drawing includes alternative and mixed-media drawing processes as potential elements in the advanced investigation of drawing as a vehicle for personal expression. Drawing thrives as an independent discipline, as an element of mixed-media investigation, and as a vital resource for the investigation of other disciplines.

It is my hope that *Drawing Essentials* will provide a resource for any student who is passionate about learning to draw. I am confident that the instruction and guidance offered here provide a solid foundation for further investigation of drawing and related disciplines at both a personal and advanced level.

Acknowledgments

Many people have encouraged, supported, and assisted me in preparing *Drawing Essentials*.

Thanks to Paris Tennenhouse, Daniel Dauser, Heidi Gidley, Corrie Eagly, Regina Salmi, Linda and Scott LaFontsee, Andrea Myers, and Diane Griffin for your friendship, for making me laugh, and for helping me see the light at the end of the tunnel. Thanks to Wendy Taylor and Cheryl Hemmer for walking the path with me.

Thanks to the special children in my life—Ruby, Evelyn, and Jenna. You bring me so much joy.

Thanks to Kelly Allen for meeting my every request with a smile and to Susan Bonner for technical support. Thanks to Sandra Starck, University of Wisconsin at Eau Claire, for great suggestions and professional feedback. Thanks to Perin Mahler for sharing teaching techniques.

Thanks to my students. It is all of you who inspire me most to share my experience of teaching and my passion for drawing. The illustrations of your work breathe life into my words.

Thanks to my colleagues at Kendall College of Art and Design from whom I have learned so much over the years. Special thanks to Dr. Oliver Evans and Kendall College of Art and Design for providing me with release time and technical/financial support to work on *Drawing Essentials*.

Thanks to my editor, Jan Beatty, for encouraging me to write another book. Thanks to all the people at Oxford University Press who have assisted me in so many ways, especially Barbara Mathieu, Production Editor; Evelyn O'Shea, Senior Designer, Michele Kornegay, Copyeditor; and Cory Schneider, Editorial Assistant.

Many colleagues across the country provided valuable feedback in response to my manuscript, and I am grateful for your praise, your suggestions, and your efforts on my behalf. Thanks to Karen Bondarchuk of Western Michigan University, Dylan Collins of Southeast Missouri State University, Bruce Erikson of Xavier University in Cincinnati, Ohio, Nan Freeman of the School of the Museum of Fine Arts in Boston, Lari Gibbons of the University of North Texas, Sally Lee of the Massachusetts Institute of Technology, Jerry Schutte of Arizona State University, Sandra Starck of the University of Wisconsin–Eau Claire, and Deborah Wall of the University of North Caroline–Charlotte.

Finally, and most importantly, love and thanks to my partner and my family. Your encouragement and support never waver.

•	

Drawing Essentials

Introduction

In 2000, I published my first book, *The Art of Teaching Art:* A Guide to Teaching and Learning the Foundations of Drawing-Based Art. This book reflected my concern for the preparation of teachers and the quality of teaching in higher education, specifically the teaching of drawing as a fundamental discipline for developing artists.

While M.F.A. curriculums are intended to educate professional artists, the M.F.A. degree is also widely recognized by colleges, universities, and accrediting institutions as the only formal requirement for teaching studio art at the post-secondary level. But few M.F.A. programs seriously address teacher preparation as an in-depth component of their curriculum. The end result is often one of frustration for everyone involved—a dissatisfying teaching experience for the fledgling instructor and an inadequate learning experience for the student that translates into additional frustration as the student finds herself or himself insufficiently prepared for more advanced course work.

Most frequently, graduate teaching assistants are assigned to foundation level courses. The significance of the foundation experience for students of visual art cannot be overstated. The quality of this introductory experience has the power to broadly influence a student's long-term attitude toward his or her education in the arts. In considering all the variables involved in a student's educational environment, including facilities, geographical location, student/teacher ratios, diversity in the student body, socioeconomic and educational background, and availability of scholarships, grants, and other financial aid, no factor is more important than the teacher. She or he has the capacity to create an atmosphere of wonder, confidence, and enthusiasm for the experience of learning-or to create an atmosphere of dread, defeat, and discouragement. As the facilitator of the learning experience, the instructor's knowledge base, communication skills, self-confidence, preparedness, and enthusiasm for teaching are vital to a positive experience for both the students and the instructor. When I wrote The Art of Teaching Art, I asked myself, "What are we doing to help prepare new teachers, and how are we facilitating their transition from graduate student to teacher?"

Seven years later, I find myself writing what I consider to be a companion book to *The Art of Teaching Art*. While my first

book was written for teachers, Drawing Essentials: A Guide to Drawing from Observation is written for students. Unlike some drawing textbooks, Drawing Essentials does not specifically address contemporary art movements or the history of drawing, nor is it focused on extensive experimentation. While I consider these issues to be important and vital parts of any art student's educational experience, my primary focus here is on essential foundational experiences that provide a rich context for more advanced and experimental explorations of drawing and related disciplines and that help to clarify the relationship of drawing to both contemporary and historical paradigms for the creation of art. Drawing Essentials provides a no-frills, nuts-and-bolts approach that addresses foundation level drawing based on the classic model of highly attuned observational drawing. It is intended for use in the classroom by those instructors who believe, as I do, that a comprehensive understanding of the fundamentals best prepares a student for more advanced and experimental investigations of drawing and the myriad possibilities it offers.

Drawing Essentials thoroughly addresses the three drawing subcategories that are generally considered most important at the foundation level—basic drawing (non-subject specific), figure drawing, and perspective drawing—and explains clearly and in depth the most essential elements necessary for depicting the illusion of form and space on a two-dimensional surface. Drawing Essentials is unique in that it clearly and thoroughly explains and illustrates key studio experiences that are not, in my estimation, satisfactorily fleshed out for students in other widely used drawing textbooks currently on the market.

Drawing Essentials is organized in terms of both direct studio experiences that are necessary for a solid and thorough two-dimensional foundation education and supplemental information that facilitates and informs the drawing experience. Emphasis throughout the book is placed on the cultivation of observational skills, increased sensitivity, technical refinement, critical thinking, and knowledge of materials. Numerous illustrations are provided with captions that clarify the primary technical, formal, and/or conceptual concern of each piece.

Chapter One addresses drawing experiences that are broadly applicable to any subject matter. Included are sighting methods for observing and recording relative proportions, the relationship between parts and the whole, and an explanation of how and why sighting works; scaling techniques for determining consistent size relationships and placement of multiple forms in a spatial environment; a comprehensive outline of fundamental compositional concerns, including a discussion of viewfinders and the ways in which they aid composition, the visual principles of composition, compositional variables, and the significance of thumbnail studies; a discussion of the Golden Section as an organizational and compositional device and its relationship to the Fibonacci Series; methods for developing the illusion of space and depth on a two-dimensional surface, including basic spatial and tonal aspects of color as an extension of achromatic drawing; techniques for creating meaningful line variation that communicates form, volume, and space; guidelines for observing and addressing tonal or value structure and how to utilize a general to specific method of tonal development; and considerations for creating and lighting an interesting and instructive still-life arrangement.

Chapter Two explores the relationship between basic drawing principles and the application of these principles to the unique challenges presented by the human form and introduces vital information that is specific to studying and drawing the figure. Included are guidelines for classroom etiquette when drawing from a model, the application of sighting in relation to the human figure, a comparison of male and female proportions, key elements of gesture drawing, consideration of volume and space in relation to the figure, an in-depth discussion of portraiture, exercises for "mapping" the figure in an observed spatial environment, the importance of artistic anatomy in the study of the figure, and a comprehensive outline of significant skeletal and muscle structure that forms the basis for understanding artistic anatomy.

Chapter Three focuses on clear and thorough explanations and illustrations of perspective with the intention of demystifying this often-intimidating subject and is presented in a sequential manner so that each new area of investigation builds naturally on prior information to maximize comprehension. Both technical and freehand perspective is introduced with an emphasis on the significance of a "perfect" cube as the geometric basis for creating a wide variety of forms and structures that define and describe space and volume. Following a discussion of the importance of proficiency in perspective and a list of relevant materials, tools, and vocabulary terms, clear and concise instructions are given for one- and two-point cube construction and estimation of cube depth. An understanding of basic cube

construction provides the building blocks (quite literally) for in-depth investigations of gridded ground planes; cube multiplication and division; construction of ellipses; inclined planes such as stairways, rooftops, and box flaps; geometric solids derived from cubes; and transparent construction as a method for drawing a variety of cube-based objects. Additional information includes the appropriate use of sliding and multiple vanishing points, specific instructions for creating 30°/60° and 45°/45° cubes, and the use of measuring lines for exploring regular and irregular cube division and multiplication. This is followed by an introduction to three-point perspective as a more dramatic extension of one- and two-point perspective. Finally, suggestions are offered for drawing exercises that offer opportunities for a more creative exploration of both technical and freehand perspective.

Chapter Four begins with a discussion of the process of self-evaluation and evaluation of the work of others. Suggestions are made for identifying technical and formal problems that repeatedly surface in foundation level work, with guidance provided for identifying and diagnosing what ails a drawing and what is required to facilitate progress and improvement. The importance of critiques is discussed in the context of both group critiques and individual critiques, citing the unique aspects and advantages of each. Key questions that should be considered when critiquing are provided to help guide the process of identifying strengths and weaknesses in one's own work and the work of others.

Chapter Five provides an extensive discussion of drawing materials and elaborates on both traditional and nontraditional drawing media, drawing papers, and other substrates. Included are instructions for alternative processes that can be combined with drawing, such as photocopy or laser print transfers and Lazertran transfer processes that expand the experience of drawing. Numerous drawings and mixed-media work by advanced students and widely recognized contemporary artists are provided as visual examples of various drawing media, substrates, and transfer processes.

Finally, the Appendix features the work of nineteen contemporary artists whose studio practice is centered on drawing and whose work both reinforces and expands upon the traditional definitions of drawing. A brief discussion of the conceptual emphasis of each artist's work provides a framework for understanding his or her intentions.

Unlike many drawing textbooks that rely primarily on illustrations by historical masters and some contemporary artists, many of the illustrations accompanying the text of *Drawing Essentials* are student works created by students at

all levels who have studied at Kendall College of Art and Design. This is important because students of drawing have many resources for viewing the work of established artists, but for the beginning student, a textbook full of masters' works can be intimidating and even discouraging. To see what other students can accomplish using *Drawing Essentials* as a course of study establishes more accessible goals based on the work of peers. *Drawing Essentials* also provides powerful examples of what more advanced students can accomplish with a strong foundation drawing background. Additionally, carefully selected drawings by historical masters and contemporary artists throughout the book highlight the accomplishments of the masters and the significance of drawing in contemporary studio practice.

While there are some very good books that address basic drawing, figure drawing and anatomy, and perspective drawing, *Drawing Essentials* brings these subjects together both as an affirmation of what areas of study should comprise a foundation drawing experience and to provide a single source for the study of these essentials of drawing. *Drawing Essentials* reflects a collective belief that drawing is the backbone for nearly all of the visual arts. Whether it is used as an end unto itself or as support for other forms of expression (painting, printmaking, sculpture, illustration, storyboards, furniture design, industrial design, interior design, architectural blueprints, advertising design, etc.), the ability to draw is an invaluable skill and drawing is an exquisitely expressive medium.

Drawing Essentials is the culmination of over twenty-five years of teaching experience and represents my passion for drawing, my love for teaching and learning, and my desire to assist students in their pursuit of excellence. Without

question, the student of drawing embarks on a journey of great challenge, reward, and personal responsibility. In the preface to his book *Drawing* (1967), the late Daniel M. Mendelowitz of Stanford University wrote most eloquently about the role of drawing in the education of today's artists. Although written over forty years ago, much remains true today:

Drawing has reappeared as one of the cornerstones of art training....[C]olleges, universities, and professional art schools, like the academies of the past, again commence the artist's training with drawing, and while much latitude prevails as to the content and procedures in today's drawing classes, certain convictions seem widely shared. First it is generally agreed that, well taught, drawing establishes a habit that is fundamental to expression in the visual arts, the habit of looking, seeing, and expressing one's perceptions in graphic, painterly, or plastic form. Second, drawing familiarizes the beginner with certain elements of the artist's vocabulary-line, value, texture, form, space-and also color, for even when drawing is limited to black and white, an increased consciousness of color often accompanies the greater awareness of the external world that is experienced when individuals commence to draw....In the final analysis it is the more incisive awareness of the concrete, visual world that is the artist's most precious heritage, and it is stimulated more by drawing than by any other activity.

Whether...a professional artist, a student with professional ambitions, or an alert, uncommitted observer with a lively interest in the arts, it is the total engagement of mind with eyes, hands, body, and feelings that will make possible drawing as a genuinely creative act and bring about the taste and judgment essential to artistic growth and enlightened connoisseurship.

Essential Skills and Information What Every Student Should Know About Drawing

Sighting and the Use of a Sighting Stick

Some of you have been introduced to sighting, and some of you have not. Even for those of you who have been introduced to this method of observation, students often acknowledge that they go through the motions of sighting without really understanding what they are doing and why it works. In this situation, sighting provides little assistance to you and may simply contribute to a sense of frustration and confusion. A basic understanding of the principles of sighting goes a long way in helping you to embrace and use the process to your advantage.

Why Use Sighting?

Many of you have found that you are shining stars when it comes to copying photographs or working from other existing two-dimensional sources. But you may be confounded when you discover that drawing from observation of three-dimensional forms does not yield the same results, the same degree of accuracy to which you are accustomed. It is helpful to understand why this occurs.

Drawing or representing a three-dimensional object on a two-dimensional surface requires in essence a language translation. The language of two dimensions is different than the language of three dimensions in that three dimensions have depth, occupying space both up and down, side-to-side, and forward and backward. You must observe the three-dimensional form and translate it into a language that will be effective on a two-dimensional surface, such as a piece of drawing paper. When you draw from an existing two-dimensional source, such as a photograph, the translation from 3-D to 2-D has already been made for you. But when you are referring to the actual form in space, you must make the translation yourself. The process of sighting provides a great method for making this translation easily and effectively.

Guidelines for Sighting

A sighting stick is the basic tool for the process of sighting. I recommend using a 10" to 12" length of ¹/₈" dowel stick. Suitable alternatives include a slender knitting needle, a shiskebab skewer, or a length of metal cut from a wire clothes hanger. Your sighting stick should be straight. I discourage the use of a drawing pencil as a sighting stick simply because the thickness of the pencil often obscures information when sighting. A more slender tool interferes less with observing what is being drawn. However, in the absence of a more suitable tool, a pencil will suffice. Some people like to add color to their sighting stick so that it is visually distinct from what they are observing.

It can be helpful when learning how to sight if you initially practice making your observations from a projected slide or an enlarged image of a still life or a figure. If you choose to do this, the 2-D image you are sighting should be large enough to see with ease and should be positioned on a wall far enough away from you so that you can fully extend your arm. Sighting from two-dimensional information is much easier than sighting from three-dimensional information because the image is already in a 2-D language. Once you begin exploring sighting in relation to actual three-dimensional objects, you will recognize the increased complexity.

Because the objective of sighting is to translate observed information into a two-dimensional language, all of your sighting observations will take place in an imaginary two-dimensional plane that is parallel to your face. It may be helpful to imagine that a pane of glass is floating directly in front of your face at arms length. If you are looking straight ahead, the pane of glass is parallel to your face. If you are looking up to make your observations, the pane of glass tilts along with your head and remains parallel to your face. If you are looking down, the pane of glass again tilts along with your head. It is *always* parallel to the plane of your face. This imaginary pane of glass represents your picture plane or your drawing surface, and all of your measurements and observations will take place in this two-dimensional plane.

Always keep your arm fully extended and your elbow locked when sighting. This establishes a constant scale, which is especially important when you are sighting for relative or comparative proportional relationships. You can rotate your sighting stick to the left or right, but you cannot tip your stick forward or backward. This is especially tempting when sighting things that are foreshortened. You can reinforce keeping the sighting stick within the 2-D pane of glass by imagining that if you tip the stick forward or backward, you

will break through the pane of glass. It is also helpful to close one eye when sighting, which further reinforces the translation to a two-dimensional language by using monocular vision (one eye) that flattens what you see rather than binocular vision (two eyes).

If more than one object or a still-life arrangement of multiple objects is to be drawn, you must begin by establishing which object will serve as your *point of reference* or *unit of measure*. Ideally it should be an object that you can see in its entirety and that can be visually broken down into at least two observable relationships—height and width (Figures 1-1 and 1-2). When working with the human figure, the head serves as a good unit of measure (Figure 1-3). In instances where the head is not visible or partially obscured, another unit of measure will need to be established.

When sighting, you are often dealing with what I refer to as "landmarks." A landmark is any point on any form that you can find or refer back to over and over again, a point that is identifiable. Landmarks usually occur at places where

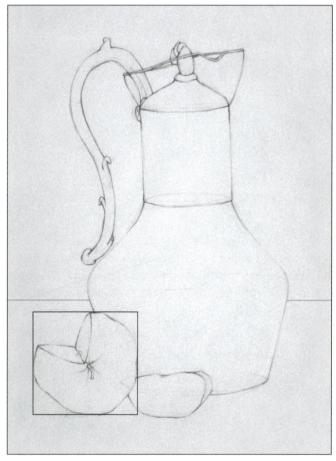

Figure 1-1. Student work. Jennie Barnes. The apple in the foreground of this simple still-life arrangement, boxed in to show relative height and width, is an effective unit of measure.

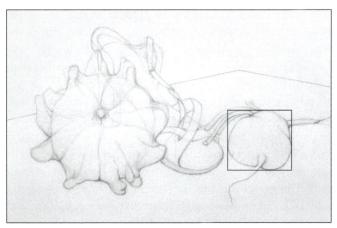

Figure 1-2. Student work. Jennie Pavlin. The extensions of the beet (root and stalks) are extraneous to the main body of the form, and so are initially excluded in sighting the height and width relationship.

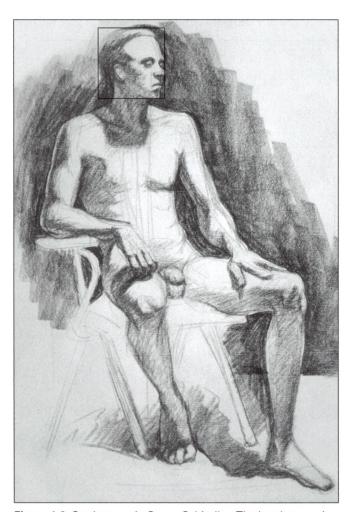

Figure 1-3. Student work. Gypsy Schindler. The head as a unit of measure is sighted from farthest points left to right and farthest points top to bottom.

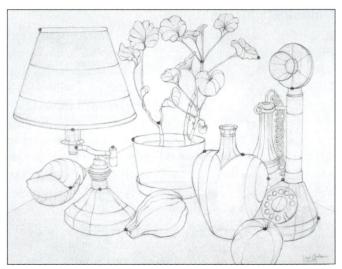

Figure 1-4. Student work. Lea (Momi) Antonio. Numerous landmarks in this still-life drawing, which do not have a particular name for identifying them, are indicated by gray dots.

different parts of a form meet or come together (also called *points of articulation*), or where there is a sudden directional change found along the edge or surface of a form, or where forms meet or overlap. It will not necessarily have a name and will not necessarily appear to be a significant part of the object being drawn, but it will be an easily identifiable reference point (Figure 1-4).

Applications of Sighting

There are three essential uses for sighting that aid in observing and recording information accurately. The first deals with relative or comparative proportional relationships, the second deals with angles and their relationship to verticals and horizontals, and the third deals with vertical and horizontal relationships between various points or "landmarks."

First Application: Sighting for Relative Proportions

Before beginning the actual sighting process, it is helpful to observe the form(s) you wish to draw (ideally through a viewfinder) and do a delicate gesture drawing based on what you see. This helps to "break the ice" of a blank piece of paper and gives a sense of how the objects being referred to will occupy the paper surface. More information on using a viewfinder is found later in this chapter.

In beginning the actual sighting process, remember that your point of reference should be sighted and drawn first (Figure 1-5). By aligning one end of the sighting stick visually with one part of a form and placing the tip of your thumb on

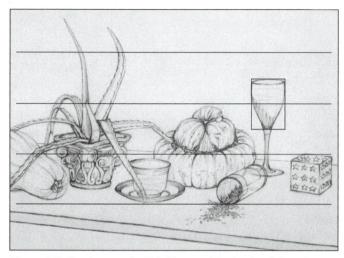

Figure 1-5. Student work. Kirk Bierens. The body of the wine glass has been chosen as a unit of measure. Horizontal lines show the height of the unit of measure in relation to the entire still life.

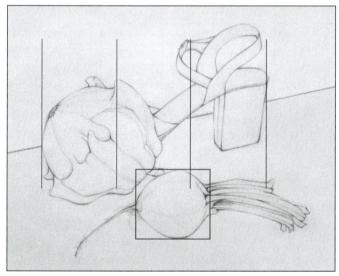

Figure 1-6. Student work. Emily LaBue. The body of the beet, which serves as the unit of measure, is isolated from the root and the stalks that are added later. Vertical lines show the width of the unit of measure in relation to the entire still life.

the sighting stick so that it corresponds visually with another part of that form, you are able to make a relative measurement of the distance between any two parts or points. By understanding this simple procedure, you can apply sighting techniques in a number of ways to help you attain greater accuracy in your drawings. When sighting for relative or comparative proportions, begin by sighting to establish the relationship between the total width of the form (distance from farthest left to farthest right point) and the total height of the form (distance from highest to lowest point) (Figure 1-6).

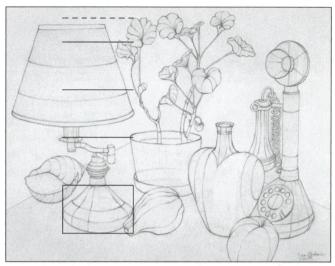

Figure 1-7. Student work. Lea (Momi) Antonio. The lamp has numerous parts, making it more complex than other forms. The relative simplicity of the base of the lamp, with a clearly defined width and height, is helpful in defining the proportions of the rest of the lamp. The broken line indicates half the height of the unit of measure.

For example, you can sight the width of a fruit or vegetable or a bottle at its widest point by extending your sighting stick at arms length and recording the distance from one edge to the other through the placement of your thumb on the stick. Keeping your thumb in position on the sighting stick, rotate the stick to a vertical position and observe how many times the width of the form repeats itself in the height of the form. You can then maintain this same relationship in your drawing, regardless of how large or small you choose to represent the object on your drawing surface. I recommend that you sight what you perceive to be the smaller measurement first, and then compare that smaller measurement to the larger measurement. Remember to begin the process by observing what you wish to use as your unit of measure.

Begin to visually break the object down, if it is more complex, into component parts, sighting the size relationships between different parts. Work from general to specific, observing and recording the larger, simpler relationships first before attending to more detailed information (Figure 1-7). When sighting, sight from one landmark to another whenever possible. Develop your drawing using the size relationships that you observe (Figure 1-8). Sighting can be applied horizontally, vertically, or diagonally. These same size relationships can be observed between an object or part of an object and other objects or their parts. In this way, it is possible to maintain an accurate size relationship between all the component parts of a more complex form or between the various individual forms found in a complex still life.

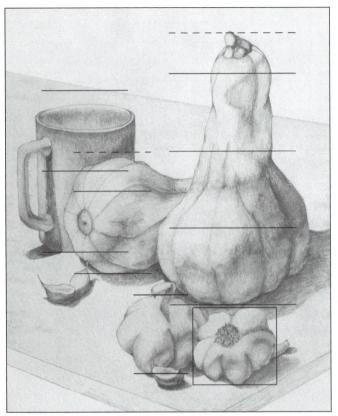

Figure 1-8. Student work. Sheila Grant. The garlic bulb in the foreground is the unit of measure. Its height in relation to each individual form in the still life is shown. Broken lines indicate half the height of the unit of measure.

Foreshortening can be especially challenging since it is often recorded with a significant amount of inaccuracy and distortion. This is because our experience or knowledge will often override what is visually presented before us. For example, a bottle lying on its side can provide a foreshortened view that measures wider from side to side than it does in length from top to bottom (Figure 1-9). Because of our experience of the bottle as an object that is generally greater in length than in width, we bypass what is observed and draw what we "know" a bottle to look like. This then creates problems in presenting a convincing illusion of a foreshortened bottle resting firmly on its side.

While sighting is an ideal way to overcome this inaccuracy, there are a few things to be particularly attentive to when dealing with foreshortening. First, be aware of the fact that when foreshortening is evident, the apparent relationship between the length and width of forms is altered to varying degrees, depending on the severity of the foreshortening. While the length may appear to "compress" considerably, the width may remain relatively unaltered (Figure 1-10). Second, be on guard against tilting your sighting stick

Figure 1-9. Student work (detail). Laura Gajewski. In this foreshortened view, the height and width of the bottle are nearly the same. The height of the bottle would be nearly twice the width if the bottle was not foreshortened.

Figure 1-10. Student work. Ann Drysdale Greenleaf. In this foreshortened figure study, the length of the torso from shoulders to buttocks is significantly compressed, measuring less than half the width of the hips. Because of this extreme foreshortening and the position of the body, the legs and feet are not visible at all.

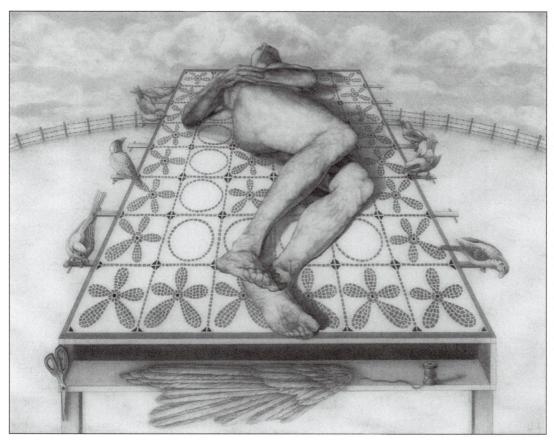

Figure 1-11. Leah Gregoire Prucka, American, Garden Series: If Given Wings..., 1999. Graphite on prepared glass, $9 \times 11\frac{1}{2}$ inches. Courtesy of the artist. Note the instances of overlapping in this foreshortened figure. The toes of the figure's right foot overlap the foot, the foot overlaps the lower leg, the lower leg overlaps the thigh, the thigh overlaps the buttocks. and the hip contour overlaps the torso. These overlaps, which are vital to conveying a convincing illusion of foreshortening, would be lacking or far less significant if this figure was standing.

in the direction of the foreshortened axis. This is easy to do without even being aware of it. If your measurement is no longer being taken in the imagined 2-D picture plane, it will not present an accurate translation from the 3-D form to the 2-D surface of the drawing. A final note regarding foreshortening. Be aware that instances of overlapping, where one part of an object meets another part, are more pronounced and dramatic in a foreshortened view and require greater attention to the interior contours that give definition to this (Figure 1-11).

Second Application: Sighting for Angles and Axis Lines in Relation to Verticals and Horizontals or in Relation to the Face of a Clock

An axis line is an imaginary line that runs through the core or the center of a form. A major axis line indicates the longest or most dominant directional thrust of that form. A minor axis line typically is at a right angle to a major axis line. More complex objects can have more than one axis line, as there may be thrusts in a number of directions (Figure 1-12). By determining the correct angle of the axis line, one can then begin to draw the edges and contours of a form around the axis line to determine the correct directional thrust.

Observed angles may be very obvious (such as the angle found along the edge of a box or a table) or less obvious (such as the implied angle found along the edge of a shoe). Regardless of whether the edge observed is an obvious, straight-edged angle or a less obvious, implied angle, it can be sighted to provide for greater accuracy. Simply align your sighting stick visually along the observed edge or axis (without tipping your stick forward or backward!) and observe the relationship between the angle (indicated by the position of your sighting stick) and a true vertical or horizontal, whichever it relates to more closely (Figure 1-13). When drawing the angle, maintain the same relationship to a vertical or horizontal that you observed. The left and right sides of your drawing paper provide fixed verticals for comparison, and the top and bottom of your drawing paper provide fixed

Figure 1-12. Student work. Glenda Sue Oosterink. A number of different axis lines can be found in this drawing of a seated figure. The angles of these axis lines are compared to fixed verticals and/or horizontals, established by the edges of the drawing paper and by the vertical and horizontal line drawn through the center of the drawing surface.

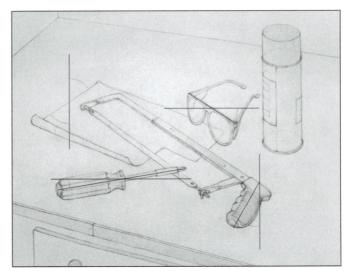

Figure 1-13. Student work. Scott Luce. A number of angles and axis lines are identified in this still life—the angle of the paper's edge, the angle of the screwdriver, the angle of the glasses' frame, and the angle of the handle of the saw. Note their relationship to the verticals and horizontals provided and the degree to which they vary from the vertical or horizontal.

Figure 1-14. Student work. Clarkson Thorp. Both major and minor axis lines are identified in this still life, as well as the verticals and horizontals provided for comparison of observed angles.

horizontals for comparison. If you need more guidance, you can lightly draw a few more vertical and horizontal lines through your drawing format against which to compare sighted angles, and these can be erased when they are no longer needed (Figure 1-14).

A second approach can be used to help you correctly record the angle that you observe with your sighting stick.

After you have aligned your sighting stick along the edge/angle that you are observing, imagine that your sighting stick is running through the face of a clock and relate it to a specific time of day—1:00, 10:30, and so on (Figure 1-15). The observed angle can then be duplicated in your drawing, keeping in mind its relationship to the face of a clock (Figures 1-16 and 1-17).

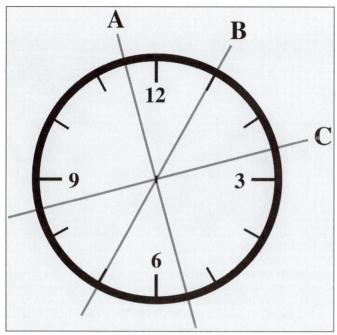

Figure 1-15. Imaginary clock face for sighting angles. Angle A is at 5:30 or 11:30, angle B is at 1:00 or 7:00, and angle C is at 2:30 or 8:30.

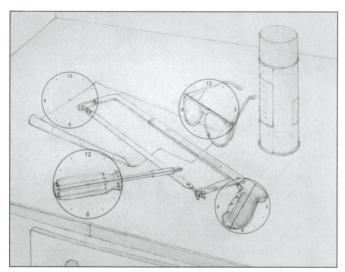

Figure 1-16. Student work. Scott Luce. The same still life used in Figure 1-13 is shown using the clock face method for determining observed angles.

Third Application: Sighting for Vertical and/or Horizontal Alignments Between Two or More Landmarks

Sighting for vertical and horizontal alignments can be applied to a single form (such as the human figure) or to a grouping of forms (such as a still life). This sighting process

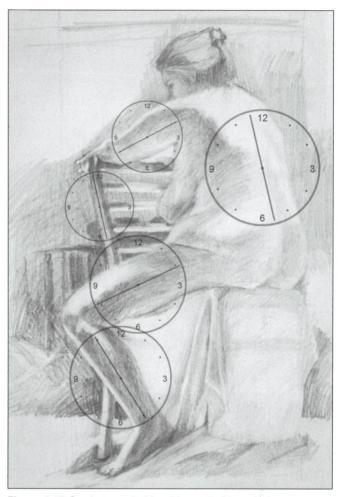

Figure 1-17. Student work. Matt Maxwell. Observed angles and axis lines in the figure can be determined using either of two methods—comparison to a vertical or horizontal or use of an imaginary clock face, as shown here.

is closely related to sighting for angles and axis lines but is used to observe a vertical or horizontal alignment (or a deviation from a vertical or horizontal alignment) that is less apparent or to observe a vertical or horizontal alignment between more distant reference points. It is useful for observing the correct position of one part of an object in relation to another part or for observing the correct position of one entire object in relation to another entire object.

To seek out these "plumb" lines or alignments, visually move your sighting stick through a form or grouping of forms and look for two, three, or more identifiable landmarks that fall within a straight line along your sighting stick, creating either a vertical or a horizontal line (Figures 1-18–1-21). Once you have observed these alignments, you

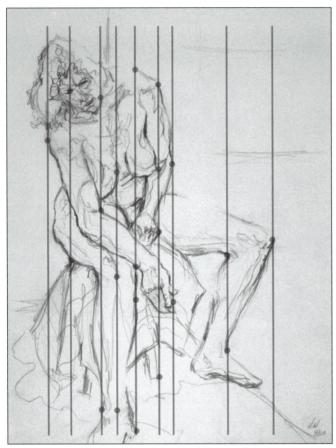

Figure 1-18. Student work. Numerous landmarks found in the figure are indicated by gray dots. The vertical sight lines extended through the figure show various alignments between landmarks that, once observed on the figure, serve to guide the alignment of these landmarks in the drawing. Note, for example, the vertical relationship between the figure's right heel, the medial edge of the calf and knee, the point of intersection of the knee and wrist, and the peak of the left shoulder.

are then made aware that this same alignment should be repeated in your drawing. It is especially useful to observe alignments between more distant points, which are less apparent to the eye than are alignments between fairly close points.

When you observe a vertical or horizontal alignment between landmarks, it is fairly simple to translate this alignment since a vertical or horizontal is fixed or constant. If, however, you observe a diagonal alignment between landmarks (which could also be considered a deviation from a vertical or horizontal alignment), you must then observe the relationship of that diagonal to either a vertical or a horizontal (whichever it relates to most closely) or to the face

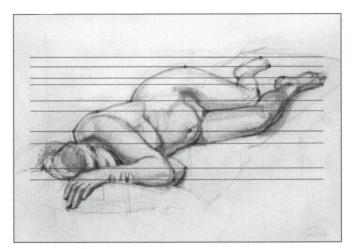

Figure 1-19. Student work. John Hale. Horizontal sight lines pulled through a reclining figure show a number of horizontal alignments between landmarks—the peak of the figure's left shoulder, the navel, and the lateral edge of the right knee; the intersection of the shoulder and head and the intersection of the belly and the upper thigh. Note that the peak of the hip is higher than the figure's right foot but lower than the figure's left foot.

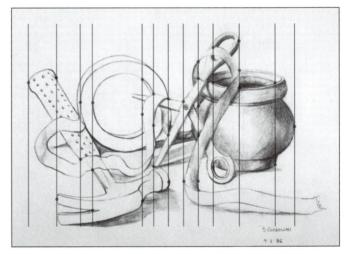

Figure 1-20. Student work. Stacy Cossolini. In this still-life arrangement of multiple objects, vertical sight lines reveal alignments between various landmarks found on different objects, such as the intersection of the prongs of the hammer's claw, the intersection of the ribbon and the shaft of the hammer, and the outermost curve of the interior of the roll of ribbon.

of a clock and maintain that same diagonal alignment in your drawing. Any of these three observed alignments are helpful, but a diagonal alignment must be more carefully translated than a vertical or horizontal alignment because of the increased possibility of error.

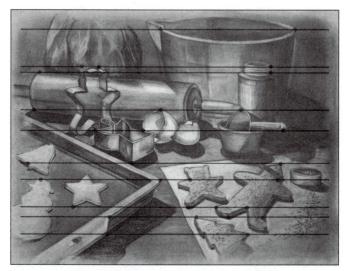

Figure 1-21. Student work. This still life, with a Christmas cookie theme, shows horizontal sight lines and resulting horizontal alignments between landmarks. When carefully observed, these visual relationships help to determine relative size and placement or position of objects in this fairly complex arrangement of forms.

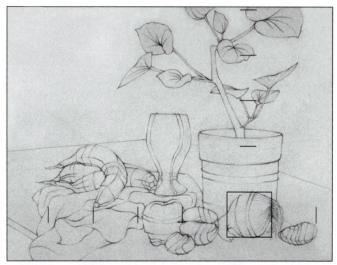

Figure 1-22. Student work. The onion in the foreground serves as a unit of measure. Repeating the width of the onion side to side across the paper and the height of the onion up and down the paper helps to determine how all of the information will fit (or not fit) within the format of the paper.

Transferring Sighting Observations to a Drawing Surface

Many students, when first introduced to sighting, learn how to use the sighting stick to observe proportional relationships but are uncertain how to apply these relationships to their drawing paper. For example, you may find in sighting a seated figure that the head length repeats itself four and a half times from the uppermost point of the figure to the lowest point of the figure. When sighting the head length with your arm fully extended, the head length may measure about an inch long on your sighting stick. But if you are drawing on an 18" × 24" piece of paper, you will certainly want to draw the head larger than an inch if you are going to utilize your drawing format effectively.

Remember that you are observing *relative* proportions. In beginning your drawing, estimate the size of the head (in a figurative composition) or other unit of measure (in a nonfigurative composition) and lightly sketch the general shape that reflects your unit of measure, estimating the size and placement of the shape based on what you observe. A viewfinder is helpful in giving you a sense of how information can be composed in your drawing. Before going any further, check to see if the size and location of your unit of measure leave adequate room for the remainder of the information you wish to include in your composition. If your unit of measure is drawn too small, you may end up with a lot of

empty or blank space in your drawing. If your unit of measure is drawn too large, you may end up not having enough room on your drawing to include everything you wish to include. Continue to adjust the size of the head or other unit of measure until it allows for a "good fit" of the information on your drawing surface. You should consider both the total height and the total width of your composition in relation to the established unit of measure (Figure 1-22).

It is helpful to make small marks on your drawing where the width and height of your unit of measure are located when repeated across the drawing surface and up and down the drawing surface. This way you don't have to keep measuring repeatedly. For example, if you are drawing a seated figure you may observe that the head length repeats itself a little over three times to the place where the buttocks rest on a chair or some other surface upon which the model is seated. If you have light indications on your drawing surface of where each head unit is positioned, you will easily be able to locate the point on your drawing where the base of the buttocks should be located (Figure 1-23).

Other factors should also be taken into account when translating what you find with your sighting stick to your drawing surface. If drawing the figure, the relationship between the body and the head differs depending upon the view you have of the figure. For example, if you are seeing the figure in profile and the figure is seated, you may observe

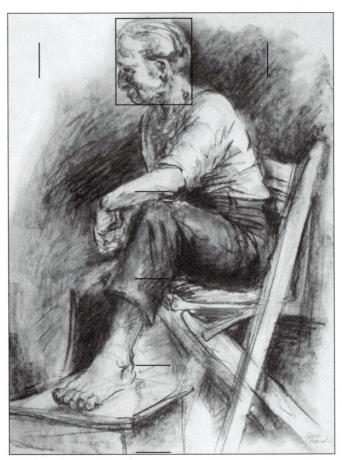

Figure 1-23. Student work. Rebecca Marsh McCannell. Marking the repeated head width across the drawing surface and the repeated head height up and down the drawing surface helps to locate the position of forms more quickly in relation to the unit of measure.

that the majority of the body is positioned more to the left or to the right of the head. This can be observed by holding your sighting stick up and passing it vertically through the head, noting where the bulk of the body is positioned in relation to this vertical extension. If you observe that a good portion of the body falls to one side or the other of the vertical extension, you will not want to place the head shape directly in the middle of the drawing surface because this will result in a poor composition with the figure crowding the right or left side of the paper. Rather, you should shift the initial head shape accordingly to the left or right.

These same guidelines for transferring your sighting observations to your drawing surface apply to any subject matter. You must begin your drawing by establishing what you are using as your unit of measure. You then determine the size and placement of this form on the drawing surface to accommodate all remaining information that you wish to incorporate into your composition.

These initial steps in starting your drawing are important ones and have a significant impact on the end result. If these initial steps reflect accurate sighting and good decisions on your part, it will help you to move further along in your drawing with greater ease. In addition to sighting for relative proportions, you will begin to utilize the second and third applications of sighting as your drawing progresses.

The Technique of Scaling to Determine Accurate Size Relationships

Scaling is a process based in perspective principles that determines the accurate size relationships of forms in an illusionistic three-dimensional space. Although it is helpful to have a fundamental understanding of perspective principles (Chapter Three) to effectively apply scaling, it is included here because of its significance to drawing and because it is a skill that can be learned in the context of basic drawing essentials without a background in technical perspective.

In the illusionistic space found on a 2-D surface, forms and figures and objects may be represented in various sizes and positions, indicating that they are closer to or farther away from the viewer. If we consider an interior space, this might include the figure, pieces of furniture such as chairs and sofas and lamps and tables, doorways, windows, counters, cupboards, walls, and more. If we consider an exterior environment, this might include the figure, buildings, autos, trees, telephone poles, fences, houses, and more. If the environment is in front of you so that you can observe it directly, sighting can help you to accurately record size or scale changes and angles that reflect accurate perspective. If, however, you wish to imaginatively move forms around in space or to add information that is not directly observable, an understanding of scaling and basic perspective principles allows you to do this successfully.

The process of scaling establishes a "corridor of convergence" that determines the change in apparent size or scale as a given object is moved to different positions within the illusionistic three-dimensional space of a drawing. Scaling also maintains an accurate size relationship between all the different elements within an illusionistic three-dimensional space

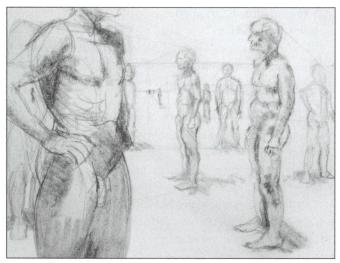

Figure 1-24. Student work. Roberta Weldon. This drawing repeats multiple figures at various positions in space using a single pose of the figure. By moving around the figure, various viewpoints are provided, and scaling is used to determine accurate relationships of placement and height.

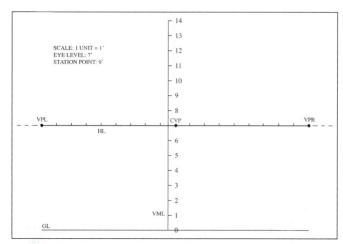

Figure 1-25. This drawing shows the establishment of scale, ground line, eye level or horizon line, vertical measuring line, and vanishing points that determine the station point or position of the viewer.

(Figure 1-24). Although the examples provided focus on the figure, scaling can be applied to any objects that have measurable height.

Establishing Scale Successfully

Scaling can be explored in a simplified fashion, which may be more appropriate if you are not familiar with perspective, or it can be explored in greater depth, which requires that you have familiarity with perspective principles. Scaling has a lot in common with sighting. In theory the two processes would yield similar results if used to establish size, scale, and placement relationships between various objects found in different spatial locations—foreground, middle ground, or background.

Sighting provides a simpler, less technical method for exploring scaling, but it is for the most part dependent on direct observation. To use sighting, begin by drawing an observed object in the foreground, middle ground, or background of your composition, and establish where your eye level is positioned in relation to the object. It is helpful to draw a delicate line representing your eye level if it falls within the parameters of your drawing surface. This object, both its size and placement, will determine the relative size and placement of all additional observed objects in your composition. By sighting the object first established in your

drawing, you can relate it to all other observed forms in terms of their comparative size and placement.

A more elaborate form of scaling, requiring an understanding of perspective principles, allows for a more in-depth exploration that is not dependent on direct observation. If you wish to explore scaling in greater depth, you must predetermine the same factors that must be predetermined in any perspective drawing—scale, eye level, and station point.

Scale or Unit of Measure

A scale of 1" = 1' indicates that 1 inch of measurable length or width in the most foreground area of your picture plane represents 1 foot in actual dimensions. Scale is a variable, depending on what you are drawing, but once scale is established for a particular drawing, it remains constant for that drawing and is also significant in indicating both the height of the eye level and the position of the station point for that same drawing.

Height of Eve Level or Horizon Line

The height of your eye level (EL) in a drawing is determined by the measurable distance on your picture plane from the ground line (GL) to the eye level or horizon line (HL), which are synonymous (Figure 1-25). If the measurable distance from the ground line (which represents the intersection of the picture plane and the ground plane) to the horizon line is 7 inches, and the established scale is 1'' = 1', the eye level is then established at 7 feet. This tells us that everything in the drawing is represented as it would appear viewed from 7 feet above the ground. A low eye level, such as 1 foot or 2 feet, suggests a "worm's-eye view," while a higher eye level suggests a "bird's-eye view." An eye level of 5 or 6 feet represents an average eye level for a standing adult.

Station Point

The station point established in a drawing indicates the distance of the viewer from the picture plane. The station point is determined by the distance between vanishing point left (VPL) and vanishing point right (VPR) in two-point perspective or by the placement of special vanishing points left and right (SVPL or SVPR) in one-point perspective. If your scale is 1" = 1', and your VPL and VPR are 18 inches apart on your drawing surface (9 inches each from the central vanishing point [CVP]), your station point is determined by one half of the distance between the VPL and VPR or by the distance from the CVP to either the VPL or the VPR. In this example, the station point is 9 feet (represented by a measurement of 9 inches and a scale of 1'' = 1'), telling us that everything in the drawing is represented as it would appear if the viewer was positioned 9 feet away from the picture plane (see Figure 1-25).

The station point is an important distinction in both scaling and perspective drawing, because the position of the viewer as symbolized by the station point determines how information will appear. For example, if you view a box or a chair or some other object from 10 feet away, it looks a certain way. If the form you are viewing remains where it is but you move closer to it or farther away from it, its appearance changes. If you are looking at a box, you may notice that you see less of the top of the box and the shape is slightly different if you are farther away, and you see more of the top of the box if you are closer. It has not changed its actual dimensions, but it does appear to be different. This change in appearance based on how near or far you are from a form applies to anything you can observe. Remember that all three factors-scale, eye level, and station point-must remain constant while drawing.

The Process of Scaling

When scaling, you have to start somewhere. At the very least, you should begin by establishing the eye level/horizon line in your drawing, as well as the ground line, which is drawn below the horizon line. You should also determine scale so

that you understand what a measurable inch on your paper represents in "real life."

In order to make this process as user friendly as possible, I suggest that once you have established the scaling environment described earlier, you then lightly draw a vertical line that originates at the ground line and extends up through the horizon line and toward the top of the paper. You can draw this vertical line anywhere you want in your drawing-in the center of the page or to the right or left of the page. This is your scaling key or vertical measuring line (VML) and should be marked with the units of measure that you establish as your scale. For example, if you establish a scale of 1'' = 1', then you mark 1'' increments on your measuring line and number them sequentially with the base of the measuring line as 0, the first mark above it as 1, the second mark as 2, and so on. If you establish a scale of $\frac{1}{2}$ " = 1', then you mark $\frac{1}{2}$ " increments on your measuring line and number them sequentially as described. This vertical measuring line will guide the development of your drawing but can be erased when you are finished with your drawing (see Figure 1-25).

Determine where you want your first figure or other form to be positioned in your drawing. If this first object is positioned with its base on the ground line, its size will correspond directly to the measuring line increments. For example, a figure or a tree or a lamppost that you want to be 6 feet tall would be the same height as the mark that denotes 6 feet on the VML (Figure 1-26). If, however, you want to draw your first object above the ground line (which indicates that it is positioned farther back in space), then you must determine its size in the drawing by building off the VML. This is achieved by drawing a "corridor of convergence" from the VML to any point on the horizon line. For example, if you want a 6' corridor of convergence, you draw a line from the base of the VML (point zero) to a chosen point on the horizon line (a special vanishing point or SVP), and then draw another line from the 6' mark on the VML to the same special vanishing point on the horizon line (Figure 1-27). This corridor of convergence becomes increasingly smaller as it moves back in space toward the horizon line. Anything with a vertical height that fits within this corridor of convergence represents a 6' object positioned accurately in the foreground, the middle ground, or the background.

Once you determine a height for a particular object using a corridor of convergence, you can then slide that form horizontally to the left or right to establish an additional form since sliding to the left or right does not move it farther forward or back in space (Figure 1-28). If you begin to get

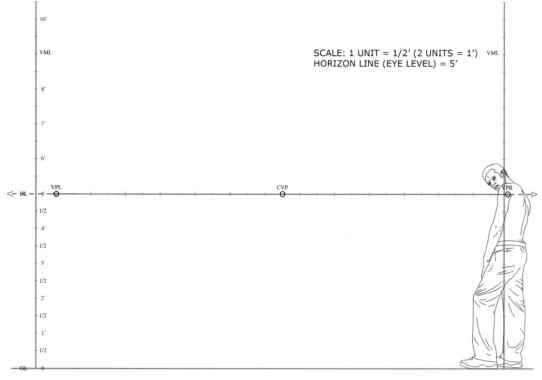

Figure 1-26. Any form that originates on the ground line will reflect the measurements established on the vertical measuring line. In this case, the figure's height corresponds to the 6-foot mark on the VML. The VML can be positioned anywhere in the scaling environment-on the left or right side of the page, in the center of the page, or anywhere else—as long as it originates at the ground line.

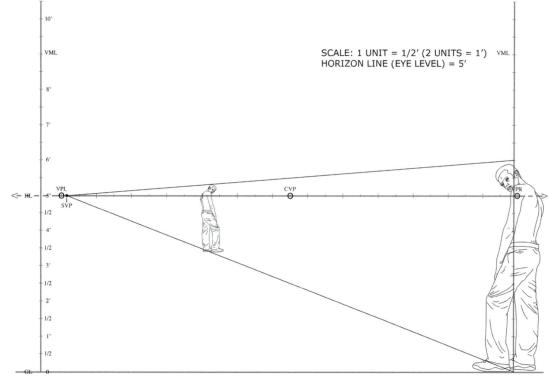

Figure 1-27. The corridor of convergence is drawn from the VML to a special vanishing point positioned on the eye level/horizon line. In this instance, the corridor represents a 6-foot height moving back in space. We know that the second figure, drawn within this corridor, is 6 feet tall because its height corresponds to the corridor of convergence.

Figure 1-28. Sliding the height of the male figure to the left or right results in no movement forward or backward in space. The added female figure is approximately 6 feet tall because she fits into the horizontal extension of the 6-foot male figure. Dotted lines indicate horizontal scaling.

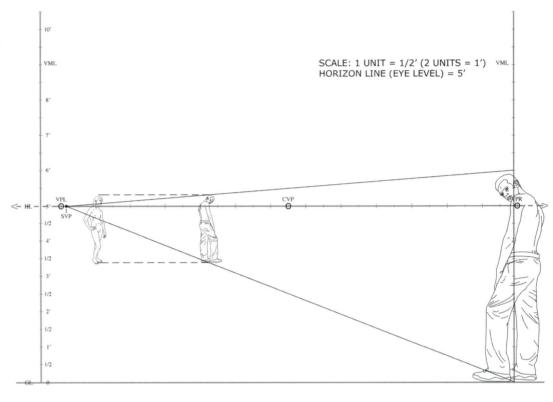

confused, remember this: If you know where you want a form to touch the ground plane and you know how tall you want the form to be, then draw a line from the base (point zero) of the VML through the desired point of contact with the ground plane and extend it until it meets the horizon line, creating a SVP. Then identify the desired height on the VML and draw a line from this point to the same SVP. The object you wish to draw will fit vertically into this corridor of convergence, rising up from the bottom line of the corridor of convergence to the top line of the corridor of convergence (Figures 1-29 and 1-30).

Multiple corridors of convergence that reflect different vertical heights can be drawn to various SVPs positioned on the horizon line. Once a form has been correctly established with a specific height, you can then scale additional forms from this form or refer back to your VML or key for guidance (Figure 1-31). A single corridor of convergence can also guide the size of objects having varying heights. For example, if you have a 10' corridor of convergence, you can create a 20' height by stacking the 10' height on top of itself, or you can add half of the 10' height to itself to create a 15' height, or you can use half of the 10' height to create a 5' height, and so on (Figure 1-32).

General Guidelines for Scaling

- The scaling guide or vertical measuring line/VML (also called the key) originates at the ground line and moves vertically up the drawing format. It is perceived as being as far forward as possible, directly on the picture plane, and it reflects actual measurable heights (Figure 1-33).
- All scaling makes direct or indirect reference to this VML or key.
- A higher eye level should be placed nearer the top of your drawing format; a lower eye level should be placed nearer the bottom of your drawing format.
- Scaling can occur diagonally either forward or backward, indicating that the depicted object is closer to or farther from the picture plane—this calls for the use of SVPs to establish corridors of convergence (Figure 1-34). Scaling can also occur vertically or horizontally, indicating movement up or down or sideways rather than forward or backward in space—this does not call for the use of SVPs because there is no size change when scaling vertically or horizontally. Think of stacking one form on top of another or sliding it from left to right. It does not change in its apparent size, but rather simply moves up and down or side to side (see Figure 1-30).

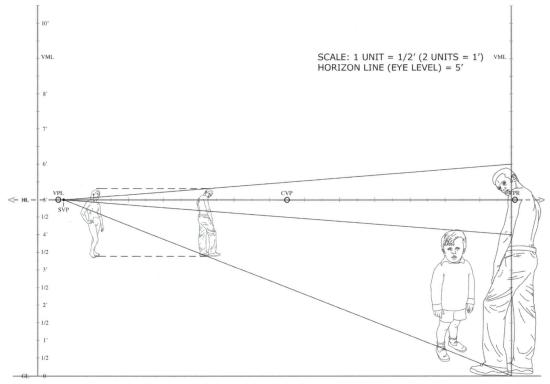

Figure 1-29. A new corridor of convergence, 4 feet in height, is established from the VML on the right using the same special vanishing point as the original corridor of convergence. It should be noted that a different special vanishing point can also be used and will yield the same results. A young boy who is 4 feet tall has been added to the composition.

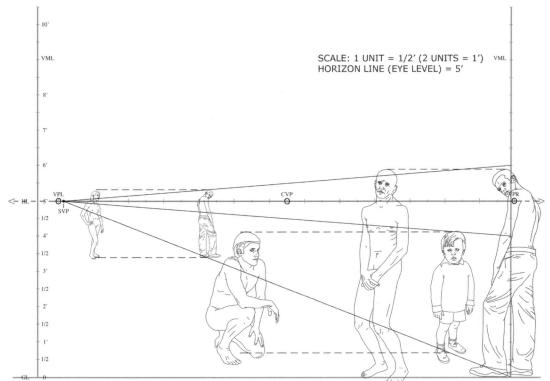

Figure 1-30. Two more figures are added to the composition using horizontal scaling. The nude man in the foreground is horizontally scaled from the original man and is also 6 feet tall. A crouching man is horizontally scaled from the young boy, and his crouching height is 4 feet tall. You may notice that his left knee and right foot extend below the horizontal scaling lines. This is because his height is measured through the head to the ground plane, and some of his body extends in front of and behind this point, falling lower and higher on the picture plane, respectively.

Figure 1-31. Any form that has been correctly scaled can be used as a point of reference for scaling additional forms. In this example, the 4-foot-tall crouching man in the foreground is the origin for another 4-foot corridor of convergence using a different special vanishing point. A second 4-foot-tall young boy is positioned farther back in space in this new corridor of convergence.

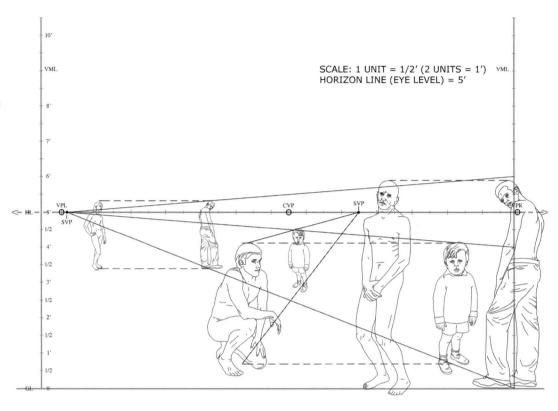

Figure 1-32. Another corridor of convergence, 10 feet tall, is drawn from the VML on the left to a new special vanishing point. A tree is drawn in this corridor of convergence that is approximately twice the height of the corridor of convergence. Consequently, we can determine that the tree is approximately 20 feet tall.

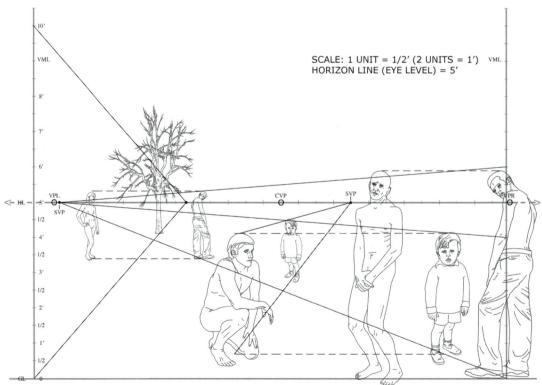

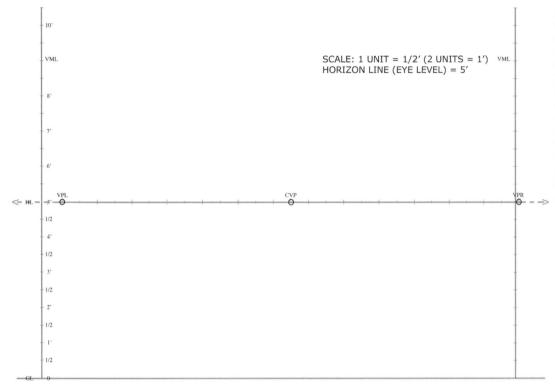

Figure 1-33. This drawing shows another example of a scaling environment with a 5-foot horizon line/eye level. There are two vertical measuring lines, both reflecting the same scale of two units equaling 1 foot. Only one VML is necessary, but having one on both sides of the drawing surface allows more flexibility in drawing corridors of convergence.

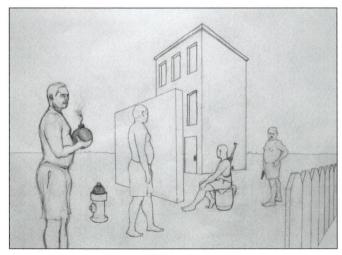

Figure 1-34. Student work. Donald Barkhouse III. Scaling forward from one of the background figures will yield the same results as scaling back from one of the foreground figures. Scaling works in either direction to determine the accurate size of forms moved to various positions in the illusionistic space.

- Special vanishing points (SVPs), which are used to establish corridors of convergence for accurate scale, can be placed *anywhere* on the horizon line, including placement on an extension of the horizon line or beyond the drawing surface. There is no limit to the number of SVPs you can use (see Figure 1-31).
- Any form that is accurately scaled from the original VML or key can then be used to scale additional forms (see Figure 1-32).
- When applying scaling, identify first where you want the point of contact with the ground plane for the object or figure, and scale up from this point of contact, which is called the baseline. In this way, what you draw will be firmly planted on the ground plane. If you wish to make a form appear to float above the ground plane or position it on an elevated surface, you would simply apply vertical scaling (Figure 1-35).

- If using vanishing points (which are necessary if you are attempting to draw any cubic-based objects like houses or walls or tables or chairs), the farther apart your vanishing points are, the farther away you are symbolically placing the viewer from the picture plane. This generally creates a more realistic or naturalistic viewpoint and is less dramatic than if the viewer is positioned close to the picture plane, indicated by vanishing points that are closer together (Figure 1-36).
- You may use multiple sets of vanishing points (VPL and VPR) to reflect various rotations or positions of things drawn in perspective as long as each set remains the same distance apart on the horizon line.
- Do not draw anything below the ground line because this suggests that you are drawing things that are seen in front of the picture plane rather than through and on the other side of the picture plane. Any form whose height extends

below the ground line would consequently be cropped at the ground line.

The Principles of Composition: Theory Versus Application

Composition is an intricate and often complex issue. Whether considering music, literature, theater, or the visual arts, composition plays a significant role from its most basic to its most sophisticated application. A strong and sensitive awareness of composition is vital to the creation of a work that is unified. While some contemporary artists are specifically and legitimately interested in subverting traditional paradigms of art

Figure 1-35. Lucas (Huyghz.) van Leyden, Netherlandish, c. 1494–1533, *Ecce Homo*, 1510. Engraving, sheet: $11^3/6 \times 17^{15}/16$ inches (28.9 × 45.6 cm). The Metropolitan Museum of Art, Harris Brisbane Dick Fund, 1927. 27.54.4. Image © The Metropolitan Museum of Art. Van Leyden's mastery of spatial illusion is evident in this exploration of one-point perspective and scaling techniques. The height of each structure and each figure can be determined based on its relationship to the predetermined height of a figure or vertical structure in the foreground. When placing figures or forms on elevated surfaces, you must account for the height of the surface on which the figures are placed. Scaling can be used to determine the height of anything, including architectural structures.

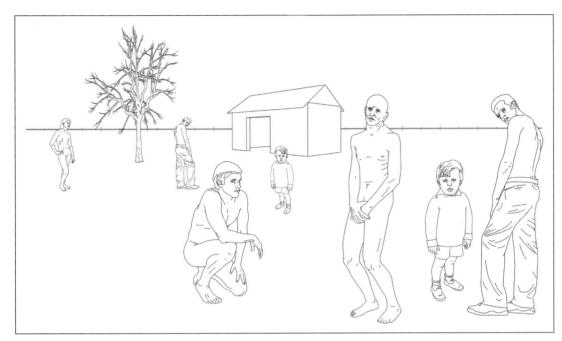

Figure 1-36. The building added to this drawing was drawn using vanishing points left and right (VPL and VPR). All construction lines and other labeling have been deleted to illustrate the full effect of scaling. The building is approximately 13 feet tall, and the doorway is approximately 7½ feet tall.

making, you must first understand rules or traditions in order to successfully subvert them. The ways in which an artist expresses concern for compositional elements can make or break a piece of music or literature or visual art. A successful composition is more than visual organization, ultimately enabling an artist to successfully convey content and meaning. And it is only with a command of composition that an artist can consciously explore alternatives to the generally accepted canons of composition.

It is one thing to understand the concepts behind the development of sound composition and another thing altogether to be able to apply these concepts successfully. Oftentimes compositional principles are discussed only in abstract or theoretical terms, and exercises in the application of these principles (particularly in two-dimensional design courses) may be limited to the use of abstract elements such as circles or squares or swatches of color or texture. This is a valid approach for the study of composition at an introductory level, but you must also understand the application of these principles at a more concrete level. How do these principles apply to a composition involving a still-life arrangement, a portrait study, an urban or rural landscape, a figure in an interior space, a figure in the landscape, an abstract image, and so on?

Bear in mind that an understanding of the principles of composition and their application should

ultimately extend beyond the abstract and the theoretical. You must recognize the application of these principles in work from a variety of visual art disciplines that utilize concrete, recognizable imagery. Numerous works by widely recognized artists provide excellent examples of the principles of composition in practice. In addition to the great Renaissance and Classical masters, a number of contemporary artists' work provides strong and interesting examples of different applications of compositional principles in relation to a variety of subject matters. Examples of work by contemporary artists who explore composition in a variety of ways can be found throughout this book.

Too often composition is a point of focus in an introductory design class but is not given significant consideration in your subsequent course work, where the emphasis may be on a particular media or technique or subject matter. Make composition an integral part of your concerns at every opportunity. Theory is one thing, application is another.

Following are some key concepts considered to be basic to the study of composition and its application. Use them as a guideline in creating, analyzing, discussing, and critiquing your work, the work of other students, and the work of historical and contemporary masters.

Review of Some Simple Definitions

Composition: The way the component parts (the formal elements) of a work of art are arranged in the given space. How the formal elements are arranged not only determines the strength of a composition but also is essential in conveying and supporting content or the communication of idea and meaning.

Elements (formal elements): The elements include point, line, plane, shape, form, mass, volume, texture, value, color, positive space, and negative space (Figure 1-37). The elements are those things in a composition that are tangible individually or as a group, regardless of subject matter or style. The elements are the basic building blocks for a realistic work of art or an abstract work of art.

Positive space: The figure(s) or object(s) or tangible thing(s) in a composition. Sometimes an object can be both positive and negative, depending upon its relationship to other tangible things in the composition.

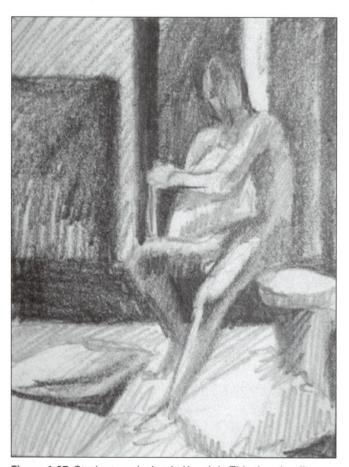

Figure 1-37. Student work. Jamie Hossink. This thumbnail study shows concern specifically for the arrangement and distribution of shape, volume, texture, value, and positive and negative space.

Negative space: The "empty" areas; the space that exists between, around, and behind tangible forms and in part defines tangible forms. Negative space is as significant in a composition as positive space. Tangible forms may act as negative space to other tangible forms (Figure 1-38).

Format: The given space in which a work of art is composed; the relative length and width of the bounding edges of a drawing surface, such as $18" \times 24"$. Format, in part, controls the composition (Figure 1-39).

Visual Principles of Composition

The visual principles of composition are concepts or ideas that become evident by examining the arrangement of the elements of composition. Principles come into being through the placement and arrangement of the elements, by the implied action of the elements, and by the artist's intent to build visual and conceptual relationships among the elements.

Balance: A feeling of equality or equilibrium in the weight or emphasis of various visual elements within a work of art. Balance can be symmetrical, nearly symmetrical (approximate symmetry), or not symmetrical (asymmetry). Simply, think of the visual weight or relative importance of the elements used in the composition.

Harmony: A consistent or orderly arrangement of the visual elements of a composition creating a pleasingly unified whole. Simply, think of *recurring similarities* in the elements used, such as recurring line, recurring value, recurring color, recurring shape, or recurring texture (Figure 1-40).

For creating harmony, consider the use of repetition, rhythm, and pattern.

Repetition: In repetition, some visual element(s) are repeated, providing stepping stones for our eye to follow.

Rhythm: Rhythm is the orderly repetition of visual elements or repetition in a marked pattern, which creates flowing movement.

Pattern: A two-dimensional application of rhythm or repetition, such as the repeated motif in a wallpaper or textile design.

Variety: Variety is the compliment or counterpart of harmony, introducing change, diversity, or dynamic tension to the recurring visual elements of harmony. Simply, think of *recurring differences* in the elements used, such as differing line, differing value, differing shape, differing size, differing texture, differing color, and so on.

Emphasis/domination: The development of focal point(s) created through some type of contrast or difference such as contrast of value, contrast of color, or contrast in the degree

Figure 1-38. Richard Diebenkorn, *Untitled*, 1962. Ink and graphite on paper, 17 × 12½ inches. (43.18 × 31.75 cm). San Francisco Museum of Modern Art. Purchased through anonymous funds and the Albert M. Bender Fund. © Estate of Richard Diebenkorn. Because of Diebenkorn's thorough attention to both the figure and the environment within which the figure is located, many tangible forms function as both positive and negative space. The bed, for example, is both negative space to the figure and positive space to the wall and other information behind it.

Figure 1-39. Student work. Gypsy Schindler. A variety of formats are explored in these compositional studies of a still life of keys, scissors, and paintbrushes.

of development or definition (Figure 1-41). You can also isolate a form to create emphasis.

Movement/directional forces: The development of primary and secondary visual paths of movement. It is helpful to keep in mind the basic notion that influences our visual priorities. Our eyes are inclined to try to join together things that are the same or similar in some visual way. If, for example, there are a number of instances of a particular shape in a composition, our eye will move back and forth between those repeated shapes in an effort to group or organize or bring them together. The same idea holds true for textures, values, and the like. Repetition of similar elements is key to creating visual paths of movement (Figure 1-42).

Proportion: Consider the proportion (relative size or amount) of one compositional element to another—proportion of dark values to light values, proportion of large shapes to small shapes, proportion of rough textures to smooth textures, proportion of foreground space to background space, proportion of positive space to negative space, proportion of near elements to far elements, proportion of stable shapes or masses to unstable shapes or masses (Figure 1-43).

Economy: Economy involves the idea of sacrificing detail for the sake of unity. Consider how you are interpreting what you see, particularly in the negative space or background information. You don't have to include everything you see—you can simplify or edit. Whether your interpretation of positive and negative space or background information is literal (based on actual visual information) or nonliteral (based on invention), consider the option to edit or simplify the composition (Figure 1-44).

Unity: Very simply, does it all work together?

Variable Compositional Elements to Consider

Variable compositional elements address indeterminate factors to be considered when composing or designing a drawing. There is no right or wrong way to consider these variables. What is important is to be aware of these variables as they relate to the elements and principles of composition and to recognize that you have choices and that you control these variables to help you achieve desired results.

Size: Large or small, long or short, size is relative. For example, a long line appears even longer when juxtaposed with a short line, and a small shape appears even smaller when seen next to a large shape.

Position: The primary positions of forms or objects in space are horizontal, vertical, and diagonal. In a given format, the positions of forms can be changed in relation to one another. The relation of one form to another may be parallel, perpendicular, diagonal, overlapping, end to end, and so on. The position of forms can be changed in relation to the total format as well.

Direction: When the position of a form implies motion, it is thought of as moving in some direction. The direction of movement can be up or down, side to side, on a diagonal, toward or away from you, back and forth, over or under, and in other ways.

Number: A single form may be repeated, added to, or multiplied any number of times. A form can occur once in a composition or many times.

Density: The density of a form is determined by the number of units within its area. The units may be close together or far apart. By increasing the density of a form, we can increase its visual weight or its visual energy. For example, by

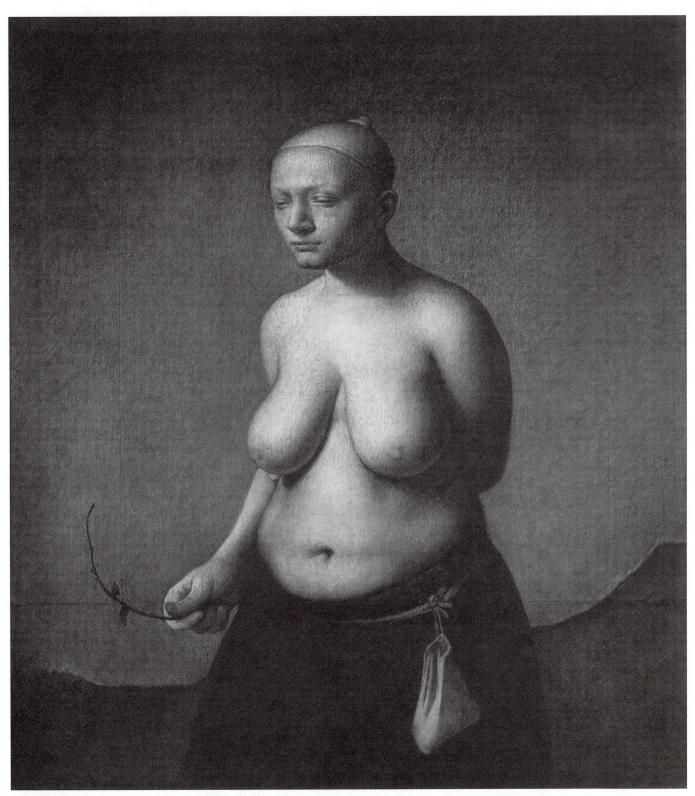

Figure 1-40. Odd Nerdrum, *Girl with Twig*, 1991. Charcoal on lambswool paper, 48 × 39 inches. Arkansas Arts Center Foundation Collection: Purchase, Collectors Group Fund. 1991.042.002. © 2007 Artists Rights Society (ARS), New York/BONO, Oslo. Nerdrum uses recurring shapes/edges throughout his composition to create visual harmony. The curve of the twig, which is significant in the title of the work, is repeated in the contours of the landscape, in the curve of the cloth, in the contour of the breasts, and in other places.

Figure 1-41. Student work. Vickie Marnich Reynolds. This drawing investigates four different compositions created by shifting the tonal focal point in each individual study of a fabric bag with a drawstring top.

massing a number of lines (units) closely together, a dense shape or form may be implied. If those same lines are spaced farther apart, the density of the implied form decreases and it carries less visual weight.

Interval: The interval is the space between forms. There can be equal intervals, unequal intervals, small intervals, large intervals, progressively smaller intervals, progressively larger intervals, intervals forming a pattern, and so on.

Proximity or nearness: The nearer forms or shapes are to each other, the more we group them together. Individual shapes can have enough proximity to create a totally new shape by their tendency to group together.

Similarity: As forms or shapes correspond to one another in shape, size, direction, value, texture, color, or some other characteristic, we perceptually tend to link or pull them together (Figure 1-45).

Using a Viewfinder: What Does It Do for You?

- Your viewfinder is your window to the world, blocking out visual distractions and helping you to focus your attention on what you are drawing, in much the same way as the viewfinder of a camera.
- Your viewfinder reflects your actual drawing format in the same proportions. (Example: an 18" × 24" drawing format is proportionately reflected in a 11/2" × 2" viewfinder, each having a ratio of 3:4).
- Your viewfinder binds and gives boundaries to your negative space, defining specific shapes and allowing you to observe these shapes outside of and around the major forms that you are drawing (Figure 1-46).
- Your viewfinder provides constant verticals (along the left and right sides) and horizontals (along the top and bottom) against which to compare observed angles.
- Your viewfinder enables you to "image" or visualize how the forms will fill or occupy the paper surface.
- Your viewfinder helps you to determine whether a vertical or horizontal orientation of your format is best, depending upon which is most effective in utilizing the entire format and establishing a strong composition (Figure 1-47).
- If you choose to crop your composition closely, your viewfinder helps you to focus on an isolated passage (Figures 1-48 and 1-49).
- Your viewfinder can be of further assistance to you if you mark one-half and one-quarter divisions along the perimeters of the viewfinder, which are then lightly repeated on your drawing format (Figure 1-50). This is helpful in locating landmarks that you observe. These divisions help you to make an effective translation of the information observed in the viewfinder to the drawing format.

It is important to recognize that your viewfinder is ineffective unless it reflects the same proportional dimensions as the format on which you are going to work. There is a simple way to find the dimensions of a viewfinder for any rectangular format on which you wish to work. You can determine the size of the viewfinder window based on the size of the full-size format, or you can determine the size of the full-size format based on the size of the viewfinder. Drawing a diagonal line from one corner to the opposite corner of any rectangular shape and extending it allows you to then scale up the rectangle or scale down the rectangle by building any larger or smaller rectangle that also utilizes the same corner-to-corner diagonal (Figure 1-51).

Figure 1-42. Richard Diebenkorn, *Still-Life: Cigarette Butts and Glasses*, 1967. Ink, conte crayon, charcoal, and ballpoint pen on wove paper, 13¹⁵/₁₆ × 16³/₄ inches. Gift of Mr. and Mrs. Richard Diebenkorn, in Honor of the 50th Anniversary of the National Gallery of Art, Image © 2007 Board of Trustees, National Gallery of Art, Washington, DC. © Estate of Richard Diebenkorn. Diebenkorn repeats rectangular shapes of various sizes, oval and round shapes, and slender elongated shapes throughout this still-life study to create a number of primary and secondary visual paths of movement.

Figure 1-43. Georges Seurat, French, 1859–1891, Embroidery; The Artist's Mother, 1882–1883. Conte crayon, $12^5/8 \times 9^7/16$ inches (31.2 \times 24 cm). The Metropolitan Museum of Art, Purchase, Joseph Pulitzer Bequest, 1951; acquired from The Museum of Modern Art, Lillie P. Bliss Collection. 55.21.1. Image © The Metropolitan Museum of Art. In this image of the artist's mother, Seurat appears to be considering the proportional relationship of dark to light shapes, large to small shapes, and background to foreground area. The limited areas of strong light on the face, chest, and hands help to emphasize her concentration on the act of sewing.

Figure 1-44. Student work. Jamie Hossink. Keeping the negative space sparse and economical helps to focus our attention on the strong light and dark contrast that gives form to this portrait study.

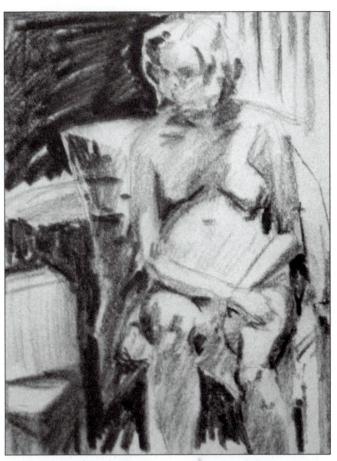

Figure 1-46. Student work. Kevin Wadzinski. In this thumbnail study using a viewfinder, note the tonal emphasis on negative spaces around the figure, which are defined and given boundaries by the edges of the viewfinder.

Figure 1-45. Student work. Elizabeth Tjoelker. A number of shapes and values in this drawing are similar to each other, such as the dark figurative shapes positioned on the left and the linear shapes found throughout the composition.

Figure 1-47. Student work. Gypsy Schindler. Even though the figure is primarily vertical in this seated position, the student uses a horizontal format to allow for exploration of the forms in the space around the figure.

Figure 1-48. Student work, University of Cincinnati. Elizabeth Reid. A close-up and cropped view of peach crates provides an interesting and somewhat abstract composition.

Figure 1-50. The toned area of the viewfinder indicates the window or opening through which you view the subject you are drawing.

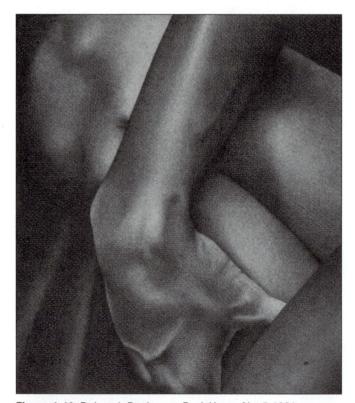

Figure 1-49. Deborah Rockman, Dark Horse No. 5, 1981. Colored pencil and charcoal on paper, 10×8 inches. Collection of Carol Fallis. The use of a viewfinder helps to reveal an interesting and somewhat ambiguous view in this figurative composition. The human form takes on a different character when aspects of the form are isolated from the rest of the body.

Figure 1-51. The lightest toned area indicates the original rectangle that has been proportionately reduced and enlarged using a corner-to-corner diagonal.

Figure 1-52. Student work. The view of the plant is such that it dominates the composition, moving off the top, right, and left sides of the drawing surface. As a result, the negative spaces around the plant are more clearly defined and are emphasized by assigning value to the negative shapes rather than to the positive shapes.

Figure 1-54. Student work (after Edward Hopper). Dave Hammar. The recurring values of white, gray, and black; the recurring rectangular shapes; and the recurring vertical elements help to create visual paths of movement.

Figure 1-53. Student work. The smaller scale of the figure in this thumbnail study requires that greater attention be paid to the space around the figure in order to more fully activate the composition.

Figure 1-55. Student work. Erik Carlson. One consideration in placing the figure closer to the right side of the page is the visual weight of the figure's gaze as he looks toward the left.

General Guidelines Concerning Composition

Pay Attention to Both Positive and Negative Space

Think of positive and negative space as puzzle pieces locking together, sharing the same edges, dependent upon one another. Would a cup still be a cup without the negative or empty space inside of it?

Consider How the Forms Occupy the Format

The forms that you are drawing can dominate the format in terms of size, which creates a natural division or break-up of negative space into tangible and identifiable shapes (Figure 1-52). The forms can be smaller in the format, forcing greater attention to the development or activation of negative space (Figure 1-53).

Watch General Placement of the Forms

- Consider directional thrusts and visual paths of movement—think of them as stepping-stones that lead you through the composition. Elements that are similar to each other in some way are visually attracted to one another, creating implied visual paths of movement (Figure 1-54). The eye will move back and forth between them in an effort to join them together. Provide room in your placement of objects for movement to occur.
- With the human figure as subject matter, consider psychological directional thrusts—the direction of the gaze of the figure carries visual weight. Consider this in the placement of the figure (Figure 1-55).
- Be aware that similar or like forms (shapes, values, textures, patterns, colors, etc.) are attracted to each other and the eye will move back and forth between them in an effort to join them together (Figure 1-56). How are they distributed throughout your format? What visual path of movement are you encouraging in the viewer?
- Avoid "shared edges"—the edge of an object and the edge
 of the paper should generally not be the same for any
 duration, as this creates an ambiguous spatial relationship. Individual forms should not share edges with one
 another if spatial clarity is desired.
- Consider outermost contours in terms of sound or movement—quiet versus loud, active versus inactive. Give these

- outermost contours the appropriate amount of room they need to breathe and move (Figure 1-57).
- Consider whether the shapes inherent in the objects you are drawing thrust out into the surrounding space or remain close to the major mass. How does this affect both placement and scale (Figure 1-58)?
- Avoid cutting your composition in half. Avoid cropping forms at points of articulation (where two parts come together) or cutting forms in half. If cropping, strive for an unequal and dynamic division such as one third to two thirds or two fifths to three fifths (Figure 1-59).

Consider the Kind of Space You Wish to Establish

Consider vertical, horizontal, and diagonal paths of movement (both actual and implied), and be aware of the role they play in establishing different kinds of space in a composition—shallow, deep, ambiguous, and so on (Figure 1-60). When vertical and/or horizontal elements dominate a composition, they reinforce the two-dimensionality of the surface being worked on, seeming to move across the picture plane from side to side and top to bottom (Figure 1-61). When diagonal elements dominate a composition, they reinforce the suggestion of depth or space, seeming to move into the picture plane (Figure 1-62).

Consider Viewpoint in Your Composition

Don't assume that the most obvious viewpoint is the best viewpoint. Alternative and unusual viewpoints offer visual excitement and an element of the unexpected. Try viewing your subject matter from a position well above or well below the subject matter, looking down or looking up (Figure 1-63). Try viewing your subject matter from off to one side or the other, rather than approaching it from a direct frontal view.

Consider the position or location of your light source, exploring unusual directional light sources—try lighting your subject matter from below, from the side, from above. Notice how the information changes (especially patterns of light and shadow) based upon the direction of the light source (Figure 1-64).

Figure 1-56. Student work. Jack Snider. In this compositional study, there is careful consideration for the distribution of repeated values and textures as a way of encouraging visual paths of movement through the composition.

Figure 1-57. Student work. Michael Moore. The main forms of this still life are shifted slightly to the left of the composition to account for the handles of the spatula and pans thrusting into the space on the right.

Figure 1-58. Student work. Emily LaBue. In establishing compositional placement and scale of forms, the stalks of the beet extending to the left in this simple still life must be considered in relation to the self-contained nature of the other forms.

Figure 1-59. Student work. Jody Williams. In this cropped study of the figure, notice that no forms are halved by the edges of the composition or cropped at a point of articulation.

Figure 1-60. Student work (after Edward Hopper). Ralph Reddig. The combination of strong diagonals and vertical elements that diminish as they recede (creating implied diagonals) pulls the viewer into and through the limited space of the train car's interior. Recurrent shapes and values support the visual movement through the composition.

Figure 1-62. Student work. Scott Luce. Numerous diagonals in this composition suggest depth or space. Viewpoint is an important consideration because the same subject viewed from a different vantage point would provide a number of horizontal elements.

Figure 1-61. Student work. Gypsy Schindler. Even though the figure is a three-dimensional form, the strong repetition of vertical and horizontal elements serves to reinforce the two-dimensionality of the drawing surface in this composition.

Figure 1-63. Student work. Nik Macaluso. In this psychologically charged drawing, the viewer is positioned well above the subject, observing the unfolding scenario from an omniscient perspective.

Figure 1-64. Student work. Gypsy Schindler. Because of directional light, compositional arrangement, and viewpoint, this drawing is as much about the beautiful patterns of light and shadows as it is about the rocking chair itself.

Consider Options for the Development of Negative Space or Environment

- You can respond to the actual information before you, editing what seems unnecessary for your compositional or expressive needs (Figure 1-65).
- You can respond to the actual information before you as a reference for the simple geometric division of space (Figure 1-66).
- You can develop a nonliteral space, a space that focuses on mood or atmosphere (Figure 1-67).
- You can invent a literal or imagined space or environment based on a working knowledge of perspective principles and scaling methods (Figure 1-68).

Thumbnail Studies as a Method for Exploring Composition

It can be a daunting task to build a strong composition while taking into account all of the variables that should be considered. And there is never just one good compositional option when observing and drawing a still life, a landscape, a figure or figures, a room interior, or any other subject matter. Depending upon your viewpoint, lighting, the size of your drawing surface, and many other variables, potentially many strong compositions can be developed based on the artist's decisions and choices. Different artists will approach the exact same subject matter in different ways and will compose their work differently.

Often times a student will develop a drawing that is well executed and sensitively drawn but poorly composed.

Visual balance may be lacking, objects may be cropped by the edge of the paper in awkward or inconvenient places, or too much empty space may surround the subject matter. There are countless ways to diminish an otherwise strong drawing by composing poorly. This indicates that there was no preplanning for composition, no exploration of different compositional options.

Thumbnail studies or sketches are an invaluable tool for exploring compositional options prior to beginning a fullscale drawing. The advantages are numerous. Thumbnail studies are by nature small, and because of this they can be done rather quickly. They allow you to explore several different options for composition without fear of failure. They are by nature more generalized, providing simplified information about placement and proportion of objects; direction of the light source; distribution of light, medium, and dark tones; and more. They provide you with an opportunity to explore different formats such as a horizontal, a vertical, or a square format. You can compose a number of thumbnail sketches together on a larger paper surface, or you can compose thumbnail sketches in a sketchbook, or you can compose on whatever you happen to have handy (Figures 1-69-1-71).

It is important that your thumbnail sketches reflect the same proportions as the surface on which you are going to draw. For example, if you are planning on doing your finished drawing on an $18"\times24"$ surface, then your thumbnails should reflect this same size on a smaller scale. You can work $9"\times12"$, $6"\times8"$, or $3"\times4"$. All of these dimensions are proportional to an $18"\times24"$ format. You can use these thumbnail dimensions both vertically and horizontally to explore different compositions.

It is extremely helpful to look at your subject through a viewfinder when drawing your thumbnail studies, as the viewfinder helps you to focus in on what you are drawing and block out unwanted information. Your viewfinder should also reflect the dimensions of the surface you will be doing your finished drawing on and should be oriented the same (either vertically or horizontally) if using a rectangular viewfinder. If you are looking through a square viewfinder and sketching in a rectangular format, you are going to have great difficulty getting the observed information (what you see through the viewfinder) to correspond to the drawing format. They simply will not correspond. If you are looking through a rectangular viewfinder that is horizontal and sketching in a rectangular format that is vertical, they will not correspond either. Although this may seem like common sense, it is surprising how often students overlook this. To reiterate, it is very important that there is a proportional

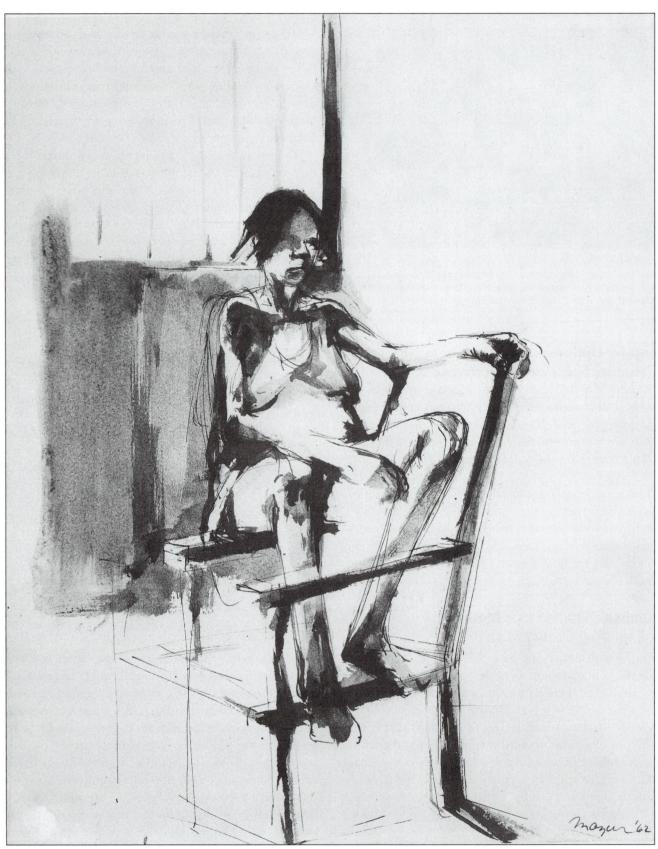

Figure 1-65. Michael Mazur, b. 1935, *Her Place #2: Study for Closed Ward Number 12,* 1962. Brush and pen and brown ink on paper, 16¾ × 13 inches. The Museum of Modern Art, New York. Gift of Mrs. Bertram Smith. Courtesy of the artist and Mary Ryan Gallery, NY. Photograph © 1999 The Museum of Modern Art, New York. Licensed by SCALA/Art Resource, NY. Mazur maintains a highly simplified negative space to focus our attention on the stark figure of the singular woman.

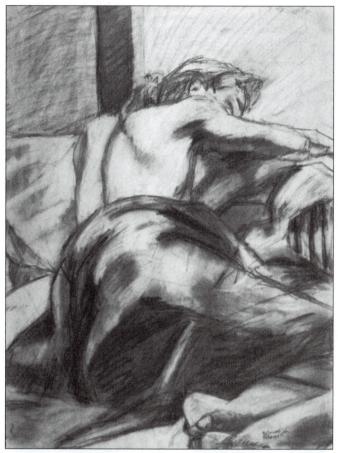

Figure 1-66. Student work. Andrea Helm Hossink. The negative space behind the figure is subdivided into rectangular shapes in response to a wall and a small faceted column.

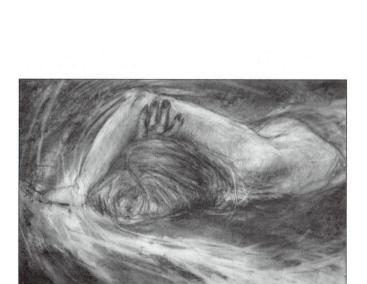

Figure 1-67. Student work, Minnesota State University—Moorhead. Kevin Olson. The negative space around the figure is based on invention rather than observation with the intention of suggesting water or a fluidlike atmosphere.

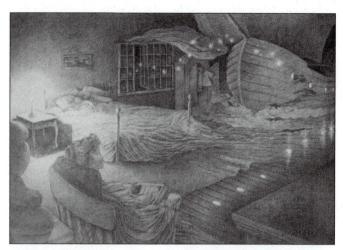

Figure 1-68. Student work. Clarkson Thorp. This student's exceptional understanding of perspective allowed him to successfully invent a spatial, dreamlike environment in this investigation of childhood imagination and metamorphosis.

or dimensional correspondence between the viewfinder, the thumbnail sketches, and the format used for the finished drawing (Figure 1-72).

Some artists like to do thumbnail sketches without initially establishing the boundaries of the sketch. They sketch their thumbnail studies, developing them to the desired degree, and then they draw boundaries around their sketch in various locations to help them find a composition that is pleasing to them. This is simply a variation on the same processes just described. Regardless of which process you use, spending the time to preplan and to explore compositional options ahead of time will save you a lot of potential frustration as you prepare to begin a full-scale finished drawing.

The Golden Section

The study of composition often begins as theory in your two-dimensional design courses and should continue to be developed and reinforced in an applied sense throughout your fine arts education. Along with informal systems and principles of organization, it is instructive and informative to investigate the various formal systems of organization that have withstood close scrutiny and the test of time. The most prominent of these is the Golden Section. Examples from art and nature showing the application and presence of the Golden Section indicate the prevalence and significance of this aesthetic device and the underlying

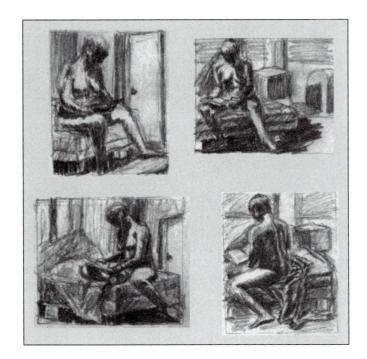

Figures 1-69, 1-70, and 1-71. Student work. These sheets of thumbnail compositional studies address both figurative compositions and still-life compositions. Some of the studies are 3×4 inches (or 4×3 inches), and some of the studies are 6×8 inches (or 8×6 inches). Both vertical and horizontal compositions are explored, and multiple viewpoints of the subject matter are investigated.

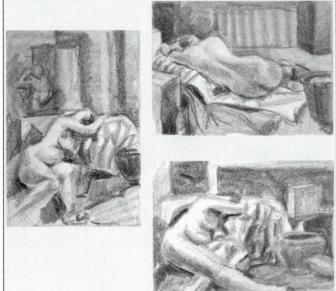

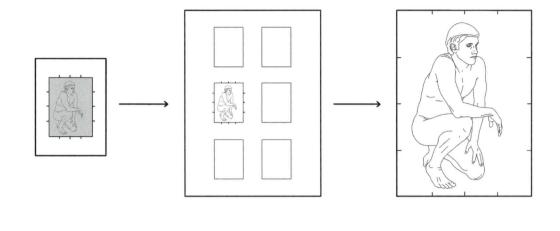

Figure 1-72. Here you see the progression from what is seen through the viewfinder (left) to a page of small thumbnail studies (center) to a full-size drawing based on a thumbnail sketch (right). Although this illustration shows all vertical or all horizontal thumbnail sketches on a single page, you can include both horizontal and vertical studies on a single page.

organization found in seemingly random or chaotic structures. Although it can be a bit overwhelming to the uninitiated with its strong foothold in mathematics, Euclidian geometry, and Pythagorean theory, proficiency in these subjects is not necessary to a basic understanding of the Golden Section and its role in nature and the arts. If you find your interest is piqued and you wish to investigate further, a number of resources are listed in the general Bibliography and in the Supplemental Bibliography for Design Principles. Following is a basic discussion of the Golden Section.

What Is the Golden Section?

The Golden Section (also known as the Golden Mean, the Golden Proportion, the Golden Ratio, the Golden Rectangle, and the Divine Proportion) is a system of aesthetically pleasing proportions based on the division of space into parts that correspond to the proportion of .618 to 1 or 1 to 1.618. An approximation of this proportion is expressed as three parts to five parts (3:5) or five parts to eight parts (5:8). Expressed differently, the smaller part relates to the size of the greater part in the same way that the greater part relates to the size

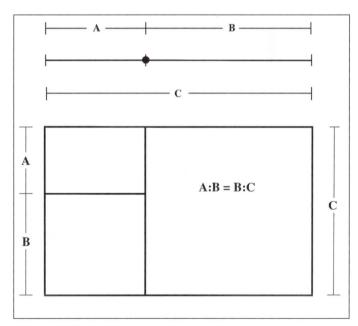

Figure 1-73. The Golden Section. A rectangle whose dimensions reflect the Golden Section is subdivided vertically and horizontally at points of Golden Section to create yet another golden rectangle. This subdivision can reoccur over and over again, creating increasingly smaller golden rectangles. This point of division can be applied to a line, to a rectangular plane, or to a three-dimensional solid.

of the whole (the sum of both the smaller and greater part). Numerically, this can be expressed *approximately* as 3 parts relate to 5 parts in the same way as 5 parts relate to 8 parts. On any given line, there is only one point that will bisect it into two unequal parts in this uniquely reciprocal fashion, and this one point is called the point of Golden Section (Figure 1-73). In fractions, the Golden Section can be generally expressed as a ¾5 or 5½8 division of space, but this is only an approximation that is used for the sake of convenience. This principle can be applied to a line, to a two-dimensional plane, or to a three-dimensional solid, and it is the only proportional relationship to increase by geometric progression and by simple addition simultaneously. This "divine" proportion is credited by some with various mystical properties and exceptional beauties both in science and in art.

Evidence of the principle of the Golden Section is found in the human body, in the capital letters of the Latin alphabet, in various forms throughout nature (including the structural formations of DNA, certain viruses, and quasi-crystals), and in architectural structures and details (Figure 1-74). Based on a Euclidean theory, Vitruvius worked out the Golden Section in the first century B.C. to establish architectural standards for the proportions of columns, rooms, and entire buildings, with the understanding that individual variations were expected of the architect. Historical masters such as Leonardo da Vinci, Piero Della Francesca, and Leon Battista Alberti all were aware of the significance of the Golden Section, and evidence of its application can be found throughout their work. More recently, the Golden Section provided inspiration for the cubists and was employed by Georges Seurat, Juan Gris, Pablo Picasso, and other renowned artists.

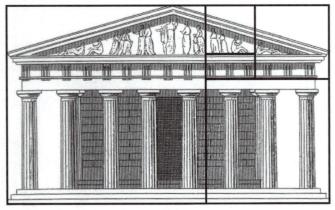

Figure 1-74. Eastern facade of the Parthenon. Courtesy of Dover Pictorial Archive Series, Dover Publications, Inc. This illustration superimposes an approximation of the Golden Section rectangle on the eastern facade of the Parthenon, showing the presence of the Golden Section proportions in the entire facade as well as the entablature and pediment.

Statistical experiments are said to have shown that human beings involuntarily give preference to proportions that approximate the Golden Section. In an October 1985 newspaper article distributed by the Associated Press and printed in the *Grand Rapids Press*, the following observations were made:

When a newborn baby first identifies its mother's face, it's not by color, shape, smell or heat, but the way the eyebrows, eyes, nose and mouth are arranged in proportions artists have known for centuries as the "golden ratio," says a noted child psychiatrist.

"It seems clear that nature has built a certain sense of proportions into the human organism that have survival value," said Dr. Eugene J. Mahon. "In other words, because it's essential for children to get to know the imprint of their mother's face, nature has not left it to chance."

Those proportions, Mahon said, happen to be the same as the famous proportion known for centuries by artists and architects as the "golden ratio," or "golden section." The golden ratio has been proven by experiments as particularly harmonious and pleasing to the human senses. It is not surprising, therefore, if it catches even the untrained eyes of a newborn, he said.

The Irish psychiatrist, who is on the faculty of Columbia University's Psychoanalytic Clinic for Training and Research as well as the Columbia College of Physicians and Surgeons, presented his findings in *The Psychoanalytic Study of the Child*.

"A mask constructed with two eyes, a nose and a mouth enclosed in an oval that resembles the human face will hold the attention of the infant as much as the human face itself," Mahon said in an interview, citing his and others' experiments.

"A mask with features out of proportion to expectable human anatomy, or the human face itself in profile, does not attract the attention of the infant nearly as intently as a human face. The distance from the top of the human head to the eyebrows and the distance from the eyebrows to the end of the chin are roughly 5 and 8, no matter what units of measurements are used. The distance from the tip of the nose to the lips and the distance from the lips to the end of the chin also relate to each other as 5 and 8. In the human face and body, we can find many combinations of the golden section."

The human preference for this particular proportion, which abounds in nature, architecture and classical paintings, has been known through the ages, the psychoanalyst said. Examples of golden rectangles are found on paper money, traveler's checks and credit cards, he said.

Constructing a Golden Rectangle

The "ideal" proportions of a rectangle are determined by the Golden Section, which explores projections of a square

Figure 1-75. Construction of a Golden Section rectangle based on the diagonal of a rectangle composed of two squares.

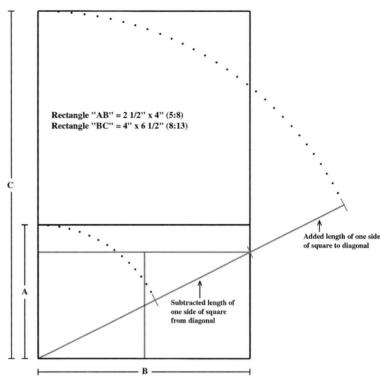

- Rectangle "AB" reflects the dimensions of the Golden Section
- Rectangle "BC" reflects the dimensions of the Golden Section
- Rectangles "AB" and "BC" are reciprocal; the long side (B) of "AB" is equal in length to the short side (B) of "BC"

within itself and outside of itself to create pleasing and harmonious proportional relationships. Geometrically, the Golden Section may be constructed by means of the diagonal of a rectangle composed of two squares (Figure 1-75). From the diagonal of a rectangle composed of two squares (1 × 2), add or subtract the length of one side of the square and place the resulting length against (at a 90° angle to) the longer side of the original rectangle. *Adding* the length of one side of the square creates the longer side of the resulting Golden Section rectangle (BC). *Subtracting* the length of one side of the square creates the shorter side of the resulting Golden Section rectangle (AB). The ratio of the two sides of the rectangle works out numerically to .618 to 1, or approximately 5 to 8.

A second method for constructing a Golden Section rectangle is based on the projection of a square outside of itself (Figure 1-76). Starting with a square, find the center point of the base of the square and from this point draw a line to the upper left or right corner of the square. Rotate this line left or right from the center point of the base of

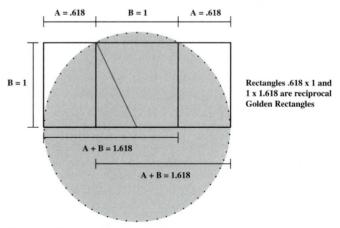

Figure 1-76. Construction of a Golden Section rectangle based on the projection of a square outside of itself.

the square until it aligns with and extends the base of the square. Constructing an additional vertical and horizontal line from this point of extension defines the proportions of a Golden Section rectangle. The Golden Section

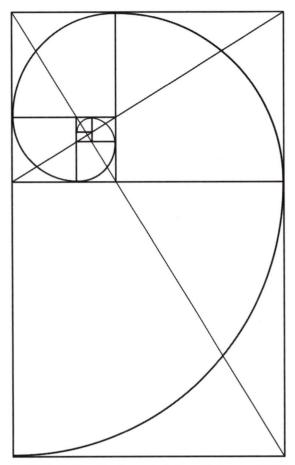

Figure 1-77. A Golden Section spiral. The spiral is created by rotating the length of the side of each square, with the squares becoming increasingly smaller. Theoretically, this process can continue indefinitely. Notice that the two diagonals, which cross at right angles at the point of Golden Section, are the diagonals for every Golden Section rectangle, both large and small, in the diagram.

spiral results from rotating the length of one side of the square within each of the series of squares that result from the repeated construction of successively smaller Golden Section rectangles (Figure 1-77). The spiral, which is theoretically infinite, ultimately focuses on a point defined by the intersection of the diagonals of both horizontally and vertically oriented Golden Section rectangles. This is called the point of Golden Section.

A rectangle that reflects the proportions of the Golden Section has four points of Golden Section, regardless of the orientation of the rectangle (Figure 1-78). But any rectangular shape also provides four points of Golden Section based on the diagonal of the rectangle intersected at right angles by a line extended from each of the four corners (Figure 1-79).

The Golden Section is unique in that its mathematical equivalent represents the only instance in which a ratio is the same or equal to a proportion. In other words, the expression of the Golden Section as a fraction is equal to the expression of the Golden Section as a ratio (Figure 1-80). It is often claimed that the Golden Section is aesthetically superior to all other proportions. A significant amount of research and data supporting this claim has been collected over the years, from both the scientific community and from the arts community. Some resources that provide in-depth information on particular applications or instances of the Golden Section and other formal systems of organization can be found in the Bibliography and in the "Supplemental Reading for Design Principles" Section of the Bibliography.

The Fibonacci Series

The Fibonacci Series is a system of expanding size relationships closely connected with the Golden Section. In mathematics, the Fibonacci Series is known as a summation series in which each number is the sum of the two previous numbers. In the twelfth century, Leonardo of Pisa, also known as Leonardo Fibonacci (1175–1230), discovered that if a ladder of whole numbers is constructed so that each number on the right is the sum of the pair on the preceding rung, the arithmetical ratio between the two numbers on the same rung rapidly approaches the Golden Section (.618 to 1 or 1 to 1.618, or phi). Beginning with 0 and 1, the first two whole numbers, each subsequent number in the series is simply the sum of the previous two. This numerical sequence, carried out a few times, yields the following series of numbers, known as the Fibonacci Series: (0, 1, 1,) 2, 3, 5, 8, 13, 21, 34, 55, 89, 144, 233, 377, 610, 987, 1597, 2584, 4181, 6765, 10946, 17711, 28657...

Again, the Fibonacci Series (shown in bold) results from the simple addition of each number and the previous number: $\mathbf{0} + \mathbf{1} = \mathbf{1}$, $1 + 1 = \mathbf{2}$, $1 + 2 = \mathbf{3}$, $2 + 3 = \mathbf{5}$, $3 + 5 = \mathbf{8}$, $5 + 8 = \mathbf{13}$, $8 + 13 = \mathbf{21}$, $13 + 21 = \mathbf{34}$, $21 + 34 = \mathbf{55}$, $34 + 55 = \mathbf{89}$, $55 + 89 = \mathbf{144}$, $89 + 144 = \mathbf{233}$, $144 + 233 = \mathbf{377}$, $233 + 377 = \mathbf{610}$, $377 + 610 = \mathbf{987}$, $610 + 987 = \mathbf{1597}$, $987 + 1597 = \mathbf{2584}$, $1597 + 2584 = \mathbf{4181}$, $2584 + 4181 = \mathbf{6765}$, $4181 + 6765 = \mathbf{10946}$, $6765 + 10946 = \mathbf{17711}$, $10946 + 17711 = \mathbf{28657}$.

The ratio of each successive pair of numbers in the series (2:3, 3:5, 5:8, 8:13, 13:21, etc.) increasingly approximates and converges on phi (1.618...). Beginning with 2, any number in this series divided by the *following* one (e.g., 5 divided by 8) approximates .618, while any number in this series divided by the *previous* one (e.g., 8 divided by 5) approximates 1.618

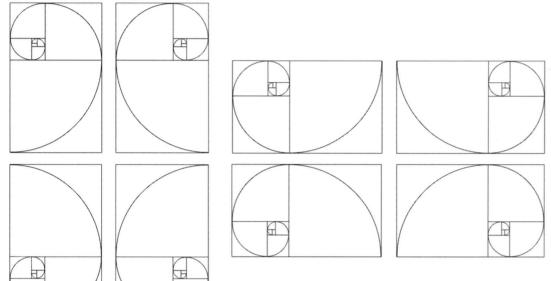

Figure 1-78. Every Golden Section rectangle, whether vertical or horizontal in orientation, has four points of Golden Section.

Figure 1-79. Rectangles that do not reflect the proportions of the Golden Section also have four points of Golden Section.

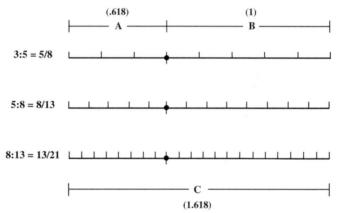

A(.618) : B(1) = B(1) : C(1.618)

Figure 1-80. The expression of the point of Golden Section on a line is expressed equally as a fraction and a ratio. For example, the fraction of $\frac{5}{8}$ essentially represents the same point of division as the ratio 5:8. Similarly, the fraction of $\frac{8}{13}$ represents the same point of division as the ratio 8:13. This illustrates the relationship between the point of Golden Section and the Fibonacci Series. These are approximations rather than precise expressions because the earlier fractions and ratios in the Fibonacci sequence are less precise reflections of the Golden Section.

(see Figure 1-80). These are the proportional rates between minor and major parts of the Golden Section: .618 (A) is to 1 (B) as 1 (B) is to 1.618 (C), or A:B = B:C. Note that the expression of the Golden Section as a fraction (5/8 or 8/13) approximates the same point of division as the expression of the Golden Section as a ratio (5:8 or 8:13). As you move higher up the ladder of numbers, this relationship becomes increasingly precise.

Further examples of a number divided by the *previous* number in the series include 3 divided by 2 equals 1.5, 5 divided by 3 equals 1.666..., 8 divided by 5 equals 1.6, 13 divided by 8 equals 1.625, and, further along in the series, 2584 divided by 1597 equals 1.6180338134. Further examples of a number divided by the *following* number in the series include 2 divided by 3 equals .66666..., 3 divided by 5 equals .6, 5 divided by 8 equals .625, 8 divided by 13 equals .6153846..., and, further along in the series, 6765 divided by 10946 equals .6180339.... After the 40th number in the series, the ratio is accurate up to fifteen decimal places.

In the study of phyllotaxis, which is the spiraling arrangement of leaves, scales, and flowers, it has been found that fractions representing these spiral arrangements are often members of the Fibonacci Series, which supports the notion that numerous instances of the Golden Section can be found in nature. One of the more striking examples of the Fibonacci Series in nature is the sunflower. Botanists have discovered that the average-size sunflower head, whose seeds are arranged in opposing spirals, shows exactly 55 seeds in a clockwise direction and exactly 89 seeds in a counterclockwise direction. Smaller and larger sunflower heads show the same ratio of opposing seed spirals such as 34 to 55 seed spirals, and 89 to 144 seed spirals. Nautilus shells, apple blossoms, daisies, artichokes, pussy willows, pineapple skins, and pinecones show similar ratios in their natural growth patterns. The proportions of the human body conform in many ways to this ratio.

The Illusion of Space and Depth on a Two-Dimensional Surface

Methods for Indicating Space and Depth

When attempting to convey a sense of space or depth on a flat or two-dimensional surface, certain variables should be carefully considered. These variables, when applied with awareness of their potential to emphasize or deemphasize space, can substantially increase or decrease the illusion of depth or distance in your drawing. These variables include size, baseline or position, overlapping, sharp and diminishing detail, converging parallels, and linear perspective.

Size: Large forms suggest nearness, while smaller forms suggest distance. Two objects or forms that are in reality exactly the same size will appear different in size when one object is positioned closer to us or when one object is positioned farther from us (Figure 1-81). Limiting size variation decreases the sense of space, while expanding on size variation increases the sense of space.

Baseline or position: Baseline refers to the imaginary point at which an object makes contact with a ground plane. The position or spatial location of objects is judged in relation to the horizon line (eye level). The bottom of the picture plane or drawing format is seen as the closest visual point to the viewer, and the degree to which a form "rises" on the page toward the horizon line or eye level indicates increasing depth or receding spatial positions (Figure 1-82). This relationship is reversed when we are dealing with forms that are floating above the horizon line or eye level; clouds are a good example of this. As a cloud is positioned lower on the page, closer to the horizon line or eye level, it is perceived as being farther away; as a cloud is positioned higher on the page, farther from the horizon line or eye level, it is perceived as being closer (Figure 1-83). Varying the baseline or position of objects increases the sense of space, while a lack of variety of baseline or position decreases the sense of space.

Overlapping: If one object covers part of the visible surface of another object, overlapping occurs and the first object is assumed to be nearer. The object that is most visible or complete is perceived to be nearer than the object that is

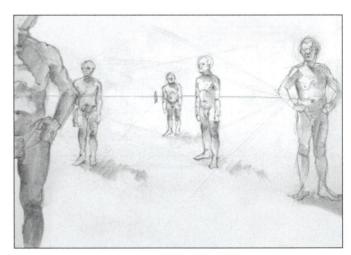

Figure 1-81. Student work. Jody Williams. The graduated size and placement of these standing male figures create a strong illusion of depth and space.

Figure 1-82. Wayne Thiebaud, Untitled (Lipsticks), 1972. Pastel on paper, 16 x 20 inches. Photo courtesy of the Allan Stone Gallery, New York, NY. Thiebaud's study of tubes of lipstick provides an excellent example of shifting baselines as an indicator of the spatial position of forms. As the tubes of lipsticks are positioned higher on the drawing surface, they appear to be farther back in space.

Figure 1-83. Deborah Rockman, Skyscape No. 2, 1990. Oil pastel on gessoed paper, 48 x 30 Inches. Collection of Calvin College, Grand Rapids, MI. Contrary to forms on the ground plane, clouds or any other forms that are above our eye level are perceived as farther away as they approach the bottom of a composition and are perceived as nearer as they approach the top of a composition.

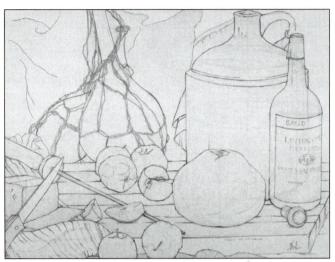

Figure 1-84. Student work. Clarkson Thorp. The many instances of overlapping in this still life help to reinforce the illusion of space or depth. Note that there are many examples of spatial contradiction as smaller forms repeatedly overlap larger forms.

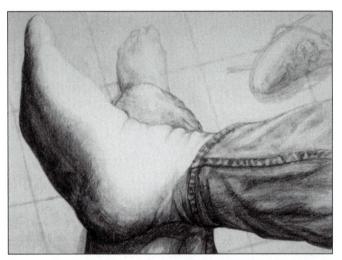

Figure 1-85. Student work. This drawing, the result of looking down on one's own body, uses changes in contrast and detail to reinforce depth and space. The forms in the foreground are sharp and clear, with detail and full value contrast. The forms in the background are softer in focus, with less value contrast and detail.

partially hidden due to overlapping. Keep in mind that overlapping can contradict the spatial indicator of diminishing size if a smaller form overlaps a larger form (Figure 1-84). Minimal instances of overlapping decrease the sense of space, while numerous instances of overlapping increase the sense of space.

Sharp and diminishing detail: Close objects appear sharp and clear in definition, while objects at great distances

Figure 1-86. Student work. As the plant forms move from the foreground to the background on this white drawing surface, the value range diminishes toward the light end of the value scale, joining the distant plant forms more closely with the light paper tone.

appear softer and lacking in definition, focus, and detail. Close objects will reveal more texture, while distant objects appear to have less texture. Minimizing differences in clarity and detail will decrease the sense of space, while maximizing differences in clarity and detail will increase the sense of space (Figure 1-85).

Value contrast: Close objects will reveal a fuller value range (higher contrast), while distant objects will reveal a limited value range with a reduction in strong darks and/or strong lights (low contrast). High contrast advances, while low contrast recedes. This is related to the concept of atmospheric perspective. Minimizing value contrast will decrease the sense of space, while maximizing value contrast will increase the sense of space.

The notion of value contrast in relation to space is often misunderstood. If objects are receding into a light space, value contrast will diminish toward the light end of the value scale, with fewer dark values (Figure 1-86). If, however, objects are receding into a dark space, value contrast will diminish toward the dark end of the value scale, with fewer light values (Figure 1-87).

Converging parallels: Any set of parallel lines (a railroad track, for example) will appear to converge or meet as they move back in space and away from the viewer toward the horizon line. This idea is closely related to linear perspective (Figure 1-88). A minimal rate of convergence will diminish the sense of space, while an increased rate of convergence will heighten the sense of space.

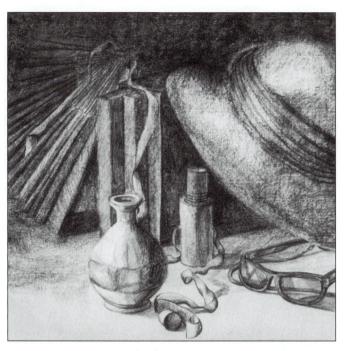

Figure 1-87. Student work. Stacy Cossolini. As the forms in this still life move from the foreground toward the dark background, the value range diminishes toward the dark end of the value scale, joining those forms more closely with the dark background values.

Figure 1-88. Student work. Craig Pennington. The converging parallel edges of this two-point perspective view of a truck strengthen the illusion of depth in this drawing.

Figure 1-89. Robert Rohm, Untitled, 1975. Graphite on paper, $19^{3/4} \times 26^{1/2}$ inches $(50.17 \times 67.31 \text{ cm}).$ Whitney Museum of American Art, New York. Gift of Dr. Marilynn and Ivan C. Karp. 75.50. Photograph by Geoffrey Clements. In Rohm's exquisitely rendered drawing of a weathered brick wall, there is little sense of movement into the picture plane, creating shallow space.

Linear perspective: A geometric/mathematical system is used for converting sizes and distances of known objects into a unified spatial order, consistent in scale, and assuming a view from a single, fixed position at a particular moment in time. Linear perspective, discussed more thoroughly in Chapter Three, is generally used to enhance the sense of space.

Different Kinds of Space

Not all drawings are concerned with creating a sense of depth or deep space, although most often a beginning student will create flat or shallow space by default or will unintentionally mix different kinds of space in a single drawing. You will benefit by knowing how to create a variety of types of space in your work and will probably need to give special attention to learning how to convey a strong and uniform illusion of space or depth. Some different kinds of space include decorative space, plastic space, shallow space, deep or infinite space, and ambiguous space.

Decorative space: A depthless surface or a space that exists across the picture plane (up and down and side to side) rather than into it. Distances between images or elements can be measured *across* the picture plane rather than *into* the picture plane. Decorative space is essentially two-dimensional space. **Shallow space:** Sometimes called "limited depth" because the artist controls the visual elements so that nothing appears to move very far beyond or into the picture plane. Shallow space makes minimal use of spatial indicators and can be compared to the restricted space of a box or a stage (Figure 1-89).

Plastic space: A space that seems to extend beyond or into the surface of the picture plane by creating the illusion of depth and volume. Images or elements have relationships of depth as well as of length and width. Plastic space is essentially the illusion of three-dimensional space (Figure 1-90).

Deep or infinite space: An illusion of space that has the quality of endlessness found in the natural environment, also referred to as "atmospheric perspective" (Figure 1-91). Size, position, overlapping images, sharp and diminishing detail, converging parallels, and perspective, discussed earlier, are traditional methods for indicating deep space.

Ambiguous space: A combination of different kinds of space, creating no single kind of space. Ambiguous space combines elements of dimension and flatness and uses spatial indicators in an intentionally contradictory way to create a vague or uncertain space (Figure 1-92).

Figure 1-90. Student work. Alison Simmons. There is a strong sense of movement both into and beyond the picture plane, creating an effective illusion of three-dimensional space or plastic space.

The Volumetric and Spatial Effects of Color

Although color is not specifically addressed in this book, it is helpful to have some guidelines concerning how color functions as a component of volume and space.

Value and space: In general, any light colors (light in value) on a dark ground will advance or come forward according to the degree of lightness of value. On a light ground, this effect is simply reversed: Colors of a light value recede and colors of a dark value advance, according to their degree of lightness or darkness. It is always important to determine which colors are acting as the ground against which other colors interact.

Figure 1-91. Georges Seurat, French. 1859–1891, Place de la Concorde, Winter (Place de la Concorde, l'hiver), c. 1881–1883. Conte crayon and chalk on Michallet paper, $9^{1}/8 \times 12^{1}/8$ inches (23.2 × 30.8 cm), Solomon R. Guggenheim Museum, New York. Gift, Solomon R. Guggenheim, 1941. 41.721. Although there is a strong presence of vertical and horizontal elements in this winter scene, Seurat's use of implied diagonals and atmospheric perspective suggests a deep twilight space.

Figure 1-92. Student work. Andrea Helm Hossink. This drawing combines opacity, transparency, dimension, and flatness, creating an intentionally ambiguous or vague space.

Temperature and space: Among cool and warm colors of equal value, the warm colors (red, yellow, and orange and their intermediates) will advance and the cool colors (blue, green, and violet and their intermediates) will recede. If value contrast is also present, the spatial effects will be increased, decreased, or canceled out accordingly.

Intensity and space: Differences or contrast in the purity or intensity of colors also affects spatial properties. A pure color advances relative to a duller color of equal value, but if value or temperature contrasts are also present, the spatial relationships shift accordingly.

One must also consider the role that other spatial indicators play, independently of the presence of color. The presence of overlapping, size variation, position on the page (baselines), sharp or dull focus, detail, and texture can support or contradict the role of color in suggesting space.

When a form is to be modeled or shaded to suggest volume and dimension, the spatial properties of color (chromatic) may be used to enhance the sense of volume and dimension. Value, temperature, intensity, and texture play a significant role in establishing volume and dimensionality when using color. The following are good general guidelines, keeping in mind that there are always exceptions.

Value and volume: Darker colors are used to define areas in shadow, and lighter colors are used to define areas that are illuminated or in light.

Temperature and volume: Cooler colors are used to define areas in shadow, and warmer colors are used to define areas that are illuminated or in light.

Intensity and volume: Dulled and low-intensity colors are used to define areas in shadow, and bright, high-intensity colors are used to define areas that are illuminated or in light. **Texture and volume:** Reduced texture is used in applying colors used to define areas in shadow, and greater texture is used in applying colors used to define areas that are illuminated or in light.

Line Variation and Sensitivity

Line as used by artists to indicate the boundaries and edges of forms is the oldest known method for depicting both animate and inanimate objects. Paleolithic cave paintings from prehistoric times provide us with evidence of early humans' use of line in their description of the various animals they hunted for food, clothing, and tools. Throughout the long history of drawing, line is the most direct and immediate way of depicting a form or expressing an idea, and it continues to play a vital role in contemporary art. Line can stand alone or play a supporting role to a wide range of media, processes, and disciplines.

Working from General to Specific

When you begin to construct a drawing using line, you don't need to initially concern yourself with line variation. Line variation becomes more significant after you have blocked in objects with concern for their general placement and proportion, their relationship to other objects, and their relationship to the entire drawing surface. During this early stage in the development of a drawing, your line work should prioritize the larger, simpler aspects of the forms you are drawing and should be gestural in nature. Reserve your attention to details until after the primary structural components are established through line. Even in this early stage of the drawing when you are blocking in generalized information, there will be some natural variation in the line work as you move your drawing tool around the paper searching for the general shapes and masses that describe what you are observing. When you are adequately prepared to incorporate details and more specific information, you can begin to develop line variation and sensitivity that addresses all aspects of form, both the general and the specific aspects.

The Medium and Surface

When thinking about line quality and line sensitivity, two of the first factors that you should take into consideration are *medium* and *surface*. What medium are you using and to what surface are you applying it? Different media respond in a variety of ways depending upon the surface employed and the technique used in applying the media. For example, a dry drawing material such as charcoal or graphite will generally yield a texture that reflects the surface of the paper. If the paper is smooth, the texture of the line will be relatively smooth. If the paper is rough or textured, such as charcoal paper, the line work will tend to reveal the texture of the paper. A charcoal line drawn with significant pressure on a textured surface may ultimately sink into the textured surface, diminishing evidence of the paper's texture.

What Is Meant by "Sensitive" Line?

Sensitive: Having the power of sensation; ready and delicate in response to outside influences; able to register minute changes or differences; degree of responsiveness to stimuli; having power of feeling; of such a nature as to be easily affected.

Sensitive line is sensitive in its description of and response to both inner and outer contours or edges of an object. Sensitive line is able to register minute changes or differences found along contours or edges. Sensitive line is responsive to both subtle and not-so-subtle activity found along contours or edges. Sensitive line has the power to convey a strong sense of volume, mass, form, weight, dimensionality, and space and can also convey a strong sense of feeling.

Sensitive line, in addition to its responsiveness to the information being described or interpreted, is also sensitive in its own right, independent of subject matter. Whether it addresses a particular form or exists independently, it can display various qualities including textured or smooth, dark or light, continuous or broken, curvilinear or rectilinear, heavy or delicate, thick or thin, and so on. But ultimately sensitive contour line can be described as having three main qualities—weight, value, and texture. Sensitive line is capable of describing a form with simultaneous regard for shadow and light, for position in space (foreground, middle ground, and background), and for perceived physical weight and the effect of gravity on a form (Figure 1-93). The shifting quality of weight, value, and texture in line work invites various interpretations regarding light source, spatial position, and weight or grounding of objects. The quality of line is determined by the artist's response to the medium being used,

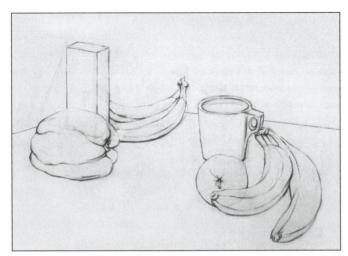

Figure 1-93. Student work. This simple but beautiful still-life drawing utilizes linear changes in weight (thick to thin), value (light to dark), and texture (soft to sharp) to convey light source, spatial position, and weight or gravity of forms.

the surface on which the medium is being applied, and the subject matter with which the artist is concerned.

Achieving Line Variation and Line Sensitivity

There are no specific "formulas" for achieving line quality and sensitivity. The kind of line employed by the artist is a decision based on the artist's personal response to the form being drawn, and that response is undoubtedly influenced by a multitude of factors. Lines vary tremendously in character, and each type of line has its own expressive potential.

Following are some examples of various ways to approach the development of sensitive, descriptive line as it concerns itself with edges or contours. The examples focus on the development of tonal or dimensional line, which through its changes suggests form, volume and/or space, and weight or grounding of an object.

Light and Dark or Light Source

This can include concern for both the effects of an actual light source or an imagined light source. Edges bathed in shadow may be depicted with a darker, heavier line, and edges washed in light may be depicted with a lighter, more delicate line (Figure 1-94). It is important not to uniformly darken all edges in shadow and uniformly lighten all edges in light, as there are other factors to consider. An edge bathed in shadow may also have numerous dips and swells or other activity that also impacts the quality of line. What is important here is the relative difference in line quality. Complex

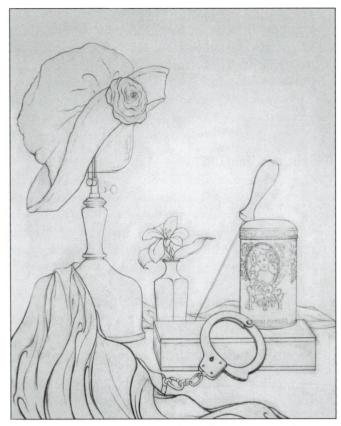

Figure 1-94. Student work. Jane Black. This linear drawing describes the direction of the light source by utilizing lighter lines along edges that are illuminated and darker lines along edges in shadow.

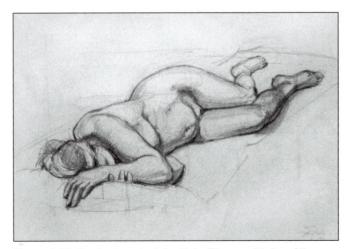

Figure 1-95. Student work. John Hale. The sensitivity of line variation in this figure study conveys weight, volume, space, and an overhead light source.

contours bathed in shadow will have variation in the line work, but the variation will occur within the darker range of the value scale. The same can be said concerning a complex contour bathed in light. There will be variation in the line work that acknowledges other factors besides light source, but the variation will occur within the lighter range of the value scale (Figure 1-95).

Weight and Tension

This method concerns itself not only with the actual weight of objects as masses in space, but also with surface tension resulting from internal or structural activity. In relation to the human form, for example, the effects of the skeletal structure and musculature on the surface of the body are considered. Where weight is supported, a darker or heavier

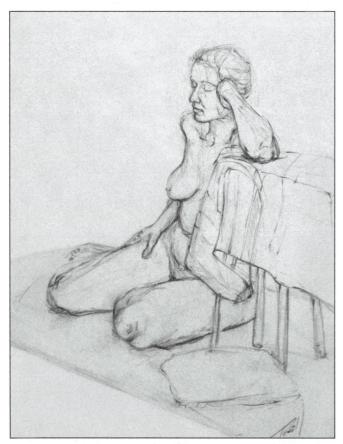

Figure 1-96. Student work. Cliff Towell. Weighted line along the model's left leg and left elbow reinforces where the model's weight is supported. Line work is lighter and more delicate at the bent knees to suggest the stretching and thinning of the skin as bone and muscle strain against the surface of the body.

line can be used. The point or edge where one surface rests on or presses against another surface can be emphasized through a darker or heavier line. When the underlying structure of the figure (bone or muscle) pushes or strains against the containment of the skin, a lighter or more delicate line can be used to suggest the "stretching" and "thinning" of the skin, whereas a more flaccid area may be suggested by the use of a heavier or darker line (Figures 1-96 and 1-97).

"Speed" of Contours and Edges

The quickness or slowness with which an edge or contour seems to move in space is considered and influences the kind of line used to describe that movement. If one thinks of the contours as a path or roadway being traveled, contours that require more careful negotiation because of complexity (*slower* contours) would be suggested by an appropriately darker or heavier line; contours that do not require such careful negotiation (*faster* contours) would be suggested by an appropriately lighter or more delicate line (Figures 1-98 and 1-99).

High and Low Points, or Dips and Swells, in Contours

This process, very simply, suggests that as contours dip into or toward the major mass of a form (depressions), they theoretically move away from light and into shadow and can be suggested through use of a darker or heavier line. Conversely, as contours swell away from the major mass of a form (projections), they theoretically move away from

Figure 1-97. Student work. Jennie Barnes. The line along the contour where the apple and beet rest on the ground plane is darkened to indicate contact with another surface. The point of contact of the stem with the apple is also emphasized through darker line.

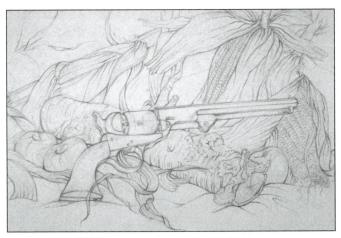

Figure 1-98. Student work. Clarkson Thorp. Slower contours, where directional changes occur or where different edges meet or overlap, are described with a darker line that reinforces the volume of the various forms.

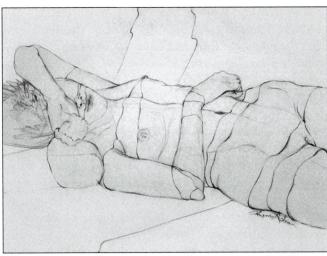

Figure 1-100. Student work. Rene Adrian Rogers. In this combined contour and cross-contour study of the figure, surfaces or edges that dip toward the major mass of the body are darkened according to the strength of the dip, and surfaces or edges that swell away from the major mass of the body are lightened accordingly.

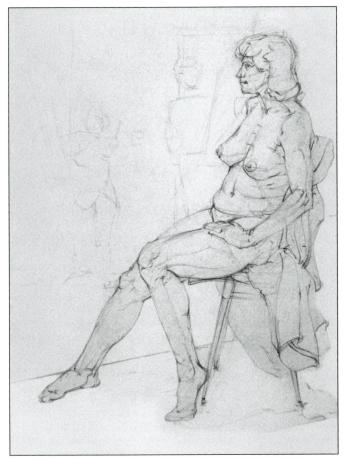

Figure 1-99. Student work. Jody Williams. Slower and faster contours of the figure are indicated by darker and lighter lines, respectively.

Figure 1-101. Student work. Lea (Momi) Antonio. The delicate lightening and darkening of line work in this page of hand studies describe the richness and subtlety of contour and surface variations in the hands.

shadow and into light and can be suggested through use of a lighter or more delicate line. You can also think of a depression into the form as a more flaccid edge, suggesting darker line work, and a projection out of the form as a more taut or stretched edge, suggesting lighter line work (Figures 1-100 and 1-101).

Strength or Force of an Edge

When using line to define and describe edges, it is vital to recognize that not all edges are equal in strength or force. Most exterior edges, like the outermost edge of a bulb of garlic or the outermost edges of a shoe or of the human figure, are firm and definite. They are the result of a form meeting negative space. But other edges, typically found in the interior of a form, can range from firm to fairly gentle to extremely delicate, and the line work used to describe these edges must reflect this difference. Think of the delicate edges found on the interior of a garlic bulb as the surface curves and undulates. Think of the delicate creases

on a boot formed by the constant bending of the boot when walking. Think of the delicate edges found on the interior surface of the human body based on the ripple of muscles or tendon, the delicate projection of a bony landmark such as the clavicle (collar bone), the hollows in the neck or the buttocks. When describing a more delicate or tentative edge, it is important to vary not only the tone of the line, but the thickness and clarity as well. Changing your grip on the drawing tool and favoring the side over the point of the tool provides a way of gently building up a softer, lighter, and less focused line, which is very capable of describing more delicate interior edges. The appropriate combination of strong, crisp lines and soft, unfocused lines greatly enhances the sense of dimension and volume (Figures 1-102 and 1-103).

Spatial Sequence

This applies not only to the spatial relationships between various objects but also to the spatial relationships found

Figure 1-103. Student work, Kirk Bierens. Both firm and delicate edges are described with great sensitivity in this simple still-life arrangement of a human-made and a natural form. The side of the drawing pencil is effectively used in describing the especially delicate contours found in the interior of the gourd.

Figure 1-102. Student work (after Albrecht Dürer). Amy Allison. The rich variety of edges and contours found in the face are explored by working with a number of factors—hard, medium, and soft drawing material; increased and decreased pressure on the drawing tool; and shifts from the tip of the drawing tool to the side of the drawing tool.

within a single object that is volumetric or three-dimensional and takes up space. On a light drawing surface, darker lines advance or come forward and lighter lines recede or move back in space. This relationship is reversed on a dark drawing surface. Using a full range of value, weight, and texture in your line work, you can suggest full volume; a clear separation between foreground, middle ground, and background; and the grounding of forms upon the surface where they rest (Figures 1-104 and 1-105). A wide, bold, heavy, or thick line (weight) that is dark (value) and sharp, crisp, and in focus (texture) will advance or come forward in space. Conversely, a thin, delicate, wispy, fragile line (weight) that is light (value) and fuzzy, soft, and out of focus (texture) will recede or move back in space. While these describe the extremes of the spatial qualities of line, there can be numerous intermediate degrees of space that are described by line work that utilizes more moderate degrees and combinations of weight, value, and texture.

Degrees of Importance

This method implies the development of focal points in a composition through greater development of line. Areas

of greater or lesser importance are described to a greater or lesser degree through line, creating dominant passages or focal points in a composition (Figure 1-106). The decision to lend greater or lesser importance to a particular area is a subjective one based on your personal response.

Combining Different Methods

Although discussed individually, the preceding methods for achieving line sensitivity and variation need not be considered separately in their application. Various methods can and should be combined and made to work together based on the needs and desires of the artist (Figures 1-107 and 1-108).

There will be instances when consideration for one method, such as the effects of light source, will conflict with consideration for another method, such as the speed of contours or weight and tension. In situations where one consideration would suggest the use of lighter line (e.g., the bony projection of the elbow in a bent arm would suggest a lighter line if you consider the stretching of the skin and the tension of the bone against the skin) and another consideration would suggest the use of darker line (this same

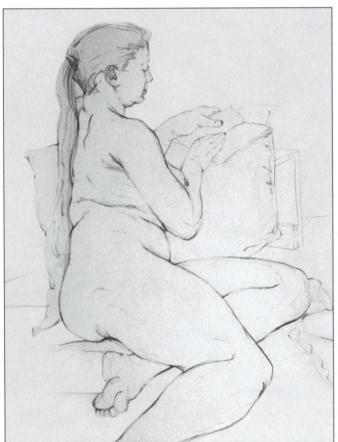

Figure 1-105. Student work. Laurie Rousseau. The shoes in the foreground are drawn using a broader tonal range in the line work, while the shoes positioned farther from the picture plane are drawn using a limited tonal range.

Figure 1-104. Student work. Chris Schroeder. Because the hands of the model and the book recede in space, the line work used to describe them is lighter in tonal range to more closely identify these receding forms with the light value of the background.

Figure 1-106. Henri de Toulouse-Lautrec, French, 1864–1901, *Study*, c. 1893. Charcoal, with colored crayons, on tan wove paper, height: 509 mm, width: 348 mm. Mr. and Mrs. Carter H. Harrison Collection, 1933.880, The Art Institute of Chicago. Photography © The Art Institute of Chicago. Through the use of heavier and more emphatic line work to describe the figure in this drawing of a lithographer, Lautrec focuses our attention on the man and his activity.

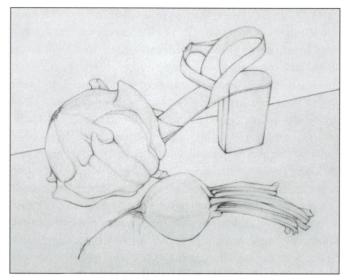

Figure 1-107. Student work. Emily LaBue. The line variation in this still-life study shows concern for a variety of factors, including light source, speed of contours, both firm and delicate contours, weight distribution, points of articulation, and so on.

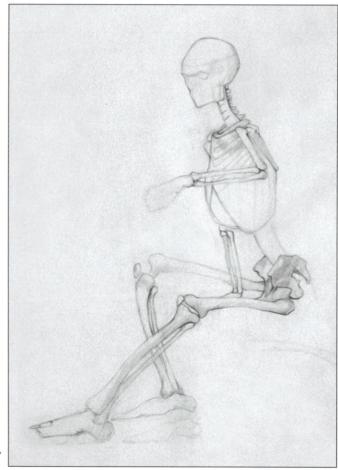

Figure 1-108. Student work. Michelle Velez. Although this study of the skeleton is in progress, the development of the line work emphasizes light source, points of articulation, weight distribution, speed of contours, and so on.

bony projection would suggest a darker line if you consider the speed or complexity of this slower contour), you must decide which consideration seems most important, and apply line variation accordingly.

Different Kinds and Functions of Line

Gesture line: Gesture line is a very rapid, generalized line that is searching in nature and establishes basic size, placement, and attitude of your subject matter. Gesture line does not focus on contours or edges, but rather duplicates the movement of the eyes as you quickly scan a figure or an object. It is not concerned with detail. Although it is most often used in relation to the figure and its inherent energy and potential for movement, it is also valuable to apply gesture-drawing principles to any subject matter.

In addition to its preparatory value, gesture drawing helps you to gain experience in making rapid observations of overall figure or object placement and proportion. For a more detailed discussion of gesture drawing, see Chapter Two.

Contour line: Contour line is a single line, deliberately and slowly executed. It defines edges—edges of planes and both interior and exterior edges. There is typically no erasure work or correction in pure contour line (Figure 1-109). Blind contour indicates that you look only at the subject being drawn, and not at the paper.

Modified contour line: Modified contour line allows you to draw a bit more quickly, with only occasional glances at the drawing surface to monitor proportions, still focusing primarily on the subject being drawn. The work of Henri Matisse and Pablo Picasso provides some good examples of simple contour line.

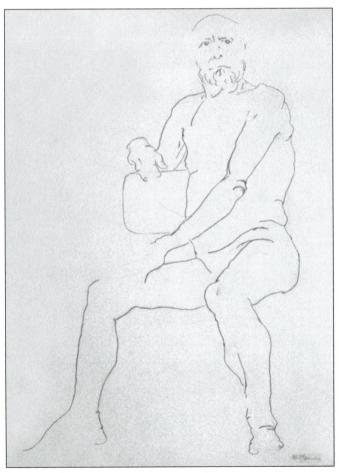

Figure 1-109. Student work. Mike O'Brien. This simple and concise contour line drawing of the figure is consistent in line weight, carefully describing all the various directional changes observed in the contours.

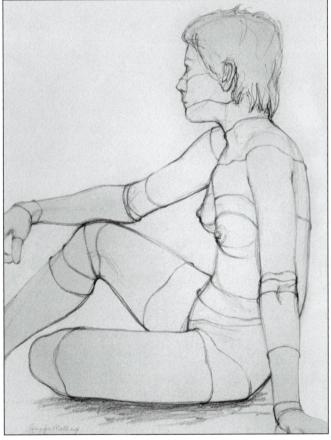

Figure 1-110. Student work. Jennifer Malleaux-Schut. This figure study serves as an example of cross-contour line as surface analysis, exploring the planes and surfaces found on the interior of the figure.

Cross-contour line: Cross-contour lines describe an object's surface *between* edges. Rather than following the edges of planes, cross-contour lines move from side to side *across* planes, describing dips and swells and surface changes and enhancing the sense of volume and dimensionality (Figure 1-110). Henry Moore's drawings are a good example of cross-contour line.

Classical line: Rooted in classical art, classical line is disciplined, restrained, and precise. It is typically crisp and delicate in character, lacking significant variation in value or weight. It usually focuses on exterior contours with minimal description of interior information and yet is capable of evoking a strong sense of volume and dimension (Figure 1-111). The drawings of Jean-Auguste Dominique Ingres provide an excellent example of classical line.

Anatomical line: Anatomical line strongly denotes the presence of the internal or underlying structure of an object. Most often used in reference to the human figure, it suggests the presence of structural or anatomical factors, such

as skeletal structure or muscle structure, that directly or indirectly influence the appearance of the surface of the figure (Figure 1-112). The figure drawings of Alex McKibbin and Egon Schiele provide good examples of anatomical line.

Organizational line: Organizational lines act as the underpinnings of a drawing and are most often absorbed into the finished work without being especially evident in the end result. Organizational lines can include axis lines indicating the major and minor directional thrusts of a form and lines indicating spatial relationships between foreground, middle ground, and background forms. Organizational lines are a construct, not actually existing to be directly observed. Alberto Giacometti's work, however, relies strongly on the enduring presence of organizational line as an integral part of his figurative and nonfigurative drawings (Figure 1-113).

Structural line: Structural line reveals the structure of an object by describing the various planes that make up the object. Line can describe the edges of planes (contour line), with structural line added to indicate the main directional

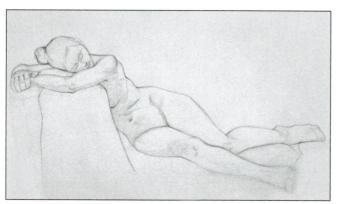

Figure 1-111. Student work. Janelle Songer. This study is an example of the delicate and precise character of classical line.

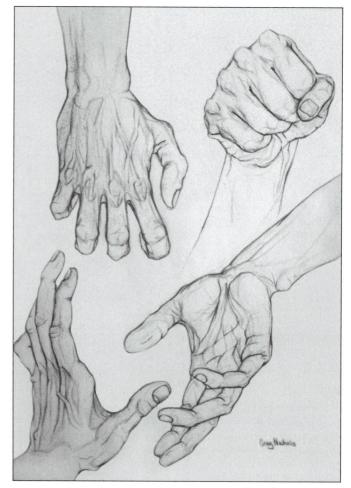

Figure 1-112. Student work. Greg Nichols. This linear composition of hand studies is especially attentive to anatomical factors, such as the heads of the metacarpal bones and the phalanges (knuckles), the styloid process of the radius (wrist bone), the tendonous extensions of muscle on the back of the hand, and the thenar and hypothenar muscles visible on the palm side of the hand.

Figure 1-113. Alberto Giacometti, Still Life, 1948. Pencil, $19^1/4 \times 12^1/2$ inches. Collection of the Modern Art Museum of Fort Worth, gift of B. Gerald Cantor, Beverly Hills, California. © 2007 Artists Rights Society (ARS), New York/ADAGP, Paris. Giacometti's drawings, both figurative and nonfigurative, consistently utilize organizational line as an integral and visible element.

thrusts of these planes, enhancing the sense of volume and dimensionality. When clustered together, structural lines can also describe value or tonal structure (Figure 1-114). The drawings of Robert Smithson and Christo provide some good examples of structural line.

Mechanical line: Mechanical line is objective as opposed to subjective and remains constant in character, without significant changes in width or value or texture. Its most obvious application would be found in the field of architecture and architectural blueprints or in technical drawings

(Figure 1-115). The drawings of Stuart Davis and Sol Lewitt provide examples of mechanical line.

Angular line: Angular line can be used to develop a precise definition of contours that are not typically considered to be angular in nature. It employs the use of a series of straight lines to interpret a curved edge or contour, without the straight lines being particularly dominant in the end result (Figure 1-116). The visual result provides a sense of full and descriptive contours. Some drawings by Oskar Kokoschka, Henri de Toulouse-Lautrec (Figure 1-117), and Pablo Picasso provide examples of the use of angular line, and an examination of any number of historical and contemporary drawings will reveal additional examples.

Decorative line: Decorative lines are typically more curvilinear than rectilinear and are generally rooted in interpretation rather than objective observation. They convey a sense of spontaneity, ease, and relaxation, moving gracefully and fluidly across the page. The drawings of Henri Matisse and Pierre Bonnard provide some good examples of decorative line.

Calligraphic line: Calligraphic line resembles handwriting and makes use of fluid, continuous movement. Eastern artists developed the art of calligraphy, in which the tool, media, surface, and technique are all considered equally important, with ink, brush, and paper serving traditional calligraphy. The calligraphic line explores extremes of thick to thin, heavy to delicate, long to short. The work of Japanese artist Hokusai is a beautiful example of calligraphic line in drawing.

Broken or implied line: Relying on the principle of closure (a perceptual phenomenon in which the viewer participates by visually filling in the "missing information"), broken or implied line is the mere suggestion of an edge or contour as opposed to the explicit definition of an edge or contour (Figure 1-118). The use of broken or implied line creates an "open" shape (as opposed to a "closed" shape), allowing a free exchange between positive and negative space. The drawings of Rico Lebrun and Egon Schiele provide some good examples of broken or implied line

Altered line: Characterized by a reworking of line, altered lines are smeared, rubbed, blurred, softened, or erased to create an imprecise line. Subjective in nature, altered lines are capable of conveying motion or movement or a sense of ambiguous form or space because of their imprecision (Figure 1-119). The drawings of Larry Rivers and Michael Mazur provide good examples of altered line.

Agitated or angry line: Characterized by irregular or choppy strokes, agitated or angry line conveys the same—a sense of agitation, anger, tension, or a similarly negative emotion

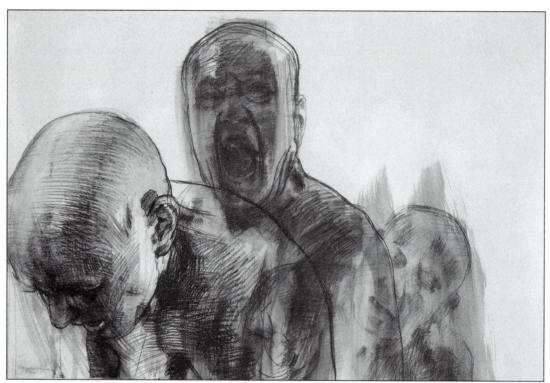

Figure 1-114. Margaret Lazzari, American, Scream, 2004. Conte on paper, 30 × 44 inches. Courtesy of the artist. The use of structural line in this drawing functions in two significant ways, reinforcing the directional thrust of a variety of planes in the figures while also creating tonal structure.

Figure 1-115. Student work. Jeff VandenBerg. Mechanical line is employed in this transparent construction study of a truck seen in two-point perspective.

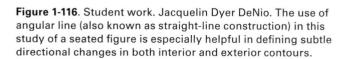

Figure 1-117. Henri de Toulouse-Lautrec, French, 1864-1901, The Model Nizzavona, c. 1882-1883. Charcoal, with stumping, on cream laid paper, 610 x 471 mm. Mr. and Mrs. Carter H. Harrison Collection, 1933.881, The Art Institute of Chicago. Photography © The Art Institute of Chicago. Lautrec's drawing of a seated male figure shows a number of passages that utilize angular line to describe the movement of contours. Note especially the model's right foot, left knee, and right arm and hand.

63

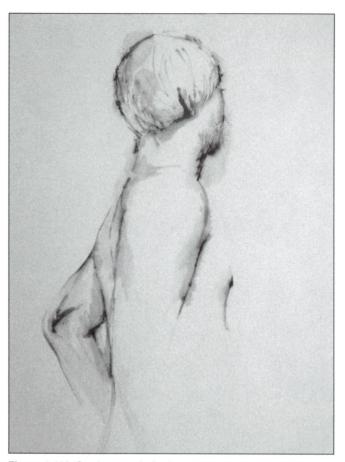

Figure 1-118. Student work. Broken or implied line is utilized in those areas where the contour is not engaged in significant directional changes or overlapping. In this drawing, implied line is found in the model's upper chest, lower arm, and stomach area.

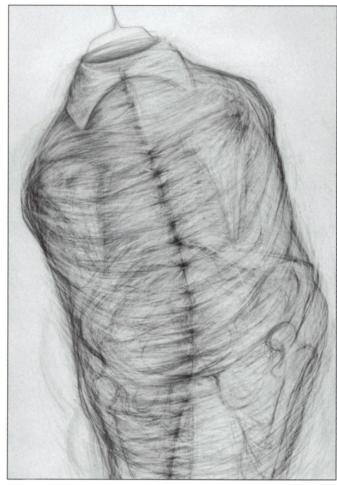

Figure 1-119. Student work. Jason Roda. Erasers are used to shift, smear, blur, and soften nearly all the line work in this drawing of anthropomorphized clothing.

(Figure 1-120). Rooted in subjective interpretation rather than objective observation, and considered the "opposite" of decorative line, agitated or angry line should be reserved for a fitting subject. The drawings of George Grosz and Ben Shahn provide good examples of agitated or angry line.

Process or searching lines: Process lines or searching lines refer to the presence of the initial marks made by the artist in seeking out correct or "true" edges and contours (Figure 1-121). They are often considered to be mistakes by beginning drawers and are erased, leaving only a single line to describe an edge or contour. If delicate process or adjustment lines are selectively allowed to remain visible to the viewer, they can add much vitality and life to a drawing and convey a strong sense of the process and search involved in drawing. Numerous examples can be found in both historical and contemporary drawings.

Tonal or dimensional line: Although addressed here as an individual kind of line, tonal or dimensional line is frequently an integral part of other functions of line previously discussed and is particularly important in conveying a sense of dimension, space, and grounding through line. Variation of the line, specifically in the weight of the line (thick and thin), the value or tone of the line (light and dark), and the texture of the line (crisp and soft), is required. This variation can address a wide range of concerns (as discussed earlier) based on the artist's response to the information at hand. Tonal line as it explores contours and edges can respond to the effects of illumination or light source, to the strength or force of an edge, to the "peaks and valleys" of form, to weight and/or tension, to the "speed" of contours and edges, to the spatial sequence of forms, or to a combination of these factors (Figures 1-122 and 1-123).

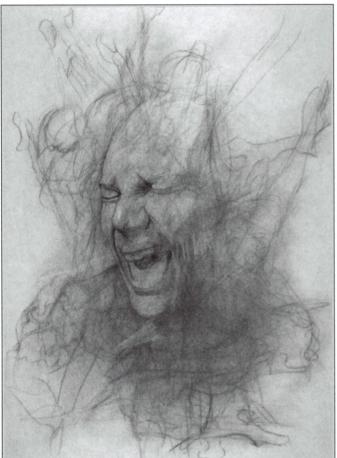

Figure 1-120. Student work. Douglas Borton. This drawing of a screaming man utilizes a dense network of agitated line work that becomes the ground or base tone for the more defined face.

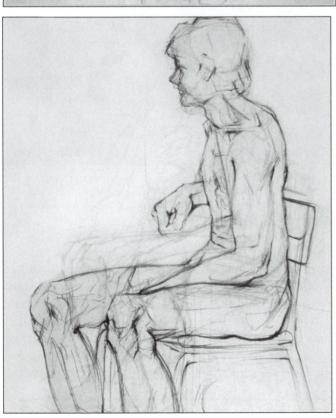

Figure 1-122. Student work (after Hans Burgkmair the Elder). Kerre Nykamp. This beautiful study of a master's portrait drawing utilizes a broad range of tonal changes in the line work that support the illusion of dimensionality even in the absence of shading.

Figure 1-121. Student work. Mary Evers. Multiple process lines in this figure study show evidence of the search for proportion, placement, and contour changes.

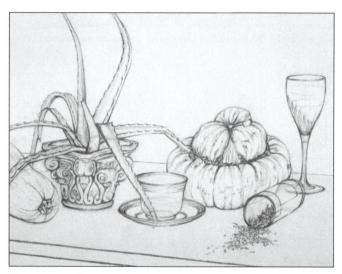

Figure 1-123. Student work. Kirk Bierens. This still-life study relies on variations in the value and sharpness of line to describe many different kinds of contours, textures, and edges.

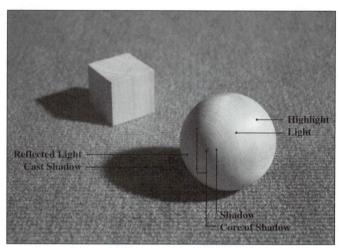

Figure 1-124. This three-dimensional form, lit with a singular light source, shows the six divisions of light and dark and how they reveal dimension—highlight, light, shadow, core shadow, reflected light, and cast shadow.

Working with Value Structure

Objects of all kinds are revealed to us by virtue of light illuminating their surface. The quality of this light can vary tremendously, from extremely faint light to very strong light, from soft and diffused light to crisp and hard light, from warm light to cool light. But without some light, the form does not reveal itself to us visually. It is this form-revealing light that creates value structure, and it is this value structure that we respond to when drawing an object using tonal structure or shading.

Although extremely minimal or weak light sources may not reveal a full range of value, general categories of light and shadow determine what we respond to when observing value structure. These categories are highlight, light, shadow, core (of) shadow, reflected light, and cast shadow (Figure 1-124). These six categories can initially be broken down into two distinct areas—direct light and indirect light. Direct light, which includes highlight and light, refers to surfaces of an object that are in the direct path of a light source and are consequently the brightest or lightest of the entire range of values on a form. Indirect light, which includes shadow, core (of) shadow, reflected light, and cast shadow, refers to surfaces of an object that are *not* in the direct path of a light source. These

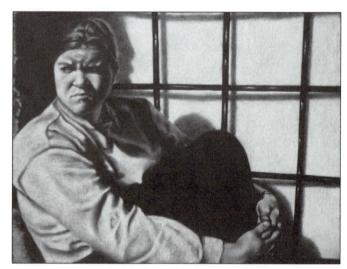

Figure 1-125. Student work. Megan Palmer. This dramatically lit drawing provides a beautiful example of the six divisions of light and shadow—highlight, light, shadow, core shadow, reflected light, and cast shadow.

surfaces are revealed and become visible only through bounced or reflected light rays and are consequently never as bright or as light as the directly lit surfaces of a form (Figure 1-125). The ability to recognize these distinct categories of light and shadow is an important beginning point in drawing value structure with accuracy and sensitivity.

A General-to-Specific Approach to Building Value Structure

Often when an inexperienced drawing student begins to address value structure or tonality in his or her drawing, there is a tendency to focus first on detail and the darkest areas of shadow, regardless of the subject matter. This can result in a very spotty and uneven drawing, with no sense of the underlying geometric structure of forms upon which detail is based. The human head, for example, can be simplified into a basic egglike shape, but it is the detail of the individual features that often first catches the eye. Regardless of how accurately the features themselves may be represented, if they do not relate correctly to the basic shape of the head, then a likeness is unlikely. If darkest values are addressed initially, the subtleties of tonality and dimension may be lost (Figure 1-126).

Utilizing a general-to-specific approach can help to keep your drawing unified and coherent and allows for much more adjustment, when necessary, as your drawing is developed. A general-to-specific approach allows for a well-orchestrated drawing, with all parts working together in a cooperative and complementary fashion. And identifying the basic distinctions between direct and indirect light is an important initial step in working from general to specific.

Imagine Building a House

Even with an understanding of the benefits of working from general to specific, it is often difficult for an inexperienced

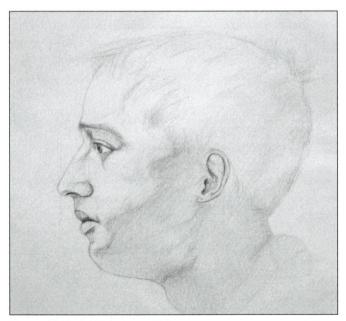

Figure 1-126. Student work. This in-progress portrait study is focused on establishing large planes of light and shadow prior to developing more detailed tonal structure.

drawer to apply the principles. Creating an analogy is a good way to illustrate the principle of general to specific at work in a situation other than drawing. The "house-building" analogy has proven effective in illustrating the application of this principle.

When a house is being constructed, there is a certain order in which things are done, with each step building upon previously completed steps. Each step in the process is carried out for the entire structure before moving on to the next step. Some of the steps include building a concrete foundation, raising the studs for the walls and roof of the structure, framing in the windows and doorways, laying the floors, putting in the plumbing and electrical wiring, putting up the drywall, installing doors and windows, and so on. After these general steps have been completed, the process slowly moves toward more detailed or finished work, such as laying carpet and other flooring, painting walls, hanging wallpaper, installing cupboards, putting up switch plates and socket covers, installing light fixtures, and more. Clearly, the work progresses from general to specific, from the largest and most general aspects of the structure to the more detailed and specific aspects of the structure. When one step in the process takes place, it is completed for the entire structure before the next step begins. When a house is built, the builders do not go through the entire process, from constructing the foundation to building the walls to painting, to carpeting, and so on for one room and then begin the entire process again for the next room. And although the earliest, most generalized steps in the process are absolutely vital in the development of the house, they are not obvious or apparent factors in the end result. Their significance remains relatively unseen.

This house-building process parallels the process of utilizing a general-to-specific approach when building a drawing and is especially relevant when applied to the building of value structure or tonality. The largest, simplest planes of value are identified first and are blocked in with a value that falls somewhere in the mid-light range of the value scale (Figure 1-127). This is best accomplished by using a drawing tool (whether it be lead, graphite, charcoal, wash, etc.) that is harder, such as a 2H or HB pencil, or a light to midlight value ink wash. As additional layers of value are added that address variations within the larger, simpler planes, and some simpler details begin to be addressed, a gradual shift is made to softer drawing materials, such as a 2B pencil, or to middle value ink washes (Figure 1-128). Finally, as full detail and darkest values are addressed, yet softer and darker drawing materials can be utilized to yield a rich and complete value range. This assumes, of course, that a full value

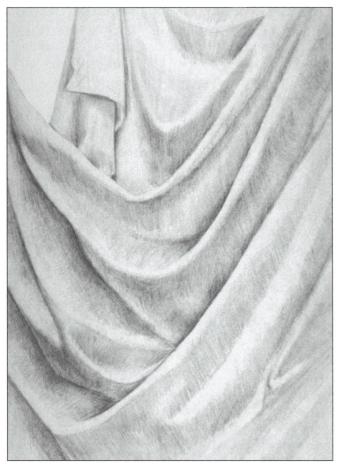

Figure 1-127. Student work. Sharon Wissner-Tabaczka. Studying the folds of drapery provides a good opportunity for developing a general to specific tonal range. This drawing shows a variety of stages of tonal development using a general to specific approach.

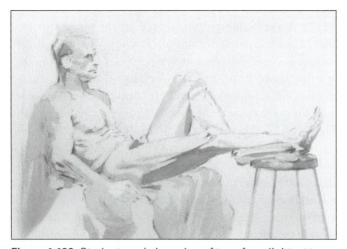

Figure 1-128. Student work. Layering of tone from lightest to darkest results in well-balanced tonal structure. In this ink wash drawing, the darkest areas of emphasis are developed in the later stages of the drawing. This is especially relevant in relation to core shadows and cast shadows.

range is desired that describes the broad range of light and shadow—highlight, light, shadow, core shadow, reflected light, and cast shadow. If, however, the desired results are for a high key drawing, then the softest and darkest drawing media would not need to be utilized while a low key drawing would encourage a shift to softer and darker drawing media earlier in the process.

Using Value to Establish an Effect or a Mood

There are a variety of ways to use value structure in a drawing. Initially, your goal may be to mimic the value that you observe as closely as possible, and this is a worthy and challenging goal. You may focus on conveying the various surface characteristics of objects through value manipulation, such as a smooth texture or a rough texture. You may wish to emphasize cast shadows or soften the impact of harsh lighting. As you become more skilled at recording value, you may desire to manipulate value toward a more expressive end, creating a particular effect or mood. The following information describes some different uses of value to create a desired result.

Chiaroscuro: Originating in the Renaissance and rooted in Italian (meaning "light and shade"), chiaroscuro is a representational use of value that uses a full value range and an even, gradual transition from light to dark to produce three-dimensional, volumetric, and spatial effects (Figure 1-129).

Tenebrism: also originating in the Renaissance and rooted in Italian (meaning "dark and gloomy"), tenebrism is an exaggeration or emphasis of the effects of chiaroscuro producing strong contrast between light and shadow and creating a dark, dramatic or theatrical mood (Figure 1-130). Frequently the main subjects in tenebrism are illuminated by a single source of light, somewhat like a spotlight, creating areas of strong darkness and deep shadows in contrast to the light.

Plastic value: Value used to describe the illusion of volume and space or plastic form, sharing characteristics of chiaroscuro. Plastic value and chiaroscuro, in their quest for the illusion of volume and space, require special consideration for contrast, detail, and edge. High contrast of value tends to advance spatially, low contrast of value tends to recede. Greater detail tends to give more dominance to an object, pulling it forward in space, while less detail helps an object to recede in space. Objects or forms with sharp, clean edges tend to advance, while softer edges tend to recede (Figure 1-131).

Figure 1-129. Deborah Rockman, *Dog*, 1997. Charcoal on paper and vinyl on glass, 29×23 inches. Courtesy of the Artist. Chiaroscuro produces a strong illusion of volume based on a singular light source and the distribution of a full tonal range.

Low key value: Predominately dark values often used to create an effect of gloom, mystery, drama, menace, heaviness, and the like (Figure 1-132). A drawing done with low key value uses variations of value to describe volume and space, but these variations fall within the range of darker values.

Middle key value: Predominately mid-range values used at the artist's discretion. A drawing done with mid key value uses variations of value to describe volume and space, but these variations fall with the range of middle values, emphasizing neither strong darks nor strong lights (Figure 1-133).

High key value: Predominately light values sometimes used to create an effect opposite of low key value, such as lightheartedness, delicateness, and so on (Figure 1-134). High key value uses variations of value to describe volume and space, but these variations fall within the range of lighter values.

Value and Texture

Value is a significant component of texture, which is defined as the tactile (can be touched and felt) surface character of

Figure 1-130. Joseph Stashkevetch, American, Crucigerous, 2003, Conte crayon on paper, 60×60.5 inches. Courtesy of Von Lintel Gallery. Dramatic light and strong value contrast lend this drawing a dramatic quality. Notice that some of the dark edges on the fish merge with the dark negative space so that the edge becomes lost. This is a characteristic often found in tenebrism.

different objects, such as a smooth ceramic vase, a rough piece of fabric, smooth or wrinkled human skin, fur on an animal, foam on the top of a glass, corrugated cardboard, bark on a tree, and the like. Additionally, texture can refer to the surface character of an object that is visible but not tactile (cannot be felt), such as stripes or some other pattern on fabric, the variations of color in the fur of a dog or a cat, the crackle pattern on a glazed ceramic surface, faux surfaces on walls or floors, and similar characteristics. Texture is also inherent in the different materials that we use to draw and is further influenced by the surface to which we apply these materials and the way that we apply them. Some papers are more heavily textured than others, and a line of soft charcoal drawn across a surface will yield a different kind of texture than an ink line drawn across the same surface. This same charcoal line will result in different textures depending on whether it is pulled heavily across a surface or pulled more gently across a surface.

Light source is a significant element in revealing texture. A form that is illuminated directly from the front, where

Figure 1-131. Joseph Stashkevetch, American, *Bristling Rocks*, 2004. Conte crayon on paper, 40 × 40 inches. Courtesy of Von Lintel Gallery. Plastic value is emphasized through the spatial use of contrast, detail, and edge quality. The rocks in the foreground are composed with full value contrast, attention to texture and detail, and clean, sharp edges. The background rocks are composed using reduced value contrast, diminished texture and detail, and softer edges.

the light source could conceivably be coming from our own eyes as we look at the object, will generally subdue texture and make it less apparent. Raking light is defined as light that rakes across the surface at a strong angle, illuminating one side of a form and leaving the opposite side in varying degrees of shadow. Raking light will generally reveal texture more strongly than direct light will (Figure 1-135). Texture that is highly visible on the lit surface of an object will diminish in strength as that same surface slides into shadow because there is a lack of direct light to reveal the texture.

There is a simple experiment that you can do to emphasize the role that directional light plays in revealing texture. You will need a clamp-on light and a roughly textured wall or other surface. Stand directly in front of the wall and shine your light directly on the wall. Note the appearance of the wall. You may notice some texture, but probably not a lot. Now take your light and begin to move it to the side, shining your light on the wall at an angle. As you increase the angle of the light to the wall (raking light), you

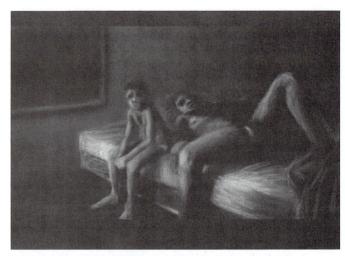

Figure 1-132. Student work. Sheila Seib. The appropriate use of low-key value in this drawing emphasizes the somber and disturbing mood conveyed by the subject matter.

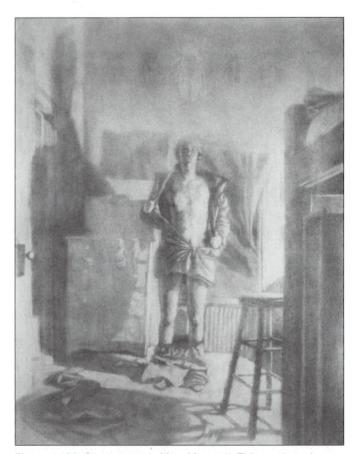

Figure 1-133. Student work. Matt Maxwell. This student chose to use middle key value structure for this somewhat bizarre and funny self-portrait of a figure in an interior environment. Middle tone and light values dominate with a pronounced absence of dark values.

Figure 1-134. Deborah Rockman, *Potential for Disaster: Razing the Children VII*, 2005. Graphite on paper, image: 10×8 inches, paper: 29×23 inches. Collection of Diane Griffin. This drawing of a six-week-old infant utilizes a high key value range and extremely subtle texture to convey the fragile and delicate nature of this sleeping baby.

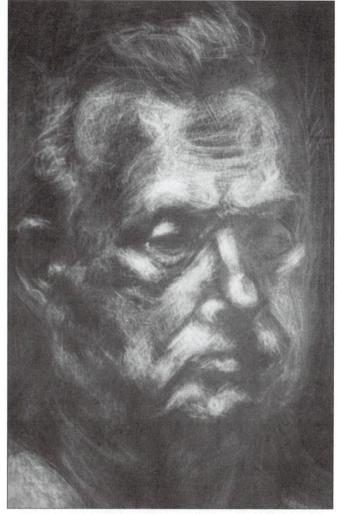

Figure 1-135. Student work. Yvette Cummings. An overhead light source raking across the face of the model reveals a tremendous amount of information concerning the major planes of the figure's face as well as more subtle information such as wrinkles and other surface variations.

will observe that the amount of visible texture increases significantly and is greatly enhanced. This simple experiment reveals the role that light plays in revealing form and surface texture.

Some Different Kinds of Texture

Actual texture can be felt with your fingers. It is the actual "feel" of an object, such as rough, velvety, smooth, soft, bumpy, fuzzy, and so on. (Figure 1-136).

Simulated texture cannot be felt with the fingers, but rather is suggested in a drawing through the artist's response to value changes that describe texture and through the use of materials. Simulated texture attempts to replicate the appearance of actual texture (Figure 1-137).

Uniform texture is the overall texture in a drawing that results from the texture of the paper or other surface on which the drawing is done. This overall texture is in part defined by the media used in the drawing and by the way it is applied. Uniform texture can be minimized or disguised by rubbing or smearing the drawing media on the surface (Figure 1-138).

Invented texture is just that—invented. It is texture in a drawing that is not based on the appearance of the actual texture. It may be texture created by hatching or cross-hatching, texture created by the use of washes, or texture created by stroking the side of a conte stick over the surface of a cold press paper. Most importantly, it is not concerned with creating the illusion of actual texture.

Figure 1-136. Student work. Cassandra Lockwood. This mixed-media drawing, exploring abstraction of natural forms, incorporates actual materials such as twine to create an actual texture (one that can be felt with the fingers) on the surface of the drawing.

Frottage, although not a kind of texture, is a technique that relies on texture for its results. Frottage is a rubbing or transfer technique made by laying a piece of paper onto a textured surface (thinner paper works best) and rubbing graphite or conte or charcoal or some other dry media across the surface of the paper to create a positive impression of the texture underneath (Figure 1-139). High spots will pick up more graphite or conte, and low spots will pick up less. Larger surfaces to be transferred are more easily done using the broad side of a stick of drawing material, while small surfaces (such as a coin) can be transferred using a graphite or charcoal or conte pencil.

Figure 1-137. Student work. Christina Zoerhof. This masterful use of pen and ink creates the illusion of actual texture through manipulation of materials. Although the textures cannot be felt, there is a strong visual sense of the texture of various kinds of stone and foliage.

Figure 1-138. Student work. Doug Stahl. The texture of the paper used in this drawing (coquille paper) is dominant throughout the drawing, uniformly visible over the entire surface.

Figure 1-139. Student work. Wen Yen Tseng. A piece of corrugated cardboard was laid beneath the drawing surface and a rubbing was made (frottage) to transfer the texture to the drawing. The texture is most evident on the left side of the drawing.

Figure 1-140. Deborah Rockman, *Bitch*, 1996. Graphite on gessoed paper and vinyl on glass. 23 × 29 inches. Courtesy of the artist. The pattern of light and shadow in this drawing is determined by the strong light source falling on the specific form of the dog. The light source is positioned above and well to the right.

Four Things to Look for When Identifying Value Structure on a Form

The Light Source

It is important to identify the light source, and for beginning drawing students it is most helpful to keep your light source as singular as possible. Ask yourself: What direction is the light source coming from? How strong is the light source? How does this affect the light and shadows found on the objects being drawn (Figure 1-140)? A good way to observe the importance of the direction of the light source is to do a simple experiment. Take a clip-on light and illuminate the subject being drawn, then slowly move the light to different positions, observing how the pattern of shadow and light shifts as the direction of the light source changes.

The Shape of Areas of Shadow and Light

What is the shape of the shadow in its largest, simplest form, and how does that shape relate to the object in its entirety?

Ask yourself: Where is the shape located? How large or small is it in relation to the surrounding area? How does it relate to other shapes of value on the object in terms of size and position and darkness or lightness (Figure 1-141)?

Conversely, what is the shape of the light in its juxtaposition with the shadow? Observing the shape of areas of light helps to more clearly define the adjacent areas of shadow. It is also helpful to think of light and shadow as puzzle pieces that lock together and are interdependent. Because the emphasis is on identifying and drawing areas of shadow in an additive drawing process, there is a tendency for the uninitiated to ignore the relationship between shapes of light and shapes of shadow in response to a particular light source.

Variations of Value Within Larger Shapes of Value

Once the largest, simplest areas of shadow have been identified and blocked in, begin to note the subtle variations found within that larger shape. A large shape of shadow, for

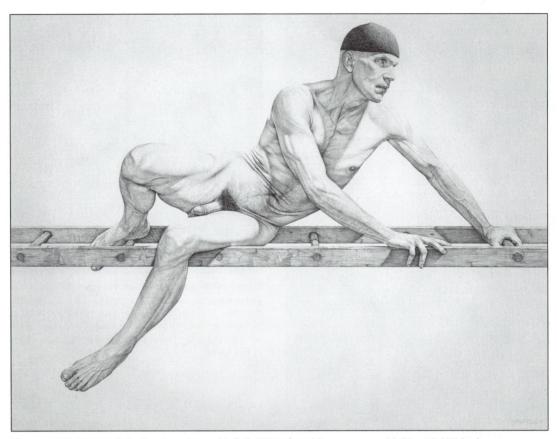

Figure 1-141. Robert Schultz, American, *Aloft II*, 2006. Graphite on paper, 20.25 × 15.375 inches. Collection of Mary Alice Wimmer. Even with the relatively delicate value range, large shapes of value in this beautifully rendered drawing of the figure are clearly defined and distinct from the shapes of light. Notice the great variety of subtle value changes found within the larger, simpler shapes. Examples of this include the shadow shape that begins on the head, face, and neck and sweeps down onto the chest and abdomen, or the shadows that shroud the lower legs. Importantly, the value in the shadow areas, even the delicate tones, is darker than the value in the lit areas. The light source is positioned above and to the right of the figure.

example, will often contain smaller passages of somewhat lighter and darker values (see Figure 1-141). It is especially helpful to understand the six divisions of light and shadow to help identify these subtler variations. An awareness of highlight, light, shadow, core shadow, reflected light, and cast shadow is useful in identifying variations and in making sense of them.

Edge Quality of Shapes of Value

What do the edges of the shape of value look like? Is the edge quality the same throughout the shape? Probably not. Does the value end abruptly on one edge and make a gradual transition to a different value on another edge? Is the edge of a value hard or soft or somewhere in between? Does the character of the edge change as you move along it, or does it remain constant? Is an edge so soft that it

is difficult to determine where the value actually ends or begins (Figure 1-142)?

Various Methods for Applying Value

There are a variety of techniques or methods for applying your drawing media to create value or shading. All methods yield slightly different results, but all can be used to create the illusion of volume and space. Variations in the results of these techniques can occur based on the drawing material being used and the character of the material (a hard or soft graphite or charcoal, a sharpened or a dull pencil, a thick or a thin marker, a ball point pen, etc.), based on the way the material is held in the hand, based on the pressure applied, based on the surface to which the material is applied, and other variables.

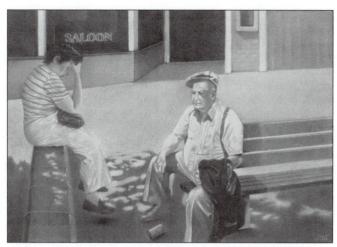

Figure 1-143. Student work. Tim Cobb. This colored pencil drawing uses continuous tone with no visible evidence of process. This results in a realistic or photographic effect.

Figure 1-142. Student work. A subtractive drawing process allows one to identify and construct shapes of both light and shadow by erasing areas of light and adding darker tones to a middle value ground. Careful examination reveals that both shapes of light and dark vary tremendously in their edge character, transitioning from extremely crisp to extremely soft as the character of the drapery fold changes in relation to the light source.

Continuous tone: Continuous tone is used to create smooth tonal structure that flows subtly and fluidly from one value to the next. There is little or no evidence of process, meaning that strokes or marks are imperceptible or not readily apparent. Continuous tone typically results in a highly realistic or "photographic" effect in a drawing (Figure 1-143).

Hatching: Hatching refers to the use of lines or strokes of varying lengths that are grouped together to form value. The spacing between the strokes can vary, creating greater or lesser density that in turn creates lighter or darker tone (Figure 1-144). There are three different kinds of hatching.

Parallel hatching: In parallel hatching the lines or strokes are uniformly aligned, parallel to each other without regard for the planar structure of the object.

Contour hatching: In contour hatching the lines or strokes follow the curvature or planar directions of the object. The strokes may curve on a curved plane or may be straight as they follow a flat plane.

Cross hatching: In cross hatching, layers of parallel hatching change angles or direction as they are overlaid, rapidly building value range. The directional change can be minimal or as much as 90 degrees.

Stippling: Often reserved for pen and ink or markers, stippling refers to the application of dots of value laid down one at a time. The density of the dots determines the resulting value.

Mark making: Mark making refers to the application of marks that vary in their weight, value, texture, length, and direction. Their density determines the resulting value (Figure 1-145).

Subtractive drawing: Subtractive drawing begins with the application of vine charcoal, compressed charcoal, or graphite to a white piece of paper. The material is then rubbed into the paper with a soft rag or cotton cloth. The intention is to create an overall *base tone* that is approximately a middle value. This is the starting point for your drawing, and it requires that you approach your observation of value

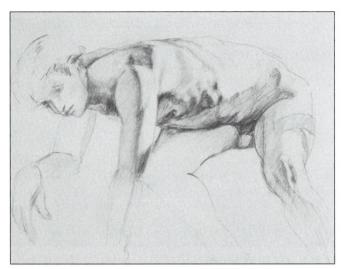

Figure 1-144. Student work, Minnesota State University– Moorhead. Chris Kowanko. Hatching is used to explore the anatomical elements of the figure's torso and left leg. The anatomical elements are more fully revealed due to raking light.

a little differently than you do when working with an additive drawing process.

An additive drawing process typically involves drawing on a white or light piece of paper, and this tends to make us far more aware of shadows (their shape, their size, their placement, etc.) than of light. Although not ideal, the light tends to be whatever is left after we've added our shadows. But in subtractive drawing, we have to create both the light and the shadow and so we are more attentive to both.

In subtractive drawing, you use erasers to remove or subtract the base tone, creating varying degrees of light. You also add additional media to create shadows that are deeper in value than the base coat with which you started. The base coat acts as an intermediate value, providing the transitional tone between light and shadow (Figure 1-146).

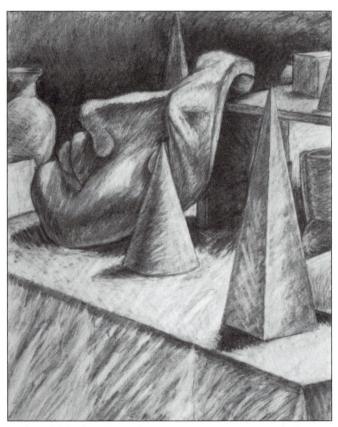

Figure 1-145. Student work. Vickie Marnich Reynolds. Mark making and use of the eraser to alter the marks dominates the surface character of this drawing. The manipulation of the marks is handled efficiently, resulting in tonal structure that effectively describes a variety of dimensional forms.

Figure 1-146. Student work. Jamie Combs. A mid-value base tone of vine charcoal prepares the surface for subtractive drawing. A variety of erasers were used to remove the vine charcoal base, creating a range of light that illuminates various forms and especially the shroud around the woman.

It is helpful to think about compatibility of materials. For example, if you create a base tone using vine charcoal or compressed charcoal, you can build a broader tonal range by adding more vine charcoal and/or compressed charcoal. If you build your base tone with graphite, you will probably want to continue using graphite to build your tonal range because graphite and charcoal are not always very compatible. Conte is not especially effective for subtractive drawing because it is more difficult to erase. When working subtractively, you can use your erasers and your dark media in a variety of ways, including continuous tone, hatching, or mark making.

An Alternative Subtractive Process

Another version of subtractive drawing utilizes a less traditional approach but has the potential to yield beautiful tonal results. The process begins with the preparation of the paper surface. A heavier weight paper works best. Tape all edges of the paper to a firm surface, such as tempered masonite, to help minimize rippling. Apply a generous coat of white acrylic gesso to the paper surface. Use a relatively stiff brush to create visible brush strokes in the gesso. You can brush the gesso in random directions, or brush vertically or horizontally. The resulting brushstrokes will be visible in the end result.

Allow the first coat of gesso to dry thoroughly, and then apply a second coat, again determining the character and direction of the brushstrokes you want. A third coat of gesso should not be necessary as long as your paper is thoroughly covered. Allow the second coat to dry thoroughly and you are ready for the next step of paper preparation.

Using a broad, soft stick of graphite, generously coat the entire surface of the gessoed paper with graphite by laying the stick on its side and, with firm pressure, dragging it across the surface. Stroke the stick of graphite in a variety of directions to deposit as much graphite as possible. Dampen a soft rag with mineral spirits (make sure you have adequate ventilation) and rub it into the surface, dissolving the graphite into a rich, uniform gray-black tone. If your first dissolved coat does not provide a deep value, apply more graphite and again dissolve it with mineral spirits. When the surface of the paper is uniformly covered with dissolved graphite and the mineral spirits is dry, you are ready to begin the drawing process.

You can begin the subtractive process with or without linear guidelines. If you want to sketch your composition on the prepared surface, you need to use a white or light drawing tool so your lines will be visible on the dark surface. White charcoal or white conte or white pastel

will work. You will use sandpaper to remove the graphite and expose the underlying gesso to describe the areas of light that you observe on your subject matter. Fine sandpaper will yield more subtle results, while coarser sandpaper will produce a rawer surface (Figures 1-147 and 1-148).

Begin by sanding lightly with a small piece of sandpaper, pressing the sandpaper against the surface with the tips of your fingers. Dampening your fingertips will help you to hold on to it. As you continue to sand the surface, creating areas of light, your sandpaper will begin to fill up with graphite. Wipe your sandpaper on a rag or on your jeans or some other clean surface to remove the excess graphite, and continue to sand. When your sandpaper wears out, you can use a new piece. For a very subtle removal of graphite, you can use some medium grade steel wool. It will not create a strong area of light, but it is good for creating some subtle atmospheric effects.

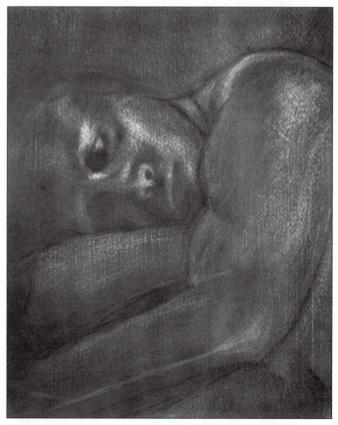

Figure 1-147. Student work. The use of coarser sandpaper in this subtractive drawing yields a relatively rough surface and highlights the texture of the gessoed ground beneath the graphite.

Figure 1-148. Deborah Rockman, Father and Child (detail), 1987. Graphite on gessoed paper, 25 × 18 inches. Private collection. The use of finer sandpaper refines the surface texture, resulting in more delicate transitional tones while still revealing the texture of the underlying gessoed surface.

Figure 1-149. Student work. Jon Vanderburg. White and black drawing media are skillfully applied to the toned paper surface in this study of drapery. The neutral paper tone is used as a transitional value between added dark and light values.

The more you sand in a particular area, the lighter the value will become as you remove more graphite and expose the white gesso beneath it. But be aware that if you sand too much and reach the raw paper beneath the gesso, the sandpaper will begin depositing graphite back onto the surface rather than removing it. If you desire to work back into your drawing to sharpen an edge or reestablish a value that became too light, you can use graphite pencils or an ebony pencil, both of which are compatible with the dissolved graphite surface.

There is often an issue with glare when using this process. Graphite tends to create glare, especially with very dark tones. Spraying your drawing with a matte spray fixative will reduce the glare, but be sure to carefully follow the instructions for using the fixative.

Toned Paper

Working on toned paper (paper that is toned when you purchase it) requires the use of both black and white drawing media. It is similar to subtractive drawing in that you begin your drawing on a toned surface. But since the tone cannot be erased, lighter values are created by applying white drawing media in various degrees (white charcoal, white chalk, or white conte), and darker tones are created by adding black drawing media (Figure 1-149).

As is the case with traditional subtractive drawing, the toned surface functions as an intermediate value, providing a transitional tone between the lighter values and the darker values. With this technique, it is important not to let the white and black media mix together. This can create a bluish tone that is out of character with the more neutral tones and can be distracting. Since the media do not directly mingle, you do not have to be as concerned about compatibility and can use one media for the lighter tones and a different media for the darker tones. For example, you can use white colored pencil for light tones and charcoal for dark tones or white charcoal for light tones and black conte for dark tones (Figure 1-150).

With both subtractive drawing and drawing on toned paper, there are different ways to approach value development. Some artists like to build all the dark tones first, and then build the light tones. Other artists like to work back and forth between light and dark tones, and still others prefer to build the light tones first and then proceed to the dark tones. What is ultimately important is that the value structure is balanced, with all tones relating correctly to each other.

Figure 1-150. Deborah Rockman, *Dark Horse No. 1*, 1981. Colored pencil and charcoal on paper, 10 × 8 inches. Collection of Dr. and Mrs. Joseph McConaughy. In this cropped figure study on toned paper, black colored pencil and white charcoal are used. These are generally not compatible drawing media, but since they do not mix on the drawing surface there is no issue with compatibility.

Exercises for Promoting a General-to-Specific Approach

When drawing from observation, such as from a still-life arrangement or from the human figure, it can be a difficult task to overlook the seductive details of form that initially attract the eye. But the importance of overlooking detail in the early stages of value or tonal development cannot be overemphasized. It is one thing to understand the concept on an intellectual basis, but an entirely different experience when attempting to apply the concept to an actual drawing. One simple suggestion is to squint as you begin to observe value structure. This softens details and allows you to observe broader, generalized groupings of tone.

Two particular exercises are recommended to reinforce the principle of general to specific as it relates to the process of observation and recording these observations. The first exercise is theoretical in nature, and the second is more practical. Both are helpful in demonstrating the effectiveness of a general-to-specific approach through a hands-on drawing experience.

Projecting an Inverted, Out-of-Focus Image as a Drawing Reference

For this exercise, a slide of a black-and-white drawing or photograph with a fairly clear division of value structure is most effective. You can also use an image on a computer monitor as your resource for this exercise, applying a Photoshop blurring filter as directed. Still lifes, landscapes, or figurative images are all suitable options. While teachers often introduce this exercise, if you have access to a slide projector or know how to use Photoshop you can investigate the process on your own. While it is helpful if you are not aware of what the image is prior to or during the drawing process, this is not possible if you are choosing the image with which you wish to work. It is also helpful to invert the image while doing your drawing to make it less familiar or recognizable.

Determine the basic format of the image you are working with-vertical, horizontal, or closer to a square. This will help you determine which way to position your drawing paper. I recommend that vine charcoal be used in the early to middle stages of the drawing because of its flexibility and the ease with which it can be erased and adjusted. As your drawing nears completion, compressed charcoal sticks and pencils can be used to address darker values and increasingly greater degrees of detail.

Observe the image upside down and severely out of focus so that it is essentially a soft blur of shapes of limited value range. Inverting the slide creates unfamiliar shapes that facilitate careful observation and diminish the tendency to make assumptions about what you see. Don't position yourself too far off to one side or the other of the image, as this will result in distortion. Begin the exercise by drawing as accurately as possible exactly what you see in the out-of-focus image, recording the vague, soft-edged shapes of delicate value that result from the image's lack of focus. Every few minutes, focus the image a bit more by either adjusting the projector's focus or changing the Photoshop filter settings. This reveals increasingly greater amounts of information, including the emergence of new shapes, an increased range of values, and increasingly sharper edges on the shapes of value.

Each time the image is brought into greater focus, you will continue to refine the information in your drawing,

again trying to duplicate what is observed. At this point you should be paying attention to the size and position of shapes in relation to the total image area, the size and position of shapes in relation to each other, and the actual value of the shapes and their tonal relationship to each other. Rags can be used to soften and blend shapes of value, and an eraser is vital for making changes and corrections as you become aware of errors in size or placement or value. The eraser also becomes important when a shape that was initially soft-edged begins to take on sharper edges due to increased focus. The image will remain fairly abstract in the early and middle stages of the exercise and will take on more specific form in the final stages of the exercise.

As the image draws closer to being completely focused, you may be tempted to turn your head to observe the image in its correct orientation. This is discouraged so as not to interfere with the pure observation of shapes. Only after the image has been completely focused and your final observations have been made and recorded should both the drawing and the image be turned right side up. At this point you will be able to evaluate how well you recorded the information, as inaccuracies will become readily apparent when the drawing and the image are compared. Following the completion of the exercise, remember the information that you began with and the drawing process that brought you to the completed image-working from general to specific and observing shapes and placement independently of subject matter. This exercise can be done in a number of different time frames, depending upon how quickly you wish to move through the experience and upon the complexity of the image.

A Sustained Approach to Gesture Drawing

The preceding exercise is very valuable in demonstrating the basic idea of a general-to-specific approach while drawing, but it is somewhat artificial. When you are observing actual three-dimensional information as a source for drawing and tonal development you will not have the luxury of being able to throw the information out of focus and then slowly bring it back into focus, although squinting can help. The following exercise is another way to explore the benefits of working from general to specific while referring to an actual three-dimensional object. Although the exercise described here is specific to the human figure as subject matter, you can tailor it to address a variety of different subject matters.

Figure 1-151. Honoré-Victorin Daumier, French, 1808–1879, *Don Quixote and Sancho Panza*. c. 1850. Black chalk and gray wash on wove paper, sheet: $7^7/8 \times 11^3/4$ inches. (20 \times 29.8 cm). The Metropolitan Museum of Art, Rogers Fund, 1927. 27.152.1. Image © The Metropolitan Museum of Art. Charcoal and ink are combined to investigate simplified tonal structure in Daumier's gestural drawing of Don Quixote and Sancho Panza. Note the absence of detail in favor of large planes of light and shadow.

This exercise is a variation of the traditional three-minute linear gesture drawing of a human figure, and it involves extending the gesture to a five-or-six-minute study during which the additional time is used to record simplified tonal structure on the figure. It is important that the light source be singular and fairly strong in order to facilitate the observation of simple tonal divisions. It is also very helpful, as mentioned earlier, to squint when trying to observe value in a simplified form during this exercise.

To encourage a rapid, generalized approach to value, work with the broad side of a stick material, such as charcoal, conte, or graphite stick, about 1" to 1½" long. Ink wash may also be used if applied with a brush broad enough to discourage detail but small enough to control (Figure 1-151). A linear gesture can be completed first to provide a framework. The remaining time is devoted to observing and recording the simple division of value, with the paper tone (white or off-white) used to describe all lit surfaces, and a drawn tone (approximately middle-gray) used to describe all shadowed surfaces. Remember that detail, such as that observed in faces, hands, and feet, is relatively unimportant in this particular exercise and can be highly simplified (Figure 1-152).

It is important to remind yourself that in actuality there are many different degrees of both light and shadow on the figure, but in this exercise the intention is to simplify and

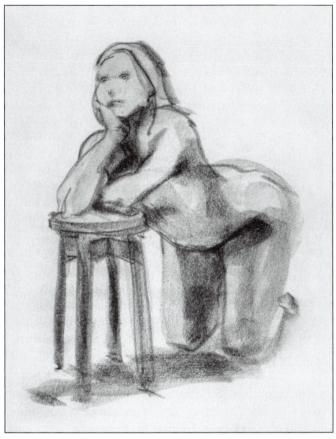

Figure 1-152. Student work. Carolee Heynen. Detail is sacrificed in favor of emphasizing the large, simplified planes of light and shadow in this 6-minute sustained gesture drawing. Generalized tonal structure is translated into approximately three values—dark, medium, and light (paper tone).

generalize as a means of reinforcing the general-to-specific approach. Keep the added tone (which signifies planes or surfaces in shadow) in the middle value range so that it remains "open" and translucent. There is sometimes a tendency to make the value nearly black, which ultimately flattens and denies volume. When done successfully, you may be pleasantly surprised at the additional descriptive properties inherent in the application of the most basic value structure.

Controlling Some Variables of Value Structure

When dealing with half tones or middle values (belonging clearly to neither dark shadow or bright light), consider this: Half tones associated most strongly with lit surfaces should be drawn lighter than they appear

- to be, and half tones associated most strongly with shaded surfaces should be drawn *darker* than they appear to be.
- Think of value in terms of two distinct groups—areas of shadow and areas of light. Simplify your value structure.
 Do not allow these two separate areas to overlap or get mixed up. In general, any value associated with lit planes or surfaces should always be lighter than any value associated with planes or surfaces in shadow.
- The greatest contrast of value should occur between general massed areas of light and general massed areas of shadow.
- If possible, keep the balance or proportional relationship of values (light, medium, dark) uneven or irregular.
 If possible, avoid an equal amount of light, medium, and dark values to create a more interesting composition and to allow one value category to dominate your composition.

Creating an Effective Still Life

Still lifes are generally considered to be an effective subject for introducing and reinforcing the processes, methods, and techniques of drawing that are based on direct observation. In examining what constitutes a good still life, a variety of considerations are taken into account.

You will probably be drawing from still lifes of some kind in your introductory drawing courses. And still lifes may be something that you continue to pursue in more advanced work. In introductory drawing courses, you will most likely be drawing from still lifes that your instructor sets up. However, homework assignments that require a still-life arrangement or an individual interest in the genre of still life warrant some discussion about what to consider in setting up and lighting a still life from which to draw.

What Kinds of Objects Should Be Included?

While nearly any object that one can see is potentially a good subject for drawing, your instructors will generally consider

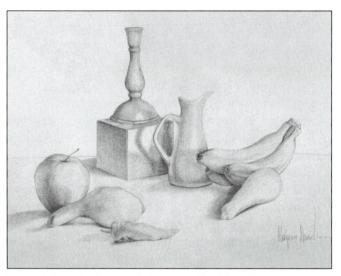

Figure 1-153. Student work. Maryann Davidson. In response to a homework assignment, this still life incorporates regular forms (candlestick and pitcher), irregular forms (fruits and vegetables), and the cubic form upon which the candlestick rests.

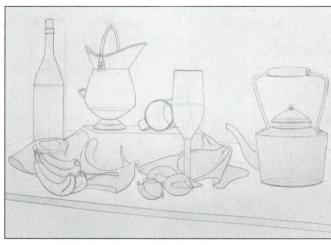

Figure 1-154. Student work. Lea (Momi) Antonio. This linear still life focuses primarily on regular forms such as the wine bottle, the pitcher, the wine glass, the teapot, and the coffee cup. These forms provide good opportunities to explore transparent construction, which is evident in the drawing.

the level of the drawing course and the specific ideas being focused on in setting up a classroom still life.

For introductory-level course work, it is important to begin with objects that are somewhat limited in their complexity, allowing you to build your skills in eye-hand coordination and to develop more confidence before tackling more complicated objects. It is also wise to utilize a variety of kinds of objects as they provide different characteristics that encourage the development of different skills. While not all possible still-life subjects are easily categorized, there are three basic categories under which many objects fall. When possible and when appropriate to the focus of a particular drawing session or assignment, you are encouraged to use elements from all three categories when setting up your still life (Figure 1-153).

Regular Forms

First is what is referred to as regular or symmetrical forms that are typically human-made or mechanical in nature and are somewhat predictable in their structure. Although not always strictly symmetrical, regular forms often require more careful analysis to capture a sense of the familiarity and function of the object. Their relationship to or basis in geometric solids (cubes, spheres, cylinders, cones, wedges, etc.) is typically more apparent than in irregular forms. Examples include bottles, vases, tools, utensils, shoes, hats, and a wide

variety of objects that can be found in most households (Figure 1-154). The advantages of including regular forms in a still life (with consideration for degrees of complexity) are numerous. They provide ample opportunities for you to utilize axis lines around which to guide the construction of symmetrical or nearly symmetrical objects, they often provide ellipses (circles seen in perspective) that require repeated freehand drawing experiences to gain proficiency, they provide opportunities to draw regular or predictable curves and contours freehand (without the aid of mechanical guides or templates), and they remain constant in appearance over an extended period of time without decaying or shriveling or changing in appearance dramatically.

Irregular Forms

Second is what is referred to as irregular or natural forms that are typically organic or derived from nature. Irregular forms range from extremely simple objects, symmetrical or nearly symmetrical, to highly complex objects with or without apparent predictability or formal organization. Their relationship to geometric solids may be clear and direct (an orange or an apple is clearly spherical) or may be vague or lacking entirely (the tangled mass of roots found in a root ball is difficult to associate with a geometric solid). Examples include the entire range of fruits and vegetables and any other forms found in nature, from driftwood to bugs to

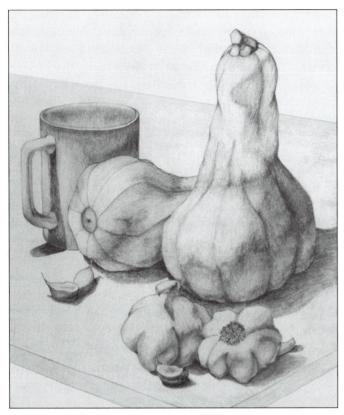

Figure 1-155. Student work. Sheila Grant. The emphasis on irregular forms provides a good opportunity to explore value structure and the effects of directional light on three-dimensional objects with multiple planes and surfaces.

boulders to trees to all variations of plant and animal life (Figure 1-155). Animal skulls and other skeletal parts provide an especially rich and interesting resource for drawing. Although some of these natural objects may have an element of symmetry or near symmetry, they are still distinct from regular forms in their natural origins.

The advantages of including irregular forms in a still life (again with consideration for degrees of complexity) are multiple. They discourage you from stylizing or simplifying information, as this will render them much less convincing; they provide a rich resource for line variation and tonal structure because of their infinite range of edge and surface character; and you can physically manipulate them for variety and interest in a way that regular or mechanical forms often cannot be manipulated. You can slice an apple, peel an orange, break off cloves from a garlic bulb, partially peel a banana, snap a twig in two, and generally observe and record changes in many natural forms over a relatively short period of time as they decay or dry or mold or shrivel.

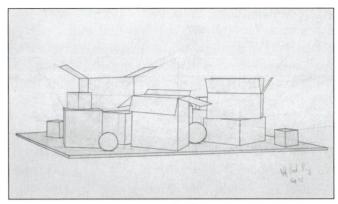

Figure 1-156. Student work. Jeff VandenBerg. This still life focuses almost exclusively on cubic forms. A combination of careful sighting and an understanding of two-point perspective is required to achieve the accuracy evident in this study of boxes and box flaps in a variety of positions.

Cubic Forms

Third is what is referred to as cubic-based forms that are generally composed of primarily flat planes and straight edges. Cubic forms include any kind of box or boxlike structure, such as a book, and any object that is composed primarily of flat planes (Figure 1-156). While they can provide surfaces upon which to place other objects, varying the height of different objects in your still life and creating object relationships, they most importantly provide you with drawing experiences that test your knowledge of basic perspective principles such as convergence, diminution, and consistent eye level.

Additional Considerations for Still Lifes

How a still life is lit is extremely important. Adequate lighting, both on the still life and on the drawing surface, is important in order for you to be able to see information without visual confusion or eyestrain. When exploring line variation or value structure or any other concern that relates to tonal structure, it is important as a beginning drawer to keep the light source as singular as possible. A consistent light source, not too strong or weak, is most effective in defining and revealing volume and dimension. While experimentation with different locations of the light source is advisable—overhead, side lighting, under lighting—and helps you to understand the significance of directional lighting, a singular and raking light source is generally best for object definition.

Raking light was addressed earlier in this chapter in relation to texture. To further explore raking light in relation

to a three-dimensional object, try the following informative experiment. You will need a clip-on light with an indoor floodlight bulb and a three-dimensional object that ideally has some surface variation. First, shine the light directly on the object from the front (from where you stand) and notice how the light source does not reveal much or any dimension. Value structure is limited. Next, begin to move the light source over to one side or the other, or move it up or down so that the light angles or rakes across the surface of the object. You will observe that with raking light, far more information is revealed and the true character of the object becomes more apparent.

Placing your still life on a white or light colored cloth or sheet helps to enhance reflected light, which plays an important role in helping to describe and define volume. Because reflected light can easily elude you in your early investigations of tonal structure, it is helpful to make it easily visible. Striped cloth can also add some pattern and interest to a still life. Incorporating drapery with folds into a still life not only provides options for more complex and unified compositions but also provides an element of softness as well as additional opportunities to explore line work and tonal structure.

In addressing a still life, whether in class or as a homework assignment, make sure you ground the objects you are drawing by clearly indicating the surface upon which the objects rest. Table edges can be shown in their entirety or can be cropped by the edges of the drawing format. In addition to grounding objects, showing the surface upon which objects rest provides an additional visual element for breaking up space and enhancing compositional interest.

The Meaning of Still-Life Objects

An apple is just an apple—or is it? A variety of still-life objects, including an apple, provide you with opportunities to draw different kinds of shapes, objects, and textures, and these can range from simple to complex. But it is not just the visual characteristics of these objects that are significant. There is also the potential for reading the objects and their interaction with other objects as symbolic or associative, communicating meaning that extends beyond the literal meaning. So yes, an apple can just be an apple. But it can also be a symbol for abstract ideas or concepts, conveying more than simply "what it is."

Some symbolic forms or objects are more readily recognized and easily understood, while others are more obscure

or have the potential for multiple meanings. For example, some obvious symbols in American political culture include the donkey as a symbol for the Democratic Party, the elephant as a symbol for the Republican Party, the eagle as a symbol for American strength and freedom, and the flag as a symbol for the United States of America. It should be noted, however, that outside of the world of politics, donkeys, elephants and eagles all carry other potential symbolic content.

Other symbols that we encounter every day are meant to have more universal meaning and are not intended to be read as anything other than what they are—symbols. These symbols provide no real potential to shift back and forth from a literal meaning to a symbolic meaning. They simply mean what they mean. Some examples of universal symbols include the symbols that mark restroom doors indicating that they are for men or for women or are unisex, the symbol for handicap accessibility, the symbol for biohazardous waste, the symbol for radiation or radioactive materials, the symbol for recycling, the no smoking symbol, and numerous symbols found in airports and along highways to assist people traveling in countries where they do not read or speak the language.

Different cultures or thought systems often assign different and varied symbolic meaning to the same object or shape or color. For example, the color white is often associated with purity and is worn at baptisms and weddings in many Western cultures, but in some Eastern cultures, white is the color for mourning and funerals, while red is the color associated with marriage. An apple can symbolize know'ledge or wisdom (as can an open book), while in Christian symbology, the apple symbolizes temptation. Animals in general have many varied symbolic meanings. In Jungian thought, animals symbolize the unconscious areas of the mind, while in broader symbolic terms, dogs as specific animals symbolize loyalty, domesticity, and vigilance. A rabbit can symbolize fertility and lust or timidity. A lion represents power, courage, and nobility. A lamb represents meekness and purity, while in Christianity both the lion and the lamb can represent Christ. Birds are generally seen as a positive symbol and can represent flight and freedom from gravity (Figure 1-157). But a raven is often seen as a negative symbol, a companion of the dead.

A rose can symbolize beauty and perfection. A red rose symbolizes romantic love and passion, while a yellow rose symbolizes friendship. Ivy can represent dependence and attachment. Water represents life and is also a symbol of the unconscious. Flowing or moving water can represent

Figure 1-157. Leah Gregoire Prucka, American, *Garden Series: Redemptive Sanctification*, 1999. Graphite on prepared glass, 7 × 11.5 inches. Courtesy of the artist. The artist uses a variety of symbolic forms in her work that make reference to Christian theology, biblical scripture, and the concept of redemption.

Figure 1-158. Student work. Jamie Combs. Water functions symbolically in this drawing of two women attempting to fill containers with water using only their hands as the water slips between their fingers. There is also symbolism in the activity depicted, which seems to be an exercise in futility.

change (Figure 1-158). A calm surface on a lake or a sea can carry very different symbolic meaning than a stormy lake or sea. The moon represents the feminine as well as the realm between the conscious and the unconscious. The stages of the moon are also associated with the stages of human development and life. A spider web can represent strength and resilience or a trap or something to be avoided. A dark and stormy sky can symbolize impending danger or turmoil. A door represents transition and metamorphosis, a way to get from one place to another. A closed door can symbolize secrecy, imprisonment, or exclusion, while an open door can symbolize freedom and discovery. A cube symbolizes stability and permanence, while a sphere represents perfection and eternity. Rope can symbolize binding and limitation or freedom, depending upon its context.

Various symbolic properties can be applied to just about anything you can draw. Some symbolic properties may be more universally understood, while others may be specific to a certain culture or religion or mythology or historical period. A symbol's meaning can be shifted by the context in which it is found, and this provides you with an opportunity to assign your own meaning to something already laden with well-known symbolic associations. An object with certain symbolic properties can be depicted as broken or decayed, shifting the symbolic meaning. For example, a wilted flower can mean something very different than that same flower alive and thriving. An animal's symbolic meaning can be subverted if that animal is depicted as dead or dying. An empty chair carries different meaning than an occupied chair. An empty vessel can be interpreted differently than a full vessel. When you have the opportunity to select your own still-life subjects, consider the conceptual impact of your choices (Figure 1-159).

How a composition is lit also has the potential to change the meaning since different qualities of light also carry symbolic significance. A drawing of a still life or a room interior or a landscape or a cityscape that is dominated by dramatic dark tones and long, deep shadows conveys a very different mood than that same subject drawn with soft, uniform light. The viewpoint taken in a drawing carries symbolic significance as well. A figure viewed from a very low eye level, towering over the viewer, places the viewer in a submissive position with the figure in a dominant position. This same figure, if drawn from a high eye level with the viewer looking down on the figure, places the figure in a more submissive position and the viewer in a more dominant position. These differences carry symbolic or conceptual potential.

Figure 1-159. Student work. Jessica Serfass. This drawing appropriates the work of Michelangelo, showing the Delphic Sibyl consulting her prophetic scroll. Notice the hourglass and the small figure of a rider on a horse, derived from *The Four Horsemen of the Apocalypse* by Albrecht Dürer. Both the hourglass and the horse and rider make reference to the passing of time and imminent death. The man on the left is a contemporary version of Father Time.

Using Photographic References

Artists use photographs as reference for their work for a variety of reasons. They may have a specific interest in photorealism, which explores the impact of the camera and photography on the way images are recorded. Many artists use photographs to capture information that may change over time or to capture a fleeting light source. Artists may use photographs as a rapid substitute for sketching to record

something that they will not have access to in the future. Artists use photographs to document figures or models that they want to draw or paint. This may be because they have limited access to the model or because the pose is too difficult for the model to hold for any length of time or because they can't afford to pay the model for extended modeling sessions. Photographs may be taken to record detailed information. Artists use photographs as a reference for many different reasons.

A photograph is not particularly useful as a reference tool if it is a bad photograph, and there are a variety of ways that a photograph can be bad. It can be poorly focused (which makes it very difficult to discern any detail information), overexposed (which washes out information in areas of light), or underexposed (which washes out information in areas of shadow). Both overexposure and underexposure limit the tonal range in a photograph.

Many students become overly dependent on a photo they are using as a reference, attempting to duplicate every aspect of the photo, even a photo of poor quality. There is often evidence of a flash, casting flat, dark shadows on surfaces near the subjects, and washing the forms in light, which ultimately flattens the volume. Poorly exposed photos often result in drawings with washed-out areas of light or flat areas of shadow and a degree of flatness that is characteristic of amateur photographs. If a color photograph is being used as reference for a black-and-white drawing, there is the challenge of translating color into a full tonal range.

When using photographs as reference, it is important to consider the ways in which elements drawn from photo references relate to elements drawn from direct observation. Ideally you want all the elements in your drawing to work well together, and this requires that you are attentive to the potential differences between photographic and directly observed references. If, for example, photo-based references have a different light source than what you are drawing from direct observation, conflict will occur. Photographs also have a tendency to flatten information, and you may have to work especially hard to create a uniform illusion of volume in your drawing when combining actual and photo-based references. You may also find the Internet especially seductive in terms of reference images, but more often than not, images downloaded from the Internet are not very useful for providing any refined or detailed information either because they are too small or because the resolution is poor. The image may look clear and detailed on the computer monitor, but printing it will reveal its relative usefulness as a resource. You also have to be sensitive to issues of copyright when using the computer as a resource for visual references.

Ultimately you have the most control if you take your own reference photos when necessary. It is important to have some basic skills in photography with respect to lighting, exposures, and depth of field or focusing, even when using a digital camera. Digital cameras should be set to record the highest quality image in terms of size and resolution.

It is helpful to take different exposures to capture light and shadow, and it is also helpful to take detail shots of more complex objects. If the photo is only intended to serve as a general guide for size and placement of objects and information and is not serving as reference for tonal structure, you can use a flash. Photographic references can be very useful and helpful, but their character and quality need to be taken into account.

Essential Drawing Principles in Relation to the Human Figure

The Human Figure

Why Study the Human Figure?

There is perhaps no more significant experience in the study of drawing than the study of the human figure. You need only to look to the ancient Greeks and Romans and to the Renaissance masters to recognize the historical importance of the human form in the study of the visual arts and the refinement of visual expression. Although the figure's presence and significance during the period known as Modernism ebbed and flowed, as form and subject it has experienced renewed significance in postmodern and contemporary art. While its influence is always felt to some degree, twenty-first-century artists affirm the significance of the figure as a powerful form for the communication of ideas (Figure 2-1), and no classical or tradition-based art education would be complete without a substantial focus on studying and drawing the human form.

Much debate in academia is currently taking place concerning the changing role and structure of foundation courses for students studying both the fine and applied arts, and some colleges and universities are tailoring introductory experiences to a student's specific major. Unfortunately, this may result in no figure drawing experience depending upon what discipline you are studying. You may be focused on studying the fine arts (drawing, painting, printmaking, sculpture, etc.) or you may be focused on studying what is generally referred to as the applied arts, such as illustration, graphic design, industrial design, furniture design, and so on.

If we examine those aspects that the fine and applied arts have in common, we find that a concern for communication is paramount, whether it takes place in a gallery or museum, in a television or magazine ad, on a showroom floor, on a computer monitor, or in any number of other locales. The power of the human form to communicate cannot be overstated, primarily because *it is what we are.* We have things in common with other human beings that we have in common

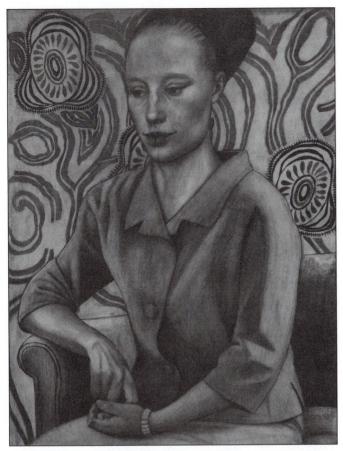

Figure 2-1. Jenny Scobel, American, Flutter in the Room, 2003. Graphite, oil, and wax on gessoed wooden panel, 32×24 inches. Private collection. Scobel uses composite resources to create female figures that are then combined with other visual references culled from the 1930s and 1940s. These drawings make both critical and nostalgic references to beauty and its underlying calamity.

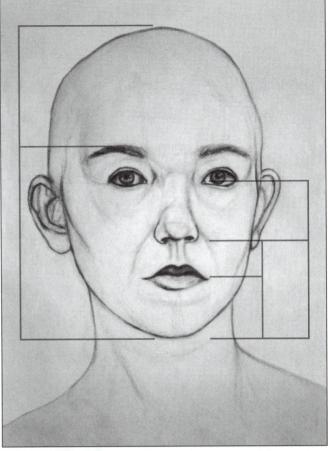

Figure 2-2. Student work. The human face exhibits proportional relationships that reflect the Golden Section. In simplifying the Golden Section to a 3/s fraction or a 3:5 ratio, we observe this same relationship in the major division between the cranial area and the facial area, the length of the nose from eye level to the chin, and the placement of the center line of the mouth from the nose to the chin.

with nothing else. Seeing a human form in any context, whether it be an actual human form or a representation, has the potential to provide us with the experience of "looking in the mirror," of seeing our own reflection, so to speak. It follows that any significant educational experience in visual communication of any kind must thoroughly examine the role of the figure, and for the visual artist this requires experience with drawing the figure.

The fine and applied arts also have in common a concern for principles of design and aesthetics. If we acknowledge the presence of these principles of design and aesthetics in nature, then we may also recognize their essential universality. Quite simply, I can think of no finer example of the application of principles of design and aesthetics than the living, breathing human form, and the human form is indeed

universal. In all of our variations—sex, skin color, body type, facial features, and more—we are exquisitely designed and literally embody a number of design principles or systems of organization, such as the Golden Section (Figures 2–2 and 2–3), discussed at length in Chapter One.

Bear in mind that the same characteristics that make the figure such an important source of study are often what make the figure such an intimidating presence as you embark on your study of the human figure. The fact that the model will often be nude in the classroom may cause you some discomfort initially, but experience indicates that your discomfort will be short-lived and that, with few exceptions, most of you will quickly come to terms with an unclothed model in the classroom as a necessary element for the study of the human body.

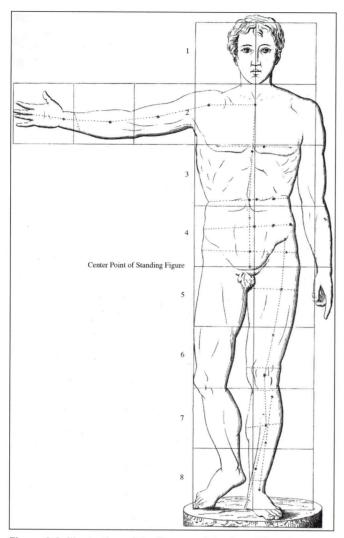

Figure 2-3. Illustration of the Theory of the Art of Drawing. Proportions of the Human Body. Courtesy of Dover Pictorial Archive Series, Dover Publications, Inc. Based on a standing figure that measures 8 head lengths tall, the Golden Section proportions are reflected in a number of ways either as fractions of 2k , 3k , or 5k or as ratios of 2:3, 3:5, or 5:8. The length of the body is divided by 5k or 3:5 at the waist, the length of the arm is divided by 2k 3 at the elbow, and the length of the outstretched arm in relation to the width of the torso is 2:3.

Because the figure is a highly complex form, it presents a greater challenge for those of you who are beginning art students. We are visually quite familiar with the human form in the sense that we often know when something is "off," even if we aren't sure exactly what is "off." The difficulty for the uninitiated lies in the challenge of identifying why things don't look quite right, and what to do about it. Therefore, it is strongly recommended that you have some successful drawing experience with simpler forms before approaching

the subject of the figure. This not only prepares you for the greater complexities of the figure but also serves to build your confidence. Of course not all foundation programs in academic institutions are in agreement with this philosophy of course sequencing, and some programs do not require basic drawing as a prerequisite or even a co-requisite to figure drawing. If, however, you have the flexibility to determine sequencing for yourself, consider the benefits of having some experience and success with the tools and processes of drawing before approaching the figure.

Classroom Etiquette When Drawing from a Model

Modeling is hard work. Unless you have done it before, it is difficult to realize the challenges involved in modeling well. Everyone in the classroom deserves to be treated with respect, and this is especially true for the models who find themselves in an especially vulnerable position because they are often nude and because all eyes are upon them. For those of you who lack experience with drawing from the figure, it is advisable to take a few minutes prior to your first session with the model to acquaint yourself with some of the rules of "etiquette," and your instructor will hopefully review some of this information with you.

The model's personal space is to be respected, and you should never touch the model while he or she is at work. There are some instances, with the model's permission, when it is appropriate for the instructor to make contact with the model in order to point something out, when teaching anatomy, when helping the model to get back into a particular pose, and so on. But the generally accepted notion is that under no circumstances should you, as a student, make contact with a model.

You should also be aware that it is inappropriate to make audible comments concerning the model's body or appearance or to laugh out loud in a way that may lead the model to think that you are laughing at her or him. Again, because of the model's vulnerability, it is courteous and professional to be particularly attentive to their well-being. Although it may seem unnecessary to discuss here what seems like common courtesy, drawing an unclothed model in a classroom with a group of fellow students is not exactly a "common" experience unless you are in art school.

The models, too, should be made aware of guidelines for their behavior. During a break, you can expect that the model will wear a robe or otherwise cover himself or herself until it is time to resume modeling. Models are generally advised not to offer comments on student work since they may unwittingly reinforce something your instructor is trying to discourage or discourage something your instructor is trying to reinforce. If you encounter an uncomfortable situation with the model, your best course of action would be to discuss the issue with your instructor and he or she can address the issue with the model. In general, common sense and courtesy provide the best guidelines.

The Process of Sighting in Relation to the Human Form

The procedure for sighting is thoroughly discussed in Chapter One. There are, however, some factors worth mentioning that relate specifically to sighting the human form.

Sighting the Human Figure for Relative Proportions

It has already been determined that a unit of measure or point of reference must first be established for comparative measurements. When working with the figure, the head is most frequently used as the point of reference (Figure 2-4). This assumes, of course, that the head is visible in its entirety. In views of the figure that do not provide an unobstructed view of the head, such as an extremely foreshortened position, an alternative point of reference must be established. Depending upon your viewpoint, a hand or a foot may provide a workable point of reference (Figure 2-5). Any part of the figure will suffice as a point of reference as long as there is a clear width and length that can be observed and measured. And as noted in Chapter One's discussion of sighting, whatever you choose to use as your unit of measure or point of reference should be established first in your drawing so that it may guide subsequent decisions regarding size and placement of the parts of the body that form the whole.

Foreshortening in the figure is often recorded with a significant amount of inaccuracy and distortion. This is because your *experience* with the human form will often override what you *see* in front of you. For example, a foreshortened view of the thigh may measure wider from side to side than it does in length from the hip area to the knee area (Figure 2-6). Because of your awareness of the thigh as a form that is generally greater in length than in width, cylindrical-like, you may bypass what is observed and draw what you "know" a thigh to look like. This then creates problems in presenting a convincing illusion of a foreshortened limb.

While sighting is an ideal way to overcome these inaccuracies, there are a few things to which you should be

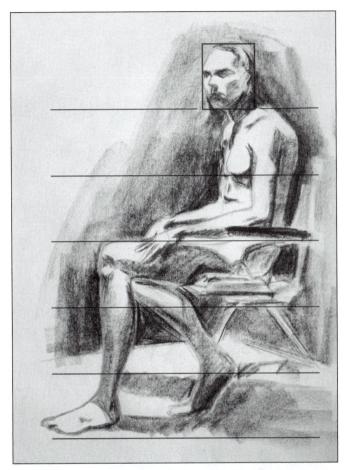

Figure 2-4. Student work. Erik Carlson. The length of the head from crown to chin is pulled down through the figure, revealing that this seated figure measures nearly 6 head lengths from uppermost to lowest point. Note that the second head length brings you to the line of the nipples, and the third head length brings you to the top of the thigh, both easily identifiable as landmarks on the body.

particularly attentive. First, be aware of the fact that when foreshortening is evident, the apparent relationship between the length and width of figurative forms (limbs, torso, hands, feet) is altered to varying degrees, depending on the severity of the foreshortening. While the length of a form may be greatly compressed in foreshortening, the width may remain relatively unchanged (Figure 2-7). Second, make sure you don't tilt your sighting stick in the direction of the foreshortened plane. This is easy to do without even being aware of it. Because the measurement is no longer being taken in the imagined two-dimensional picture plane if you tilt your sighting stick, it will not present an accurate translation from the three-dimensional form of the figure to the two-dimensional surface of the drawing or painting. A final

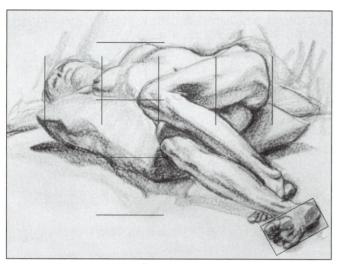

Figure 2-5. Student work. Stephen Amor. Because of the extreme foreshortening of the head and the fact that it is partially obscured, the foot is used as the unit of measure. Lines show the length of the foot pulled horizontally and vertically through the figure. Note that the length of this foreshortened reclining figure from head to buttocks is 4 foot lengths.

Figure 2-6. Student work. Janet Drake Helder. The foreshortened thigh of the reclining figure measures greater in width than in length, which is contrary to what we might expect to see based on what we know about a thigh.

note regarding foreshortening: Be aware that instances of overlapping, where one part of the body meets another part of the body, are more pronounced in a foreshortened view and require greater attention to the interior contours that give definition to this (Figure 2-8).

Sighting the Human Figure for Vertical and Horizontal Alignments Between Two or More Landmarks or Reference Points

Keep in mind that the human form is rich in visual landmarks. Although many of these landmarks are readily apparent and easily identified verbally (the tip of the nose, the back of the heel, the tip of the elbow, the right nipple, the wrist bone, the navel, the inside corner of the eye, the side of the face, etc.), many more landmarks are available to you that are a bit more difficult to describe when discussing a drawing with your instructor or with a fellow student. These landmarks may be defined by a significant directional change in a contour, by a point of overlap or intersection, or by the outermost or innermost point of a curve. Although less easily identified verbally, they can provide helpful reference points for seeking vertical or horizontal alignments between distant points on the figure, and these alignments help to maintain an accurate relationship of size and placement when drawing the figure and its component parts (Figure 2-9). Some examples of landmarks that aren't easily named include the point at which the contour of the neck intersects the contour of the shoulder; the contour where the upper leg meets the lower torso; the point at which the contour of the upper, inner arm disappears into the shoulder area; the outermost part of the curve of the calf muscle; and others. Be creative in finding ways to verbally describe and discuss these landmarks on the figure (Figure 2-10).

Sighting for vertical or horizontal alignments between figurative landmarks that are spaced far apart on the body is especially helpful. For example, you may observe that the left or right side of the face aligns vertically with the foot or ankle area. These alignments can be difficult to observe without the aid of a sighting stick when they occur at distant points on the figure. In addition, you can use sighting to observe when a significant landmark falls to the left or right of a vertical extension of another landmark or when a landmark falls above or below a horizontal extension of another landmark (Figures 2–11 and 2–12). As always, these concepts will become clearest for you when they are actually applied to a drawing experience. Understanding the basic concepts of sighting when they are presented in a classroom lecture or demonstration is a great beginning. But you will undoubtedly find that applying these concepts while drawing will raise questions and occasionally leave you uncertain how to proceed. With the guidance of your instructor, these challenges will provide you with the opportunity to gain a stronger understanding of sighting and the numerous ways that it can serve you in making accurate observations of the

Figure 2-7. John Singer Sargent, American, 1856–1925, Study of a Nude Man, c. 1874–1880. Pencil on paper, $9^7 k \times 7^3 k$ inches. Wadsworth Atheneum Museum of Art, Hartford, CT. Bequest of George A. Gay. 1941.447. Given that our eye level is low and we are looking up at the figure, the head length repeats itself only twice to bring us near the pubic arch. In a standing figure without foreshortening, the head length would repeat itself nearly three times to bring us to this same point. While the length of the torso is compressed, the width of the torso remains relatively unaffected by foreshortening.

Figure 2-8. Student work. Gypsy Schindler. Overlapping is intensified when foreshortening is present. Interior contours are more pronounced in numerous places in this page of foot studies. Note especially the toes of the center foot, the ankle bone (medial malleolus) of the lower right foot, and the heel area of the upper left foot.

figure. You will learn most quickly through the practical application of sighting techniques. And what first may seem awkward and time consuming will become, with experience, second nature.

Comparative Proportions in the Male and Female Figure

As you begin your exploration of the human figure, it is helpful to have information that furthers your understanding of basic proportional relationships. An awareness of classical and idealized figure proportions, derived from the Greeks and the Renaissance, is important in understanding both the historical and contemporary depiction of the human form. But in reality, very few human forms fall so neatly into these

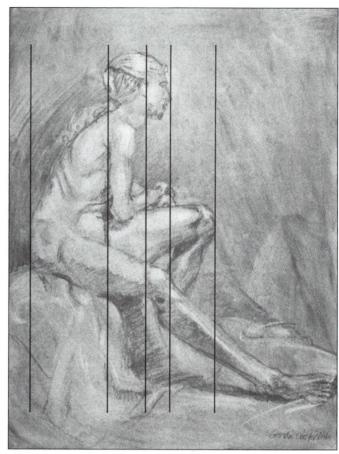

Figure 2-9. Student work. Glenda Oosterink. Vertical sight lines are extended through the figure at various points using a sighting stick. Vertical relationships between identifiable points or landmarks are sought, with the intention of maintaining these observed relationships in the drawing.

canons of proportion. We know that there is considerable variation of proportional relationships within human forms, especially with regard to the length of the limbs.

While the idealized canon of proportions tells us that a standing adult figure is 8 head-lengths tall, reality and experience tells us that many figures are closer to 7½ heads tall, and some are closer to 7 heads tall (Figure 2-13). This information is only applicable when dealing with a standing figure. Careful observation and utilization of the sighting process is most important in establishing actual proportions, whether the figure is standing, seated, reclining, crouching, or in any number of other positions.

Some general information regarding comparative differences in proportion between the female and male form is follows. Differences are most evident when comparing

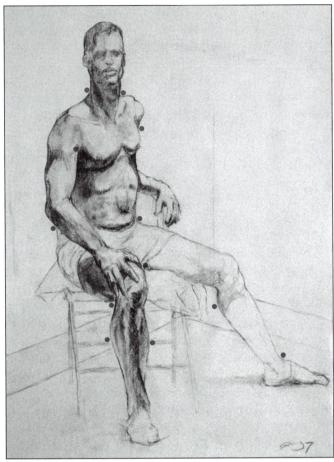

Figure 2-10. Student work. Phil Scally. A variety of landmarks are identified in this drawing by the placement of gray dots. While they lack a specific name, they are places on the figure that can be easily returned to. Most of them involve two edges that meet, overlap, or intersect; a significant directional change in a contour; or the outermost or fullest point of a curve.

standing figures (Figure 2-14). These observations pertain to adult figures who have reached their full height, and it should be noted that there are exceptions to these comparative proportions.

Female

- Torso longer (from shoulders to hips) in relation to total body length because of the greater distance between rib cage and pelvis.
- Lower limbs (legs) shorter in relation to total body length.
- · Neck longer in relation to head height.
- Shoulders narrower than male shoulders.
- Pelvis or hips broader than male pelvis or hips.
- · Hips deeper from front to back than male hips.

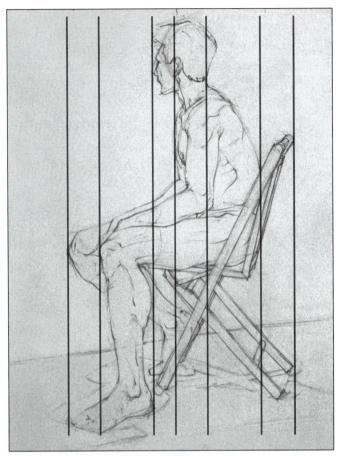

Figure 2-11. Student work. Jody Williams. Vertical sight lines can help identify when two or more points do not precisely align, with one point falling to the left or right of another point. In this example, note that the figure's right heel is positioned between a vertical extension from the front of the chest and a vertical extension from the back of the neck. Although this may seem obvious in looking at the drawing, it is much less apparent when scanning an actual three-dimensional figure without the aid of a sighting stick.

- Hips shorter from top to bottom than male hips.
- Pelvis tipped farther forward, creating a stronger curve in the lower back.
- Hips typically the broadest part of the body, wider than shoulders.
- Arms shorter in relation to total body length because of a shorter humerus.
- Elbows positioned higher in relation to torso.
- Hands positioned higher in relation to upper legs or thighs.

Male

 Torso shorter (from shoulders to hips) in relation to total body length because of the smaller distance between rib cage and pelvis.

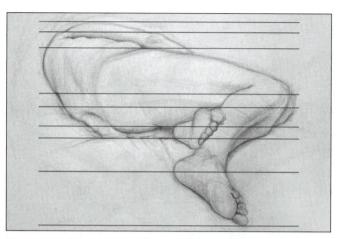

Figure 2-12. Student work. Both vertical and horizontal sight lines can be used in seeking alignments or nonalignments between significant points or landmarks on the figure. This particular drawing illustrates the use of horizontal sight lines to investigate the placement of various aspects of the body in relationship to each other.

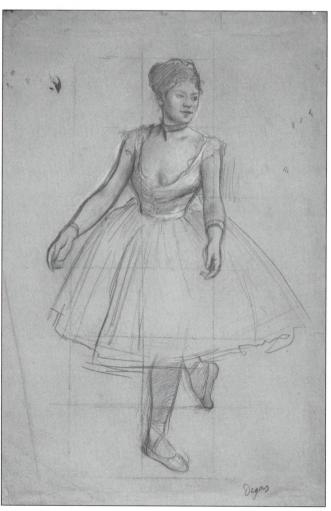

- Lower limbs (legs) shorter in relation to total body length.
- · Neck shorter in relation to head height.
- · Shoulders broader than female shoulders.
- Pelvis or hips narrower than female pelvis or hips.
- Hips shallower from front to back than female hips.
- Hips longer from top to bottom than female hips.
- Pelvis more upright, diminishing the curve in the lower back.
- Shoulders typically the broadest part of the body, wider than hips.
- Arms longer in relation to total body length because of a longer humerus.
- Elbows positioned lower in relation to torso.
- · Hands positioned lower in relation to upper legs or thighs.

When using the head as a unit of measure, you can make some general proportional observations about a standing adult figure, whether male or female. Beginning with the head length and repeating that length down the body toward the feet, you can anticipate some figurative landmarks that the head lengths will come close to if the standing adult is approximately 7 to 7½ head lengths tall. This relationship can shift in older adults, who may lose height because of bone loss and compression of the spinal column.

The first head length is determined by measuring from crown to chin, taking into account the axis of the head if it is tipped (Figure 2-15). The second head length will bring you near the nipples of the breasts, although there is considerable variation here in women based on breast size. The third head length will bring you to the region of the navel, which will also correspond roughly to the position of the elbows with the arms hanging at the sides. The fourth head length brings you slightly below the actual midpoint of the body, which is located at the pubic bone in the male form and slightly above the pubic bone in the female form. Continuing to drop the head length down the body will usually bring you to regions of the body that lack significant landmarks, such as the mid-thigh area and the middle of the lower leg.

Figure 2-13. Hilaire-Germain-Edgar Degas, French, *A Ballet Dancer in Position Facing Three-Quarters Front*, c. 1872–1873. Graphite, prepared black chalk, white chalk, and touches of blue-green pastel on pink wove paper, squared in prepared black chalk; actual: 41 × 27.6 cm (16½ × 10½ inches). Courtesy of the Fogg Art Museum, Harvard University Art Museums. Bequest of Meta and Paul J. Sachs. Photo: Allan Macintyre © President and Fellows of Harvard College. 1965.263/76981. Rather than applying the idealized figure proportions of 8 head lengths tall, Degas records in this standing figure a height of approximately 6¾ head lengths. The drawn grid is used to transcribe the drawing to another surface rather than to represent repeated head lengths.

Figure 2-14. Jean-Auguste-Dominique Ingres, French, *Studies of a Man and a Woman for "The Golden Age,"* 1843–1848. Graphite on cream wove paper, backed, traced with a stylus after mounting, squared, actual: 41.6 × 31.5 cm (16³/₈ × 12³/₈ inches). Courtesy of the Fogg Art Museum, Harvard University Art Museums. Bequest of Grenville L. Winthrop. Photo: Katya Kallsen © President and Fellows of Harvard College. 1943.861/51488. This drawing by Ingres provides an opportunity to compare the proportional variations between a standing male nude and a standing female nude.

Figure 2-15. Statue of Germanicus, from the fifteenth century. Courtesy of Dover Pictorial Archive Series, Dover Publications, Inc. This representation of a standing male figure, approximately $7^1/2$ head lengths tall, shows the location of head lengths when they are repeated through the length of the body. Head lengths are more likely to fall near a landmark in the upper body than in the lower body.

Figure 2-16. Student work, Regina M. Westhoff. In this student drawing that appropriates a Renaissance image of the Christ child and the Virgin Mary, the difference between adult and infant proportions as they relate to head length is clear. Infants have a much larger head in relation to their body length, and this slowly yields adult figure proportions as the infant grows and matures.

In infants and children, the head is much larger in relation to total body length at birth, progressively reaching adult proportions as growth and development continue through childhood, adolescence and puberty, and young adulthood (Figure 2-16). In old age, the proportion of the head to the body changes slightly once again as bone mass shrinks somewhat and there is some loss of height.

Gesture Drawing or Rapid Contour Drawing

Gesture drawing is an essential exercise for "warming up" prior to a more extended drawing session. While it is advantageous to apply gesture-drawing processes to every subject matter, it is indispensable with regard to figure drawing because of the human form's inherent energy and potential for movement. When applied to the figure, gesture drawing not only

helps to energize you, but also helps to energize the model. It gets the body moving and the blood flowing, which can in turn energize a sluggish brain. This can be especially valuable in getting started in a class that meets first thing in the morning when you may be struggling to wake up, or right after lunch when your food is being digested and your biological clock often desires an afternoon siesta, or in the evening following a long and tiring day.

In addition to its preparatory value, gesture drawing is a great exercise in and of itself, and it provides the perfect compliment to a longer, more sustained drawing experience that eventually focuses on details and specifics. The generalized nature of information gathered in a gesture drawing (Figure 2-17) provides solid reinforcement for the process of working from general

7.18

Figure 2-17. Student work, Minnesota State University—Moorhead. Kevin Olson. Note the absence of any detail or refinement of specific information in this gesture drawing.

to specific and helps you to gain experience in making rapid observations of overall figurative placement and proportion.

A typical gesture drawing or gesture pose lasts anywhere from three minutes to thirty seconds or even fifteen seconds. Some instructors prefer to begin with shorter poses and progress to "longer" poses, while some begin with three-minute poses and work toward fifteen-second poses, which you will generally find more challenging because of their brevity. To facilitate the qualities of energy and immediacy, hold your drawing material (whether it be pencil or stick or brush) loosely so that you can utilize your entire arm. Often the tendency is to grip the tool in the same way you would if writing, but writing generally requires more precise and constricted movement than is desirable in gesture drawing.

Seeing Is the Key

- Spend some time just looking at the pose before you begin to draw.
- Spend the majority of your time looking at the model rather than at your drawing.
- The movement of your hand should duplicate the movement of your eyes as you rapidly scan the figure for proportion and general disposition.
- Establish general scale and proportion purely through visual observation. A formal use of the sighting stick and the sighting process is inappropriate in gesture drawing because of the limited time involved.
- Stand at arm's length from the drawing surface in a position allowing a broad view of both the model and your drawing surface. Keep your drawing surface at a height that is most comfortable for you.

Using Axis Lines

- Use axis lines to indicate directional thrusts or to show the major masses of the body (head, upper torso or rib cage, lower torso or pelvis, limbs) in opposition.
- You can indicate significant angles or angular relationships such as the angle of the head, the curve of the spine, the angular relationship between left and right shoulder, between left and right hip, between left and right breast, or between left and right foot in a standing or crouching figure.

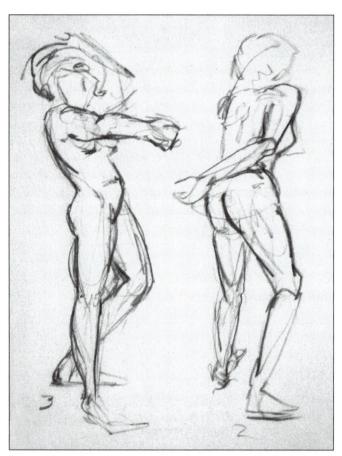

Figure 2-18. Student work. Susan Cannarile-Pulte. The shape and placement of the feet in these gesture studies are key elements in accurately describing posture, weight distribution, and position in space.

Keeping It Simple

- Details of the figure, such as specific facial features or individual fingers and toes are unimportant in gesture drawing and should not be of concern.
- Try to be economical with your marks—don't overwork your gestures. Let gesture drawing be a statement of essentials or essence.
- Define the general characteristics of the figure–movement or directional thrusts; shape; weight distribution or

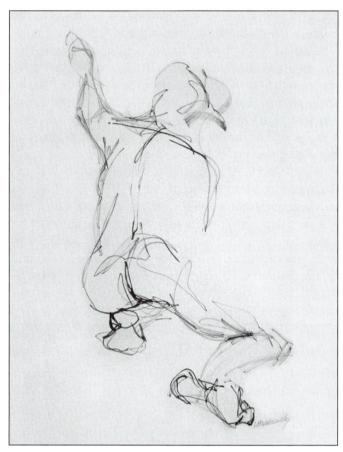

Figure 2-19. Student work. Lisa Kolosowsky-Paulus. This gesture drawing, executed with a stick dipped in ink, utilizes principles of closure in defining the general characteristics of the figure.

- muscle tension (through weighted line); basic position of head, hands, and feet; position in space; and so on (Figure 2-19).
- Generally speaking, do not be concerned with light and dark or value structure of the figure unless the emphasis is on sustained gesture, which is a variation of gesture drawing that allows for a rapid and simplified indication of planes of light and shadow.

Setting the Pace

- The figure and its position should be suggested in its entirety within the first few moments of drawing. This is accomplished by recording the largest and most apparent shapes and axis lines first.
- Think energy and immediacy—gesture drawing is a record of the energy and movement that goes into making the marks.

- Use the entire arm and wrist and shoulder to draw; use your whole body.
- Stand up when doing gesture drawings to enable fluid and rapid drawing.

Working from the Inside Out

- Have an awareness of underlying structure, which acts as
 the armature for the flesh of the figure. In a longer gesture
 drawing, you can indicate the simple underlying masses
 of the skeletal system—skull, rib cage, and pelvis—using
 geometric simplification of these forms.
- Indicate general points of articulation, such as the joining of the limbs with the torso. These are good places to cross over into the interior of the figure and to reinforce the idea that gesture drawing should not focus solely on outermost contours (Figure 2-20).

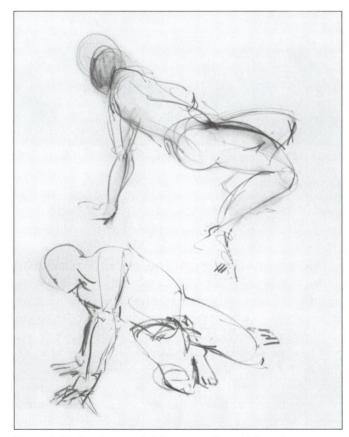

Figure 2-20. Student work, Minnesota State University—Moorhead. Chris Kowanko. Key points of articulation, such as where the thigh meets the hips or where the hips meet the torso, are addressed through marks that move into the interior of the figure. These interior lines can also indicate the path of eye movement as you scan the figure quickly for information.

Gesture drawings of the figure call for an awareness of the model's body and movements, and it is helpful for you to extend this awareness to self. Be aware of the relationship of your own body to the drawing easel (assuming a standing position, which is recommended for executing gesture drawings). It is best to be turned slightly in relation to the model so that there is no need to constantly peek around your drawing board or drawing pad to see the figure. If you are right-handed you should position yourself so that you are looking toward the left to see the model. This allows for the greatest range of motion with your right arm. Conversely, if you are left-handed you should position yourself so that you are looking toward the right to see the model. Position the height of your drawing surface so that your eye level falls within the top half of your drawing surface. This helps to prevent arm or back fatigue caused by reaching too far up or down, especially during an extended gesture drawing session.

Enhancing the Illusion of Volume and Space in the Human Form

Line Variation in Figure Drawing

Chapter One provides an in-depth discussion of line work in relation to a variety of subject matter. It is worth noting, however, that the human form provides a particularly rich opportunity to explore the relationship between line and edge and the power of line to convey tremendous nuance and subtlety or extreme power and forcefulness while addressing the physical aspects of volume, mass, movement, weight, gesture, dimension, and space (Figure 2-21).

The tremendous variety that is inherent in the human body, both at rest and in motion, explains in part its value in the study of drawing. There is also a powerful psychological element that makes the study of the human form an especially rich and satisfying experience. The simplicity and directness of line as an element of image making lends itself well to the expression of both the physical and psychoemotional presence of the human form.

Scaling Techniques in Figure Drawing

Scaling, as a means of developing accurate spatial and size relationships, is especially useful when approaching more

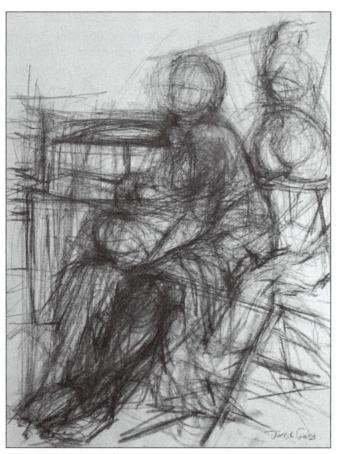

Figure 2-21. Student work. Jamie Combs. Rich linear variation and a dense network of lines indicate a very active search for and discovery of the figurative form in an interior environment.

Figure 2-22. Student work. Jody Williams. With the help of scaling, the figures are composed in correct scale and placement to each other and to the visible horizon line.

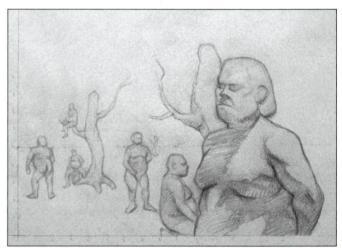

Figure 2-23. Student work. B. A. Miltgen. Based on this student's solid understanding of scaling and perspective, a standing and seated figure are convincingly repeated throughout an invented exterior space, with one seated figure placed in the crotch of a tree.

One interesting exercise for exploring scaling in relation to the human form is useful to your study of the figure regardless of your amount of experience. This exercise can be made more or less complex by controlling the degree of difficulty or complexity of the model's poses. Once you have become familiar with the basics of scaling, you can ask your model to alternate back and forth between two different poses, perhaps one seated pose and one standing pose, for about fifteen or twenty minutes in each pose. Using a refined or sustained gestural approach, draw the figure five or six times in different locations on a ground plane with a clearly established horizon line (Figure 2-23). Variety is provided through the two different poses and also by moving around the model in order to see the poses from different vantage points. If desired, you may explore scaling more

thoroughly by drawing additional forms in relation to the figure, such as buildings or walls with windows and doorways or other architectural or natural forms. If you understand scaling and apply it correctly, you should be able to identify the height of every form that you draw and know that it is firmly in contact with the ground plane.

A General-to-Specific Approach to Form and Value in Figure Drawing

A general-to-specific approach to building linear structure and value structure is discussed at length in Chapter One. It is, however, worth noting some aspects of figure drawing that benefit significantly from the application of general to specific principles. The philosophy of working from generalto-specific is intended to assist in seeing large, generalized forms as the foundation upon which smaller forms or details are based. Because there are many aspects of the figure that are rich in detail, it can be especially difficult for the uninitiated to remain focused first on the larger, simpler forms. Instead, there is premature attention given to details at the expense of the larger forms, which typically results in problems with proportion and a loss of coherent volume. It is a natural tendency for our eyes to note areas of detail or areas of increased visual information. Consequently, the need to suspend or delay interest in this information is especially challenging if you are a beginning student. Emphasizing the "house-building" approach in your figure drawings, as discussed in Chapter One, supports and reinforces general to specific techniques.

The head, the hands, and the feet are frequent trouble spots or stumbling points in the figure when trying to suspend interest in details until the larger, simpler forms are clearly and proportionately established. The inexperienced drawing student often focuses on the individual features of the face while overlooking their relationship to each other and to the larger form upon which the features are based, the ovoid-shaped head. The same is true for the hands and the feet. You may be inclined to focus on individual fingers or toes without concern for their relationship to each other or to the larger, simpler planes of the hand or foot. When this happens, it often results in a loss of unity of the form, and because linear and value structure must be seen in its broadest context first, a loss of volume is also to be expected.

The exercises suggested in Chapter One for reinforcing a general-to-specific approach to building form can easily accommodate the figure as subject matter. Spending time studying the head, hands, and feet as individual units of the

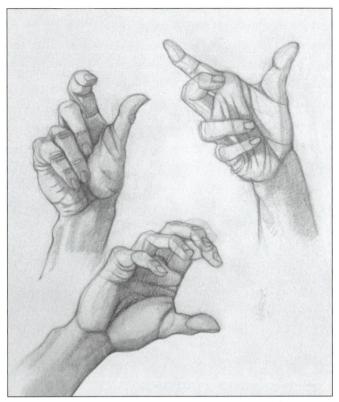

Figure 2-24. Jay Constantine, American, *Hand Studies*, 1987. Black conte crayon on paper, 24×18 inches. Courtesy of the artist. Following the initial linear investigation, basic tonal structure is blocked in using the broad side of a conte crayon and/or parallel linear strokes. Significant form begins to emerge with the use of only two tones that describe planes in light and planes in shadow.

figure with their own hierarchy of general and specific information can help reinforce this working process as it applies to both the parts of a form and the entire form (Figure 2-24). It is especially helpful to first observe and record simple planes or planar structure with line, and then progress to assigning simplified value structure to these planes.

If you want to avoid premature involvement with detail, consider imposing a few limitations on yourself. When working on an 18"×24" format or larger, limit yourself initially to the use of sticks of charcoal, conte, or graphite as opposed to pencils that encourage greater attention to detail (Figure 2-25). Use these sticks in varying lengths by making strokes with the broad side of the stick. Limit the amount of time you allow yourself to do a study of the full figure—between fifteen and twenty minutes—with emphasis on a simplified but proportionate drawing of the entire figure. Try to initially avoid specific fingers or toes or individual features,

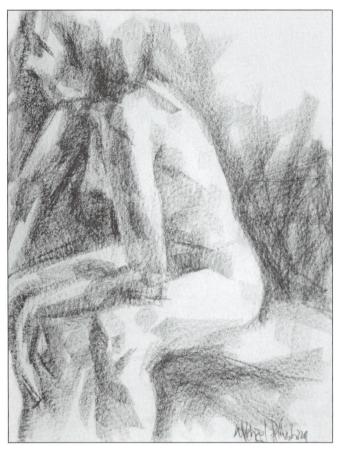

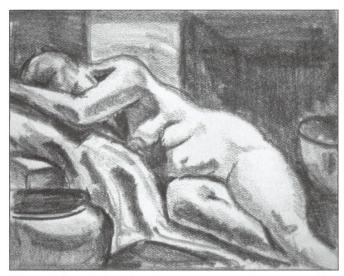

Figure 2-26. Student work. This small and rapid study of the figure and the surrounding environment, measuring about 3×4 inches, is highly simplified. The nature of a thumbnail study discourages premature attention to detail.

Figure 2-25. Student work. Michael Pfleghaar. Use of the broad side of a stick of conte allows for a more generalized tonal description of the form of the figure. A shift to the end of the conte stick can facilitate greater definition of detail if desired.

and again, limit the material to stick form as opposed to pencil form. Finally, consider working on thumbnail sketches of the full figure that are small enough to discourage attention to fine detail (Figure 2-26). Remember that we are talking here about building tonal or value structure. You can use a graphite, charcoal, or conte *pencil* to establish general linear contours, switching to a compatible *stick* of graphite, charcoal, or conte to establish general value structure.

An Introduction to Portraiture

Two things in particular are necessary in learning how to draw a portrait study in a way that will yield a likeness, or at least approximate a likeness, while presenting believable human proportions. First, you must undo any bad habits and dispel any myths you may adhere to that often surround portraiture; and second,

you must learn to really see the human face, bypassing assumptions and eliminating any cursory examinations of the head and the facial features.

As a student, you need to be aware of the most frequent errors that occur in portrait studies with the intention of avoiding these errors, and you must commit to studying and carefully observing placement, proportion, individual variations, and other aspects of the head and its component parts. Sighting is an integral part of the process of observation. Because of the detail involved in portrait studies, effective sighting and informed observation require that you be closer to the subject than you may need to be when doing a full-figure study.

The following information, which begins with a discussion of common errors, is a guideline for the study of portraiture, progressing from general information to more specific information. This information is most effective when you can make direct observations of the human head while reading and studying the

accompanying illustrations. If you are not in the studio with a portrait model, you can use your own reflection as a source of study and can also observe the heads and faces of friends, family members, housemates, spouses, and others.

Common Errors

With the human head as subject matter, two critical errors occur in our perception more often than any others, and these errors are typically reflected in our drawings. The first is the placement of the eye level in relation to the total length of the head, from the crown of the head to the tip of the chin. The second is the placement of the ear, particularly in profile and three-quarter views.

Most people perceive the eye level (an imaginary line that runs through the inside corners of the eyes) to be approximately one-third of the way from the top of the head. This perceptual error occurs in part because, in comparison to the rest of the face, the forehead, hairline, and top of the head are relatively uninteresting, lacking specific features or significant landmarks. Things that may psychologically seem less important are typically perceived to be physically smaller. As a result, the forehead and the top of the head are diminished in size, resulting in what Betty Edwards, in *Drawing on the Right Side of the Brain*, refers to as the "cut-off skull" error.

All proportions can be perceived merely by looking for size relationships. In a direct view of the head in an upright position, look for the following size relationships:

- Measure the distance vertically from the inside corner of the eye to the tip of the chin.
- Compare this distance to the distance from the inside corner of the eye (eye level line) to the uppermost part of the head (the crown).
- The distances are approximately the same, and possibly the upper measurement is even greater when accounting for the height of the hair.
- Therefore, the eye level line is approximately central in the head (Figure 2-27).

In a profile or three-quarter view, similar perceptual errors occur. Because the "cheek" area and the side of the face lack specific features or strong landmarks, most people perceive this area to be less important and diminish it in portraiture. As a result, the ear is thrust forward closer to the other features of the face, often appearing in an incorrect drawing to be growing out of the cheekbone. This also diminishes the

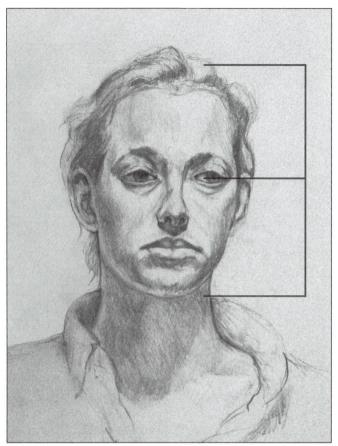

Figure 2-27. Student work. Cliff Towell. The location of the eye level line in relation to the distance from crown to chin is approximately half.

total width of the head in profile and three-quarter views, since the back of the head is often placed or drawn in relationship to the back of the ear. This again results in a variation of the "cut-off skull" error. Look for the following size relationships for placing the ear in profile and three-quarter views, assuming a direct view of the head in an upright position:

- In a pure profile view, measure the distance from the inside corner of the visible eye to the tip of the chin.
- This measurement or distance should approximately repeat itself from the *outside* corner or back of the eye to the back edge of the ear (Figure 2-28).
- In a three-quarter view, measure the distance from the inside corner of the eye closest to you to the tip of the chin.
- This measurement or distance should approximately repeat itself from the *inside* corner or front of the eye to the back edge of the ear (Figure 2-29).

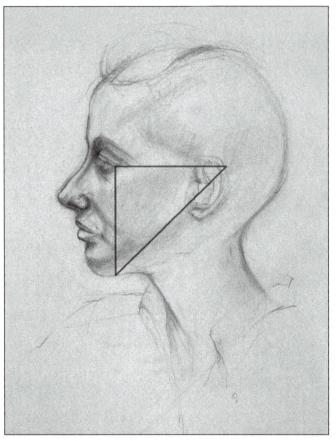

Figure 2-28. Student work. Placement of the ear in a profile view of the head relates to the distance from eye level to chin. The distance from the eye level to the chin is roughly equivalent to the distance from the *outside* corner of the eye to the back of the ear.

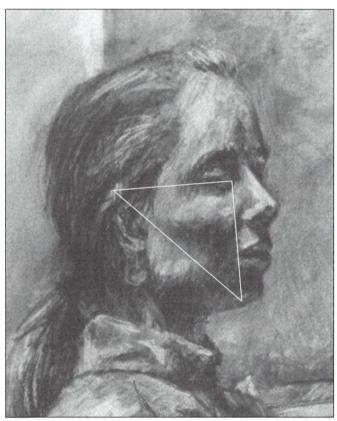

Figure 2-29. Student work (detail). Jamie Hossink. Placement of the ear in a three-quarter view of the head relates to the distance from eye level to chin. The distance from the eye level to the chin is similar to the distance from the *inside* corner of the eye to the back of the ear.

It is important to understand that these measuring systems are for the purpose of comparison—something to check against. There are all kinds of subtle proportional differences from one head or person to another, and this includes variables based on gender, age, and ethnicity (Figure 2-30). Therefore, these measurements are not intended as rules, but rather as guidelines to help you discover true proportions for each individual.

General Guidelines for Locating Facial Features and Other Landmarks

The following guidelines assume that you have a direct view of the subject's head in an upright position. You as the artist are not positioned significantly above or below the model, and the model's head is not tipped forward or back.

The **central axis** (an imaginary line running through the center of the forehead, the nose, and the mouth) is always at 90° (a right angle) to the eye level line (Figure 2-31). Even when the head is tilted, creating a tilt in the central axis, a 90° relationship will be maintained between the central axis and the eye level line. In an extremely foreshortened three-quarter view, this angle may differ slightly from 90° because of the effects of perspective and convergence.

The **length of the nose** (the point at which the nose meets the face above the mouth) is typically between one third and one half of the distance between the eye level line and the tip of the chin (Figure 2-32). Rarely will the length of the nose be less than one third of this distance or more than one half of this distance. The tendency for most beginning portrait drawers is to make the nose half the length of the distance between the eye level and the tip of the chin. This

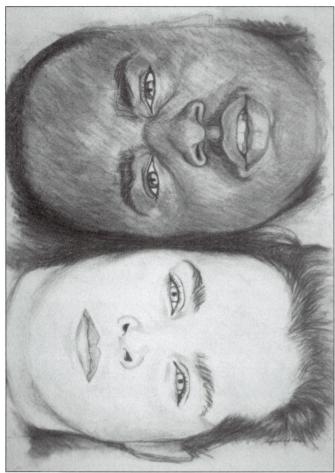

Figure 2-30. Student work. Gypsy Schindler. This drawing provides a comparison of differences and similarities in facial features based on gender and ethnicity.

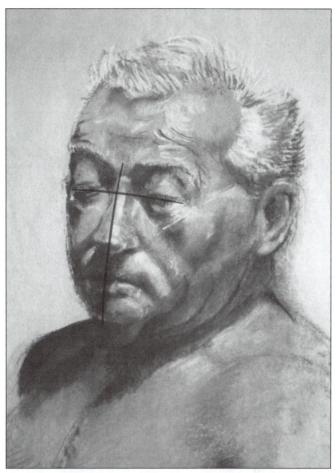

Figure 2-31. Student work. Aaron Adams. The eye level line and central axis maintain a 90° angle even when the head is tilted. In a three-quarter view, the central axis will take on a slight curve to acknowledge the rounded volume of the head. Perspective and foreshortening may increase or decrease the angular relationship slightly, depending upon the viewpoint of the artist in relation to the subject.

generally creates a nose that is too long, which then causes problems in placing the mouth.

The **centerline of the mouth** (the line formed where upper and lower lips meet) is located approximately one third of the distance from the end of the nose (where the nose joins the face) to the tip of the chin (Figure 2-33). The centerline can then guide the size and shape of the upper and lower lips.

The **distance between the eyes in a frontal view** (and some three-quarter views) is approximately 1 eye width. The distance from the outside corner of the eyes to the apparent edge of the head is again approximately 1 eye width in a frontal view. This means that in a frontal view of the head,

the total width at eye level is approximately 5 eye widths (Figure 2-34).

The **edges or wings of the nostrils**, in determining the width of the base of the nose in a frontal view, form an approximate vertical relationship with the inside corner of the eyes (Figure 2-35). Based on different facial structures and ethnic influences, there is significant variation in the width of the base of the nose, but the vertical relationship with the inside corner of the eyes provides a point of comparison.

The **outside corners of the mouth**, in determining the width of the mouth in a frontal view, form an approximate vertical relationship with the center of the eyes (see Figure 2-35). Again, this vertical relationship is intended

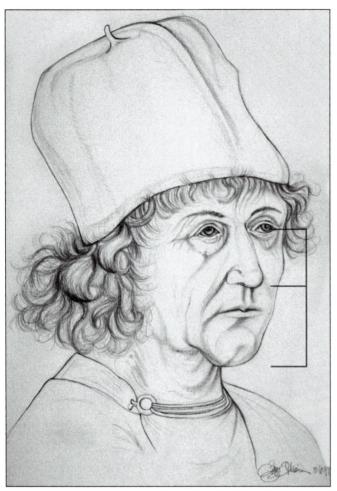

Figure 2-32. Student work (detail, after Albrecht Dürer). Amy Allison. The length of the nose in relation to the distance from eye level line to chin is typically between one half and one third.

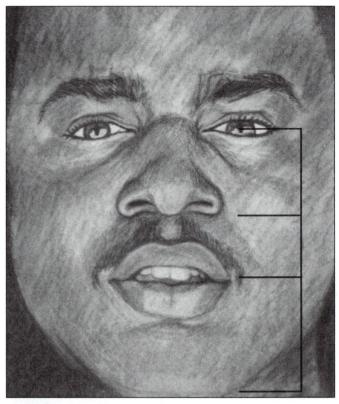

Figure 2-33. Student work (detail). Gypsy Schindler. The centerline of the mouth in relation to the distance from nose to chin is approximately one third.

to provide a point of comparison as this width may vary considerably.

The **top of the ears**, where the ears meet the head, are approximately level with the eye level line, forming a horizontal relationship between the top of the ears and the eye level line when the head is upright (Figure 2-36). Be aware that if the model's head is tipped forward or back even a little bit, this can impact the apparent position of the ears considerably.

The **bottoms of the ears, or the bottom of the ear lobes**, form an approximate horizontal relationship with the space between the nose and the mouth when the head is upright (see Figure 2-36).

The **width of the neck** is generally greater than you may think, although there is a tremendous amount of variation from female to male and from person to person. Note carefully the point at which the neck appears to emerge from the contour of the face and the frequent asymmetry of these points of emergence, especially when the shoulders or head are turned even slightly (Figure 2-37).

In a **three-quarter view**, the symmetry or "mirror image" that we associate with the features of the face is radically altered. The eyes take on different shapes and different sizes in relation to each other, the far side of the nose and near side of the nose can appear significantly different in terms of size and shape, and the far side of the mouth and the near side of the mouth can also appear different, all because of the turning of the head and the effects of perspective (Figure 2-38). As always, careful observation will help you to perceive these differences and avoid drawing what you think you "know," drawing instead what you actually see.

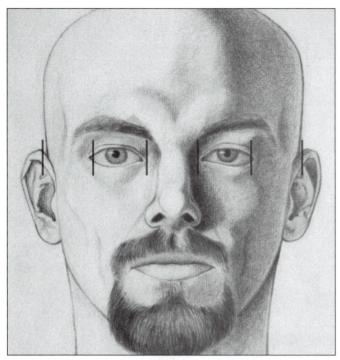

Figure 2-34. Student work (detail). Michael Williams. A comparison of the width of one eye in a frontal view to the width of the full face at eye level reveals five nearly equal units—two containing the eyes, one containing the space between the eyes, and two containing the space adjacent to each eye. This comparison can reveal subtle asymmetry from one side of the face to the other.

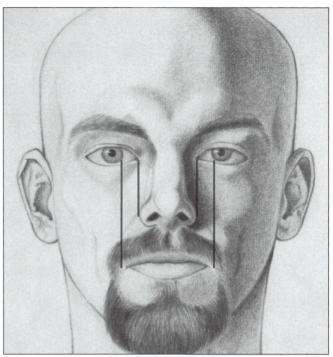

Figure 2-35. Student work (detail). Michael Williams. In a frontal view of the face, the wings of the nostrils can be compared to the inside corners of the eyes by extending a vertical sight line. Similarly, the width of the mouth can be compared to the middle of the eye. This comparison can reveal subtle asymmetry from one side of the face to the other.

The Features and Other Significant Aspects of Portraiture

The Eyes

Look carefully at the actual shape of the eyes (Figure 2-39). Observe the angle or axis line, in a frontal view, from the left to right side of each individual eye. Does the eye angle up from inside to outside corner? Does it angle down, or does it remain horizontal from inside to outside corner? Even in a frontal view, the two eyes are often shaped somewhat differently.

Note in a frontal view that the highest point of the curve of the upper lid is usually located nearer the inside corner of the eye, while the lowest point of the curve of the lower lid is usually located nearer the outside corner of the eye. The tendency is to place the peak of both curves in the same location so that they mirror each other, but this does not accurately represent the shape of the eye.

When drawing the iris, remember that it is circular in shape. Look at the white of the eye, and draw the white

shapes around the iris that are bound by the upper and lower lid. Sometimes this will be one large white shape, unbroken beneath the iris, but more often it will be two separate shapes divided where the iris meets the upper and lower lid.

Notice that the eyelashes are often not apparent and can be indicated simply by darkening the line used to define the edge of the eyelid, especially the upper eyelid. Eyelids are not paper thin, but have thickness, and the eyeball is seated behind the lids—it is recessed. This is particularly evident in a profile view, and you should notice that the front, slightly curved edge of the eyeball does not sit vertically in the face but slants back slightly from top to bottom (Figure 2-40).

When incorporating tone or value, notice the value changes that occur on the eyeball itself (Figure 2-41). This is affected by the light source, both the strength of the light and the direction of the light. The white of the eye is not actually white and because the eyeball is a sphere and recessed behind the eyelid, there is frequently a shadow cast on the eyeball by the upper lid. Look for strong highlights in the eye, resulting from the moisture in the eye picking up

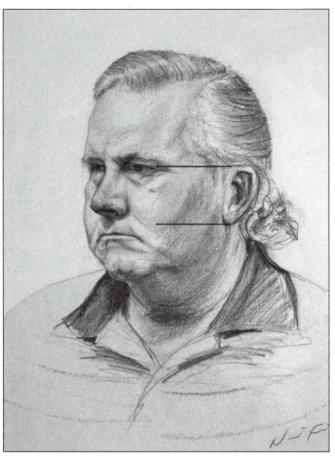

Figure 2-36. Student work. Naomi Fish. The top and bottom of the ears often relate horizontally to the eye level and the space between the nose and upper lip, respectively. If the head is tipped up or down, the horizontal sight lines tilt with it.

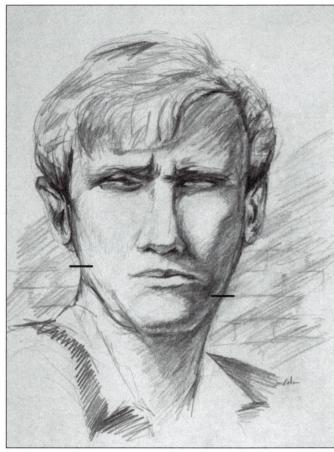

Figure 2-37. Student work. Because the shoulders and neck are turned away from the picture plane, the point where the neck appears to emerge from the contour of the face is different from the left to the right side.

and reflecting your light source. This highlight information adds life to the eyes, although it may not be evident if the eyes are in deep shadow.

Look for the value changes around the eye, and note carefully the shape of these areas of value. This information is particularly important in showing that the eyes are recessed in the head, set back in the sockets and resting beneath the ridge of the brow to protect them. By observing the shadows around the eyes and drawing them carefully, you will avoid a portrait drawing in which the eyes appear to be floating in the face.

The nose

Notice the shape of the nostrils, which is different in a frontal view than in a profile view where only one nostril is visible (Figure 2-42). In a three-quarter view the two nostrils take on entirely different shapes. Depending on the structure

of the nose and the view from which you are observing it, note that some nostril openings will be more angular, some gently curved, some full and "open," some narrow and "closed." Note the overall axis of the nostril, even though it may be very subtle. Is the axis vertical or horizontal, or does it move on a diagonal? Careful observation will reveal key information.

In a profile view, you are able to perceive a definite edge along the length of the nose, and this can be carefully observed and drawn through the use of line. In a three-quarter view, this "edge" may be observed as a linear edge even though it may not be as clearly distinguished from the surrounding information as in a profile view (depending on the degree of the three-quarter view). In a frontal view one does not actually observe a firm linear edge running along the length of the nose (Figure 2-43). Defining, through line, the form of the nose in a frontal view depends upon the

Figure 2-38. Student work (detail, after Hans Burgkmair the Elder). Kerre Nykamp. A three-quarter view of the face reveals asymmetry in the shape and size of the facial features. Note the differences in size and shape from the right to the left side of the face of the eyebrows, the eyes, the nostrils, and the lips.

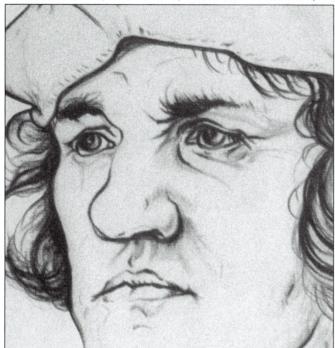

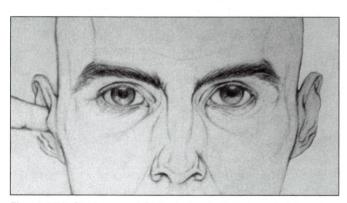

Figure 2-39. Student work (detail). James Peterson. A detail view of a self-portrait emphasizes the eyes and the use of line and line variation to represent them. Note that this person's eyes angle up slightly from the inside corner to the outside corner.

strength and direction of light source and requires a delicate touch since the "edges" along the length of the nose in a frontal view are typically very vague. With side lighting, creating shadow on one side and light on the other, you can use an appropriately delicate line to draw the contour along the length of the shaded side of the nose. With overhead lighting, you can delicately draw both the left and right

Figure 2-40. Student work. John Hale. In a profile view of the face, the upper and lower eyelid rest at an angle. This angle is frequently misrepresented as a vertical, which makes the eye appear to bulge unnaturally. Notice, too, that the eyeball is recessed behind the lid due to the thickness of the eyelid.

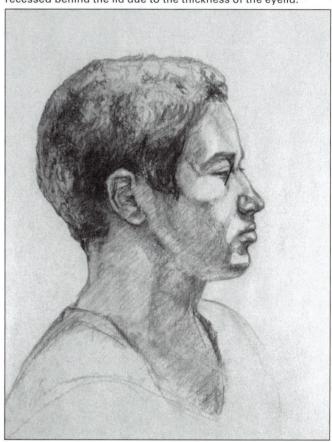

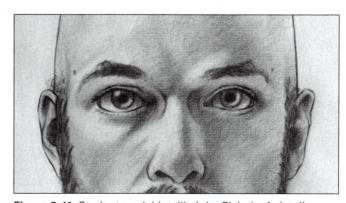

Figure 2-41. Student work (detail). John Elsholz. A detail view of the eyes in this self-portrait study reveals information about tonal changes in and around the eye. Notice the value structure on the eyeball itself resulting from the shadow cast by the upper lid and the shapes of value around the eye socket.

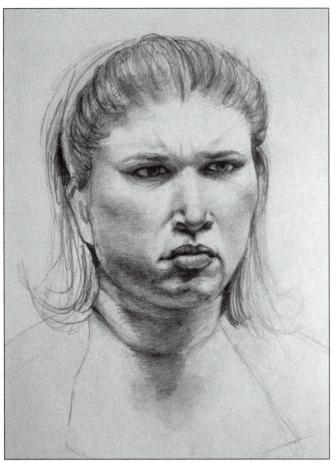

Figure 2-42. Student work. Naomi Fish. This portrait study provides a slight three-quarter view of the facial features. Notice the shape of the nostrils, their slight asymmetry, and their width-to-height relationship. This particular woman has strong, somewhat flared nostrils.

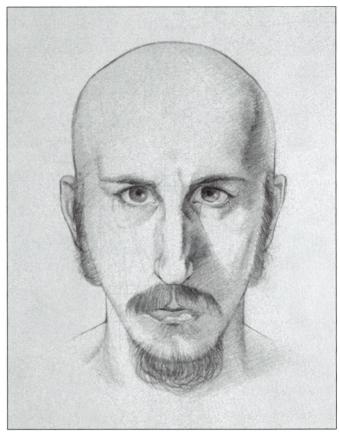

Figure 2-43. Student work. Andrew Shirey. Side lighting in this self-portrait creates shadow on one side of the nose and light on the other. If represented with line only, the length of the nose could be described with a soft focus line along the shaded edge where the core shadow is located.

contour of the length of the nose, defining the top plane of the length of the nose and distinguishing it from the delicately shaded side planes.

Observe the location of the tip of the nose, which varies greatly from individual to individual. In some cases, the tip of the nose is considerably higher than the place where the base of the nose meets the face. This is often referred to as a "turned-up" nose. In some cases the tip of the nose coincides with the place where the base of the nose meets the face, and in some cases the tip of the nose is positioned below the place where the base of the nose meets the face (sometimes called a "hooked" nose).

In a profile view, note the relationship between the point where the nose meets the face between the eyes (the bridge of the nose) and the point where the base of the nose meets the face (Figure 2-44). Do these two points align vertically, or is one point positioned behind or in front of the other point? Look for additional vertical alignments between landmarks along the profile. Notice the negative space adjacent to the profile and use it to guide your drawing (Figure 2-45).

The Mouth

In all views of the mouth, the shape of the upper and lower lip is best defined through a combination of sensitive line work and value changes rather than solely through line. A strong line drawn all the way around the mouth will look artificial, more like a lipstick line than the actual shape of the lips, because the edges along the outermost contours of the mouth vary in strength. Some areas that we perceive as edge, particularly along the left and right side of the lower lip, are often not edges at all but simply a color shift.

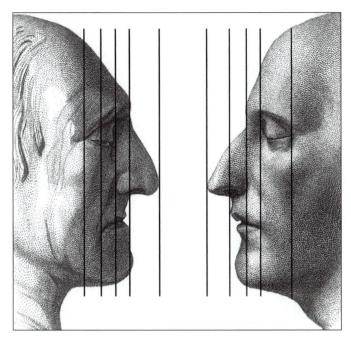

Figure 2-44. From illustrations of the psychological relations of the brain (phrenology). Courtesy of Dover Pictorial Archive Series, Dover Publications, Inc. Extending vertical sight lines through the facial features helps us to identify the relationship of one part of the face to another in terms of size, placement, and so on. In comparing these two different profiles, note that in the older man's face on the left, the bridge of his nose aligns with the point where his lower nose meets his face, while his upper lip is positioned behind this alignment. In the face of the younger man on the right, the bridge of the nose aligns with the back of the wing of the nostril and the contour of the upper lip is well in front of this alignment. Further analysis of the two profiles reveals a number of differences in the relationship of the features to each other.

The center line of the mouth where the upper and lower lip meet is a strong edge, and it can be represented by the darkest line work in drawing the mouth (Figure 2-46). Carefully observe the length of the centerline of the mouth and the directional changes that occur all along the length of the centerline. Note that the centerline of the mouth is not equally dark along its length, but changes subtly in value as well as direction. It is often not exactly the same on one side of the mouth as on the other. The centerline of the mouth is of particular importance in capturing the personality and expression of the model.

Note the direction of the centerline of the mouth at the corners, as well as value changes and shapes of value found at the outermost corners. Do the corners of the mouth slant down or slant up, or does one corner of the mouth slant one way and one corner another? Typically speaking, you may notice that the upper lip is darker in value than the lower lip

Figure 2-45. From illustrations of the psychological relations of the brain (phrenology). Courtesy of Dover Pictorial Archive Series, Dover Publications, Inc. In again comparing these two profiles, notice the significant differences in the negative space around the profiles bounded by diagonal extensions from the tip of the nose to the tip of the chin and from the tip of the nose to the outermost projection of the forehead. Note also that the older man's forehead slopes away from the plane of his face more dramatically than the younger man's forehead does.

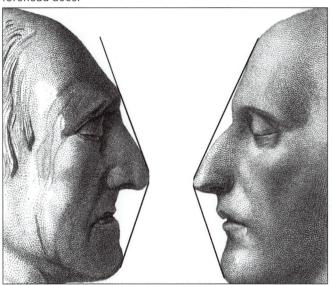

Figure 2-46. Student work (detail). Jamie Hossink. In this detail view of a self-portrait, the mouth is almost exclusively defined by the centerline where upper and lower lip meet. The centerline is nearly always the darkest line found in contours of the mouth. Although the facial hair obscures the mouth somewhat, there is evidence of delicate line work used to describe some of the outermost contours of the upper and lower lip.

and that the lower lip's shape and size can be indicated by drawing the shadow that is cast just beneath it, noting that this shadow varies greatly in size and shape from one person to another (Figure 2-47). Observe carefully the activity at the outermost corners of the mouth. Again, this information is vital in capturing the expression of the model.

Pay attention to the relationship between the upper and lower lip in terms of length from side to side and width from top to bottom. There is great variation from person to person. Are the top and bottom lips roughly equal in their width or fullness, or is one lip or the other much fuller or much narrower in width? In terms of length, does the upper lip appear longer than, the same as, or shorter than the lower lip? Does the upper lip protrude beyond the lower lip, or vice versa?

In a profile view, there are many places where contours change direction, creating landmarks, and this is true of the mouth area, or the space between the base of the nose and

Figure 2-47. Student work. Melissa Vander Ark. This subtractive drawing illustrates the fact that the upper lip, with overhead lighting, is often darker in value than the lower lip and the lower lip is often defined by the shadow that it casts below itself. A linear contour or a tonal description of the lower lip typically breaks toward the outside edges, acknowledging the loss of a tangible edge in these areas.

the tip of the chin. Notice the relationship in placement between outermost and innermost projections, or land-marks. Note the angles between these points and the negative space found adjacent to these contours. Often, although not always, the lower lip is positioned slightly behind the upper lip. It can be helpful to draw a sight line that joins the tip of the nose and the outermost projection of the chin, observing then the relationship of the contour of the lips to this diagonal line (Figure 2-48).

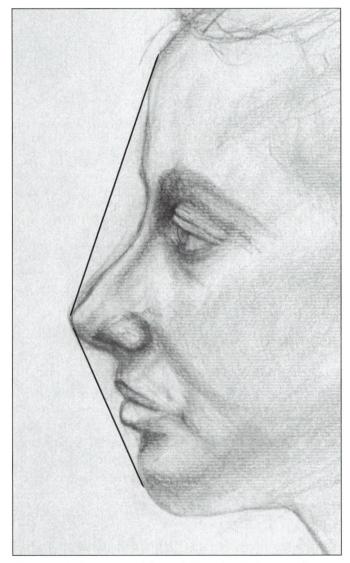

Figure 2-48. Student work (detail). This detail of a portrait study in profile shows the relationship of the contour of the lips to a diagonal sight line joining the tip of the nose and the chin. In this instance both upper and lower lip rest behind this diagonal. Note, too, the extreme difference in the angle of the forehead (nearly vertical) and the angle of the nose.

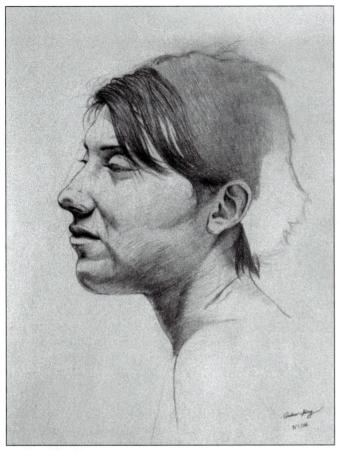

Figure 2-49. Student work. Andrew Shirey. This portrait study shows the ear's relationship to the facial features in terms of up and down placement and distance from the features. Although not evident in this profile view, many of us have one ear positioned higher than the other, which accounts for the fact that glasses often rest crookedly on our face without an adjustment to the earpieces.

The Ears

Whether in a frontal, three-quarter, or profile view, the correct placement of the ear or ears is vital. Always take note of the position of the ear in relation to other features or landmarks in the face or head that you have already drawn (Figure 2-49). Note the overall shape of the ear—squared-off, rounded, long and narrow, full at the top and narrow at the bottom—and describe the shape to yourself as you are drawing it.

In a three-quarter or profile view, note that the ear is often not purely vertical in its placement, but is slightly diagonal with the top of the ear leaning more toward the back of the head (Figure 2-50). This diagonal orientation is most evident when looking at the front edge of the ear where it attaches to the head.

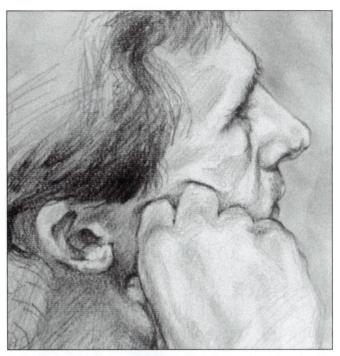

Figure 2-50. Student work (detail). Chris Schroeder. This detail view of a head and hand study shows the diagonal orientation of the ear.

Look carefully for shapes of light and dark within the overall shape of the ear. As with all the features, ears vary tremendously from one individual to another. Note whether the earlobes are "attached" or "unattached."

The Neck

In frontal and three-quarter views, take note of where the contour of the neck appears to emerge from the head (Figure 2-51). This will vary greatly depending on your viewpoint, the position of the model, and gender to some degree. Note that this point of emergence is often very different from one side of the neck to the other.

In a profile view, use the negative space in front of the neck to help you observe the correct contour of the underside of the chin and the neck (Figure 2-52). The front contour of the neck is usually at a diagonal, slanting back away from the profile, and in a male may include a more prominent projection of the "Adam's apple." Notice in a profile view that the point at which the back of the neck appears to emerge from the head is higher than the point at which the front of the neck emerges. The back of the neck typically emerges at a point that relates horizontally to the bottom of the ear.

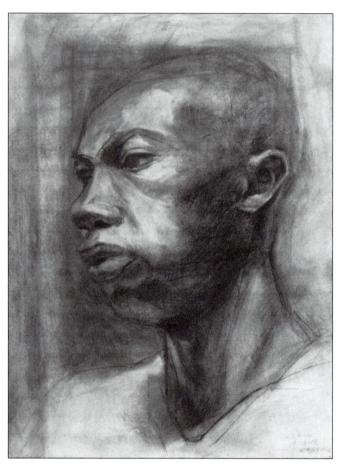

Figure 2-51. Student work. Matt Maxwell. Because the shoulders and head are turned, the neck appears to emerge from the contour of the face in very different places from left to right side. On the left, the contour appears to emerge from the area under the chin, while on the right the contour appears to emerge from the back of the skull. Notice, too, that the neck contour overlaps the shoulder area on the left but not on the right.

The Shoulders

Make sure that the shoulders are wide enough, and observe the height of the shoulders in relation to each other. The angular relationship or axis line from one shoulder to the other shoulder is important in capturing the attitude of the model and is often complimentary to a tilt in the central axis of the head.

If the shoulders do not face you directly, note the difference in size and overall shape between the shoulders (Figure 2-53). The contour of one shoulder may emerge far beyond the contour of the head, while the contour of the other shoulder may not. If the shoulders are drawn too large, the head will appear too small. If the shoulders are drawn too small, the head will appear too large. Careful observation will help you to perceive the true appearance of forms.

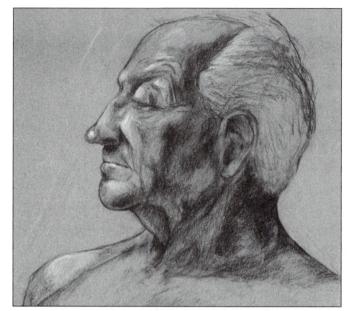

Figure 2-52. Student work (detail). Phil Scally. In this profile portrait study, a distinct negative shape is formed by the edges of the chin, the neck, and the shoulder. This shape is a useful guide for drawing the surrounding contours accurately.

The Hair

Observe the shape of the hairline. Use the "negative shape" of the forehead to help you see the shape of the hairline. Note the differences in the shape of the hairline from one side to the other, particularly in a three-quarter view (Figure 2-54). In drawing the hair, use strokes that move in the direction that the hair grows or in the direction that the hair falls, and use line to indicate places where the hair separates. Rather than drawing individual strands of hair, which is contrary to our actual perceptions of hair, look for shapes of light and dark values within the hair and draw these (Figure 2-55). Hair contains light and dark passages just as flesh does, and by observing these value changes you can avoid drawing hair that appears flat and wiglike.

In drawing the overall shape of the hair, make sure that you account for the presence of the skull beneath the hair. Try to see the skull shape underneath or through the hair and indicate it lightly, adding the hair to this underlying shape.

In observing the hair that makes up eyebrows, take careful note of the shape and placement of the eyebrow in relation to the eye, and indicate the subtle value changes in the eyebrow based on the density of the hair at different points in the eyebrow. Notice that the two eyebrows are often shaped somewhat differently, and one may be positioned higher or lower than the other.

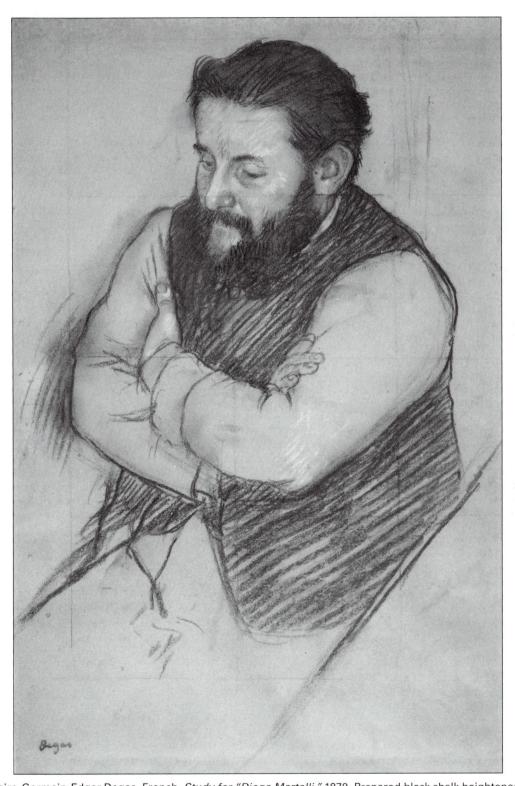

Figure 2-53. Hilaire-Germain-Edgar Degas, French, Study for "Diego Martelli," 1879. Prepared black chalk heightened with white chalk, traces of white gouache, on green-gray wove paper, discolored to tan, squared in black chalk, actual: 45×28.9 cm $(17^{11}/16 \times 11^{3}/6)$ inches). Courtesy of the Fogg Art Museum, Harvard University Art Museums. Bequest of Meta and Paul J. Sachs. Photo: Allan Macintyre © President and Fellows of Harvard College. 1965.255/77319. In Degas' three-quarter view portrait study, the shape and size of the shoulders vary greatly from the left to the right side because the upper body is also seen in a three-quarter view. Note, too, that because the viewpoint is above the model looking down, the shoulders appear to emerge from a point much higher on the head than if viewed from a less dramatic angle.

Figure 2-54. Deborah Rockman, *Study of Man's Head*, 1982. Black conte crayon on paper, 24 × 18 inches. Courtesy of the artist. The shape of the hairline and the forehead reflects the asymmetry associated with three-quarter views of the head and face.

Figure 2-55. Student work. Andrew Shirey. The strokes used to selectively describe the hair show concern both for the direction the hair grows and falls and for the patterns of light and shadow found in the hair as determined by hair color and by light source.

Value Structure

Value structure is important in defining the volume and three-dimensionality of the head. In observing value structure, look for the following (Figure 2-56): What are the shapes of light and dark values observed? How do these shapes relate to the surrounding features in terms of size and placement? Are the edges of these shapes of light and dark crisp and sharp, or soft and fuzzy, or somewhere in between? Does a single shape of value contain both crisp edges and soft edges? Does the value change from light to dark occur suddenly, creating a sharp edge, or does the value change occur gradually, creating a soft transition from one value to another?

Are there subtle value changes that occur within a shape of light or dark? Does a large dark shape of value contain some lighter areas? Does a large light shape of value contain some darker areas? Keep your light and shadow distinct

from one another. Make careful observations. Most significantly when studying value structure, be very aware of your light source—where it is positioned, how strong it is, how far away it is from the model you are drawing. Connect what you see in terms of value structure on your subject's face with the light source.

An Alternative Viewpoint in Portraiture

In discussing the placement of features in portraiture and the general appearance of these features, we assumed a direct view of an upright head. In other words, you are studying and drawing the subject's face and head from a position similar to that of your subject. Even under these circumstances, a tremendous amount of variety in terms of placement of features is possible.

Figure 2-56. Student work. Phil Scally. This portrait drawing defines the form of the face primarily through value structure. Note in particular the shapes of darker value that define the side planes of the face and the cranial area, as well as the muscles in the neck. The value structure describes his specific facial structure in response to a light source positioned in front of and above his head.

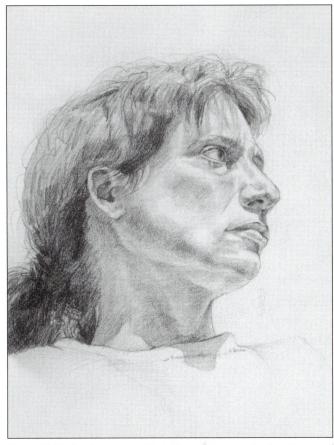

Figure 2-57. Student work. Chris Schroeder. In viewing the model's face and head from a position well below the model's eye level, proportional relationships, placement of features, and general appearances deviate significantly from what we might expect to see with a more direct viewpoint.

In instances where the viewpoint is significantly altered, it must be noted that proportional relationships, placement of features, and general appearances are also significantly altered. An altered viewpoint implies that the model's head is tilted forward or backward, and possibly tilted significantly to one side or the other, or that you, as the artist drawing the portrait, are positioned well above the model looking down or are positioned well below the model looking up. When the viewpoint is so altered, careful observations must be made to accurately capture a sense of this viewpoint.

If, for example, the model's head is thrown back or the artist is below the model looking up, several things will change (Figure 2-57):

• The eye level line in relation to the total length of the head will rise, appearing closer to the top of the head and above the halfway point of the height of the head.

- The ear level will drop in relation to the other features of the face.
- More of the underside of the nose will be visible and the apparent length of the nose will be shorter. You may observe, for example, that the tip of the model's nose is nearly at the same level as the eyes.
- More of the underside of the jaw will become visible.
- Less of the top of the head will be visible.

If, for example, the model's head is thrown forward or the artist is above the model looking down, several things will change (Figure 2-58):

- The eye level line in relation to the total length of the head will drop, appearing closer to the chin and below the halfway point of the height of the head.
- The ear level will rise in relation to the other features of the face.

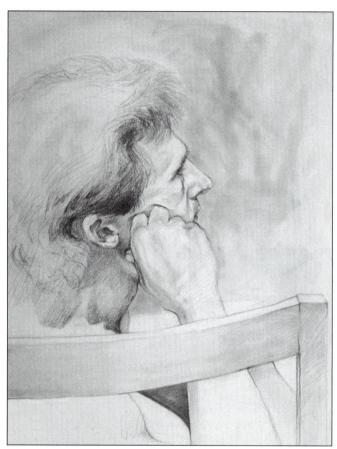

Figure 2-58. Student work. Chris Schroeder. The viewer is a bit above the model looking down, and the model's head is both tipped and tilted. Careful observation is critical in accurately observing placement of and relationship between features and landmarks.

- The apparent length of the nose will increase in relation to the distance between the eye level line and the chin.
- Less of the underside of the nose and the jaw is visible.
- More of the hair and the top of the head is visible.
- The apparent contour of the shoulders may appear to emerge from the head or from a point much higher than we are accustomed to observing. The apparent length of the neck will be shortened.

In observing the different aspects of portraiture, it is very useful to have a model on hand who is comfortable with having his or her head and face and features scrutinized. For the sake of clarity when initially studying portraiture, it is recommended that your model be free of facial hair or, if the model normally wears makeup, to refrain for the portrait study. Make sure that you are close enough to your subject to be able to see clearly. If you are in a classroom setting with a lot of other students, your instructor may bring in

two models from which to draw so that you can get closer in order to aid your observations.

When studying the tremendous variation in details of facial features, such as the shape and slant of the eyes, the shape and size of the nostrils, the fullness of the lips, the size and shape of the ears, and so on, it is very informative to select two or three people who are willing to serve as examples and use them for comparison. You can do this with friends or family members or roommates. If you are comparing eyes, look for differences in the angle from inside corner to outside corner. Look for differences in the shape and size of the eye. Look for differences in the heaviness or width of the upper lid and the space between lid and eyebrow. If done respectfully, it can be both entertaining and extremely informative to note actual differences in facial features based on careful visual comparison.

Mapping the Figure in Space

Introductory experiences in figure drawing often focus on the figure as a singular form alone on the page. Because of the complexity of the figure, it is understandable that initial investigations would not include much or any attention to the environment within which it is located. But as your skill and comfort level with drawing the figure increase, you will benefit from beginning to address the specific environment you observe around the figure with which it interacts spatially (Figure 2-59).

Drawing the Figure in an Observed Environment

The term "mapping" refers to the idea of intersecting contours both within a form and between various forms. The exercise of mapping emphasizes where contours meet, one passing in front of another, indicating a directional or spatial change. For example, a contour in the foreground may appear to intersect or overlap a contour in the background. The contours meet visually, with a shift in space occurring. Mapping calls attention to these changes in space by emphasizing where contours that appear to meet in your drawing are actually moving forward or backward in space. Although

mapping is discussed here in relation to the figure, it is a legitimate exercise in relation to any subject matter.

Mapping the figure and its environment is primarily a linear exercise, although it can be easily extended into a study that incorporates tonal structure. It explores the figure as the central element in a composition that includes other "secondary" forms in various spatial locations. With the figure functioning as a primary component in a larger pictorial matrix, all forms in proximity to the figure can be discovered in terms of where their contours meet or emerge from the contours of the figure or where their contours cross in front of or behind the figure. Depending upon whether the environment is an interior or an exterior space, secondary forms may include chairs, tables, walls, windows, doors, stairways, counters, cupboards, benches, trees, fences, lampposts, houses, animals, or other figures.

Using Straight-Line Construction

The process of mapping the figure begins by drawing the figure using straight-line construction. Straight-line construction requires that you translate the contours of the figure into a series of straight lines that emphasize those places where planes and contours shift and overlap or change direction (Figure 2-60). Once you have completed your straight-line analysis of the figure, you erase or lighten everything but the intersections and observe that the figure remains readable and coherent. This emphasizes that it is the changes in form as planes meet, overlap, and change direction that are most important and that the figure remains intact without defining the entire contour (Figure 2-61).

The next step in the process involves analyzing and drawing the immediate background or environment in which the figure is located, using the same straight-line construction process that you used in drawing the figure.

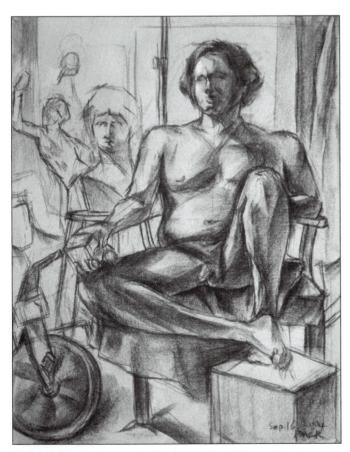

Figure 2-59. Student work. Chul-yeon Park. Through both line and value, this composition explores the figure and the environment in which the figure is located.

Figure 2-60. Student work. Jacquelin Dyer DeNio. Straight-line construction utilizes a series of straight lines to interpret and emphasize the directional shifts and changes found in the contours of the body.

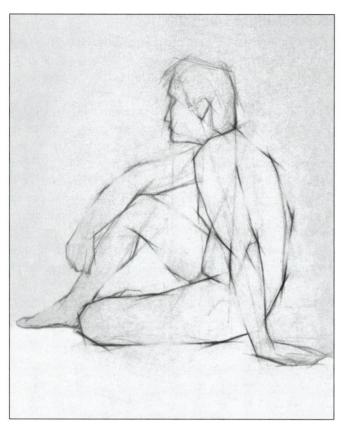

Figure 2-61. Student work. Jacquelin Dyer DeNio. Removing some of the straight lines to emphasize points of overlap or intersection yields a drawing of the figure that retains clarity and coherence.

Forms in the immediate background will provide the same instances of overlapping and intersection that you find in the figure. In your drawing you will want to emphasize points of intersection with particular concern for clarifying the spatial sequence (which contour is closer to the viewer or which contour overlaps another contour). This can be achieved through shifting pressure on your drawing tool, gently darkening points of intersection, emphasizing most strongly the forward contour at the point where two or more contours meet or overlap. At this point you may begin to soften some of the angularity of line to create a more natural contour in the figure and other organic forms (Figure 2-62).

Creating Visual Paths of Movement

Not all instances of intersection or overlap need to be equally emphasized, as you will be using these points of emphasis

Figure 2-62. Student work. John Hale. In this example of linear mapping, points of intersection are emphasized, creating visual connections between various spatial planes and establishing visual paths of movement through the composition.

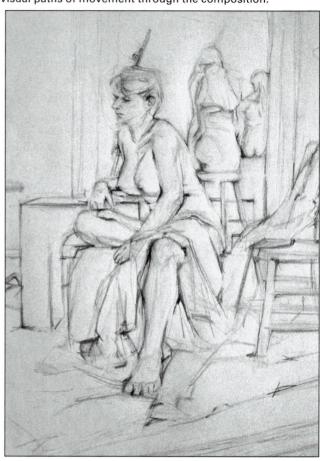

to create visual paths of movement in your composition, directing the viewer's eye through the emphasized intersections and back into space. Atmospheric perspective should also be taken into account. This means that line work in the most distant space will have less contrast than line work in the foreground space will. You will still be emphasizing points of intersection, but will do so with greater subtlety (Figure 2-63). As you include more information about the surrounding space, your composition will gradually increase in complexity. As your attention moves farther away from the primary form of the figure, additional forms will be discovered in terms of where their contours meet or overlap other contours. In essence, you will be observing the interconnectedness of all forms and shapes in the space of your composition, both figurative and nonfigurative, both positive and negative space.

This exercise can be extended to incorporate tonal structure in addition to line work. The same concerns apply in

Figure 2-63. Student work. Amy Dyjak. Atmospheric perspective is considered in this investigation of linear mapping. Forms in the background are drawn with less tonal contrast, and points of intersection are emphasized with greater subtlety.

Figure 2-64. Student work. Abbey Bradley. This drawing shows linear mapping of the figure in an environment with the incorporation of tonal structure. Points of intersection continue to be emphasized through line, but are less visually evident with the addition of value. Stronger tonal contrast is utilized in the foreground, and tonal contrast is reduced in describing forms in the background.

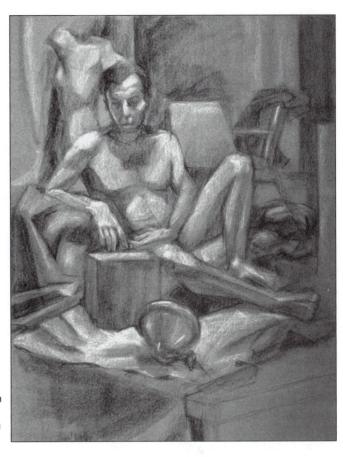

terms of emphasizing changes in space, with strong tonal contrast and harder edges indicating greater shifts in space, and subtle tonal contrast and softer edges indicating minor shifts in space (Figure 2-64).

The Figure and Anatomy

Artistic Anatomy Versus Medical Anatomy

The human form is a complex form, whether you are studying it from an artistic perspective or from a medical or physiological perspective. It is important to distinguish the study of anatomy as it relates to the artist from the study of anatomy as it relates to other disciplines. Artistic anatomy, as it has come to be known, concerns itself primarily with the substructure of the human form as it influences surface appearance. With the exception of those

who are pursuing an interest in medical illustration, the typical emphasis of artistic anatomy falls upon the skeletal structure and the muscle structure and their relationship to each other and to the visible surface of the fleshed figure (Figure 2-65).

In your initial experiences of drawing directly from the human form, you will be focused on what you see along the contours and on the surface of the figure. As anyone who has drawn the figure knows, there are an enormous number of dips and curves, bumps and knobs, projections and indentations encountered along the way, and sensitivity to these is vital for a convincing study of the figure. Some of this surface activity is remarkably subtle while some is rather abrupt, seeming nearly disruptive at times (Figure 2-66). If you are a beginning student, there is no need to complicate matters by trying to fully understand the anatomical explanation for every hill and valley. But it is advisable to ease into an awareness of the source of this visual information as early as possible in your figure drawing experience.

An understanding of artistic anatomy takes some of the mystery out of drawing the figure and helps to prevent the displacement of surface landmarks and other key information (Figure 2-67). If you understand the anatomical source of a gently bulging area of muscle in the forearm, or a bony projection of the skeleton in the pelvic region, it encourages not only attention to that particular information but also correct placement of that information in relation to the larger form (Figure 2-68). There is also an element of satisfaction with having an increased awareness and understanding of your own body. As often as possible when studying the skeletal structure or the muscle structure, try to identify the location of significant forms on your own body in addition to observing the presence of anatomical landmarks on the model.

Anatomy Reveals Itself

Depending upon where you are pursuing your art education, there may not be any significant exposure to or study of anatomy. But this is something that you can pursue independently if it is not integral to your course work. You may begin by studying the skeleton, for example, as an isolated entity. It is an interesting and complex form in and of itself, and it provides a rich and challenging drawing experience. But the greatest value in studying the skeleton lies in understanding its relationship to the living, breathing human form and in understanding its influence on the appearance of the figure both in its entirety and in specific areas where skeletal structure rises to the surface and makes itself evident (Figure 2-69). This requires more in-depth awareness than

Figure 2-65. Student work (after Edgar Degas). Sean Hemak. Based on a drawing by Degas, this highly imaginative study of the skeletal structure's relationship to the exterior surface of the body indicates a solid understanding of the influence of bony masses and bony landmarks on the surface appearance of the figure.

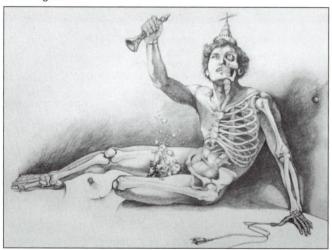

Figure 2-66. Student work (after the sculpture *Laocoon* attributed to Hagesandros, Athenodoros, and Polydoros of Rhodes). James P. Miller II. This anatomical study, based on *Laocoon*, explores the underlying skeletal structure and the surface evidence of muscle structure as seen in the struggling figure's right leg and arm.

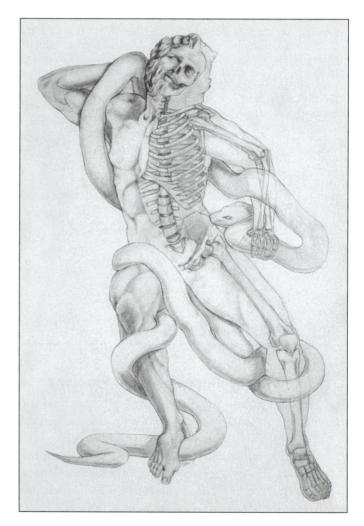

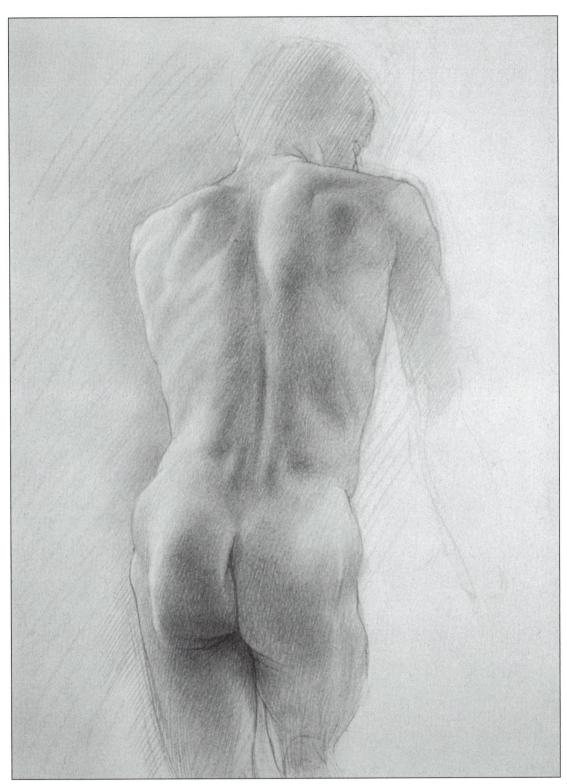

Figure 2-67. Martha Mayer Erlebacher, American, *Male Back*, 1980. Graphite on paper, 11^7 /s \times 8^7 /s inches. Arkansas Arts Center Foundation Collection. Purchased with Gallery Contributions. 1982.031.001. Erlebacher's command of media and subject reveals the complex and subtle interaction of superficial muscles and bony landmarks as they ripple across the surface of the male figure's torso.

Figure 2-68. Student work. Phil Scally. Working from a flayed figure helps to increase understanding of the muscle structure that lies beneath the surface of the fleshed figure. This drawing focuses primarily on the muscles of the arm and the shoulder.

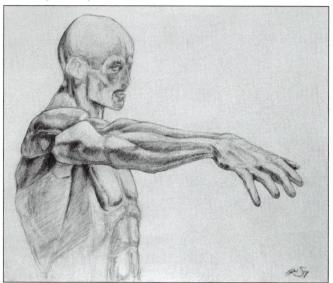

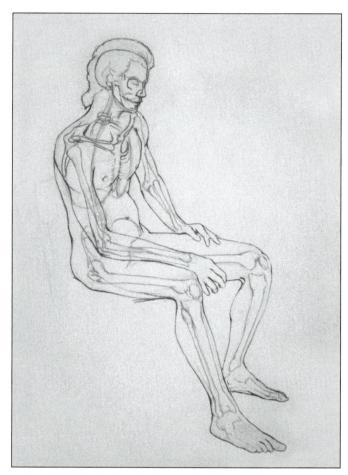

Figure 2-69. Student work. Dennis M. O'Rourke II. A seated model in the classroom provides an excellent challenge for the student of figure drawing to accurately construct the skeletal structure within the body.

simply being able to identify and name the major bones of the body.

The locations on the body where the skeletal structure consistently reveals itself, regardless of gender, age, weight distribution, or other variables, are commonly referred to as "bony landmarks." Bony landmarks are particularly helpful in identifying the placement or location of skeletal structure within the mass of the body (Figure 2-70). They are usually a specific part of a larger bone or bony mass, are often located along the edge or the end of an individual bone, and warrant specific study as an elaboration of general skeletal structure.

The same philosophy applies to the study of the musculature. Initially, it is valuable to be able to identify the major

superficial muscle masses, but it is also important to understand to some degree the relationship of the muscles to the skeletal structure and to various movements and positions of the body (Figure 2-71). Because of the relative complexity of the muscles and their dependence on the skeletal structure, it is wise to reserve an in-depth study of muscle structure until after you have come to understand skeletal structure.

In the case of both skeletal structure and muscle structure, there are a variety of ways to study them through sketching and more developed drawing. You can draw isolated parts of the skeleton and/or the muscle structure, and then investigate these isolated parts in relation to the fleshed figure (Figures 2-72–2-76). You can also draw the entire skeleton or

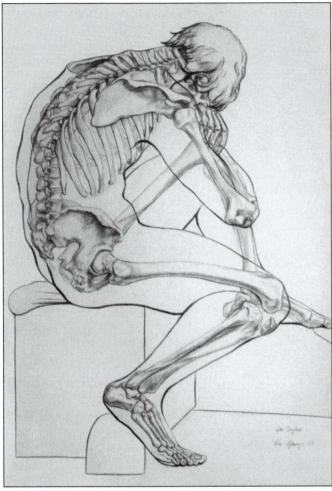

Figure 2-70. Student work (after Julius Schnorr von Carolsfeld). Kerre Nykamp. In this student study derived from a master's drawing, an understanding of the location of bony landmarks in the body provides important clues in imaginatively constructing the skeleton within the body.

Figure 2-71. Student work. Jason Roda. This sketchbook study of the torso of a crucified figure reveals an awareness of musculature and other anatomical landmarks in relation to the specific pose. Some of the anatomical forms studied include the sternomastoid muscles, the deltoid muscles, the biceps, the pectoralis muscles, the flank pad of the external obliques, and the thoracic arch.

Figure 2-72. Student work. A study exploring the impact of skeletal and muscle structure on the surface appearance of the arm and shoulder area.

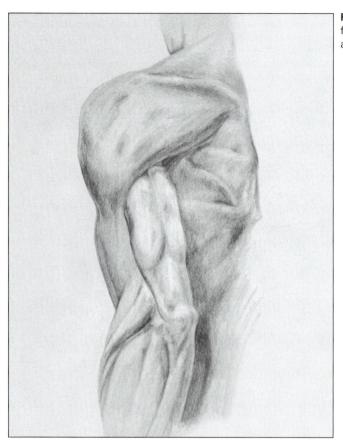

Figure 2-73. Student work. Jamie Hossink. A study drawn from a flayed figure explores the muscles of the upper arm, the shoulder, and the upper back.

Figure 2-74. Student work (detail). A graphic study of the muscles of the arm combines the appearance of both the muscles and muscle fiber with the surface of the fleshed figure.

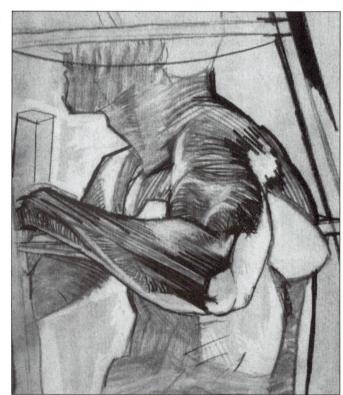

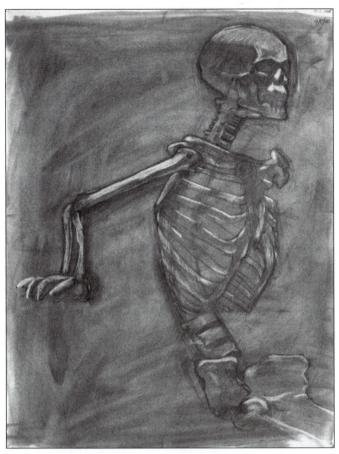

Figure 2-75. Student work. David Conn. A subtractive study (in progress) of the skull, the rib cage, the pelvis, and the right arm.

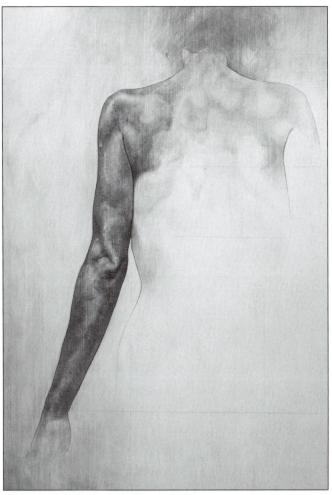

Figure 2-76. Scott Van Der Velde, American, *Lot's Daughter* (study in progress), 2007. Graphite and oil on canvas, $48^{1/4} \times 34^{3/4}$ inches. Courtesy of the artist. Van Der Velde's in-progress drawing methodically investigates the external appearance of the back of the arm, the shoulder area, and the upper back. As evidenced in the upper back, the early stages of his drawing begin with delicate veils of graphite that are built up gradually into a rich and full range of values.

the entire surface musculature (Figures 2-77–2-80), and then investigate them in their entirety as they relate to the fleshed figure (Figures 2-81 and 2-82). While in-depth anatomy books can provide some good visual resources, ideally you want to be able to refer to a fully articulated life-size skeleton and a

life-size flayed figure, which is a sculpted form that depicts the muscle structure of the body as it would appear if the skin was stripped away. If you do not have access to these, smaller versions of both skeletons and flayed figures can be purchased through a variety of biological supply companies.

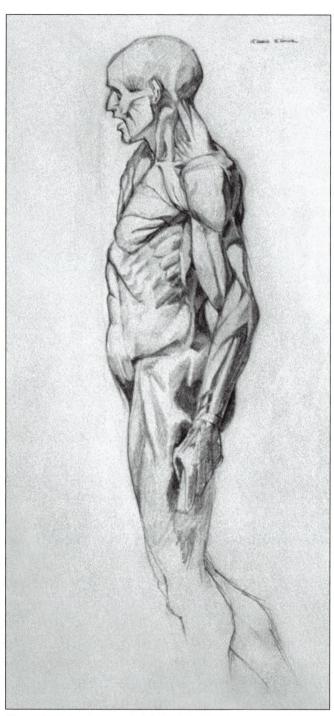

Figure 2-77. Student work. Michael Griffin. A drawing of a profile view of a full-size flayed figure.

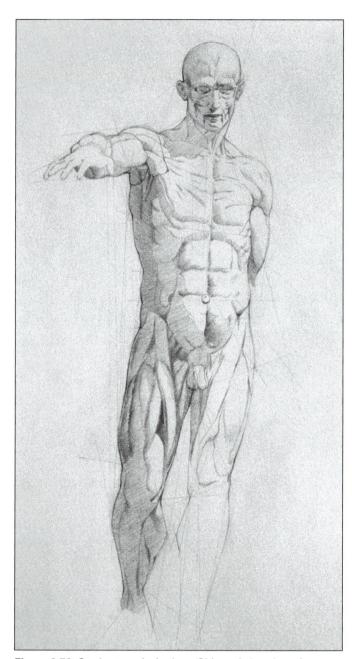

Figure 2-78. Student work. Andrew Shirey. A drawing of a frontal view of a full-size flayed figure.

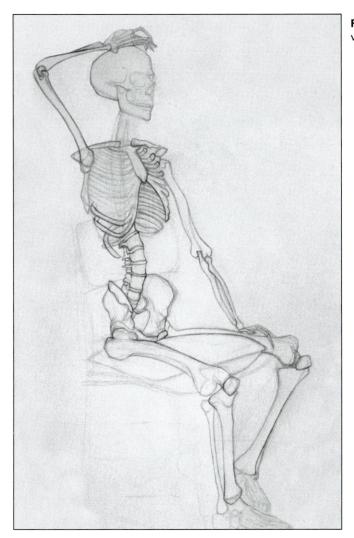

Figure 2-79. Student work. A drawing of a three-quarter frontal view of a full-size human skeleton.

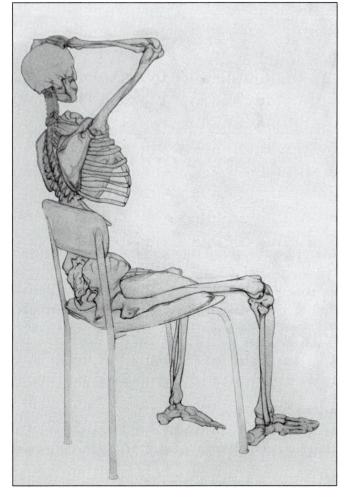

Figure 2-80. Student work. Dennis M. O'Rourke II. A drawing of a three-quarter back view of a full-size human skeleton.

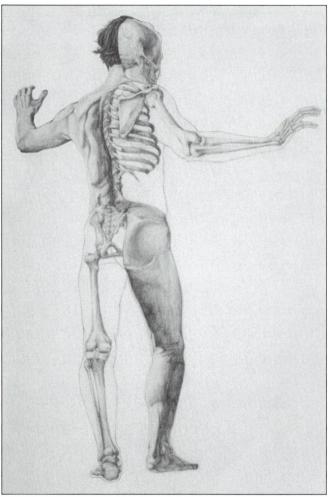

Figure 2-81. Student work (after James Valerio). A drawing of a back view of the skeletal structure as it relates to the fully fleshed figure.

Major Bones of the Human Skeletal Structure

Following is a list of bones that influence to varying degrees the external appearance of the human figure. While this is a fairly comprehensive list of all the bones in the human body, it does not include a specific breakdown of some groupings of smaller bones, but rather identifies them by the name given to the collection of bones that creates a larger mass. For example, the grouping of eight small bones found in the region of the wrist is simply identified as the carpal bones, and the grouping of seven bones found in the region of the ankle is identified as the tarsal bones. For some bones, the commonly used lay term is provided in parentheses. A number following the name of the bone indicates bones that are found in groupings of more than two.

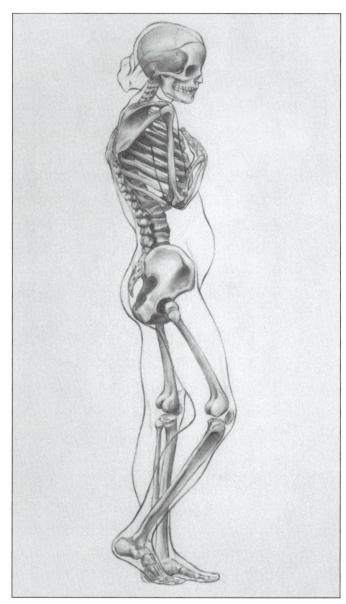

Figure 2-82. Student work (after Edgar Degas). John Elsholz, A drawing of a profile view of the skeletal structure as it would appear in the fully fleshed figure.

A breakdown is provided for a number of bones that identifies specific parts of the bone, such as the sternal and acromial end of the clavicle. These are significant in that they are bony landmarks, and you will find them cross-referenced under the heading of *Bony and Other Landmarks in the Figure*, along with a more comprehensive list of other significant bony landmarks. The number that precedes each bone or bony landmark identifies its location in the illustrations provided of the full skeletal structure (Figures 2–83 and 2–84).

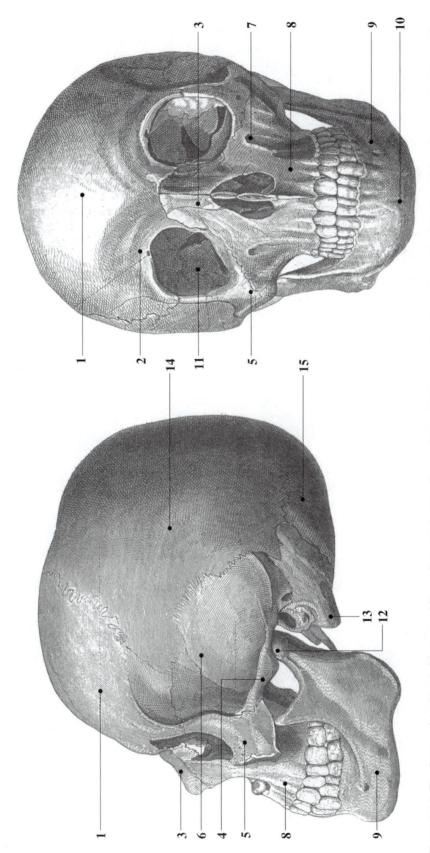

Figure 2-83. The Bones of the Head. Courtesy of Dover Pictorial Archive Series, Dover Publications, Inc. A profile and frontal view of the human skull with specific bones and bony landmarks identified.

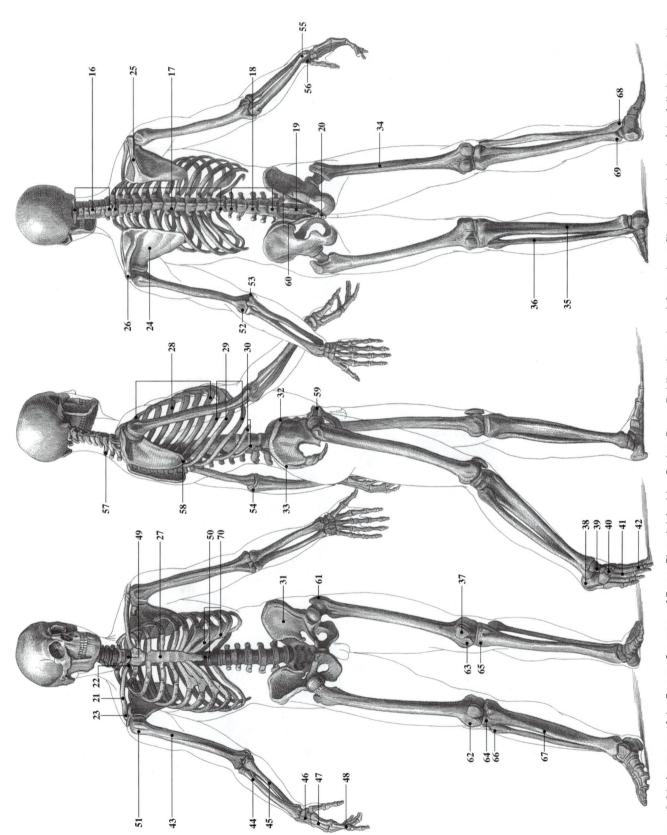

Figure 2-84. Anatomy of the Bones. Courtesy of Dover Pictorial Archive Series, Dover Publications, Inc. A frontal, profile, and back view of the full skeleton with specific bones and bony landmarks identified.

Skull/Cranium

- 1. Frontal bone
- 2. Superciliary ridge (brow bone)
- 3. Nasal bone
- 4. Zygomatic arch
- 5. Zygomatic bone (cheek bone)
- 6. Temporal bone
- 7. Canine fossa
- 8. Maxilla
- 9. Mandible (jaw bone)
- 10. Mental protuberance
- 11. Orbit (eye socket)
- 12. Styloid process
- 13. Mastoid process
- 14. Parietal bone
- 15. Occipital bone

Torso

Vertebral column (spinal column)-26 total:

- 16. Cervical vertebrae-7
- 17. Thoracic vertebrae-12
- 18. Lumbar vertebrae-5
- 19. Sacrum
- 20. Coccyx (tail bone)
- 21. Clavicle (collar bone)
 - 22. Sternal end
 - 23. Acromial end
- 24. Scapula (shoulder blade)
 - 25. Spine of scapula
 - 26. Acromion of scapula
- 27. Sternum (breast bone)

Ribs-12 pairs, 24 total

- 28. True ribs-7 pairs
- 29. False ribs-3 pairs
- 30. Floating ribs-2 pairs
- 31. Pelvis (hip bone)
 - 32. Anterior superior iliac spine
 - 33. Posterior superior iliac spine

Leg and Foot

- 34. Femur
- 35. Tibia (shin bone)
- 36. Fibula
- 37. Patella (knee cap)
- 38. Calcaneus (heel bone)
- 39. Talus
- 40. Tarsals-7 total, including calcaneus and talus
- 41. Metatarsals-5
- 42. Phalanges-14

Arm and Hand

- 43. Humerus
- 44. Radius
- 45. Ulna
- 46. Carpals-8
- 47. Metacarpals-5
- 48. Phalanges-14

Bony and Other Landmarks in the Figure

- 27. Sternum (breast bone/cross-referenced)
- 49. Suprasternal notch
- 50. Infrasternal notch
- 22. Sternal end of clavicle (cross-referenced)
- 23. Acromial end of clavicle (cross-referenced)
- 51. Head of humerus
- 52. Lateral epicondyle
- 53. Medial epicondyle
- 54. Olecranon process (elbow)
- 55. Styloid process of ulna (wrist bone)
- 56. Styloid process of radius
- 57. Spine of 7th cervical vertebra
- 25. Spine of scapula (cross-referenced)
- 58. Inferior angle of scapula
- 32. Anterior superior iliac spine (cross-referenced)
- 33. Posterior superior iliac spine (cross-referenced)
- 59. Pubic arch
- 60. Sacral triangle
- 61. Great trochanter
- 62/63. Lateral and medial condyle of femur
- 64/65. Lateral and medial condyle of tibia
- 66. Head of fibula
- 37. Patella (knee cap/cross-referenced)
- 67. Tibial shaft (shin bone)
- 68. Lateral malleolus of fibula (ankle bone)
- 69. Medial malleolus of tibia (ankle bone)
- 70. Thoracic arch or border

Superficial Muscles of the Human Figure

Following is a list of significant superficial muscles that influence to varying degrees the external appearance of the human figure. There is considerable complexity in the musculature of the human body, but it is not necessary to overwhelm yourself by delving into muscle structure to the degree that would be expected of a medical student. The emphasis here is generally on the outermost layer of muscles that most often affect how the figure appears in a variety of

positions and activities. Muscles create movement by contracting, which causes them to shorten in length. Because muscles attach to bone via tendons, overlaying muscle hides much of the skeletal structure of the body.

The muscles listed here are grouped according to the area of the body in which they are located, although some muscles (such as the deltoid) are listed twice if their location is associated with two different parts of the body (both the upper arm and the torso). In those instances when the muscle presents itself as more than one significant mass, it is broken down into its component parts (such as the clavicular head and the sternal head of the sternomastoid muscle).

When a number of smaller muscles are perceived visually as a single unit or mass, they are listed first as a grouping and then a breakdown is provided. Some examples of this include the grouping of muscles in the lower arm known collectively as the extensor muscles or the grouping of muscles in the upper inner thigh area known collectively as the adductor muscles. You may choose to study these either as a group or as individual muscles of the group or as both. Some muscles, such as the medial head of the triceps, are rarely visible in the fleshed figure and consequently bear little influence on the surface form. These muscles, although considered superficial muscles, are not included in the listing because of their relative visual insignificance.

Occasionally an anatomical form is listed that is not actually a muscle but is a significant landmark that is related to muscle structure. Examples of this include the thyroid cartilage (commonly known as the "Adam's apple") or the ulnar crest, which is a grooved landmark in the forearm visually separating the flexor muscles from the extensor muscles. The number that precedes each muscle or muscular landmark identifies its location in the illustration provided of the full superficial muscle structure (Figure 2-85). Some key anatomical terms are included to facilitate the study of both the skeletal structure and the muscle structure.

Face and Head

- 1. Masseter: Pulls the lower jaw up; closes the mouth.
- 2. Temporalis: Pulls the lower jaw up; closes the mouth.
- 3. Frontalis: Moves the skin of the scalp.
- 4. Corrugator: Draws the eyebrows toward each other.
- 5. Orbicularis oris: Closes the mouth and purses the lips.
- 6. Orbicularis oculi: Closes the eyes.
- 7. Zygomaticus major: Pulls the corners of the mouth up.

Neck

8. Sternocleidomastoideus (sternomastoid): Contraction of both muscles on either side of the neck flexes the

- head; contraction on one side only turns the head to the opposite side.
- 9. Clavicular head of the sternomastoid: Connects with the clavicle.
- 10. Sternal head of the sternomastoid: Connects with the sternum.
- 11. Thyroid cartilage ("Adam's apple")
- 12. Trapezius (extends into torso): All three parts working together pull the scapula toward the spinal column and steady the scapula during movement of the arm.
- 13. Splenius: Extends, rotates, and flexes the head and the upper spine.
- 14. Scalenus medius: Rotates the neck to the opposite side.

Torso

- 15. Deltoid (extends into upper arm): Raises the arm to the horizontal plane.
- 12. Trapezius (extends into neck/cross-referenced): All three parts working together pull the scapula toward the spinal column and steady the scapula during movement of the arm.
- 16. Pectoralis major: Adducts the arm; lowers the raised arm.
- 17. Serratus anterior: Pulls the scapula forward; helps the trapezius to raise the arm above the horizontal plane.
- 18. External obliques: Works in cooperation with other abdominal muscles; contraction on both sides of the body bends the trunk or torso forward; contraction on one side of the body flexes and rotates the trunk or torso to the same side.
- 19. Flank pad of external obliques
- 20. Rectus abdominis: Flexes the trunk or torso forward; constricts the abdominal cavity.
- 21. Latissimus dorsi: Pulls the raised arm downward; draws the upper arm backward; rotates the arm medially.
- 22. Rhomboid: Pulls the shoulders toward each other and upward; stabilizes the scapula during movement of the arm.
- 23. Teres minor: Rotates the arm laterally.
- 24. Teres major: Rotates the arm medially.
- 25. Infraspinatus: Rotates the arm outward and backward.
- 26. Sacrospinalis (also known as erector spinae): Essentially invisible as part of the deep muscles of the back, they have a profound influence on the form or appearance of the back.
- 27. Gluteus medius: Abducts and medially rotates the thigh.

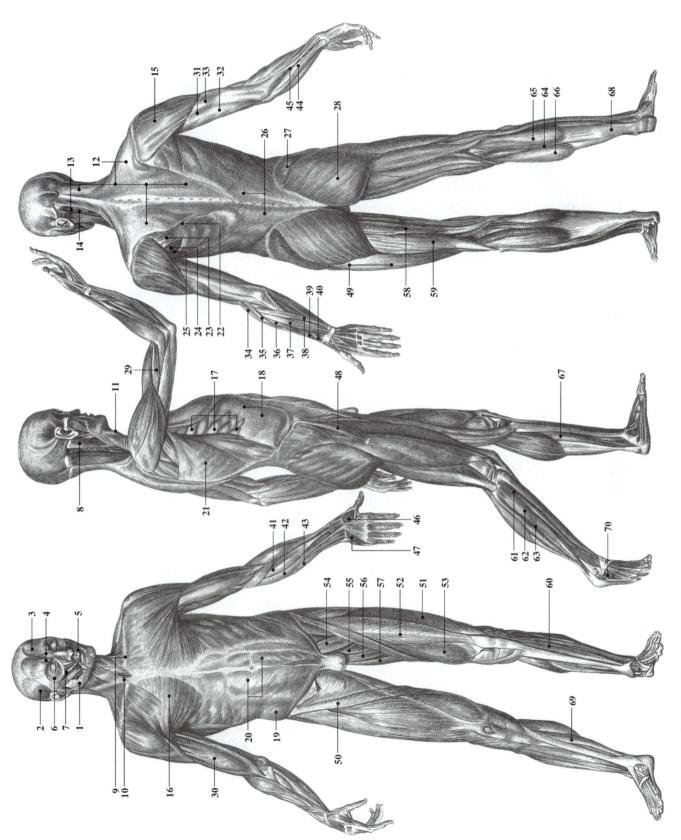

Figure 2-85. Anatomy of the Muscles. Courtesy of Dover Pictorial Archive Series, Dover Publications, Inc. A frontal, profile, and back view of the superficial layer of muscles with specific muscle masses identified.

28. Gluteus maximus (extends into leg): Extends the thigh; extends the hip joint when climbing stairs or standing from a stooped position.

Arm and Hand

- 15. Deltoid (extends into torso/cross-referenced): Raises the arm to the horizontal plane.
- 29. Brachialis: Flexes the forearm.
- 30. Biceps: Flexes the arm; supinates the pronated arm.
- 31. Triceps: Extends the forearm; adducts the arm.
 - 32. Long head of triceps
 - 33. Lateral head of triceps

Extensor muscles of the forearm are located on the lateral or outer side of the forearm with the arm dangling at rest, on the top side of the forearm with the hand in pronation. Extensors (also known as supinators) are responsible for *extending or stretching* the wrist, *opening* the hand, and *lengthening* forms.

- 34. Brachioradialis (also known as supinator longus): Flexes the elbow joint.
- 35. Extensor carpi radialis longus: Extends and abducts the hand.
- 36. Extensor carpi radialis brevis: Extends the hand.
- 37. Extensor digitorum: Extends the fingers (not the
- 38. Extensor carpi ulnaris: Extends the wrist; adducts the hand.
- 39. Abductor pollicis longus: Extends and abducts the thumb.
- 40. Extensor pollicis brevis: Extends the thumb.

Flexor muscles of the forearm (not individually identifiable on the surface of the body but rather seen as a group) are located on the medial or inner side of the forearm with the arm dangling at rest, on the underside or underbelly of the forearm with the hand in pronation. Flexors (also known as pronators) are responsible for *flexing or bending* the wrist, *closing* the hand or *grasping*, and *shortening* forms.

- 41. Flexor carpi radialis: Flexes the hand and rotates it inward.
- 42. Palmaris: Flexes the hand.
- 43. Flexor digitorum: Flexes the fingers (not the thumb) and the wrist.
- 44. Flexor carpi ulnaris: Flexes the wrist and pulls it toward the ulnar side of the forearm.
- 45. Ulnar crest: Grooved landmark on the forearm visually separating flexor muscles and extensor muscles.

- 46. Thenar: Located on the thumb side of the palm of the hand, a grouping of muscles that create a variety of movements related to the thumb.
- 47. Hypothenar: Located opposite the thumb on the palm of the hand, a grouping of muscles that create movement in the little finger and the palm of the hand.

Upper Leg

- 28. Gluteus maximus (extends into torso/cross-referenced): Extends the thigh; extends the hip joint when climbing stairs or standing from a stooped position.
- 48. Tensor fasciae latae: Raises and abducts the thigh.
- 49. Iliotibial band: Provides stability to the outer knee joint.
- 50. Sartorius: Longest muscle in the body; helps to abduct and flex the thigh; rotates the thigh laterally; flexesthe leg.

Quadriceps femoris (extensor muscles) form the muscle group on the front of the thigh with some individual definition (also called "quads").

- 51. Vastus lateralis: Extends the leg and knee joint.
- 52. Rectus femoris: Extends the leg and knee joint.
- 53. Vastus medialis: Extends the leg and knee joint.

Upper inner thigh muscles (adductor muscles) are not individually identifiable on the surface of the figure and are seen as a group.

- 54. Pectineus: Adducts and flexes the thigh.
- 55. Adductor longus: Adducts the thigh.
- 56. Adductor magnus: Adducts the thigh.
- 57. Gracilis: Flexes, medially rotates, and adducts the thigh.

Back thigh muscles (flexor muscles) are not *usually* individually identifiable on the surface of the figure and are seen as a group (also called "hamstrings").

- 58. Semitendinosus: Forms medial tendon at knee; flexes and medially rotates the leg.
- 59. Biceps femoris: Forms lateral tendon at knee; flexes and medially rotates the leg.

Lower Leg and Foot

- 60. Tibialis anterior—anterior location: extends the foot; raises the arch of the foot.
- 61. Extensor digitorum longus—lateral location: extends the four smaller toes.
- 62/63. Peroneus longus/Peroneus brevis—lateral location: Raises the lateral edge of the foot; flexes the foot; steadies the leg when standing on one foot.

- 64. Gastrocnemius—posterior location: Flexes the sole of the foot.
 - 65. Lateral head
 - 66. Medial head
- 67. Soleus-posterior location: Flexes the sole of the foot.
- 68. Achilles tendon—posterior location: Single strongest tendon in the body; transfers the power of the gastrocnemius and soleus to the foot, flexing the foot downward and enabling walking and running.
- 69. Flexor digitorum longus—medial location: Flexes the second through fifth toes; helps to flex the foot.
- 70. Extensor digitorum brevis—lateral location on foot: Extends the toes.

Anatomical Terminology

Medial: Positioned toward the center or midline of the body.

Lateral: Positioned toward the side of the body, away from the midline.

Anterior: Positioned toward the front of the body. **Posterior:** Positioned toward the back of the body.

Superior: Toward the top or a higher position; uppermost.

Inferior: Toward the bottom or a lower position; directed downward.

Extensor/extension: To straighten or lengthen a limb or a form; to unbend.

Flexor/flexion: To bend or shorten a form; to unstraighten; a forward raising of the arm or leg by a movement at the shoulder or hip joint.

Rotator/rotation: Spiraling, twisting, or pivoting motion along an axis; often originates at a ball-and-socket type of joint.

Abduction/abductor: Movement *away from* the center of the body or from an adjacent part or limb.

Adduction/adductor: Movement *toward* the center of the body or toward an adjacent part or limb.

Supination: To turn or rotate the hand or forearm so that the palm faces up or forward; to turn or rotate the foot so that the outer edge of the sole bears the body's weight.

Pronation: To turn or rotate the hand or forearm so that the palm faces down or back; to turn or rotate the foot so that the inner edge of the sole bears the body's weight.

Longus: A long structure in the body.

Brevis: A short or brief structure in the body.

Magnus: A large structure in the body.

Condyle: A rounded projection at the end of a bone where it forms a joint with another bone.

Epicondyle: A rounded projection at the end of a bone, located on or above a condyle and usually serving as a place of attachment for ligaments and tendons.

Tendon: A band of tough, nonelastic fibrous tissue that connects a muscle with its bony attachment.

Origin attachment or point of origin: Less mobile or moveable point of attachment of muscle to bone and positioned *nearer* the greater mass of the body.

Insertion attachment or point of insertion: More mobile or moveable point of attachment of muscle to bone and positioned farther from the greater mass of the body.

Isometric tension: As the muscles on one side of a limb contract, those on the other side must relax if the limb is to move. Equal tension on both sides results in no motion at all (isometric tension), with the length of the muscles remaining the same as the pull of opposing muscles neutralizes each other.

Spatial Thinking and Visualization The Essential Principles of Perspective Drawing

An Introduction to Perspective

What Is Perspective?

CHAPTER

Perspective drawing is a system for creating a two-dimensional illusion of a three-dimensional subject or three-dimensional space. Information, whether observed (empirically based) or imagined (theoretically based), is translated into a language or system that allows three-dimensional forms and space to be illusionistically represented on a two-dimensional surface.

Although Brunelleschi is credited with the discovery or creation of perspective theory during the Renaissance in Italy, it is Albrecht Dürer, a German artist, who is best known for his exploration of perspective theory, and his prints and drawings illustrate this theory.

Different Types of Perspective

Perspective theory is often separated into two partstechnical or mechanical perspective (Figure 3-1), which is based on systems and geometry and is the primary focus of this chapter, and **freehand perspective** (Figure 3-2), which is based on perception and observation of forms in space and is a more intuitive exploration of perspective theory. Freehand perspective relies to a significant degree on the process of sighting to judge the rate of convergence, depth, angle, and so on.

Technical or mechanical perspective utilizes drafting tools such as T-squares, compasses, and triangles, while freehand perspective generally explores perspective principles without the use of technical tools. While it is useful to study perspective in its most precise form with the aid of drafting tools and a simple straight-edge, it is also useful to explore these same principles in a purely freehand fashion, which allows for a more relaxed application of perspective principles.

In studying perspective, it also becomes important to make a distinction between linear perspective and atmospheric perspective. **Linear perspective** addresses how the shapes, edges, and sizes of objects change in appearance

Figure 3-1. Nate Heuer, American, *Bath* (detail), 2006. Graphite on paper, 30×44 inches. Courtesy of the artist. This two-point perspective drawing, done from imagination, explores a wide variety of technical perspective processes, including two-point cube construction, cube multiplication, inclined planes, measuring lines, and more.

Figure 3-2. Student work. Laura Gajewski. The rural setting represented in this drawing provides a great visual resource for freehand investigation of one- and two-point perspective as well as atmospheric perspective.

when seen at different positions relative to the observer—off to one side or the other of the observer, directly in front of the observer, close to the observer, far from the observer, above the observer, below the observer, and any number of infinite variations (Figure 3-3). **Atmospheric perspective** describes other characteristics seen in objects that are some distance from the observer. A veil of atmospheric haze

Figure 3-3. Student work. Aaron Rossell. This gridded drawing explores nine different views of an interior space. Although the perspective is accurate, each drawing relies on a tilted horizon line, creating a sense of disorientation.

affects and decreases clarity, contrast, detail, color, and so on. Atmospheric perspective, which is not mathematically or geometrically based, is a powerful compliment to linear perspective, and when used together the illusion of three-dimensionality and space can be powerful (Figure 3-4).

This chapter focuses primarily on linear and technical perspective and their emphasis on changes in apparent size as a foundation for understanding and exploring freehand perspective. Understanding perspective is critical in developing the skill of visualization, which is the process of constructing an illusionistic image of a subject that cannot be or is not drawn by direct observation (Figure 3-5). It is based on theoretical circumstances, allowing one to construct a form based on imagination, without the support of direct observation.

Basic Principles of Linear Perspective

There are a number of different methods for drawing in perspective, which becomes readily apparent in paging through the wide range of books that address the subject. All of the methods, however, assume some shared principles:

- A perspective drawing creates the illusion of reality by relating the observer or viewer, the picture plane, and the object or objects being drawn.
- The observer or viewer is in a fixed position and sees with one eye, like a camera. The position of the viewer, or the viewer's eye, is called the station point.

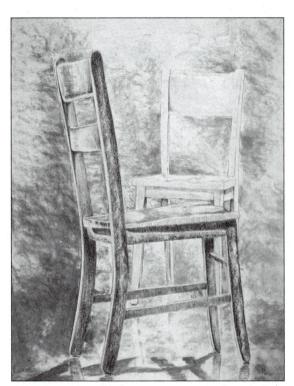

Figure 3-4. Student work, Minnesota State University—Moorhead. Steve Nowatzki. Two-point perspective and atmospheric perspective combine to emphasize dimension and space in this drawing of two chairs that seem to be in conversation with each other. Notice that the more distant chair is depicted with much less detail and tonal contrast than the chair in the foreground is.

- The surface on which the drawing is made is called the picture plane and is assumed to be an imaginary plane placed between the observer or viewer and the object(s) observed. It is perpendicular to the observer's line of sight.
- The horizon is assumed to be at an infinite distance from the observer, so that parallel lines meet or converge at the horizon and objects on the horizon appear to be points. These points of convergence are called vanishing points.
- Objects drawn in perspective are reduced to lines, representing edges and planes. These are then observed for degrees of diminution (how the lines and planes diminish as they recede in space).
- The cube is the most basic form in perspective, having uniform height, width, and depth, and it is used as a perspective unit to measure height, width, and depth concurrently. In theory, the perspective cube can be multiplied and divided into any combination of height, width, and depth to provide an underlying structure for drawing any object.

Perspective and Sighting

It is interesting to note the relationship between perspective principle and theory and the practice of sighting, which is discussed in depth in Chapter One. While the strict application of perspective can result in a convincingly illusionistic depiction of three-dimensional forms in space, the careful application of sighting techniques can result in an equally convincing depiction (Figure 3-6). Sighting techniques generally have more relevance than technical perspective when dealing with forms that are less apparent in their relationship to geometric solids, such as the human figure. Technical perspective is more applicable when dealing with forms whose relationship to geometric solids is more apparent—buildings, architectural structures, furniture, and other forms that are obvious variations on a basic cubic structure.

There are some clear parallels between perspective methods and sighting methods, with perspective methods based on a more technical approach, and sighting methods based on a more freehand approach. Devices that aid in checking the relative size and position of the parts of a subject or multiple subjects help tie together what the artist sees (visual perspective) with the theories of linear or technical perspective.

- The concept of diminution and scaling methods in linear or technical perspective are roughly equivalent to sighting techniques for determining relative proportions (visual perspective).
- The location of vanishing points along the horizon line and degrees of foreshortening and convergence in linear or technical perspective are roughly equivalent to the process of sighting for angles in relation to the fixed elements of verticals and horizontals (visual perspective).

Limitations of Linear Perspective

Although the principles of perspective are based on precise geometric and mathematical systems, perspective is a system with limitations. It is important to recognize these limitations when exploring perspective:

- A fixed viewing position or fixed position of the head is implied in perspective, even though in actuality, we typically move our viewing position and/or our head in any number of directions when observing the world around us.
- The application of perspective principles yields an image that is based on monocular rather than binocular vision. Monocular vision means that we are observing the world through one eye only, while binocular vision means that we are observing the world through two eyes simultaneously.

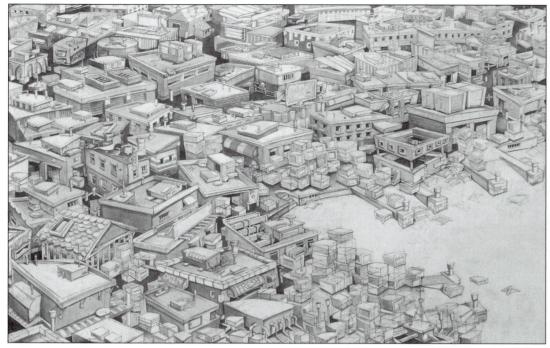

Figure 3-5. Kiel Johnson, American, Ship Up or Shape Out, 2006. Graphite and ink on paper, 76 x 48 inches. Courtesy of Hyperbolestudios.com. This highly inventive drawing depicts an absurdly dense and crowded waterfront area with security cameras keeping careful watch. Although the image suggests a flurry of activity, a human being is not to be found anywhere. Johnson's strong understanding of perspective allows him to create this scenario purely from imagination and to take liberties with expressive distortions of perspective principles.

- There are boundaries or limitations of the picture plane in perspective that are not a part of actual observation of the world around us. One example is the cone of vision. When approaching these boundaries in a perspective drawing, distortions will begin to occur in the resulting drawing. But in actual observation, we are able to make perceptual adjustments that correct these distortions.
- In perspective drawings, the horizon line is idealized in that it is always parallel to the ground line or ground plane, which we know is not always the case in the real world
- There are some distortions that occur in the application of perspective principles that do not coincide with the real world. For example, using strict perspective techniques in a drawing for duplicating a precise cube as it recedes spatially will eventually result in a cubelike form that no longer describes a precise cube. The degree of error increases as the duplicate cubes move farther away from the original cube upon which the duplication is based.

Being aware of some of the limitations from the onset allows you, as a student of perspective, to make adjustments at your discretion. Even with the limitations of the system, an understanding of perspective and its most basic principles is vital to spatial thinking and the ability to visualize spatially. Experience suggests that, without an understanding of perspective, this ability to think and visualize spatially is one of the most difficult things for a student of drawing to accomplish successfully.

Recommended Sequencing for Maximum Comprehension

In understanding perspective processes and their applications, each new technique or concept introduced typically builds upon techniques and concepts already presented. A broad and working knowledge of perspective requires comprehension of one skill before moving on to the next skill. For example, if you do not understand cube multiplication processes, you will not be able to explore with success the process of transparent construction. If you do not understand ellipse construction, you will be unable to effectively represent various geometric solids. If you do not understand the scaling process, you will be unable to explore multiple forms in their correct size relationship to each other.

To facilitate ease of comprehension, the following list is given as suggested sequencing for studying perspective processes and concepts. Although some argument can be made for variations in the sequencing, experience suggests that studying information in this particular order will facilitate more effective comprehension.

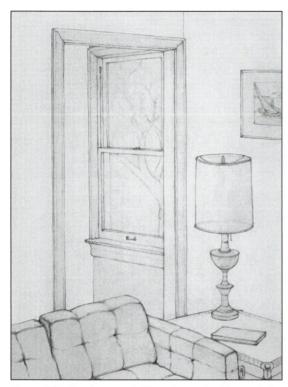

Figure 3-6. Student work. Scott Luce. In this study for a homework assignment, students were instructed to draw a two-point perspective view of their living environment using only sighting to discover angles, rates of convergence, and proportional relationships.

- What is perspective?
- · Review of materials list
- Perspective vocabulary and definitions
- One-point cube construction
- Two-point cube construction (estimation of depth)
- Estimating cube depth in two-point perspective
- One-point gridded ground plane
- Two-point gridded ground plane using measuring line, "fencepost," and converging diagonals method
- Scaling methods for cube-based forms (see Chapter One)
- Multiple and sliding sets of vanishing points
- Cube multiplication using the "fencepost" method and the measuring line method
- Cube division using the "X"ing method and the measuring line method
- Precise 30°/60° cube construction
- Precise 45°/45° cube construction (center and off-center)
- Alternatives for constructing a 45°/45° cube
- 30°/60° gridded ground plane
- 45°/45° gridded ground plane
- Ellipse construction in relation to cubes

- Measuring lines for regular (equal) and irregular (unequal) cube division
- Inclined planes, including stairways, rooftops, and box flaps
- · Geometric solids derived from cubes and ellipses
- Transparent construction based on geometric solids
- Three-point perspective made simple

Suggestions for Effective Perspective Drawing

Before beginning initial exercises in perspective drawing, it is wise to consider some suggestions that are broadly applicable to all perspective drawings and are intended to facilitate the *making* as well as the *reading* of a perspective drawing.

Determining the Variable Elements of Perspective Drawing

On each drawing a key should be provided that indicates information that remains fixed or constant in that particular drawing and provides a means of checking the accuracy of the drawing (Figure 3-7). Three elements must be indicated in the key—scale, eye level, and station point—with a fourth optional element, the size of the key cube or "mother cube," which should accurately reflect the scale used in the drawing. All four of these elements are variables to be determined by the artist at the onset of a drawing. Once these variables are determined, which in turn establishes the perspective environment, they must remain constant for that particular drawing. In the following review of these elements, we will elaborate on definitions given in the section on perspective terminology.

Regarding **scale**, if you are drawing on a standard piece of $18" \times 24"$ paper, and you wish to explore forms that relate to human scale, then a scale of 1" = 1' is quite convenient. If, however, you wish to explore forms that are well beyond human scale, such as large buildings or skyscrapers or airplanes or space stations, your scale must reflect this. In this case, 1 inch could equal 10 feet or more. Scale is a variable determined by you.

Regarding **eye level (EL)**, if you wish to explore a worm'seye view or a relatively low eye level, then place your eyelevel line closer to the bottom of the page to accommodate this viewpoint. If you wish to explore a bird's-eye view or a relatively high eye level, then place your eye-level line closer to the top of the page to accommodate this viewpoint. You may even choose to place your eye-level line beyond the confines of the drawing surface.

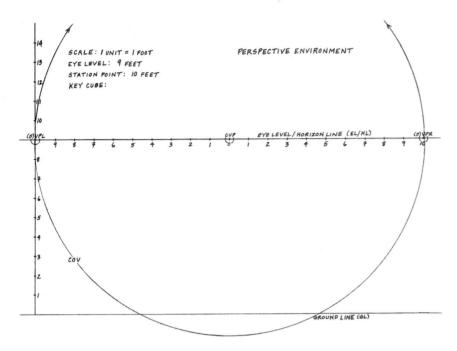

Figure 3-7. A perspective environment shown here is ready to receive a perspective drawing. Included are scale, vanishing points (indicating station point), eye level or horizon line, ground line, cone of vision, and units of measure established vertically and horizontally.

Establishing the height of the eye-level line in your drawing requires that you place your **ground line (GL)** appropriately. The ground line represents or symbolizes the intersection of the picture plane and the ground plane. If, for example, you wish to work with an eye level of 6 feet in your drawing, and you have determined a scale of 1'' = 1', then place your ground line 6 inches below the eye-level line to effectively establish the height of the eye level.

Station point (SP) indicates how close to or far from the *picture plane* the viewer is positioned. This is important information because the proximity of the viewer to the picture plane determines, in part, how forms will appear. Like the other three elements, the station point cannot be moved or adjusted during the construction of a drawing.

Assuming that a cube's position does not change and its relationship to the picture plane does not change, how that cube appears in a perspective drawing is different if the viewer is very near to the picture plane than if the viewer is farther away from the picture plane. For example, imagine a cube resting on the ground plane. With the viewer positioned near the picture plane, more of the top face of the cube is visible than if the viewer is positioned farther from the picture plane (Figure 3-8).

The station point, in one-point perspective, is indicated by the distance between the **central vanishing point (CVP)**

Figure 3-8. This photograph illustrates how the same cube viewed from the same eye level can appear very different based on the position of the vanishing points, which indicates the distance of the viewer from the picture plane. The top image shows the cube viewed from a position closest to the picture plane, while the middle and bottom image show the cube viewed from farther away.

and **special vanishing point (SVP) left or right.** For example, with a scale of 1'' = 1' and a desire to place the viewer 6 feet from the picture plane, you place an SVP 6 inches to the left and 6 inches to the right of the CVP. The SVP then acts as a guide in determining the depth of a true cube in one-point perspective when seen from a position 6 feet away from the picture plane.

The station point, in two-point perspective, is indicated by the distance between **vanishing point left (VPL)** and **vanishing point right (VPR)**. *Half* of that total distance, in relation to the established scale, indicates the station point. For example, with a scale of 1" = 1' and a distance of 18 inches between VPL and VPR, *half* of that distance (9 inches) establishes a station point of 9 feet. This tells us that for this particular drawing, the viewer is positioned 9 feet away from the picture plane. If you wish to place the viewer closer to or farther from the picture plane, simply move the VPL and VPR closer together or farther apart accordingly.

The **key cube**, or "**mother cube**" as it is sometimes called, is an optional element that may be included in a drawing as a reference point. It reflects the scale indicated in the key of the drawing, and for this reason the key cube should always be drawn with the leading edge or leading face in the nearest

foreground, resting on the ground line. In this way we know that the key cube is in contact with the picture plane, positioned as far forward as possible, and that its leading edge or face is a measurable reflection of scale.

Before advancing to a more in-depth study of perspective, it is vital that you have a clear understanding of these elements and the role they play in determining the character of a particular perspective drawing. Without a clear understanding, it is difficult or impossible to progress to the study of more complex processes of perspective drawing.

Keeping Things Simple

In your beginning investigations of perspective, it is advisable to consider working initially with a standardized format. While it is important that you understand the significance of scale, eye level, and station point and the steps for establishing these variables, it is beneficial at first to standardize them when checking for accuracy or errors. As understanding increases, the opportunity to work with different scales, eye levels, and station points reinforces comprehension and clearly illustrates the impact they have on end results. However, if extreme scales, eye levels, and station points are attempted prematurely, confusion and error usually result.

In the study of technical linear perspective, a degree of accuracy and precision is required. Verticals must be vertical, horizontals must be horizontal, lines of convergence must meet at a shared point, and so on. There are ways to ensure a greater degree of accuracy as a beginner, particularly if you are attempting to explore technical perspective with a limited number of tools. Although a T-square and a triangle are recommended, there are ways to work effectively in the absence of these tools:

- Working on nonphoto-blue gridded or graph paper, which
 comes in a variety of sizes, provides visible guidelines for
 keeping horizontal and vertical lines true without visually
 interfering with lines drawn in lead or graphite.
- Keeping drawing pencils sharpened or working with a
 fine lead mechanical pencil will facilitate crisp and precise lines. Sharp pencils will also provide a higher degree
 of consistency and precision when using a ruler to draw a
 line between two points. A dull, fat lead will deposit a line
 along a straight-edge differently than a sharp lead and will
 make it more difficult to connect two points accurately.
- Using a nonskid ruler will help to ensure that a carefully placed ruler will remain in place as you pull your pencil along the length of the ruler. If a cork-backed ruler is not

- available, placing a strip of masking or drafting tape along the back of the ruler will help to prevent sliding. Make sure that the tape used is narrower than the ruler itself, so that the tape does not interfere with the true edge of the ruler.
- Construction lines are an integral part of any perspective drawing, although when a more refined drawing is desired they may be deleted from the end result. Most exploratory work will include construction lines as a way of indicating process and providing a means of checking for inaccuracies or errors in process. By decreasing the pressure on the drawing tool and using harder leads, construction lines can be kept as delicate as possible to prevent visual confusion and overload.

Perspective Materials List

30"-36" metal T-square, ruled

18" ruler (preferably metal)

Drawing pencils-4H, 2H, H, HB, B, 2B, 4B

Technical pencil, .5 mm maximum, HB drop lead (optional)

45° triangle-12" or 8"

30°/60° triangle-12" or 8"

Protractor

Pink Pearl erasers

Kneaded erasers

Roll of drafting tape-1/2", 3/4", or 1" (not masking tape)

Compass with minimum 6" span

Lead sharpener or sanding pad

Pad of gridded or graph paper, nonphoto blue, 11" × 14" or larger

18" × 24" pad of smooth white Bristol drawing paper

Drafting brush

Eraser shield

Drawing board large enough to accommodate drawing paper (commercial or homemade)

1/8" dowel stick, 12" long

Viewfinder, $2^{1/4}$ " × $2^{3/4}$ ", $2^{3/4}$ " × $3^{1/2}$ ", 2^{11} × $2^{2/3}$ ", 2^{11} × 2^{11}

Optional Items

Straight pins

Small roll of string

Roll or pad of tracing paper

Single-edge razor blades

Assorted colored pencils (Verithin by Prismacolor)

The Terminology of Perspective

It should be understood that many of these terms will not be fully comprehended without direct, hands-on experience with the concept being described. Rather than an alphabetical arrangement, they are organized roughly in the order in which they may be encountered in a progressively in-depth study of perspective principles.

Primary Working Terminology

One-point perspective (1-PT): A drawing is in one-point perspective when one "face" or plane or side of a cube or cubelike form is parallel to the picture plane, facing the observer directly. The left and right sides and the top and the bottom of the cube all converge on a single vanishing point located on the horizon line or eye level. In other words, all edges that are *perpendicular* to the picture plane converge on a single vanishing point. All vertical edges (*perpendicular* to the ground plane and *parallel* to the picture plane) are represented as vertical lines in your drawing, with no evidence of convergence. One-point perspective is also referred to as **parallel perspective.**

Two-point perspective (2-PT): A drawing is in two-point perspective when *no* face or plane or side of a cube or cubelike form is parallel to the picture plane, but rather all planes are at an oblique angle to the picture plane. This means that the front or leading edge of a cube is closest to the observer or to the picture plane. All vertical edges (*perpendicular* to the ground plane and *parallel* to the picture plane) are represented as vertical lines in your drawing, with no evidence of convergence. The top, bottom, and four side planes of the cube converge on two different vanishing points located on the horizon line or eye level. Two-point perspective can be combined with one-point perspective. Two-point perspective is also referred to as **oblique perspective**.

Eye level (EL): The eye level always represents the height of the viewer or observer in a perspective drawing. As the height of the artist's eye changes (the difference between sitting or standing), so does the eye level of the drawing. Eye level is synonymous with horizon line, which is the place in reality where earth and sky appear to meet. The eye level is an important reference line in every perspective drawing. The horizon may be blocked from view by tall buildings, or it can be placed beyond the limits of the page. Regardless, in every perspective drawing there exists an eye level (horizon)

that appears as a horizontal line drawn across the picture plane or across an extension of the picture plane. The placement of the eye level is a variable determined by you.

Horizon line (HL): In perspective drawing, the horizon line is synonymous with the eye level.

Scale: Scale is the size of the subject in a drawing in relation to the actual size of the subject in reality. If the scale of a drawing is 1'' = 1', then every 1 inch on the picture plane represents 1 foot in reality. Scale is a variable determined by you.

Station point (SP): The station point is either the actual or the imagined location of the observer in a perspective drawing. Based on the assumption in perspective that the artist's position and direction of sight do not change during the making of the picture, the station point cannot be moved during the construction of a drawing. The station point is a variable determined by you.

Picture plane (PP): The picture plane is an imaginary, transparent flat surface, infinite in size, on which the drawing is made. The picture plane is located between the subject being drawn and the observer. The drawing surface (paper) is synonymous with the picture plane in perspective theory, representing a portion of the infinite picture plane.

Ground plane (GP): The ground plane is the surface upon which objects rest. The most obvious example of a ground plane would be the surface of the earth or the actual ground in an exterior space or the floor of a room in an interior space.

Ground line (GL): The ground line represents the intersection of the picture plane and the ground plane. The ground line is always drawn parallel to the eye level or horizon line. The measurable distance from the ground line to the horizon line tells us what the eye level of the observer is in relation to the scale established for the drawing. If the scale is 1" equals 1', then a measurable distance of 5 inches from the ground line to the horizon line tells us that the eye level is at 5 feet.

Cone of vision (COV): The cone of vision represents a limited area that can be clearly seen at any one time by the observer and remain in focus. It can be visualized as an imaginary three-dimensional cone with the vertex of the cone positioned at the station point or the location of the observer. The cone of vision is represented by a circle that passes through vanishing points left and right in two-point perspective and special vanishing points left and right in one-point perspective. Trying to draw objects beyond or outside of the cone of vision results in pronounced distortion.

Vanishing point (VP): A vanishing point is where two or more parallel receding lines appear to converge. The vanishing points for all horizontal parallel receding lines are always located on the eye level or horizon line.

Central vanishing point (CVP): The central vanishing point is the point of convergence (meeting point) for all lines or edges perpendicular to the picture plane. A central vanishing point is used in one-point perspective and is located directly in front of the observer's station point, at the intersection of the observer's line of vision and the eye level (this intersection forms a 90° or right angle).

Special vanishing point (SVP): Special vanishing points are vanishing points that are established for measuring foreshortened lines or edges or planes and for other construction purposes. A special vanishing point is formed by the point where one or more diagonal measuring lines intersect the eye level or horizon line. There is no limit to the number of SVPs that may be found on the eye level/horizon line.

Auxiliary vanishing point (AVP): Auxiliary vanishing points are for parallel lines or edges on receding diagonal or inclined planes, such as angled box flaps or rooftops or stairways. Auxiliary vanishing points are never on the eye level, but rather are located at the appropriate position along a vertical extension of a vanishing point located on the eye level. This vertical extension is referred to as a **trace line** or **vertical trace**. AVPs are also sometimes referred to as **trace points**.

Vanishing point three (VP3): Vanishing point three is the vanishing point for receding *vertical* lines or edges or planes. This occurs only in three-point perspective, when the observer is positioned at a very low eye level, looking up (a worm's eye view), or at a very high eye level, looking down (a bird's eye view), which causes the picture plane to tilt.

Measuring line (ML): A measuring line (also called horizontal measuring line [HML]) is used for direct scale measurements in a drawing. A measuring line must be parallel to the picture plane. As an example, the ground line can be used as a measuring line. In one- and two-point perspective, vertical lines in the drawing can also be used as **vertical measuring lines (VMLs)** as they too are parallel to the picture plane.

Diagonal measuring line (DML): Diagonal measuring lines are used in one-point perspective to determine the actual depth of a true, equal sided cube and in one- and two-point perspective to determine consistent scale for cubes in relation to the key cube or "mother cube" (scaling). Diagonal measuring lines always converge at a special vanishing point (SVP) located on the eye level/horizon line.

Related Terminology

The following terms, although not specific to formal perspective theory, are vital to the understanding of perspective.

Foreshortening: Foreshortening is the apparent diminishing of the length of lines or edges or planes to create the illusion of depth. Lines or edges or planes appear progressively shorter as their angle to the picture plane increases. Therefore only lines, edges, or planes that are parallel to the picture plane show their true or actual length.

Convergence: Lines or edges that in reality are parallel to each other appear, in perspective, to come together (converge) or meet as they recede from the observer toward the horizon line. A classic example of this is railroad tracks appearing to converge at a single vanishing point on the distant horizon line.

Position or base line: The closer an object is to the viewer on the ground plane, the lower its apparent position on the drawing paper. Objects lowest on the page are considered to be closest to us and in the foreground, followed by objects in the middle ground and objects in the background. This applies to objects at or below our eye level; the relationship is simply reversed for objects above our eye level (floating).

Overlap: Overlap is a device that defines which object is forward or in front of another. Without utilizing any other aspect of perspective principles, placing one object partially in front of another generates a sense of depth and spatial order in the picture.

Diminution: Objects and forms appear to become smaller as they recede or move away from the observer.

Additional Useful Terminology

Convergence: To move toward a common point or toward one another; to come together or meet.

Perpendicular: At a right angle (90°) to a given line or plane.

Parallel: Extending in the same direction, equally distant apart and never meeting.

Diagonal: At an angle to a given line or plane.

Vertical: Moving straight up and down.

Horizontal: Moving side to side, level with the ground plane. **Plane**: A flat surface that may be level or may be tilted.

Square: A rectangle with four equal sides.

Rectangle: A four-sided plane with all right angles and with opposite sides that are equal in length.

Circle: A closed, curved plane in which every point is equal distance from a fixed point within the curve.

Ellipse: A circle whose plane is tilted; a circle seen in perspective; an oval.

Axis: A real or imaginary straight line that goes through the center of a form.

Cube: A solid object with six square sides of equal size.

Pyramid: A solid object with a square base and four equal triangular sides that slope toward each other and meet to form a point at the top.

Cylinder: A solid or hollow tube-shaped object with straight sides and two equal-size circular ends.

Cone: A form with a flat, circular base and a uniformly curved surface that narrows upward in diameter, finally narrowing to a point.

Sphere: A round, three-dimensional form, like a ball.

Vessel: A hollow utensil, such as a cup, vase, or pitcher, used as a container most often for liquids.

Right angle: An angle of 90°.

Acute angle: An angle less than 90°.

Oblique: Having a slanting or sloping direction, course, or position.

Diameter: A straight line that bisects a circle into two equal halves.

Circumference: The distance around the outermost part of a circle.

Vertex: The point where two lines meet to form an angle, or the point that is opposite the base of a shape.

Tangent point: A single point of contact along a line, touching but not intersecting.

Perspective and Cubes

As mentioned earlier, the cube is the most basic form in perspective, having uniform height, width, and depth, and it is used as a perspective unit to measure height, width, and depth concurrently. In theory, the perspective cube can be multiplied and divided into any combination of height, width, and depth to provide an underlying structure for drawing any object. Consequently, it is very important that you understand both freehand and technical construction of cubes as a foundation for further study of perspective.

Constructing a Cube in One-Point Perspective

- 1. Determine what conditions must prevail in order to use one-point perspective. One plane or face of the cube or cubelike form must be parallel to the picture plane [PP] or plane of vision (Figure 3-9).
- 2. Establish **scale** for the drawing (e.g., 1'' = 1').
- 3. Draw the **horizon line** or **eye level (HL/EL).** If you think you want a relatively high eye level, place your horizon

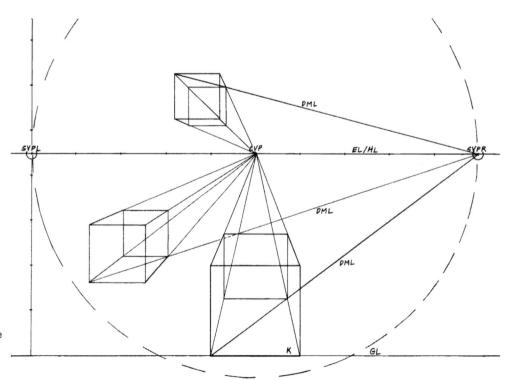

Figure 3-9. This drawing shows the process of constructing a cube in one-point perspective.

Figure 3-10. This drawing shows the results of stacking and sliding transparently drawn cubes in one-point perspective to create "elevator shafts." Note that corresponding vertical and horizontal edges of each cube remain constant, indicating that all cubes are the same size.

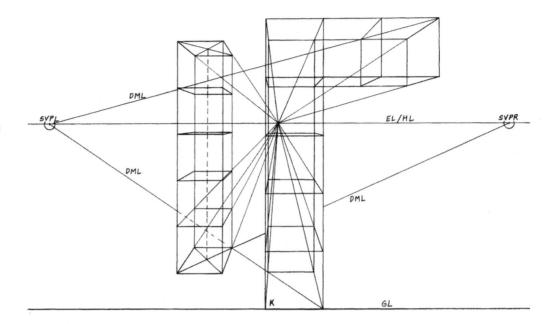

line closer to the top of the page. If you think you want a relatively low eye level, place your horizon line closer to the bottom of the page.

- Locate the central vanishing point (CVP), typically located in the middle of the horizon line in one-point perspective.
- 5. Locate **special vanishing points left** and **right (SVPL/SVPR).** The placement of the SVPL and SVPR in relation to the CVP is determined by the chosen location of the **station point (SP),** which tells us the distance of the observer from the picture plane.

For example, if your scale is 1'' = 1', and your SVPL and SVPR are each located 5 inches from the CVP, then you are establishing that the station point (the position of the observer) is 5 feet away from the picture plane.

The location of the SVPL and the SVPR is used in conjunction with a **diagonal measuring line (DML)** to determine the actual depth of a true cube in one-point perspective.

- 6. Lightly mark horizontal **units of measure** along the eye level line that correspond to the established scale.
- 7. Determine the location of the **ground line (GL)** based on a chosen height for the eye level or horizon line. Place the ground line by measuring the vertical distance from the horizon line to the ground line in relation to the established scale.

For example, with a scale of 1'' = 1' and a chosen eye level of $4^{1/2}$ feet, the ground line would be drawn $4^{1/2}$ inches below the horizon line. The ground line can be no

- farther below the horizon line than the distance between the central vanishing point and SVPL or SVPR without violating the cone of vision.
- 8. Lightly mark vertical units of measure from the ground line to the horizon line and above that correspond to the established scale. These can be used later for applying scaling techniques and are an abbreviated form of a key cube.
- 9. Determine the **cone of vision (COV)** by lightly drawing a circle whose center is at your CVP and whose circumference passes through SVPL and SVPR. The diameter of the cone of vision would equal the distance between SVPL and SVPR. The radius of the cone of vision would equal the distance from the CVP to either SVPL or SVPR. All cubes must remain within the COV.
- 10. Draw the front face of a cube (which is an exact square) on the ground line according to the desired scale. For example, with a scale of 1" = 1' and a desired 4-foot cube, the initial cube face would sit on the ground line and measure 2 inches × 2 inches. Make sure that this initial square cube face is constructed of true vertical and horizontal lines that are at right angles to each other.
- 11. Draw a **line of convergence** from each corner of the face of the cube to the central vanishing point (CVP).
- 12. Extend a **diagonal measuring line (DML)** from either bottom corner of the cube face to the *opposite* SVP. The point where the DML intersects the line of convergence for the base of the cube face indicates the true

- depth of the cube by defining where the back face of the cube begins to rise vertically.
- 13. Using this point of intersection, build the back face of the cube as an exact square parallel to the front face of the cube and connecting to all lines of convergence. Your cube is now complete and precise. This cube becomes the **key cube** (**K**), or the "mother cube," which determines the scale for all subsequent cubes in the drawing.

Note that all edges parallel to the picture plane or plane of vision and perpendicular to the ground plane remain *vertical* in your drawing. All remaining edges of the cube converge on the CVP.

When drawing multiple cubes, remember to initially draw all cubes transparently in order to clearly establish the base of the cube and to help you determine if any cube is trespassing on any other cube or occupying the same space on the ground plane (Figure 3-10).

Constructing a Cube in Two-Point Perspective Based on Estimation of Cube Depth in Relation to Cube Height

- 1. Determine what conditions must prevail in order to justify the use of two-point perspective. No planes of the cube or cubelike form are parallel to the picture plane (PP) or the plane of vision. An edge of the cube (place where two planes meet) is closest to the picture plane, and this edge is referred to as the **leading edge** (Figure 3-11).
- 2. Establish **scale** for the drawing (e.g, 1'' = 1').
- 3. Draw the **horizon line** or **eye level (HL/EL).** If you think you want a relatively high eye level, place your horizon line closer to the top of the page. If you think you want a relatively low eye level, place your horizon line closer to the bottom of the page.
- 4. Locate the **central vanishing point (CVP),** typically located in the middle of the horizon line in two-point perspective.
- 5. Locate vanishing points left and right (VPL/VPR). The placement of the VPL and VPR in relation to the CVP is determined by the chosen location of the station point (SP), which tells us the distance of the observer from the picture plane.

For example, if your scale is 1" = 1', and your VPL and VPR are each located 5 inches from the CVP (10 inches apart total), then you are establishing that the station point (the position of the observer) is 5 feet away from the picture plane.

- 6. Lightly mark horizontal **units of measure** along the eye level line that correspond to the established scale.
- 7. Determine the location of the **ground line (GL)** based on a chosen height for the eye level or horizon line. Place the ground line by measuring the vertical distance from the horizon line to the ground line in relation to the established scale.

For example, with a scale of 1" = 1' and a chosen eye level of 4 feet, the ground line would be drawn 4 inches below the horizon line. The ground line can be no farther below the horizon line than the distance between the central vanishing point and VPL or VPR without violating the cone of vision.

8. Lightly mark vertical units of measure from the ground line to the horizon line and above that correspond to the established scale. These can be used later for applying scaling techniques and are an abbreviated form of a key cube.

Determine the **cone of vision (COV)** by lightly drawing a circle whose center is at your CVP and whose circumference passes through VPL and VPR. The diameter of the cone of vision would then equal the distance between VPL and VPR. All cubes must remain within the COV unless adjustments are made to correct the resulting distortion.

- 9. At this point, methods for constructing an exact cube in 30°/60° two-point perspective and 45°/45° two-point perspective can be explored, and separate instructions are available in this chapter. The following additional steps for two-point cube construction, however, are based on visual estimation of true cube depth in relation to the height of the leading edge of the cube. Guidelines for accurately estimating the proportions of a cube are provided below.
- 10. Draw the **leading edge** (front edge) of the cube on the ground line and within the COV. This is a vertical line. The height of the leading edge is a random decision unless a specific size is desired.
- 11. Extend lines of convergence from the top and bottom of the leading edge to both VPL and VPR (four separate lines of convergence). This is a good time to check for distortion if you are approaching the limits of the cone of vision in the placement of your leading edge. Distortion occurs when the angle found at the front base corner of the cube is less than a 90° or right angle.
- 12. Watch for distortion, and continue building the cube by estimating the depth of each foreshortened plane based on the visual clues provided.
- 13. In estimating the depth of foreshortened planes, consider the placement of the cube in relation to the VPL

Figure 3-11. Estimating cube depth in two-point perspective involves informed estimation based on an awareness of the guidelines for accurately estimating cube depth. The dotted lines indicate an adjustment to a cube that was originally drawn too shallow from front to back.

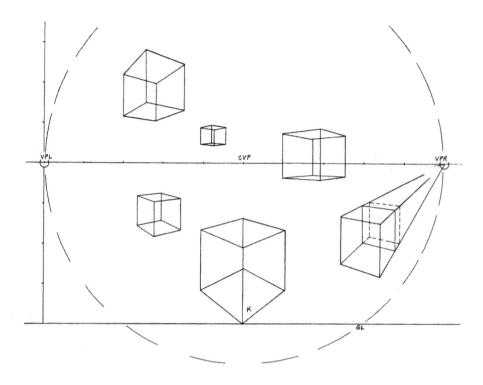

and VPR. As a cube approaches the VPL, the rate of convergence and degree of foreshortening for the left-hand plane increase, resulting in a visually shortened plane. Conversely, the rate of convergence and degree of foreshortening decrease for the right-hand plane in relation to its proximity to the VPR. These relationships simply reverse as a cube approaches the opposite vanishing point. A cube placed halfway between VPL and VPR will have two equally foreshortened planes.

The closer the foreshortened plane of a cube is to a vanishing point, the shorter its length will appear visually. The farther away the foreshortened plane of a cube is from a vanishing point, the longer its length will appear visually.

No receding edge or plane may be greater in measured length than the length of the leading edge. In two-point perspective, the leading edge is always the *longest* edge of a true cube.

- 14. When cube depth has been estimated, indicate by drawing a vertical line between the lines of convergence drawn from the bottom and top of the leading edge. Repeat this procedure for both the right-hand and left-hand planes.
- 15. From each of these two vertical edges, draw lines of convergence to the opposite vanishing point from both the top and the bottom of the vertical edge. Where these

lines of convergence intersect indicates the location of the back vertical edge of the cube. Your cube is now complete. This cube becomes the **key cube** (**K**), or the "mother cube," which determines the scale for all subsequent cubes in the drawing.

Note that all edges parallel to your plane of vision or picture plane and perpendicular to the ground plane remain *vertical* in your drawing. All remaining edges converge on either VPL or VPR.

When drawing multiple cubes, remember to initially draw all cubes transparently in order to clearly establish the base of the cube and to help you determine if any cube is trespassing on any other cube (Figure 3-12).

Estimating Cube Depth in Two-Point Perspective

In studying cubes in two-point perspective, you can use precise methods for cube construction as described in relation to 45°/45° and 30°/60° cubes, or, if absolute precision is not required or desired, you can draw cubic forms based on estimation of cube depth. Following are some guidelines for accurately estimating cube depth and avoiding distortion in a variety of positions within the perspective environment (see Figure 3-11).

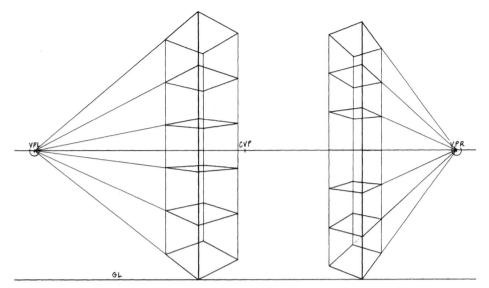

Figure 3-12. Stacking transparently drawn cubes in two-point perspective creates a structure that is often referred to as "elevator shafts" even though it can represent any number of structures from small scale (a stack of children's building blocks) to large scale (a skyscraper or a stack of shipping crates). Note that corresponding vertical edges of each cube remain constant, indicating that all cubes are the same size.

Respecting the Cone of Vision

The cone of vision must be respected to avoid cube distortion. If a cube's leading edge falls outside of the cone of vision, even partially, cube distortion will occur at the leading corner of the cube. The cube will appear to be "dropping" too suddenly, or, in the case of a cube that is positioned above the ground plane (floating), it will appear to be "rising" too suddenly.

There is a clear way of identifying this kind of distortion. Very simply, if the leading corner of a cube measures less than 90°, less than a right angle, it is distorted. It must measure 90° or greater. Either its position within the perspective environment needs to be adjusted, or the vanishing points need to be slid slightly to adjust the cone of vision and consequently correct mild distortion.

Proximity to Vanishing Points Left and Right and Proximity to the Central Vanishing Point

In estimating the depth of foreshortened planes in a cube, consider the placement of the cube in relation to the VPL and VPR. As a cube approaches the VPL, the rate of convergence and degree of foreshortening for the left-hand plane increase, resulting in a visually shortened plane. Conversely, the rate of convergence and degree of foreshortening decrease for the right-hand plane in relation to its proximity to the VPR. These relationships simply reverse as a cube approaches the opposite vanishing point. A cube placed halfway between VPL and VPR, directly above or below the central vanishing point, will have two equally foreshortened planes.

The Leading Edge of a Cube

The closer the foreshortened plane of a cube is to a vanishing point, the shorter its length will appear visually. The farther away the foreshortened plane of a cube is from a vanishing point, the longer its length will appear visually.

In estimating the length of foreshortened planes and edges, it is important to note that the leading edge of a cube is the most forward edge and is a true vertical unaffected by foreshortening. Because we know that a cube consists of six equal planes with all edges equal in length, it follows that no receding edge or plane may be greater in measured length than the length of the leading edge. In two-point perspective, the *leading* edge is always the *longest* edge of a true cube.

Using Perspective Grids

A grid, when not seen in perspective, is a series of lines parallel and perpendicular to one another that indicate units, usually squares, of uniform size. The units of this grid, when presented in perspective, provide an accurate reference for the size, scale, placement, angles, and proportions of various objects.

Perspective grids can serve a number of very useful purposes, either as a drawn environment in which to practice constructing a variety of perspective forms, such as cubes, "elevator shafts" of stacked cubes, ellipses in vertical and horizontal planes, geometric solids derived from cubes, and more, or as a precise

Figure 3-13. Shown here is the process for constructing a gridded ground plane in one-point perspective. If each section of the grid represents 1 square foot, the ground plane would measure 9 feet wide by 18 feet deep. The outermost squares in the front row of the grid are outside of the cone of vision, and distortion begins to be evident.

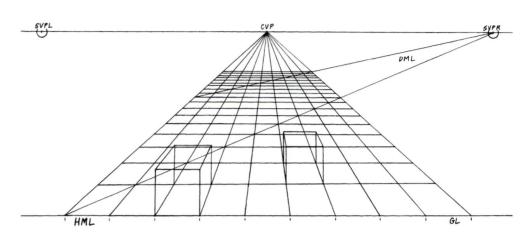

Figure 3-14. A one-point gridded structure can represent structures of various sizes and dimensions, such as the interior of a box or a room interior. If each section of the grid in this illustration represents 1 square foot, the structure would measure 6' tall \times 6' wide \times 9' deep. If each section of the grid represents 10 square feet, the structure would represent dimensions of $60' \times 60' \times 90'$.

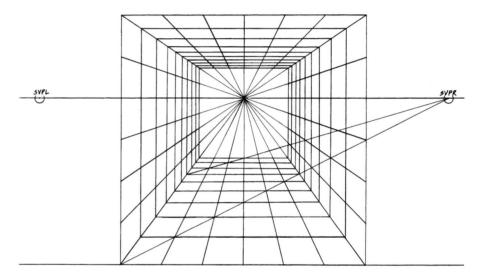

guide when objects and/or spaces to be drawn are more elaborate or complex.

Perspective grids can be drawn in one-point or two-point perspective. In two-point perspective, they may be based on a foreshortened horizontal square seen from a 45°/45° view or a 30°/60° view. If less precision is acceptable, the grid may be based on an estimated foreshortened square without relying on the technical approaches required to create a precise foreshortened square. Perspective grids can be enlarged, multiplied, divided or subdivided, stacked, layered, and used again and again.

When working with a grid based on a foreshortened square, you will note that as the grid extends toward the limits of the perspective environment (as defined by vanishing points left and right and the cone of vision), distortion is more pronounced. This can be addressed in advance by adjusting/increasing the space between vanishing points left and right, effectively enlarging your cone of vision and your working space as necessary.

Constructing a Gridded Ground Plane in One-Point Perspective

- 1. All preliminary information should be established and drawn, including scale, eye level/horizon line, ground line, station point, central vanishing point, special vanishing points left and right, units of measure along the horizon line that reflect your scale, units of measure along a vertical measuring line that reflect your scale, and cone of vision (Figure 3-13).
- 2. Construct a one-point cube below the CVP and within the cone of vision, following the instructions provided for one-point cube construction earlier in this chapter. To most fully utilize your perspective environment, you can position your cube so that it rests on the ground

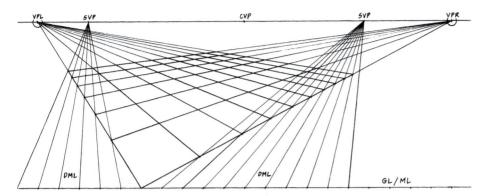

Figure 3-15. Shown here is the construction of a two-point gridded ground plane using the (horizontal) measuring line method. This ground plane is drawn in a 30°/60° orientation to the picture plane.

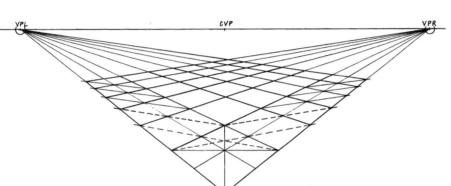

Figure 3-16. Shown here is the construction of a two-point gridded ground plane using the fencepost method. The upper left drawing shows the fencepost method applied to vertical planes that are not seen in perspective.

line. Erase all parts of the cube except the base plane, which serves as the first foreshortened square in your gridded plane.

- 3. Draw a horizontal measuring line (HML) extending to the left and right of the front edge of the foreshortened square. If the cube base rests on the ground line, then the ground line functions as the HML.
- 4. Mark off increments along the HML that equal the width of the front edge of the cube base. From these increments draw lines of convergence back to the CVP. Extend the back edge of the original cube base to the left and right, creating the back edge for all foreshortened horizontal squares in the front row.
- 5. Draw a diagonal measuring line through the foreshortened square on the far left or right of the front row to the *opposite* special vanishing point. Remember that the diagonals for all horizontal planes of cubes in a onepoint perspective environment will converge on a common point (SVP) on the horizon line.
- 6. Draw a horizontal line through the points where the diagonal measuring line (DML) intersects each line of

convergence. These horizontal lines define the depth for each new row of foreshortened horizontal squares in a one-point gridded ground plane.

By utilizing the DML to the SVPL or SVPR, you can extend the gridded ground plane all the way to the horizon line. Note that the width of each square remains the same in any horizontal row of squares and that each horizontal row appears shallower from front to back as it recedes in space. Note that if the grid extends beyond the cone of vision, distortion will occur. Using the gridded ground plane as a guide, you can construct corresponding walls and a ceiling, in effect constructing a gridded room interior or a gridded box interior (Figure 3-14).

Constructing a Gridded Ground Plane in Two-Point Perspective

1. All preliminary information should be established and drawn, including scale, eye level/horizon line, ground line, station point, central vanishing point, vanishing points left and right, units of measure along the horizon line that

- reflect your scale, units of measure along a vertical measuring line that reflect your scale, and cone of vision.
- 2. Construct a two-point cube below the horizon line and within the cone of vision, following the instructions provided for two-point cube construction earlier in this chapter. You may construct a cube using cube estimation to determine the height/width/depth relationship, or you may construct a precise cube using one of the methods outlined for 45°/45° cube construction or 30°/60° cube construction. To most fully utilize your perspective environment, you can position your cube so that its front or leading corner touches the ground line. Once completed, erase all parts of the cube except the base plane and it's lines of convergence to VPL and VPR, which serves as the first foreshortened square in your two-point gridded ground plane.

At this point, you may develop your grid by employing one of three approaches: the measuring line method, the fencepost method, or the method that relies on the fact that all individual squares in the grid have a diagonal that converges on a common SVP (special vanishing point) located on the horizon line. It is interesting to note that, although all three methods are legitimate, each will yield slightly different results. As the grid units approach the outer limits of the cone of vision and distortion becomes more pronounced, the differing results of the three methods become increasingly evident.

To Continue Using the Measuring Line Method

1. Draw a horizontal measuring line (HML) extending to the left and right of the front or leading corner of the foreshortened square. If the leading corner touches the ground line, then the ground line functions as the HML (Figure 3-15).

Remember that your HML, like your horizon line, can extend infinitely to either side and may extend beyond the edges of your drawing format if necessary.

- 2. Mark off equal increments along both sides of the HML from the point where the leading corner touches the HML. These increments should be small enough to accommodate the number of units in your grid, but large enough to prevent error and inaccuracy. These increments represent the depth of the foreshortened square (originally the cube base) and each additional square in the grid.
- 3. From the first increment to the left and right of the leading corner, draw a diagonal measuring line (DML) through the back corner of each foreshortened side and extend it to meet the horizon line, creating two separate SVPs.
- 4. Draw DMLs from each additional increment to its respective SVP established in step 5. Where the DML intersects the lines of convergence for the original foreshortened square indicates the depth of the right and left foreshortened sides of each additional square or unit in the grid. From these points of intersection draw lines of convergence to the left and right VPs to create your grid.

To Continue Using the Fencepost Method

1. Find the center of your foreshortened square by drawing two corner-to-corner diagonals and noting their point of intersection. Draw lines of convergence through this center point to vanishing points left and right (Figure 3-16).

Figure 3-17. Shown here is the construction of a two-point gridded ground plane using the common point of convergence (converging diagonals) for foreshortened squares. The upper right drawing shows the parallel relationship of corner-to-corner diagonals in a vertical gridded plane that is not seen in perspective.

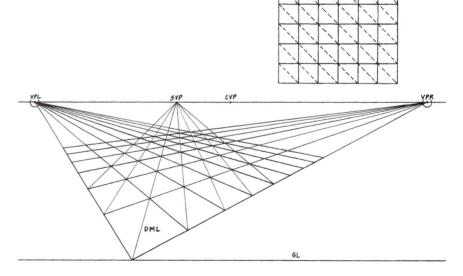

2. Use the fencepost method for cube multiplication as it applies to horizontal planes. Draw a line from the back of each forward edge through the center of the opposite edge and extend it until it intersects an original line of convergence. Where these two lines intersect indicates the depth of each additional grid unit. Repeat this process until you have the desired grid.

To Continue Using the "Converging Diagonals" Method

Remember that the front-to-back diagonal for all aligned horizontal planes of cubes in two-point perspective will converge, when extended, on a common point (SVP) on the horizon line. If the cube is a 45°/45° cube, the front-to-back diagonal will converge on the CVP.

1. Draw the front-to-back diagonal for the foreshortened square and extend it until it meets the horizon line. This establishes your SVP, the point at which all front-to-back

- diagonals will converge in a two-point gridded ground plane (Figure 3-17).
- 2. From the left and right corners of the foreshortened square, draw a DML to the SVP established in step 3. The point at which the DML intersects an original line of convergence indicates the location of the opposite corner of a foreshortened square.
- 3. Drawing lines of convergence through these points of intersection to the corresponding vanishing point left or right creates an additional unit of the grid and provides the framework for repeating the process. By utilizing the extended front-to-back diagonal converging on an SVP, you can construct a gridded ground plane of any desired size.

Note that if the grid extends beyond the cone of vision, pronounced distortion will occur. Using the gridded ground plane as a guide, you can construct corresponding walls and a ceiling, in effect constructing a gridded room interior or a gridded box interior (Figures 3-18 and 3-19).

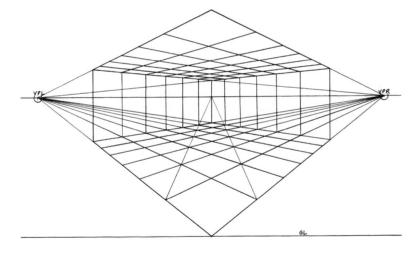

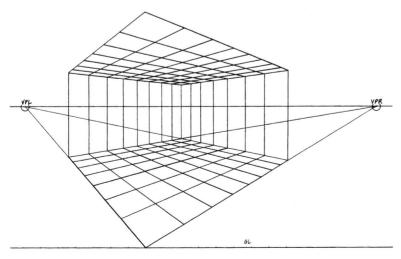

Figures 3-18 and 3-19. A two-point gridded box or room interior, open on two sides, is seen in both a 45°/45° view and a 30°/60° view. The floor and ceiling planes are fully gridded while the side walls are vertically gridded only to create some visual variety.

Increasing Complexity in the Perspective Environment

Multiple or Sliding Vanishing Points

In two-point perspective, a single set of vanishing points is sufficient as long as all horizontal edges receding to the left are parallel to each other and all horizontal edges receding to the right are parallel to each other. But if cubic forms are not all aligned, you need multiple sets of vanishing points to accommodate the different rates of convergence toward the horizon line (Figure 3-20). You can also use multiple sets of vanishing points (also known as sliding vanishing points) to correct cube distortion resulting from a cube falling outside of the cone of vision. By sliding your vanishing points left or right, you shift the position of the cone of vision as needed. Remember that distortion is indicated when the leading corner of an accurately drawn cube is *less* than a 90° angle.

As the position of a cube rotates in relation to the picture plane, the vanishing points shift. Because the distance

Figure 3-20. The lower section of aligned squares, viewed from overhead, shows that all edges converging to the right and left are parallel to each other. The upper section shows misaligned squares viewed from above. The numbers indicate which squares would converge on common sets of vanishing points, indicating that three sets of vanishing points would be necessary to represent these squares if seen in perspective.

between the vanishing points indicates the station point, which must remain constant, the VPL and VPR must remain the same distance apart as they are shifted along the horizon line (Figure 3-21). To accommodate cubic forms in a variety of positions or rotations in relation to the picture plane, you can use as many sets of vanishing points as necessary. To avoid confusion and facilitate an accurate drawing, it is wise to label each set of vanishing points clearly—VPL/VPR, VPL2/VPR2, VPL3/VPR3, VPL4/VPR4, and so on.

Cube Multiplication

Cube multiplication allows you to repeat a cubic-based form with correct foreshortening and rate of convergence as it recedes in space along a shared "track" or corridor of convergence. Examples of applications in the real world include a line of railroad cars along a length of track, a row of boxes on a conveyor belt, or a series of row houses along a city street.

Cube multiplication techniques can also be used to repeat horizontal or vertical planes as they recede in space along the same plane, as it is these planes that make up a cubic form. Examples would include the receding segments of a sidewalk (horizontal planes) or the receding segments of a fence (vertical planes).

Reducing the cubic form further, the vertical edges of cubes can be repeated with equal spacing as they recede along the same plane using cube multiplication techniques. Real-world examples include fenceposts, telephone poles, equally spaced trees, or people standing in formation.

There are two different methods for implementing cube multiplication—the "fencepost" method and the measuring line method. While both provide convincing results, it is interesting to note that the two systems yield results that differ slightly from one another. Both methods require that the depth of the original cubic form or cubic plane be defined as the basis for further repetition.

The "Fencepost" Method for Cube Multiplication

To use the fencepost method, bisect the vertical or horizontal plane to be multiplied (it can be either an individual plane or one plane of a cubic form) by constructing cornerto-corner diagonals, identifying the perspective center at the point of the diagonals' intersection, and pulling a line of convergence through the point of intersection to the corresponding vanishing point (Figure 3-22).

To identify the correct depth of the adjacent vertical or horizontal plane, draw a line from the corner of the front edge of the original plane through the middle of the opposite

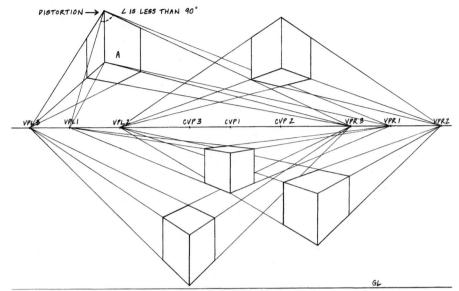

Figure 3-21. Shown here are two-point cubic forms (not all forms depicted here are perfect cubes) with multiple sets of vanishing points. Three different sets of vanishing points are used to accommodate the different orientations of the cubes to the picture plane. The central vanishing points shift as well, remaining midway between the corresponding vanishing points left and right. Cube A illustrates how sliding vanishing points can be used to correct a cube that is distorted due to a violation of the cone of vision.

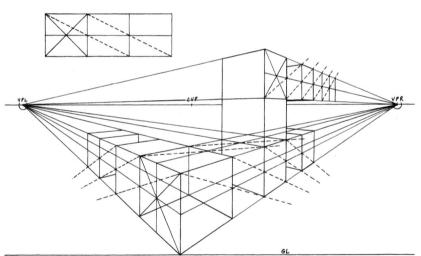

Figure 3-22. The fencepost method shown here for cube multiplication can be applied to both vertical (side) and horizontal (top and bottom) planes. Note the distortion that begins to occur in the partially obscured cube at the far left as cube multiplication extends beyond the original cube in the foreground. The leading edge ceases to be the longest edge as it should be in a true cube. The upper left drawing shows the fencepost method applied to vertical planes not seen in perspective.

or back edge and extend it until it intersects the line of convergence for the original plane. This point of intersection identifies the location of the depth of the repeated plane as it recedes in space. If desired, it may also identify the depth of an empty space that is equal in size to the original plane. This same process can be used in reverse to multiply a form that is advancing in space rather than receding. Be careful not to violate the cone of vision when multiplying forms forward to avoid distortion.

If this plane serves as one side of a cubic structure, simply complete the cube by constructing the remaining sides of the cube along the corresponding track or corridor of convergence. Repeat the procedure for each repetition desired. Vertical or horizontal forms such as fenceposts, telephone poles, or railroad ties correspond to the edges of the vertical or horizontal planes.

The Measuring Line Method for Cube Multiplication

To use the measuring line method, draw a horizontal line that touches the nearest corner of the plane (vertical or horizontal) or cubic structure you wish to multiply and extend it to the left and right (Figure 3-23). This measuring line (also called a horizontal measuring line) should be parallel to both the

ground line and the horizon line. In the case of a cube whose nearest corner rests directly on the ground line, the ground line will function as the measuring line. Since the measuring line is parallel to the picture plane, it is not affected by diminution and can provide constant measurable units.

To begin the multiplication process, you must mark a length or increment of your choosing along the horizontal measuring line that represents the depth of the plane or cubic structure you wish to repeat. This increment originates at the point where the measuring line touches the nearest corner. If you are multiplying a form toward vanishing point right, your increment would be drawn to the right along the measuring line, and vice versa. The length of the increment is arbitrary, although if it is too small it can more easily lead to error, and

if it is too large it can require extensions of your paper surface and become unwieldy. Common sense should prevail.

For purposes of explanation, imagine that a ½" increment on the horizontal measuring line represents the depth of the original plane or cube to be multiplied. Draw a diagonal measuring line (DML) from the ½" mark through the back corner or edge of the original form and extend it until it intersects the horizon line. This point of intersection establishes a special vanishing point (SVP) upon which all other DMLs will converge when multiplying that particular form. To determine the depth of a second form, establish a second ½" increment adjacent to the first one on the measuring line. Draw a DML from this point to the SVP established earlier. Where this DML intersects the line of convergence for the original form indicates the depth of the second plane as it recedes in space.

Figure 3-23. The (horizontal) measuring line method for cube multiplication can be applied to determine the depth of both vertical and horizontal planes. Like the fencepost method, distortion will occur and become more pronounced in perfect cubes as you move farther away from the original cube, appearing increasingly shallow in relation to their height. Note that different increments are used on the left and right side of the measuring line to multiply the foreground cube, vielding different locations for the SVPs on the horizon line. Increments established on the measuring line may be different on the left and right side of the leading edge, but once established they must remain consistent on each side for accurate cube multiplication.

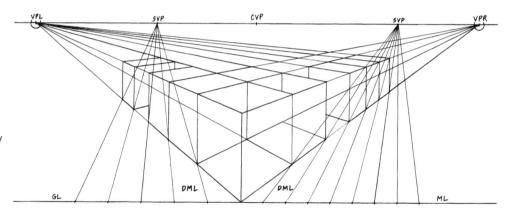

Figure 3-24. Cube multiplication using both the fencepost and the measuring line methods will yield the same results. Again, note the increased distortion as the multiplied cubes move farther away from the original cube.

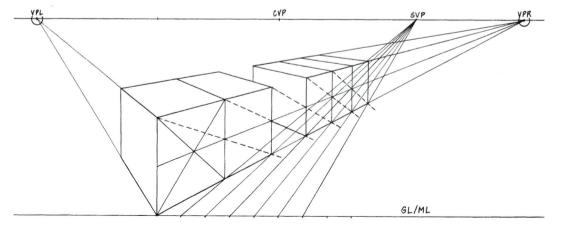

If you have a plane or a cubic form that you wish to multiply ten times along the same corridor of convergence, then you will have ten ½" increments along your horizontal measuring line. It is equally viable that you initially decide to use a ¼" increment on the measuring line to represent the depth of the original plane or cube to be multiplied. Each ¼" increment on the measuring line represents the depth of a duplicate of the original form when the ¼" increment is drawn back to the SVP and intersects the original line of convergence.

Taking this idea a step further, if you desire to repeat only one half the depth of a cubic form, you can subdivide your established increment along the horizontal measuring line and work with it accordingly. You can also repeat the depth of the original form and allow it to function as an empty space between repeated forms. A solid understanding of the use of the horizontal measuring line is especially important because it serves a variety of other significant purposes that will be addressed in the section on measuring lines in this chapter.

Distortion in Cube Multiplication

Based on the techniques presented here, we should be able to multiply an accurately drawn cube in any direction and use it as a blueprint for constructing a great variety of forms ultimately rooted in cubic structure. But you may note that cube multiplication, whether using the measuring line method or the fencepost method, yields cubes that are distorted in appearance as they move farther away from the original cube. They may appear more rectangular than cubic (Figure 3-24), even though these distorted cubes are found within the "safe" area defined by the cone of vision. We cannot correct these distortions in perspective language without resorting to extremely lengthy, technical, and confusing methods that ultimately increase the incidence of error, and

so we must learn to accept these distortions as part of the limitations of the perspective system. In the event that these distortions must be corrected, or if you are interested in studying the process for correcting these distortions, refer to Jay Doblin's *Perspective: A New System for Designers*, listed in the general section of the Bibliography.

It is important to remember that, in technical perspective drawing, accuracy is relative. With all of the possibilities technical perspective offers us for creating the illusion of depth and space on a two-dimensional surface, it remains limited to *symbolizing* what the eye actually sees. For general drawing purposes, it is most effective when combined with careful observation and sighting.

Cube Division

Cube division allows us to divide and subdivide a cube into increasingly smaller units, carving away sections of a cube. Cube multiplication and cube division combined form the basis for transparent construction, which uses the cube and the broad range of geometric solids derived from it as the framework for constructing countless dimensional forms as if we can see through them to the parts that are obstructed from view.

Cube division can be approached in two basic ways. The first method, which relies on finding the center of any given plane at the point where the two corner-to-corner diagonals intersect, allows us to divide and subdivide a cube in increments of ½, ¼, ⅓, ⅙, ⅓, 1,16, ⅓, 1,32, and so on, by dividing any given area into two equal halves (Figure 3-25). The second method, which relies on the use of a measuring line, allows us to divide and subdivide a cube into regular *or irregular* increments. The measuring line method allows for cube divisions that are not available using the corner-to-corner,

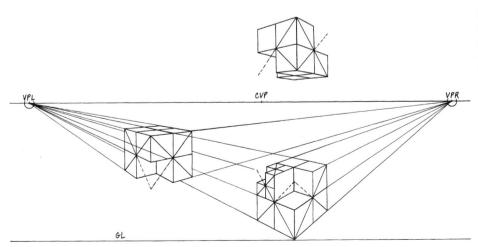

Figure 3-25. This illustration shows cube division and subdivision based on increments of one half, one quarter, one eighth, and so on. The dotted lines end or converge where the corner of a removed cube was positioned before it was removed.

Figure 3-26. Corner to corner diagonals can be used to enlarge or reduce a rectangular plane proportionally. The upper left drawing illustrates the technique of proportionally enlarging and reducing a vertical plane with no foreshortening. Compare it to the same process used in the foreshortened plane on the lower

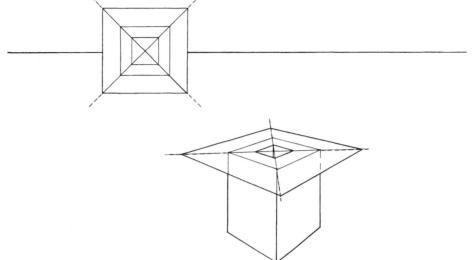

Figure 3-27. This drawing illustrates how a point identified on one edge or plane of a cube can be located on other corresponding edges or planes by wrapping lines of convergence around the cube, much like wrapping ribbon around a package.

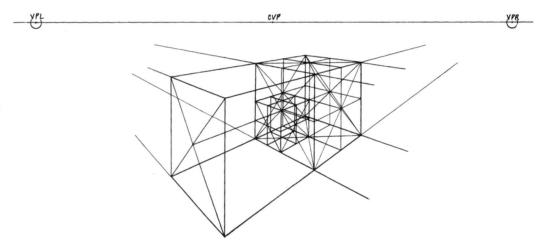

or "X"ing, method because this method only allows us to create one-half divisions. Related to the use of measuring lines for cube multiplication, this method is described in detail in this chapter under the heading "Using Measuring Lines for Regular (Equal) and Irregular (Unequal) Divisions of an Area".

Corner-to-corner diagonals can also be used to proportionally scale down or reduce a square or rectangular plane and, when extended beyond the corners, can be use to proportionally scale up or enlarge a square or rectangular plane (Figure 3-26).

Additionally, once a point of division has been identified on one side or plane of a cubic form, the corresponding point can be found on any other plane of the cube by simply wrapping the cube with construction lines that correspond to the vanishing points used to construct the original cube (Figure 3-27).

Mathematically Precise Cubes in Two-Point Perspective

Constructing a 30°/60° Cube Based on Initial Determination of the Height of the Leading Edge

The following steps create the height of the leading edge of a cube and a horizontal foreshortened square that becomes the *base* of a cube in 30°/60° two-point perspective. A 30°/60° cube in two-point perspective is a cube whose foreshortened sides are at different angles to the picture plane, one at 30° and one at 60° (Figure 3-28). The leading edge of a 30°/60° cube will be positioned halfway between the CVP and VPR or VPL.

1. All preliminary information should be established and drawn, including scale, eye level/horizon line, ground

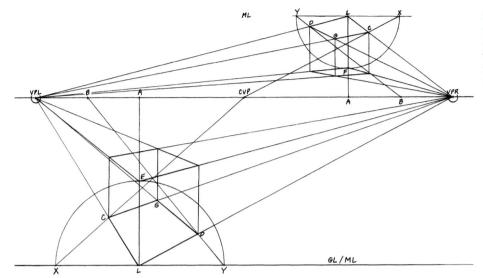

Figure 3-28. This illustration shows the construction of a 30°/60° cube based on initial determination of the height of the leading edge. Note that the process flips for cubes that are positioned above the eye level.

Figure 3-29. Shown here is the construction of a 45°/45° cube directly aligned with the CVP based on initial determination of the size of the base square. The upper right drawing illustrates the geometric principle guiding the process.

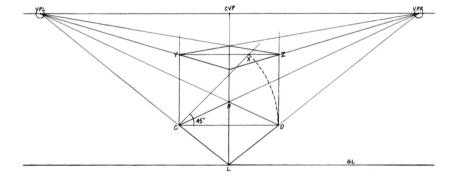

line, station point, central vanishing point, vanishing points left and right, units of measure along the horizon line that reflect your scale, units of measure along a vertical measuring line that reflect your scale, and cone of vision.

- 2. Bisect the distance between the CVP and VPL or VPR to locate point A.
- 3. Bisect the distance between A and VPL to locate measuring point B.
- 4. Draw a vertical line through point A and determine on this vertical the desired location of the leading corner (L) of the cube, which may be positioned above or below the horizon line.
- 5. Draw a horizontal measuring line (ML) through L. If you placed your leading corner on the ground line,

- the ground line functions as the horizontal measuring line.
- 6. Determine the height of the leading (F) edge from L. Rotate the leading edge to the left and right from point L to the horizontal measuring line, locating points X and Y.
- 7. Draw lines of convergence from L and F to vanishing points left and right to construct the leading corner and to begin cube construction.
- 8. Draw a line from CVP to X, locating its point of intersection (C) along the line of convergence. Draw a line from B to Y, locating its point of intersection (D) along the line of convergence.
- 9. Draw lines of convergence from C and D to the opposite vanishing points to complete the base or horizontal square of the cube (LCGD).

Figure 3-30. Shown here is the construction of a 45°/45° cube slightly off-center of the CVP based on initial determination of the size of the base square. The upper right drawing illustrates the geometric principle guiding the process.

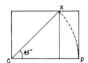

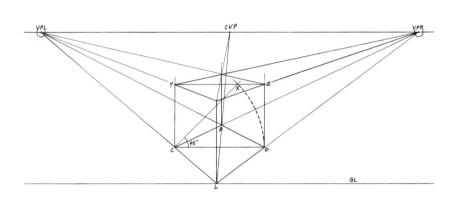

10. Draw verticals at the sides (C and D) and back corner (G) of the square. Draw the remaining lines of convergence to VPL and VPR to complete your cube.

This is an accurate 30°/60° cube that can be positioned noncentrally in a perspective environment. Keep in mind that distortion will become pronounced if the cube, through cube multiplication, crosses over the center of the perspective environment (indicated by the location of the CVP) or approaches either vanishing point too closely.

Constructing a 45°/45° Cube Based on Initial Determination of the Size of the Base Square

The following steps create a horizontal or foreshortened square in 45°/45° two-point perspective, which becomes the *base* of a cube in 45°/45° two-point perspective. A 45°/45° cube in two-point perspective is a cube that rests halfway or nearly halfway between the VPL and VPR and whose foreshortened sides are each at a 45° angle to the picture plane (Figure 3-29).

- 1. All preliminary information should be established and drawn, including scale, eye level/horizon line, ground line, station point, central vanishing point, vanishing points left and right, units of measure along the horizon line that reflect your scale, units of measure along a vertical measuring line that reflect your scale, and cone of vision.
- 2. Drop a vertical line (in the case of the *exact* 45°/45° method) or a slightly diagonal line (in the case of the

- off-center 45°/45° method) from the CVP to the ground line (GL). This line will become the diagonal of the foreshortened base square (Figure 3-30).
- 3. Draw two lines of convergence, one each from VPL and VPR, to intersect at the point along the vertical (or diagonal) line where you wish to position the nearest angle or corner of the foreshortened base square (L).
- 4. Draw two more lines of convergence from VPL and VPR to intersect at a second point along the vertical (or diagonal) line based on the desired *depth* of the cube (B), and *through* the vertical (or diagonal) line to intersect the original lines of convergence established in step 3. This defines the back angle or corner of the foreshortened base square (B), locates points C and D, and completes the base plane or square of the foreshortened cube (CBDL).

To Complete the Cube by Building Off the Base Square

- 1. Draw vertical lines up from all four corners of the square (C, B, D and L).
- 2. Rotate CD 45° upward to create point X (CX is equal in length to CD), and draw a horizontal line through point X to intersect the two side verticals of the cube (Y and Z).
- 3. Construct the upper square or plane of the cube by drawing four lines of convergence from these two points of intersection (Y and Z) to VPL and VPR. Two of these lines of convergence must also be pulled forward to meet at the leading edge of the cube and define its height.

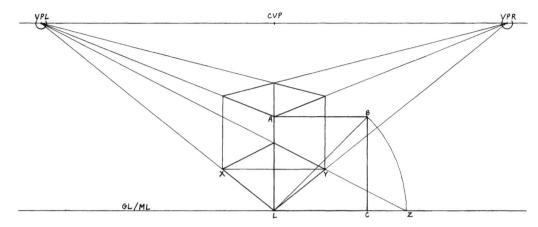

Figure 3-31. This drawing illustrates the first alternative method for constructing a 45°/45° cube based on initial determination of the height of the leading edge.

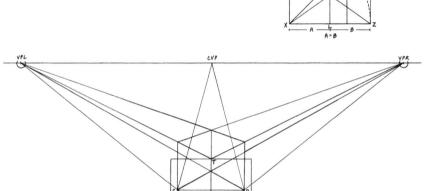

Figure 3-32. This drawing illustrates the second alternative method for constructing a 45°/45° cube based on initial determination of the height of the leading edge. The upper right drawing illustrates the geometric principle guiding the process.

This is an accurate 45°/45° cube that can be positioned in a variety of centrally located positions in a perspective environment. Keep in mind that distortion will occur if the diagonal of the base square deviates *significantly* from a true vertical. In cube multiplication, distortion will become pronounced as the cube approaches the point halfway between the CVP and VPL or halfway between the CVP and VPR.

First Alternative Method for Constructing a 45°/45° Cube Based on Initial Determination of the Height of the Leading Edge

1. All preliminary information should be established and drawn, including scale, eye level/horizon line, ground line, station point, central vanishing point, vanishing points left and right, units of measure along the horizon

line that reflect your scale, units of measure along a vertical measuring line that reflect your scale, and cone of vision (Figure 3-31).

- 2. Draw the leading edge of a 45°/45° cube to the desired height. This is a vertical line that should be located directly below the CVP and should remain within the COV. The height of the leading edge is a random decision unless a specific height is desired.
- 3. Draw lines of convergence from the top and bottom of the leading edge to VPL and VPR.
- 4. From this leading edge (LA), construct a square to the left or right side, and extend the base of the square to the left and right to establish a measuring line (ML). If the leading edge rests on the ground line, then the ground line functions as a measuring line. Draw the diagonal of the square (LB) from the bottom of the leading edge (L) to the opposite upper corner of the square (B).

- 5. Rotate the diagonal down in an arc from the upper corner until it intersects the measuring line. From this point of intersection (Z), draw a diagonal measuring line (DML) back to the opposite VP.
- 6. Where the DML intersects the lower line of convergence (Y) indicates the depth of one side of the cube. From this point of intersection, draw a vertical line to meet the upper line of convergence. This establishes one foreshortened plane of the cube.
- 7. From this same point of intersection (Y), draw a true horizontal line (parallel to the ground line/measuring line) across the base of the cube until it intersects the opposite line of convergence. This point of intersection (X) indicates the depth of the remaining side of the cube.
- 8. From this point of intersection (X), draw a vertical line to meet the upper line of convergence. This establishes the remaining foreshortened plane of the cube. Note the depth of the two sides of the cube is equal.
- 9. From the four back corners of these foreshortened planes, draw lines of convergence to the opposite VPs. Where these lines intersect establishes the back edge of the cube, which aligns with the leading edge. Constructing a vertical between these points of intersection completes the 45°/45° cube.

Second Alternative Method for Constructing a 45°/45° Cube Based on Initial Determination of the Height of the Leading Edge

- 1. All preliminary information should be established and drawn, including scale, eye level/horizon line, ground line, station point, central vanishing point, vanishing points left and right, units of measure along the horizon line that reflect your scale, units of measure along a vertical measuring line that reflect your scale, and cone of vision (Figure 3-32).
- 2. Outside of your desired image area, construct a square whose height is equal to the desired height of the leading edge of a 45°/45° cube.
- 3. Draw the diagonal of the square (XY) and rotate the diagonal down in an arc until it meets a horizontal extension of the bottom edge of the square. From this point (Z), draw a vertical line up until it meets a horizontal extension of the top edge of the square. You now have a rectangle that is derived from the diagonal of the original square.
- 4. Find the center of the rectangle by drawing the two corner-to-corner diagonals of the rectangle. Their point of intersection (M) is the center of the rectangle.

- 5. Draw a vertical line through the center point, bisecting the rectangle. This completes the schematic form that will be used to construct the 45°/45° cube.
- 6. Moving back to your perspective environment, draw the bisected rectangle in the desired location with the vertical bisection aligned with the CVP. This vertical bisection (LT) is the leading edge of your cube. Draw lines of convergence from the top and bottom of the leading edge to VPL and VPR.
- 7. From the lower right and left corners of the rectangle (X and Z), draw DMLs to the CVP. Where the DMLs intersect the lower lines of convergence indicates the depth of the left and right sides of the cube. From these points of intersection (C and D), draw vertical lines to meet the upper lines of convergence. This establishes the left and right foreshortened planes of the cube, which are equal in depth.
- 8. From the four back corners of these foreshortened planes, draw lines of convergence to the opposite VPs. Where these lines intersect establishes the back edge of the cube, which aligns with the leading edge. Constructing a vertical between these points of intersection completes the 45°/45° cube.

Constructing Ellipses in One-Point and Two-Point Perspective

Simply speaking, an ellipse is a circle seen in perspective, a foreshortened circle. A circle fits precisely within a square, touching the exact midpoint of each side of a square and intersecting the square's diagonals in the same two places on each diagonal. With an awareness of how to construct squares and cubes in perspective and with the knowledge that a cube consists of six equal squares, we are able to construct accurate ellipses using the foreshortened square as a guide.

The Eight-Point Tangent System for Ellipse Construction

Eight points (tangent points) within a square must be identified to guide the construction of a circle or an ellipse. These eight points can be recognized most clearly by referring to a full view of a circle within a square, without any foreshortening of the circle or the square.

The point of intersection of two corner-to-corner diagonals drawn through the square identifies the midpoint or center of the square. Drawing a vertical and horizontal line through the center point and extending them to meet the sides of the square identifies the midpoint of each of the four sides of the square. These are the first four tangent points for guiding ellipse construction. A circle drawn within the square will touch the square at each of these four points (Figure 3-33). For a foreshortened square, the lines drawn through the center point that identify the midpoint of each side of the square must be drawn in perspective, converging on the appropriate vanishing point(s) when necessary.

To identify the remaining four tangent points, each half diagonal, defined by the point of intersection with the other diagonal, is divided into equal thirds. A circle drawn within the square and touching the first four tangent points will fall just outside of the outermost one-third division of each half diagonal. These outermost divisions of the diagonals comprise the second, and more flexible, set of four tangent points. For a foreshortened square, it is important to remember that the one-third divisions will not be equal in actual measurement because of the effects of diminution. It is acceptable to estimate the one-third divisions since the resulting tangent point is flexible. After identifying only one point of division, you can then pull a line originating from that point of division around the foreshortened square (with correct convergence when

appropriate) and identify the remaining points of division based on the line's intersections with the corner-to-corner diagonals.

By applying this process to any foreshortened square, whether seen in one-point or two-point perspective, you can identify the eight tangent points required to guide ellipse construction. Ellipse construction requires a lot of practice before one can confidently draw an ellipse that is accurate and convincing—uniform in its curvature with no flat, high, or low spots (wobbles); no points or sharpness at the narrowest part of the ellipse (footballs); a correct tilt or angle (major axis) of the ellipse in relation to the foreshortened square from which it is derived; an identifiable major and minor axis at a 90° angle to each other; and other factors (Figure 3-34). Further discussion and examination of the illustrations will help to clarify the importance of these points.

Major and Minor Axes, Distortion, and Fullness of Ellipses

When a circle is foreshortened, becoming an ellipse, it has a major axis and a minor axis. The major axis is an imaginary line that bisects the ellipse at its widest or longest point, while the minor axis is an imaginary line that bisects the ellipse at its narrowest or shortest point (Figure 3-35). The major and minor axes of an ellipse will always remain at 90°

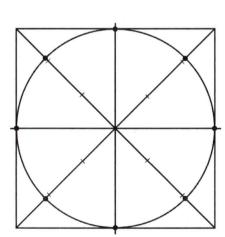

Figure 3-33. The relationship of a circle to a square helps with identifying the eight tangent points necessary for guiding ellipse (a circle seen in perspective) construction.

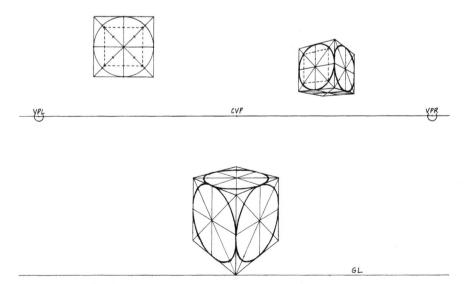

Figure 3-34. The relationship of ellipses to a variety of foreshortened cube faces is shown here. The upper left drawing notes the relationship of a circle to a square without the element of foreshortening.

Figure 3-35. The relationship between major and minor axes of an ellipse is 90°. Because of foreshortening, the perspective center of ellipses is not the same as the major axis and is positioned *behind* the major axis.

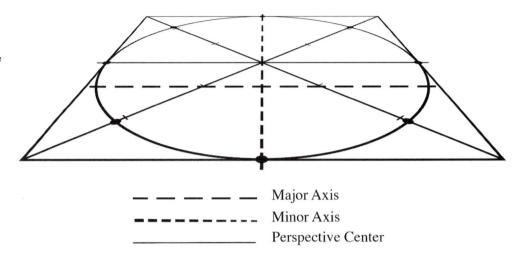

Figure 3-36. The behavior of ellipses receding in space is different depending upon whether they are in parallel planes or in the same plane. In parallel planes, ellipses lean more strongly and open up as they recede, while in the same plane ellipses become more upright and close up as they recede.

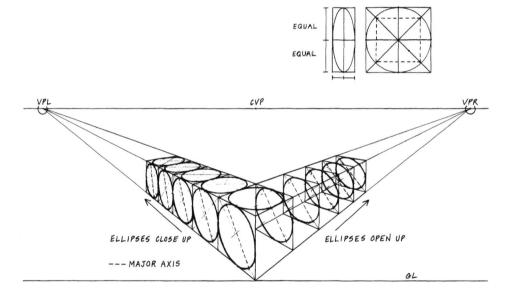

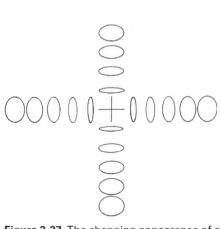

Figure 3-37. The changing appearance of ellipses based on their proximity to the eye level and the CVP is shown here. Note that ellipses appear as straight lines with no visible depth when they are positioned horizontally at eye level or vertically at the CVP.

Figure 3-38. The correct and incorrect relationship of ellipses in parallel planes is shown in these two forms, which are positioned well below eye level. The glass on the left shows an accurate relationship between upper (more closed) and lower (more open) ellipses, while the glass on the right is inaccurate, actually representing how the glass on the left might appear if positioned above the eye level.

to each other, regardless of their position in space or their degree of foreshortening. It is helpful to note that these major and minor axes rarely coincide with the diagonal or bisecting lines of the foreshortened square within which the ellipse lies and that the major axis falls in front of the perspective center of the ellipse.

It is important to remember what has been noted about distortion in perspective. As squares and cubes are positioned farther away from the original cube or square from which they are derived, distortion increases. Elliptical forms drawn within these distorted squares are not true or precise ellipses, although they may appear to be. When this distortion is present, the 90° relationship between major and minor axes of ellipses is altered.

When a series of ellipses is constructed in the same vertical plane, the major axis will be most strongly angled in the foreground, and as the ellipses recede in space along the vertical plane, the major axis is less angled, approaching a more vertical orientation. When a series of ellipses is constructed in parallel vertical planes, the opposite is true: The major axis will be closer to a vertical in the foreground and will have a stronger diagonal orientation as the ellipses recede in space (Figure 3-36).

As ellipses approach the eye level in a horizontal plane or the central vanishing point in a vertical plane, they narrow or close up dramatically. As they move farther to the left or right in a vertical plane or move farther above or below the eye level in a horizontal plane, they widen or open up dramatically (Figure 3-37).

Because there are numerous degrees of foreshortening, ellipses can be very full when seen in relation to a square that is only minimally foreshortened, appearing to be nearly a full circle. When seen in relation to a square that is extremely foreshortened, ellipses can be very thin, appearing to be nearly a single straight line. When ellipses are positioned close to each other as part of the same form, such as at the top and bottom of a drinking glass or the outside and inside of a wheel, they must correspond correctly to each other in order to convey that the glass or wheel is seen from a fixed viewpoint (Figure 3-38). If one ellipse is extremely wide or open, and the other is extremely narrow or closed, the results are visually confusing, implying that the form is being viewed from two different eye levels.

Using Measuring Lines for Regular (Equal) and Irregular (Unequal) Divisions of an Area

We have already seen how horizontal measuring lines can be used for multiplying any unit in perspective—a cube, a rectangular solid, a horizontal or vertical plane of any dimensions, or even an empty space. The use of a horizontal measuring line (HML) also allows us to divide and subdivide a cube, a plane, a rectangular solid, or an empty space into either regular (equal) or irregular (unequal) increments. The measuring line method allows cube divisions that are not available using the corner-to-corner, or "X"ing method, as this technique is only capable of creating ½ divisions of any given area.

Setting Up the Measuring Line

To use the measuring line method, draw a horizontal line (the measuring line) that touches the nearest corner of the vertical or horizontal plane or cubic structure you wish to divide and extend it to the left and right. This line should be parallel to both the ground line and the horizon line. In the case of a cube whose nearest or leading corner rests directly on the ground line, the ground line will function as the horizontal measuring line. Since the measuring line is parallel to the picture plane, it is not affected by diminution and can provide constant measurable units. Remember that your HML, like your horizon line, can extend infinitely to either side and may extend beyond the edges of your drawing format if necessary.

The Process of Dividing a Form

1. To begin the process of dividing a form into equal or unequal increments, you must mark a length or increment of your choosing along the measuring line that represents the total depth of the plane or cubic structure or space you wish to divide (Figure 3-39). This increment originates at the point where the measuring line touches the nearest corner. If you are dividing a form that converges toward VPR, your increment will be drawn to the right along the measuring line, and vice versa. The length of the increment is arbitrary, although if it is too small it can more easily lead to error or inaccuracy, and if it is too

Figure 3-39. Irregular divisions of a cube or cube face using a horizontal measuring line can be wrapped around all faces of the cube. The cube on the right shows unequally spaced horizontal planar divisions of a cube using the leading edge as a measuring line.

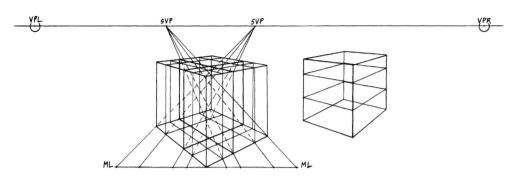

Figure 3-40. The use of a horizontal measuring line makes it possible to translate information found on a nonforeshortened plane (left) to a corresponding foreshortened plane (right).

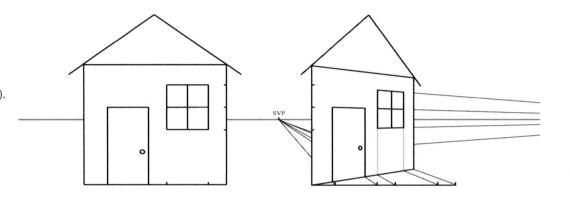

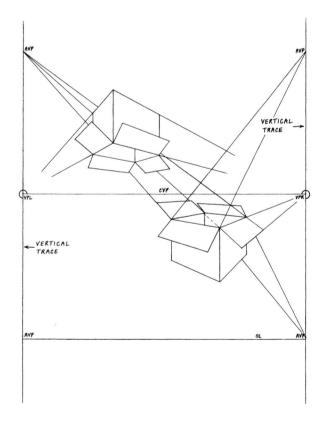

Figure 3-41. Inclined planes in the form of box flaps are explored in a variety of positions. Note that each flap has two points of convergence, one on the eye level line at VPL or VPR and one above or below a vertical extension of VPL or VPR. Note the floating, inverted box above the eye level. Not all construction lines or lines of convergence are shown in this illustration. See if you can locate the vanishing points for the inclined planes of the box flaps that do not have visible construction lines.

- large it can require extensions of your paper surface and become unwieldy. Common sense should prevail.
- 2. For purposes of explanation, imagine that a 2" increment on the measuring line represents the depth of the plane or cube or space you wish to divide. Draw a DML from the 2" mark through the back bottom corner or edge of the form you wish to divide and extend it until it intersects the horizon line. This point of intersection establishes an SVP upon which all other DMLs will converge when dividing that particular form.
- 3. To determine the location of a point one third of the way along the depth of the form, come back to the 2" increment on the HML and locate a point one third of the way along its length. Draw a DML from this point to the established SVP. Where this DML intersects the base of the original form indicates a one-third division of the form as it recedes in space.

- 4. If you are dividing a vertical plane, you can extend a line up from this point of intersection, and if the vertical plane is one side of a cubic structure, you can wrap the line of division around the cubic structure (respecting perspective convergence) to find the corresponding one-third division on additional faces of the form. If you are dividing a horizontal plane, you can pull a line across the plane from this point of intersection, making sure to respect the perspective convergence.
- 5. If you have a plane or a cubic form that you wish to divide into ten equal units, then you will have ten equal increments within the original 2" increment along your HML. If you have a plane or a cubic form that you wish to divide into a number of unequal units, then you will first establish these unequal units within the original 2" increment along your HML.
- 6. It is equally viable that you initially decide to use an increment other than 2", such as a ½" increment on the measuring line to represent the depth of the original plane or cube to be divided. But if you are going to subdivide a number of times, whether regular or irregular divisions, an initial ½" increment may be a bit small to work with comfortably.

These techniques assist you in identifying the location of a point from side to side on any given foreshortened plane. To locate the height of a point from top to bottom on a vertical foreshortened plane, you can use the leading edge of the plane as a vertical measuring line. Because this vertical edge is not foreshortened, you can apply measurements directly to it and pull them back across the foreshortened plane toward the appropriate vanishing point to identify the height of points located on the foreshortened plane.

Applications for the Use of Regular (Equal) and Irregular (Unequal) Divisions

You may be asking yourself under what circumstances would you use this process of division, which essentially allows you to identify different points along a line or plane that is receding in space. There are innumerable applications. Imagine, for example, that you are drawing a rectangular solid that represents a house based on the scale you have established for your drawing (Figure 3-40). On any given side of the house are windows and doors and other architectural elements that are positioned at irregular intervals and at various heights, and you want to represent their location accurately on the foreshortened planes of the house. By determining their location on any given side of the house when it faces you directly, without foreshortening, you can translate that

information to a foreshortened representation of that side of the house by using the measuring line system as described here. In order to identify the height of doors or windows or other architectural elements, use the vertical leading edge as a vertical measuring line. Again, because it is not foreshortened, it can be used to transfer measurements directly.

That same rectangular solid, with a different scale applied to it, may represent the basic geometric shape of a computer monitor, a child's toy, an automobile, an air-conditioning unit, a reclining chair, a gasoline-powered generator—the possibilities are endless. A thinner rectangular solid could represent an iPod or a cell phone, for example. Using the measuring line system can help you identify the correct location of knobs, buttons, slots, wheels, doors, switches, and any other details, variations, or elaborations of the form.

If the form you wish to represent is roughly ½ cube deep, 2 cubes tall, and 3½ cubes long, you can create the basic geometric solid from which the form is derived by first drawing a precise cube, then finding the depth of ½ cube by using cube division techniques, then extending it up to a height of 2 cubes by stacking it, and finally extending it back in perspective 3½ cubes by using cube multiplication techniques. This process forms the basis for transparent construction drawing, described later in this chapter.

Inclined Planes in Perspective

Inclined planes in perspective are neither parallel to the ground plane nor perpendicular, and so the rules that govern the construction of vertical and horizontal planes do not fully apply to inclined planes. Inclined planes are tilted in space, angling up or down as they recede in space (Figure 3-41). Some examples of inclined planes include rooftops at various pitches, wheelchair ramps, box flaps in a variety of positions, and stairways, which are essentially a series of small vertical and horizontal planes that fall within a larger inclined plane.

Inclined planes, whether seen in one-point or two-point perspective, are governed by principles of perspective with which we are familiar, along with some variations of these principles. We know that a plane derived from any rectangular solid, whether inclined, vertical, or horizontal, is composed of four sides. The sides or edges opposite each other are parallel. Unless these edges are vertical in their orientation (perpendicular to the ground plane), we know that as they recede in space they will converge upon a common vanishing

point that is located on the horizon line. Here is where the variation occurs. In representing an inclined plane, any parallel receding edges that are not vertical or horizontal (perpendicular or parallel to the ground plane) will converge on a common point that is positioned directly above or below the VPL or VPR. This vertical extension of the VPL or VPR is called a vertical trace, and any vanishing points located on the vertical trace are called auxiliary vanishing points (AVPs).

Figure 3-42. This drawing of a compound form shows two separate rooftops at different pitches or degrees of incline. Note that the greater the incline, the farther the AVP is positioned above or below the corresponding vanishing point. Both rooftops are equally pitched on either side, resulting in an equal distance above and below the vanishing point for the AVP.

Auxiliary Vanishing Points and the Vertical Trace

In the case of an inclined plane that angles *up* as it recedes away from us, the AVP will be positioned *above* the corresponding vanishing point. How far above the vanishing point the AVP is positioned is determined by the degree of the incline (Figure 3-42). In the case of an inclined plane that angles *down* as it recedes away from us, the AVP will be positioned *below* the corresponding vanishing point. How far below the vanishing point the AVP is positioned

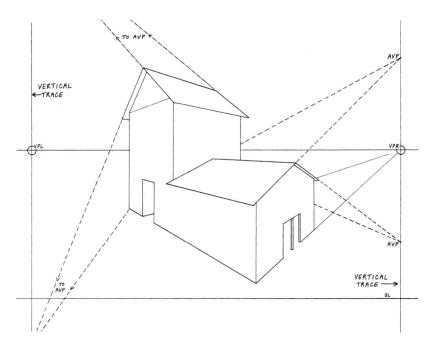

Figure 3-43. A two-point perspective view of ascending stairs shows the inclined planes within which the stairs are positioned. The greater the incline, the farther the AVP is positioned above or below the corresponding vanishing point.

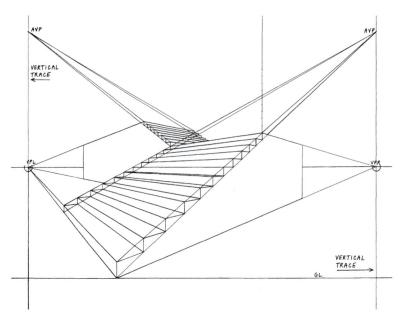

is determined by the degree of the incline. Vertical traces (the line along which AVPs are located) can be extended above and below vanishing points left and right as far as you desire. It is important to note, however, that once an inclined plane reaches 90°, it is no longer treated as an inclined plane but as a vertical plane whose vertical edges do not converge.

In the examples given of inclined planes (rooftops, box flaps and stairs), it is important to note that each inclined plane seen in two-point perspective has one set of vanishing points located directly on the horizon line and one set of vanishing points located on a vertical trace that is an extension up or down from the remaining vanishing point. In the case of one-point perspective, vertical trace lines extend from the CVP. More specifically, those edges of an inclined plane that are horizontal (parallel to the ground plane) will converge on a traditional vanishing point left or right. The two remaining edges that are neither parallel nor perpendicular to the ground plane will converge on an AVP located above or below the opposite vanishing point (Figures 3-43 and 3-44). In the case of one-point inclined planes, receding edges will converge on an AVP located above or below the CVP (Figures 3-45 and 3-46). All inclined planes in two-point perspective will have one

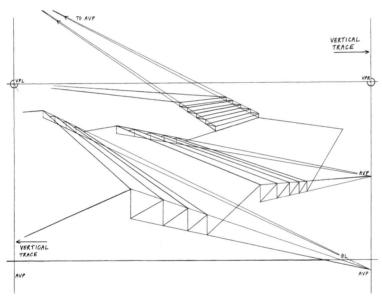

Figure 3-44. A two-point perspective view of descending stairs shows the inclined planes within which the stairs are positioned. Landings are positioned between each stairway's pitch or directional change. The two closest sets of stairs are at different pitches, the first steeper than the second. This is indicated by different positions of the AVPs. The most distant stairs are ascending at the same pitch as the central stairs.

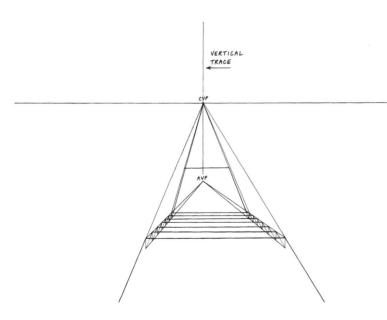

Figure 3-45. This drawing illustrates a one-point perspective view of descending stairs as inclined planes with a landing at the top and bottom. Note that the AVP is located along a vertical extension of the CVP. Only the treads, or horizontal planes, of the stairs are actually visible from this viewpoint.

Figure 3-46. A one-point perspective view of two adjoining sets of stairs shows only one set with a receding inclined plane (foreground). No convergence is necessary for the pitch of the other inclined plane that moves across the picture plane rather than into it.

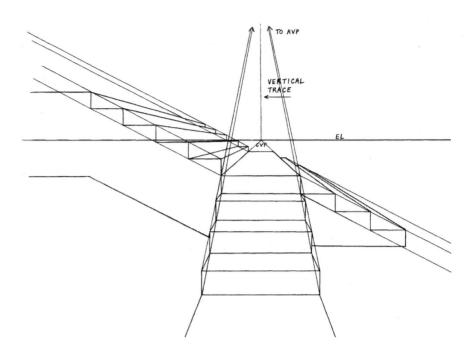

point of convergence to the left and one point of convergence to the right.

In the case of a peaked rooftop that has an equal pitch on both sides, the AVPs for the upward pitch and downward pitch are positioned equal distances above and below the horizon line to assure uniform pitch on both planes of the roof (see Figure 3-42). For inclined planes that have no edges parallel or perpendicular to the ground plane, both left and right points of convergence will fall on an AVP located on a vertical trace, one above the horizon line and one below the horizon line.

Geometric Solids and Transparent Construction

The geometric or Euclidean solids known as the cube, the cylinder, the cone, the sphere, and the pyramid provide the basic forms from which all other forms are composed. All forms, to varying degrees, can be ultimately reduced to one of these geometric solids or a combination of these geometric solids (Figure 3-47). With an understanding of cube construction and ellipse construction as it relates to a cube, any of these basic forms can be created, as well as infinite variations of these forms.

What Is Transparent Construction?

Geometric solids, along with gridded ground planes, cube multiplication, and cube division, also provide the foundation of understanding for transparent construction. Transparent construction involves the reduction of three-dimensional forms, both simple and complex, to their basic geometric solids (Figure 3-48) and a depiction of these three-dimensional forms that suggests their transparency, essentially defining information that is not actually visible from a fixed viewpoint. For example, one may draw a shoe in which we see simultaneously both the near side of the shoe and the far side of the shoe—a perspective version of X-ray vision (Figure 3-49)! The most basic skill necessary for exploring transparent construction is the ability to draw a transparent cube in perspective, defining all six faces of the cube as if it was made of glass.

To apply transparent construction to the depiction of an object, it is best to start with a form whose relationship to a cubic structure is readily apparent—a form that is composed of simple planes and perhaps some curvilinear contours that are rooted in ellipses. Certain children's toys, for example, are excellent subjects for beginning to explore transparent construction because of their inherent simplification and their obvious relationship to a rectangular solid. Examples include toy cars, trucks, or trains; cash registers; telephones; work benches; and other simplified versions of cube-based

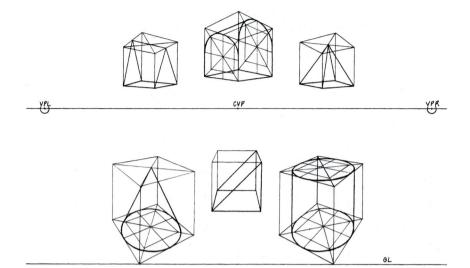

Figure 3-47. A variety of geometric solids and related forms are shown in their relationship to cubes. As cubes (such as the one on the lower right) approach the cone of vision, some distortion in the resulting geometric solid begins to appear as evidenced by the tilting ellipses of the cylindrical form.

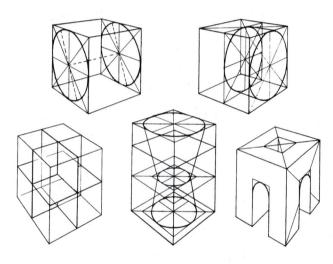

Figure 3-48. Cubes and cubic forms provide the structure for a variety of both simple and compound geometric solids and ellipses.

Figure 3-49. Student work. Scott Luce. A transparent construction drawing of a ski boot shows both the visible near side and the invisible far side. Cubic forms that remain lightly visible in the drawing provide a structural basis for analyzing the boot.

forms that are typically constructed of wood or plastic (Figures 3-50 and 3-51). More complex forms may be introduced as comprehension of the process increases.

Establishing the Cubic Connection

The important first step in the process involves determining the relationship of the form to a cube. Pick up the object you are going to draw and, by viewing it from all sides, determine what its cubic dimensions are (Figure 3-52). An object that roughly measures 12" tall, 18" long, and 6"

deep can be translated into cubic dimensions a few different ways. If you wish to work with a 12" cube as the basic unit of measure, then the object in its simplified form can be represented as 1 cube tall, 1½ cubes long, and ½ cube deep, using cube multiplication and division to create the proper dimensions. If you wish to work with a 6" cube as the basic unit of measure, then the object can be represented as 2 cubes tall, 3 cubes long, and 1 cube deep. If you wish to work with a 3" cube as the basic unit of measure, then the object can be represented as 4 cubes tall, 6 cubes long, and 2 cubes deep. If you encounter dimensions that

Figure 3-50. Student work. Theron J. Willis. An in-progress transparent construction drawing of a toy train car provides evidence of the numerous two-point perspective lines that guide the transparent construction of this form.

Figure 3-52. Student work. Liisa Rupert-Rush. Identifying the cubic structure of a cowboy boot in adjacent schematic drawings provides vital information for a more informed investigation of the boot.

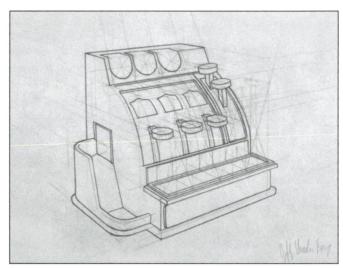

Figure 3-51. Student work. Jeff VandenBerg. A fully developed transparent construction drawing of a toy cash register reveals numerous delicate construction lines that guide the drawing process.

involve more irregular fractions of a cube, such as thirds, you can either estimate thirds of a cube or use a measuring line for a precise determination of thirds. A gridded ground plane may also be used as a sort of template in helping to determine cubic dimensions. The object's relationship to a gridded ground plane in a plan or overhead view can be translated to the object's relationship to that same gridded ground plane when seen in perspective.

If you wish to begin your drawing with a cube whose dimensions are estimated, then you can place your initial cube in any number of positions within your perspective environment, being careful not to violate your cone of vision as you multiply the initial cube to create the overall dimensions (Figures 3-53 and 3-54). If you wish to begin with a drawn cube whose dimensions are precise, then you must determine whether you want to work with a 45°/45° view of the object you are drawing or a 30°/60° view, and construct your initial cube using one of the appropriate cube construction methods described earlier in this chapter. With the object in front of you as a reference, you can represent the form from any desired vantage point—above or below or on eye level—without actually viewing it from that particular vantage point.

Initially, the process of transparent construction can be time consuming and somewhat frustrating as it requires patience and some careful consideration about the best way to approach the form. It is helpful to work from general to specific, identifying and defining the largest and

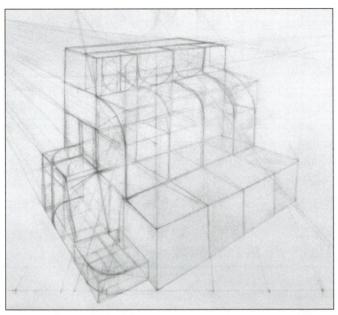

Figure 3-53. Student work. The cubic structure of this toy cash register is shown to be approximately 5 cubes wide including the side tray, $3\frac{1}{2}$ cubes deep, and $3\frac{1}{2}$ cubes high. The eye level (horizon line) is just beyond the upper edge of the drawing surface.

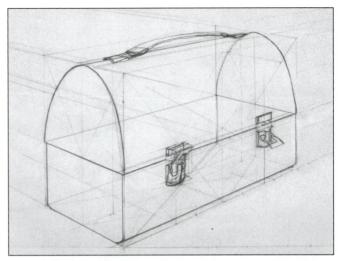

Figure 3-54. Student work. The cubic structure of this lunchbox is shown to be approximately 4 cubes wide, 2 cubes deep, and $2\frac{1}{2}$ cubes high.

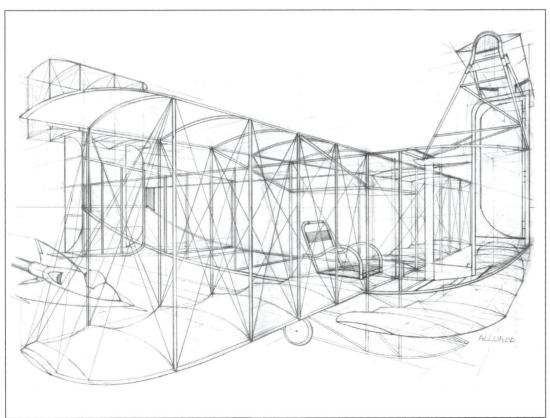

Figure 3-55. Ralph Allured, American, Imaginary Flying Machine in Two-Point Perspective, 1997. Graphite on paper, 11 x 17 inches. Courtesy of the artist. The large, basic shapes of the wings and body of this imagined flying machine were established first using technical perspective and some mechanical aids, followed by details in the structure of the wings and the body using both technical and freehand methods.

Figure 3-56. Ralph Allured, American, Study of Reclining Chairs in Two-Point and One-Point Perspective, 1997. Graphite on paper, 11 × 17 inches. Courtesy of the artist. A ruler, compass, and gridded ground plane were used to develop this technical perspective drawing of reclining chairs viewed in a variety of positions. A number of inclined planes in this study converge on AVPs, but here the AVPs are labeled as ECVP (elevated central vanishing point) and LCVP (lowered central vanishing point).

Figure 3-57. Ralph Allured, American, Boat Studies in Three-Point Perspective, 1997. Graphite on graph paper, 11 × 8½ inches. Courtesy of the artist. As the artist's notes in the upper right corner indicate, these three-point perspective studies of two boats are drawn freehand, with no established vanishing points. A ruler is used to sharpen significant edges when considered necessary.

simplest characteristics of the form first before addressing more detailed information that is rooted in the simpler form (Figure 3-55). If you are initially approaching transparent construction through technical perspective, then the use of rulers and T-squares and other mechanical devices requires a bit more care and precision (Figure 3-56). Once you have an understanding of the process, it is wise to explore the application of transparent construction principles in a freehand manner as well, using no mechanical aids or using them minimally (Figure 3-57).

Three-Point Perspective

In one- and two-point perspective, it is assumed that all edges that are truly vertical (perpendicular to the ground plane) are also parallel to the picture plane, and therefore do not converge on a vanishing point but rather remain true verticals in the drawing. In three-point perspective, which is typically used to address forms that extend well above or below the eye level/horizon line, it is acknowledged that in order to observe these forms we must tilt our head up or down. Because the picture plane remains parallel to the plane of our face in perspective, the picture plane must also tilt in relation to the object or objects being observed, and consequently no edges of a cubebased structure remain parallel to the picture plane. Therefore, all parallel edges (including verticals) must converge on vanishing points (Figure 3-58).

We already know that all edges that are parallel to the ground plane (horizontal) and moving away from us converge on either VPL or VPR. The third vanishing point, upon which vertical edges parallel to each other will converge, is positioned directly above or below the CVP, depending upon whether the form is viewed from a low vantage point or a high vantage point.

Three-point perspective is actually applicable far more often than it is used, but because of its increased complexity and time intensity, its use is reserved for drawings that demand three-point perspective for visual accuracy or effect. For some artists or designers, mathematical precision may be desirable or mandatory, and a more in-depth investigation of strict three-point perspective may be required for work of greater complexity. Because in three-point perspective there are many more steps required for the precise

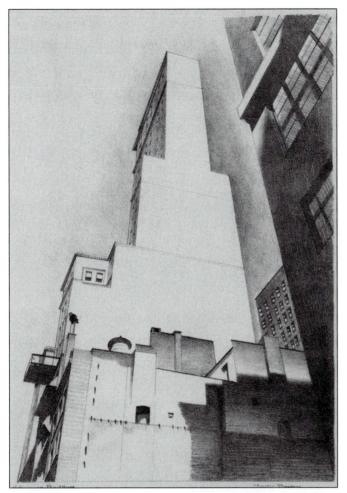

Figure 3-58. Charles Sheeler, 1883–1965, *Delmonico Building*, 1926. Lithograph, composition: $9\% \times 16^{11/16}$ inches, sheet: $14\% \times 11\%$ inches. Gift of Abby Aldrich Rockefeller. 1267. 1940. The Museum of Modern Art, New York. Digital Image © The Museum of Modern Art/ Licensed by SCALA/Art Resource, NY. In three-point perspective, shown here from a worm's-eye view, the vertical edges of the buildings converge on a single vanishing point that is positioned directly above the CVP located on the eye level line.

construction of even a simple cube, we allow here for informed estimation of heights, widths, and depths as often as possible to make the process more expedient and user-friendly. This more relaxed approach is especially applicable for artists whose work does not require absolute precision but are simply interested in the ability to convey the illusion of three-dimensional form and space convincingly.

Constructing a Form in Three-Point Perspective

- 1. All preliminary information should be established and drawn, including scale, eye level/horizon line (EL/HL), ground line (GL), station point (SP), central vanishing point (CVP), vanishing points left and right (VPL/VPR), vanishing point three (VP3), units of measure along the horizon line that reflect your scale, units of measure along a vertical measuring line that reflect your scale, and cone of vision (Figure 3-59).
- 2. If your EL is high, as in a bird's-eye view (if you are above, looking down), position your EL/HL nearer the top of your drawing format. If your EL is low, as in a worm's-eye view (if you are below, looking up), position your EL/HL nearer the bottom of your drawing format. From this point on, we are assuming a worm's eye view in three-point perspective for purposes of explanation.
- 3. In establishing the scale for your drawing, think in terms of a scale that can represent larger structures such as buildings (e.g., 1'' = 10' or $\frac{1}{2}'' = 10'$).
- 4. Draw a vertical line up from the CVP and off the top of the drawing format. The third vanishing point (VP3), which identifies the point of convergence for all vertical edges in three-point perspective, must be plotted somewhere along this line. The farther up this line VP3 is located, the less the picture plane is assumed to be tilted, and the less the verticals will be foreshortened. This yields a more subtle effect. Conversely, the closer VP3 is located to the EL/HL, the more the picture plane is assumed to be tilted, and the more the verticals will be foreshortened. This yields a more dramatic effect. As a general rule, the minimum distance of VP3 from the eye level/horizon line should be no less than the total distance between VPL and VPR. This serves to minimize distortion. If VPL or VPR or VP3 are located outside of your drawing format, then wings will need to be attached to your paper.
- 5. Locate and *estimate* the height of the leading edge of a cubic structure in a centrally located position, along or near the vertical line that passes through the CVP. This leading edge must converge upon VP3. Keep in mind the scale you have established in estimating the height of the leading edge. Because the leading edge is foreshortened (contrary to two-point perspective), it will be shorter than if the same size cubic structure was drawn in two-point perspective. This will be your "key" structure, which will help to determine the size of all other structures. Stay within the cone of vision to avoid distortion.

Figure 3-59. This drawing illustrates threepoint perspective from a low eye level or worm's-eye view. The perspective set up is the same as for a two-point perspective drawing with the addition of a third vanishing point (VP3) that is positioned well above the eye level and upon which all vertical edges converge. The convergence of vertical edges is indicated by dotted lines.

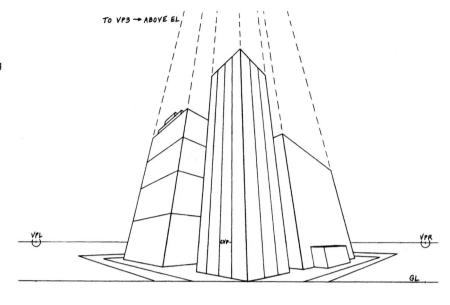

Figure 3-60. This drawing illustrates three-point perspective from a high eye level or bird's-eye view. The three main structures are similar to those presented in the worm's-eye view, but because they are viewed from such a different eye level, their appearance changes dramatically. A horizontal measuring line was used in this drawing and in Figure 3-59 to determine the vertical divisions in the tallest structure.

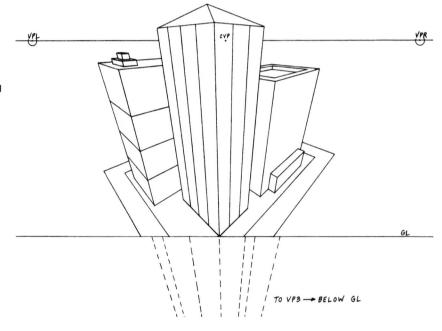

- 6. Draw lines of convergence from the top and bottom of the leading edge to VPL and VPR, estimate the desired width of the structure, and extend all verticals to converge at VP3. This completes your cubic structure in three-point perspective.
- 7. The height of the leading edge of additional structures can be scaled as usual from the leading edge of the key structure, using SVPs located along the horizon line. Additional structures can be made larger, smaller, or the same size as the key structure. This process is essentially
- the same process used for scaling the height of a leading edge in one- or two-point perspective, but all verticals determined by scaling will converge on VP3.
- 8. To determine divisions in the width of a structure (either equal or unequal divisions), use the familiar horizontal measuring line system explored in two-point perspective and explained earlier in this chapter (Figure 3-60).
- 9. For determining divisions in the height of a structure (comparable to the number of stories in a building), it is recommended that you estimate these divisions, keep-

- ing in mind that as you move up the structure (a worm'seye view) or down the structure (a bird's-eye view), the increments will become increasingly smaller to reflect diminution.
- 10. For drawing inclined planes in three-point perspective, AVPs will still be located on vertical traces, but these vertical traces will extend from VP3 to VPL and VPR and beyond rather than being truly vertical.

Suggestions for Perspective Exercises

Following are some suggestions for both technical and freehand exercises that encourage creative exploration and application of both beginning-level and more advanced and complex perspective processes and techniques. These exercises are accompanied by illustrations of student solutions. They require your understanding of the essential building blocks of perspective, including systems and processes such as one- and two-point cube construction, one- and two-point gridded ground planes, scaling techniques, sliding vanishing points, ellipse

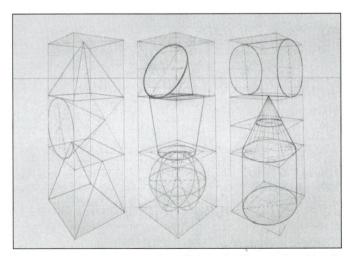

Figures 3-61. Student work. Dean E. Francis. The relationship of various geometric solids to a cubic solid is explored in this linear perspective study. Cubes, cones, cylinders, vessels, a wedge, a pyramid, and a sphere are shown at different positions in relation to the eye level and the central vanishing point.

construction, various methods for cube multiplication and division, inclined planes, the relationship of geometric solids to transparent construction, and three-point perspective.

You are encouraged to determine the specifics and the variables of the exercises, including any restrictions or requirements you wish to impose upon yourself. While some exercises are better suited for technical perspective, it is reinforcing to explore a technical system using freehand techniques. It is strongly suggested that you incorporate at all levels of exploration the use of a variety of different eye levels, scales, and station points, including forms drawn below, at, and above the eye level, both grounded and floating.

- Draw a series of cubes in both one- and two-point perspective and practice constructing various geometric solids that incorporate both straight lines and planes and elliptical forms within the cubes (Figure 3-61).
- Create and draw a still life of various boxes—small, medium, and large—and arrange them in a variety of positions. Stack them, lay them on their side, and arrange the flaps at different angles. Remember that, in these various positions, there will be multiple sets of vanishing points upon which the receding planes will converge (Figures 3-62 and 3-63).
- From imagination, draw a complex maze or mazelike structure in two-point perspective. Practice stacking forms, varying cubic structures, and drawing construction lines to converge on vanishing points precisely (Figures 3-64–3-66).
- From imagination, draw a cityscape in one-, two-, or three-point perspective. Vary the shape, height, and position of the buildings, and include architectural details and embellishments (Figures 3-67 and 3-68).
- Using freehand two-point perspective, draw from observation a room interior with which you are familiar. Use sighting and your understanding of perspective principles to accurately represent the structure of the room and the things found in the room (Figures 3-69–3-71).
- Practice transparent construction in relation to both simple and more complex forms. The more clearly you can see the relationship of the form to a cubic shape, the easier it will be to apply transparent construction. Be patient as you explore more complex forms, as they require more time and incorporate a greater range of perspective processes (Figures 3-72–3-82).

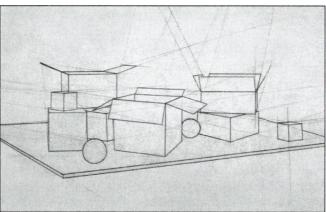

Figures 3-62 (student work—Matt Grindle) **and 3-63** (student work—Jeff VandenBerg). Arrangements of boxes and box flaps on tabletops are explored in these two drawings. Sighting, freehand perspective, and technical perspective are used together to create convincing illusions of three-dimensional forms and space.

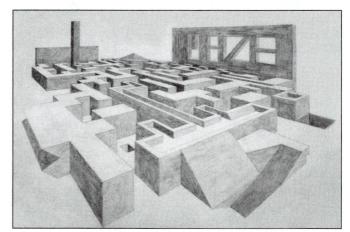

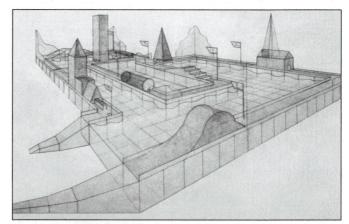

Figures 3-64 (student work—Gill Whitman), 3-65 (student work), and 3-66 (student work—Jennifer Rocco Castaneda). These three drawings are examples of invented two-point perspective mazes and mazelike structures. Cube construction, cube multiplication, stacking cubes, and creating forms that are variations of cubes are all vital elements in this particular exercise.

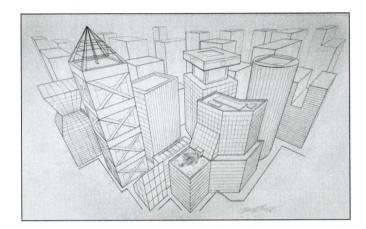

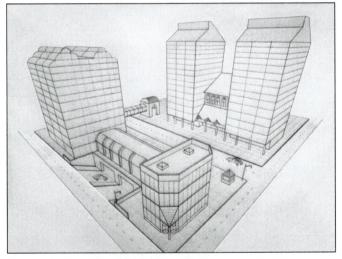

Figures 3-67 (student work—Dean E. Francis) and 3-68 (student work—Gill Whitman). These two drawings are examples of imaginary three-point perspective cityscapes. Various architectural variations are introduced for visual interest and authenticity. Note that all vertical edges converge on a common vanishing point that is positioned below the drawing surface.

Figure 3-69. Student work. Dean E. Francis. This two-point perspective drawing focuses on the construction of an imagined room interior and its furnishings. The circular format describes the cone of vision.

Figures 3-70 (student work—Lea [Momi] Antonio) and 3-71 (student work—Chris Johnson). These two drawings are examples of two-point perspective studies of observed room interiors and their contents. The rooms are drawn from direct observation with all angles and size relationships determined through sighting only.

Figures 3-72 (student work—April Maturia) and 3-73 (student work—Peggy Jackson). Delicate construction lines indicate that these drawings include an exploration of transparent construction. The construction lines guide the shape and placement of ellipses and help to maintain the relative symmetry of the forms.

Figures 3-74 (student work) and 3-75 (student work—Jeff VandenBerg). Metal lunchboxes are relatively simple forms with a clear relationship to cubes, providing a good introductory experience for exploring transparent construction.

Figure 3-76. Student work. Cubic forms can easily be compared to the strong vertical and horizontal aspects of a ski boot, providing a form with more detail for the investigation of transparent construction. Establishing the larger and simpler forms first establishes more structure for drawing the details that are based on the larger, simpler structure.

Figures 3-77 (student work), 3-78 (student work—Matt Grindle), and 3-79 (student work). Children's toys provide a good opportunity to investigate transparent construction as it might apply to actual full-scale forms such as a mailbox, a truck trailer, or a jeep. All three of these drawings were done from direct observation of children's toys. Note the differing degrees of success in interpreting the elliptical shapes of tires.

Ganthalia 200 Students work (data) Debanda America

Figure 3-80. Student work (detail). Deborah Augustine. Common household objects are readily available and provide a good resource for exploring transparent construction with varying degrees of complexity. As your understanding increases, you can explore more complicated forms in greater detail.

Figures 3-81. Student work. Paul Brandt. A foreshortened view of a handgun is drawn using transparent construction. On the right is a more detailed analysis of a portion of the interior of the handgun.

Figure 3-82. Student work. Steve Kilgore. The upper drawing shows three different views of the reel of a fishing pole and two fishing lures. The lower drawing shows a portion of the drawing in greater detail. Although construction lines are not evident in this final version of the drawing, transparent construction was used to analyze the different views of the objects.

Developing Ideas, Resolving Problems, and Evaluating Results

Ideation: Generating Ideas

Ideation is really just a fancy word that refers to the process of forming or generating ideas or images, and clearly this process is vital to the creation of art. All the technical skill in the world does not rescue a work of art that is poorly conceived and/or lacking in strength of idea.

For hundreds of years, human beings have explored various methods for coming up with ideas—some of which have been unconventional to say the least. For example, Beethoven would often pour cold water over his head, thinking that it jogged his creativity. And the story goes that Schiller, the famous German poet, could only write if he smelled rotten apples, so he would keep decomposing apples in the drawer of his writing desk. The great novelist Dickens aligned his bed to the North Pole, believing the magnetic lines in the earth gave him his creative abilities. But in fact ideation is a

natural process, one that we all knew well as children but may have lost sight of as adults. As children we were driven by imagination and curiosity, and as artists these remain vital components in the process of nurturing creativity and developing compelling ideas.

Imaginative Thinking and the Brain

The following information (edited for length) is taken from the writing of Dr. Marvin Bartel, Emeritus Professor of Art at Goshen College in Goshen, Indiana.

Central to the process of art and central to the success of artists is the ability to generate original ideas, designs, and compositions. Imaginative thinking is at the core of art as well as a number of other disciplines, but the art of imaginative thinking is often not well understood by students and is often not practiced as an integral part of course work. For many of you, the source of ideas for art really remains a

mystery, and this can lead to a lack of confidence in your ability to generate and develop your own ideas.

Studies show that we lose our divergent thinking ability, our ability to think outside the box, as we mature. Why does this happen? We should not assume that education, parenting, and societal factors are the only things causing this loss of creative thinking habits and skills. The normal biological development of our brains may be programmed to change the way the brain works as we mature. Divergent thinking allows our brains to scan all compartments and categories and to look in all the unexpected places for possible ideas. Young children have fewer fixed categories, so it may be natural for their brains to be flexible and quick in this respect. As we accumulate more knowledge we categorize things and our brain tries to keep a log (remember) of where everything is. As we mature the volume of information and the categories become immense and overwhelming at the same time that our brains become less flexible. It gets harder and harder for us to scan all these compartments. The need to get things organized seems to be a very important part of our evolved genetics (and sanity). Furthermore, we know that genetics varies between individuals, so we may be genetically predisposed to be more or less capable of divergent thinking and creativity.

To the extent that the youthful brain is malleable, creating art is a perfect venue in which to practice and nurture the brain's imaginative powers to make choices and connections between experience and expression. Art is an ideal venue with which to practice imagining scenarios that go beyond anything experienced in the past. When you write about art, describe it, have discussions about artistic quality, and create aesthetic descriptions of your surroundings, you can be learning to make creative connections with your own experiences and you can imagine and speculate about experiences you have never actually observed or experienced. Like good science education that encourages observation and wonderment about how things work, art education can build minds that observe, wonder, imagine, and create. In this way, art history and the study of art world content can become concept centered rather than product centered. Works can be studied for why they were made and for how the artist strategized them.

Imagination, Creativity, and Brainstorming

Imagination requires divergent thinking and allows us to form a mental image of something that is not perceived as real and is not present to the senses. Imagination reveals what the world could be rather than what it is. Imagination is the capacity to see the unseen. Imagination can give us practice in the ability to hold a variety of different and conflicting notions in our minds simultaneously.

Creativity and imagination compel us to look at one thing and see another, to entertain a new or different arrangement of known, existing elements. A creative person is not necessarily someone who tries to create something totally new, but rather someone who mixes existing elements into a new or different arrangement. Consider, for example, the world of music and the piano as instrument. All composers for the piano use the same known elements to create their musicthe eighty-eight keys of a piano. They simply arrange them differently, or, in the case of the composer John Cage, they conceive of different ways to coax sound from the piano. This idea applies not only to music but also to so many creative endeavors, including literature, poetry, filmmaking, choreography, screenwriting, and the visual arts. As visual artists, we have the potential to create limitless variations from a menu of options-point, line, plane, shape, form, mass, volume, texture, value, color, positive space, and negative space-regardless of process, media, or subject matter.

The Process of Brainstorming

Brainstorming is a rapid, spontaneous, idea-generating activity, and it is a great way to get the creative juices flowing. It can be done singly or as a group. The idea behind brainstorming is to generate a lot of different ideas or solutions to a problem or a question. Ideas generated by brainstorming can be recorded in a sketchbook through written words, quick sketches, collaged images or information, diagrams, digital photos, voice recording, and any other means that allows you to record ideas quickly in a way that you can understand and access later. Because you are brainstorming for drawings, ultimately your ideas will be expressed in a visual form.

When brainstorming, begin by defining the problem to be solved or by asking a question relevant to the task at hand. Write it down and speak it out loud. Brainstorming in response to this problem or question may likely generate more problems or questions that generate even more ideas. Think in broad terms initially, allowing yourself to freely associate and letting one idea build upon another. Don't edit or censor any ideas. The very nature of brainstorming suggests that at this point in the process, everything is valid for consideration. Try to imagine ideas or solutions through an unfamiliar viewpoint by placing yourself in an imaginary role or position—as a child, as a large or small animal, as an inanimate form, as an alien, as someone from another culture or country, as a member of the opposite sex, as your father or your mother, and so on. Try to see, both literally and in your mind's eye, from as many different viewpoints as possible.

Your sketchbook is an ideal place to record the results of a brainstorming session and to take these results and begin developing and exploring them more thoroughly. The advantage of a sketchbook is its portability and its privacy. It is a place to record possibilities freely without the fear of "making mistakes" or "messing up." And ideally, as an art student, you should always have a sketchbook of some sort in your possession because you never know when an idea may come to you or when a grand opportunity to sketch will present itself. You can also keep multiple sketchbooks of various sizes if you prefer. Sketchbooks range in size from $4" \times 6"$ to $14" \times 17"$. They come in a wide range of formats and papers, including hardbound sketchbooks and wirebound sketchbooks, which have the advantage of being folded back to provide a flat surface on which to draw. You may have one sketchbook that is less private, especially if your instructor requires you to submit a sketchbook for evaluation. You may also want to have a sketchbook that no one will see unless you decide to show it to them.

Diagnosing Problems in Your Work

Regardless of our efforts to the contrary, it is nearly impossible to critique work in a purely objective fashion, particularly when it is our own work that we are critiquing. But objectivity is a worthy goal. Bear in mind that there are those aspects or qualities of a drawing that can elude analysis, rooted instead in intuition or personal sensibility. While you may not be able to specifically identify their presence in a drawing, you may know when you encounter them, and efforts to describe them through language may find you marveling at the essential inadequacy of words in the face of something that defies a language-based description.

In your initial experiences of formal art education where observation of form/subject is the primary objective, it is quite possible to identify some recurring problems that you will encounter in your drawing experiences. An awareness of some of the more insistent hurdles and problems will provide you with a solid framework for diagnosing problems and critiquing your own work and the work of others. As is the case in any situation where troubleshooting takes place, effective solutions are more readily arrived at

when there is a clear identification of the problem. In some instances, a problem will be a problem in relative terms only, as an element of a particular drawing. What may be troublesome in one drawing may be a necessary and working element in another. In many other instances, a problem or defect in a drawing will be nearly universal—that is, it would be a problem in the context of any drawing.

An example of this would be a drawing of the human head, based on observation and the desire for a likeness, in which the eyes are located too high in the overall shape of the head, which in turn alters all of the proportions of the face. This is a perceptual error that would not be relative—it would be considered a problem in any drawing. Some may say that altering proportional relationships of the features of the face can have powerful expressive properties, and this is most certainly true. But the distinction here is grounded in *intention*. Your *intention* to distort for expressive purposes is distinctly different from an *accidental* and inconsistently applied distortion based on perceptual and observational errors.

Following are some general drawing problems that you may encounter on a fairly regular basis in your own work or in the work of others, regardless of subject matter.

Inaccurate Proportional, Scale, or Shape Relationships

This is perhaps one of the most common weaknesses in the work of students in the early stages of their development. Whether in a drawing of the human form or of a still-life arrangement of forms, an awkward and inaccurate size relationship between parts of a form or between one form and another is apparent. In this instance, there is generally a disregard or lack of understanding for sighting techniques or other measuring techniques used to observe size and shape relationships between parts of a subject or between multiple subjects in a drawing. In the event that sighting techniques are understood but not applied, there is a tendency to draw what you experientially know about your subject rather than what you actually observe, and these two attitudes are frequently in conflict. For example, we know that a particular chair has a square seat and four legs that are equal in length. We know this because the square shape of the seat of the chair has room for and supports our buttocks when we are

seated on it, and the chair rests firmly on the floor because its legs are all the same length and meet the floor simultaneously. But when observing the chair from an oblique angle, the seat does not appear to be in the shape of a square, and the legs appear to meet the floor or ground plane in different places, implying that the legs are not all equal in length. With this example, it is easy to understand how an emphasis on "knowing" versus observation can contribute to a drawing's demise.

With the human form as subject, proportional problems are common, indicating a lack of regard for relating the scale or size of various parts of the figure. Proportional problems may also indicate a disregard for establishing a unit of measure as the basis for determining the relative scale of all other forms to this unit of measure. In the case of the figure, the unit of measure is most often the head. Again, the tendency to draw what you experientially know about your subject rather than what you actually observe contributes to degrees of visual illiteracy. We know that there is a certain length to the thigh or upper leg, for example, in relation to the length of the lower leg. But when we observe the figure seated in a chair, we see a foreshortened view of the thigh that often does not relate to the lower leg in the way that we would expect. This difference between what is known and what is seen may create a conflict, and the more familiar "what we know" will override the less familiar "what we see." So we lengthen the thigh in an effort to get it to match what we "know" about a thigh, and the figure appears to be sliding off the seat of the chair because of the conflict between the position of the body and the adjusted proportions.

In some instances when proportional problems surface in your work, there is an emphasis on length relationships at the expense of width relationships. What may at first appear to be a torso that is much too long, for example, may actually be the result of a torso whose length is accurate in relation to the unit of measure but whose width is too narrow. The converse is also true. What may at first appear to be an arm that is incorrect in length may actually be an arm whose length has been accurately observed but whose width is incorrect, having been assumed or guessed at.

These perceptual short circuits require a more careful study and understanding of the principles of observing size, shape, and scale relationships and the underlying language translation from 3-D (the actual, observed form) to 2-D (the flat plane upon which the form is represented). Sighting and scaling are addressed in Chapters One, Two, and Three.

Multiple Perspective Eye Levels

If you are familiar with the principles of perspective, then forms that have an observable relationship to perspective (any forms derived from a cubic structure) can be represented with a clear sense of a fixed eye level or horizon line and with a clear sense of converging parallel edges meeting at a single point on that horizon line. But even if you have no prior understanding of perspective principles and no experience with drawing in perspective, sighting provides a method for accurately observing and recording the angles and lengths of a form's edges and axes. If sighting principles are applied with care and concentration, and if all forms are seen in their spatial relationship to all other forms, a unified sense of spatial placement and location can be achieved, even in the absence of specific perspective training. Once again, sighting provides a key component for accurate observation.

Foreshortening Inaccuracies or a Lack of Foreshortening

Foreshortening, especially in the extreme, can throw off even the most careful observer. Not only are the axes and the length and width relationships of forms altered (often radically), but the resulting shape of a form seen in a foreshortened view often bears no resemblance to how we typically imagine that form to look. Once again, sighting techniques are tremendously helpful in observing and recording foreshortened forms, whether they are found in the human figure, in a still life, in a study of an interior space, or in some other subject.

Foreshortening is related to the perspective principle of diminution in size. Not only does it alter the appearance of an isolated foreshortened form, but it may also create a radical shift in size or scale relationships between the various parts of a more complex form. This is highly evident in drawing a reclining figure. If the observer is positioned at the figure's feet or head, with the main axis of the body at a pronounced angle to the plane of vision, there will be various degrees of foreshortening observed in the limbs and the torso of the body. But there will also be dramatic differences in the size or scale relationship between near and distant parts, such as the feet and the head. Entire parts of a form may disappear in a strongly foreshortened view. Instances of overlapping increase or are heightened in a foreshortened view. In the event that these are not observed and recorded with care, the visual impact of foreshortening will not be achieved.

When confronted with foreshortening you must utilize sighting techniques to observe the often unexpected width, height, and size relationships. Avoid the strong inclination to tilt your sighting stick along the axis of a form, often unconsciously, as opposed to the correct technique of keeping the sighting stick within the two-dimensional plane of vision that represents the picture plane.

Flat and Restricted Line Work

This inadequacy in a drawing is characterized by line work that is uniform in tone, width, and texture and is generally found along the outermost contours of a form. Because of its uniformity and placement, it serves primarily to describe a flat shape rather than a volumetric form. If the line work ventures into the interior of a form, it usually does so reluctantly and lacks the sensitivity to describe a range of undulating surfaces such as may be found in the human form or other organic forms. Rather, that same uniform line within the interior of a form will tend to read more like a scar or a tear than as a description of a changing and shifting surface.

In this instance, you may have a very narrow idea of what constitutes an edge (the place where form meets negative space is one narrow definition), and you may view line as capable only of defining this particular kind of edge. The idea that line can describe volume and space is not a familiar one. If you accept the notion that line can beautifully describe form, volume, and space, you may still struggle with knowing when, why, and how to introduce variation into your line work. In addition to an awareness of the systems used to denote hard, medium, and soft drawing materials and their role in developing line variation, you must become familiar with the ideas governing the use of lighter and darker, thicker and thinner, softer and sharper, textured and smooth lines to denote edge, form, volume, and so on. Line variation is discussed in depth in Chapter One.

Detail or Specifics at the Expense of the Larger and More General Underlying Forms

Although overattention to detail can develop in linear drawings, this is an issue that is usually closely related to the use or misuse of value or tonal structure. In many cases, your drawing may progress well in the linear state only to begin to fall apart when you begin to explore value or tone as a description of form, volume, and light source. The problem is rooted in overattention to details and specifics at the expense of the larger, simpler forms and volumes upon which the details are

based. Detail attracts our eye, and it can be especially challenging to bypass detail until the "sponsoring or host form" is clearly established as a volumetric form.

In the figure, this issue most often develops in relation to areas of greater detail, such as the head and face or the feet and hands. Nostrils may be colored in as dark holes before the nose takes on any volume or structure. Eyelashes and irises may take precedence over the spherical form of the eyeball and the eyelids. On a grander scale, the eyes, nose, mouth, and ears may all be properly positioned and well defined, through tonal structure, as individual forms. But the facial features may be lacking a sense of cohesiveness because the greater form and volume of the head itself, upon which these features are based, has been ignored or underdeveloped. Hands may show all sorts of lines and creases and knuckles and fingernails, but this information may rest on fingers that lack volume and fullness. Nipples may rest on breasts with no volume.

The same premature scrutiny can be found in the study of inanimate or nonfigurative forms as well. A still-life arrangement of fruits and vegetables may focus on surface texture without acknowledging the spherical form upon which the texture is found. A study of a tree may excessively describe the texture of bark without sufficient emphasis on the columnar volume of the trunk and branches. A drawing of a shoe may obsessively describe laces and eyelets or the pattern found on the sole of the shoe while denying the larger volume of the shoe itself. A drawing of a house seen in two-point perspective may beautifully describe doors and windows and roof lines and columns and brick patterns, while missing the overall tonal shifts from one large plane or side of the house to another, which describes the house as a large cubic structure upon which the details of doors, windows, and other features can be found. As you can see, the list of examples is endless.

The solution to this problem is in repeated emphasis on working from general to specific and in utilizing techniques and exercises that facilitate this approach to observation. Exercises for reinforcing the process of working from general to specific are outlined in Chapter One and, in relation to the figure, in Chapter Two.

Scaling Inaccuracies in Relation to Perspective Principles

In its most fundamental state, problems with scaling are directly related to problems with proportional relationships between individual elements in a composition. If these individual elements do not relate to each other convincingly in terms of size, the integrity of the drawing is compromised. When forms can be observed directly, sighting techniques provide a means for determining accurate size relationships.

In its more specific application, scaling refers to a process based in perspective that determines the accurate size relationships of forms on a fixed ground plane in an illusionistic three-dimensional space. If you are attempting to invent elements in an illusionistic three-dimensional space without the benefit of direct observation, scaling issues will be evident through size and placement discrepancies. Forms may appear to be too big or too small in relation to other forms, or forms may appear to be unintentionally floating above a ground plane or crashing through a ground plane. Drawing situations where scaling problems may arise include attempts to address multiple forms within an interior space or a room environment or attempts to address multiple forms in a deep exterior space, such as a landscape or a cityscape. Doorways and furniture may appear too small to accommodate figures or too large; houses and trees and cars may appear too large or too small in relation to each other.

The process of scaling effectively establishes a corridor of convergence that determines the change in apparent size or scale as a given form is moved to different positions within the illusionistic three-dimensional space of a drawing. It also maintains an accurate size relationship between different forms within this same illusionistic three-dimensional space. The process of scaling is addressed in depth in Chapter One, in relation to the figure in Chapter Two, and again in Chapter Three as an element of perspective.

Lack of Volume or Timid Value Structure in Three-Dimensional Forms

As already discussed, lack of volume can result from excessive emphasis on detail at the expense of the sponsoring or host form. If this is not the cause, lack of volume is often rooted in inadequate tonal structure resulting from fear or timidity about tones getting "too dark." It may also result from a misuse of media based on a lack of awareness of different grades of lead, charcoal, graphite, conte, and other materials. You may be limiting yourself unwittingly to harder media that in turn limits the resulting tonal range.

It is important to make a distinction between timid, underdeveloped value structure and high key value structure. High key value structure would be sensitive to the six divisions of light and shadow (highlight, light, shadow, core shadow, reflected light, cast shadow) and would intentionally represent them using tones found on the lighter end of

the value scale. An anemic or timid value/tonal structure would not acknowledge the full and rich range of lights and shadows necessary for describing volume effectively.

In the event that you are misusing media because of a lack of awareness of the systems used to denote hard, medium, and soft drawing materials, you must inform yourself of the system and what it means. Harder tools make a lighter mark and can incise the paper if too much pressure is applied in an attempt to make a mark darker than what the medium is intended for. This is especially true in the case of drawing pencils. The softer the tool, the darker a mark it makes, the more easily that material will smear and move around, and the less easily or thoroughly it will erase.

In the case of timidity, you are encouraged to push tonal ranges further. It can prove helpful to set aside harder drawing materials and use medium and soft materials only. It may also prove helpful to "break the ice" by establishing an overall ground or base tone of vine charcoal from which to work both additively (with compressed charcoal pencils and sticks) and subtractively (with erasers). It may also prove helpful as an exercise to draw some lit forms whose local tone is dark to begin with, which can relieve some of the anxiety of making shadows on a light form too dark. Information on what to look for when identifying value structure can be found in Chapter One.

Overly Generalized Drawing

Overly generalized drawings are characterized by a lack of development beyond a certain intermediary point. The drawing is on the right path but is not reaching the destination. Description of volume or form does not address any details of surface or form, and value structure, if applicable, does not develop beyond an initial limited tonal range. The drawing is developed competently up to a certain point, but moving beyond that point is something that you either don't pursue or pursue hesitantly and with negative results. Often it is because you are afraid of "ruining" a drawing that is working well in the early or intermediate stages because you may not feel confident in developing darker passages that define a full value range (timid value), or because you are overwhelmed by the shift from generalized information to detailed information, or because your attention span is limited and you are unwilling or ill equipped to move beyond general analysis of form to more careful scrutiny. Encouraging yourself to "take the plunge" is important, with the understanding that practice and experience will make this transition from a moderately developed drawing to a fully developed drawing easier.

If technical issues seem to be more the problem than perceptual issues, understand that this is often a good time to make a shift in drawing materials, particularly if the initial drawing was developed using stick media. Detail is more easily addressed using pencil forms of lead or graphite or charcoal or conte, which provide greater control.

Substituting Recipes or Formulas for Careful Observation

This is a common problem in drawing, particularly when the form being drawn is one that has historically been the subject of "how-to" books or instruction that encourages you to use recipes or formulaic solutions. Careful analysis and observation is replaced with generalizations and stylizations (what you "know" vs. what you see) that result in generic-looking forms lacking unique character and integrity. If this approach to drawing is firmly established, it can be a difficult habit to break. It is often far more challenging to unlearn something that has become second nature than to learn something about which one has no prior experience.

Unintentionally Ambiguous Space

Ambiguous space that is arrived at unintentionally delivers mixed messages to the viewer, characterized by passages that convey form and volume juxtaposed with passages that read as flat, two-dimensional shapes. There may be a shift in technique or process or media from one part of the drawing to another, from continuous tone modeling to hatching and cross-hatching to outlining, for example. A unified language or "voice" is markedly absent, resulting in a drawing that is visually confusing, weak in presenting the compositional principle of harmony, and lacking in authority. It is a drawing that is hard to believe, difficult to trust. Addressing these shortcomings requires that you clarify your intention (what is the drawing intended to speak to) and that you are attentive to maintaining a relatively constant language that works toward realizing your intention.

Rigid or Pristine Drawings Lacking a Sense of Process

A drawing may be well composed and reflect accurate and careful observations of form, but still lack freshness and a sense of the process of drawing. This is often the result of your fear of making a mistake or your fear that a drawing will become too "messy." In an attempt to avoid this, there

may be evidence of an overly restrained approach that is reflected in a stiff or rigid drawing. A lack of enjoyment of or appreciation for the *process* of drawing is evident in the results. Line work may lack fluidity and every indication of process, if any even exists, may be painstakingly erased and "corrected." Fear and caution become obstacles, and the desire for perfection stands in the way of discovery through process and trial and error. Exercises that emphasize process over product can help you to develop enthusiasm for the act of drawing and for visual evidence of the search that is vital to the life of a drawing.

Sometimes this excessive caution is the result of previous drawing experiences, such as technical drafting, that may have emphasized a degree of precision that is frequently inappropriate for a freehand drawing. In this instance it is helpful to examine the different approaches and their relationship to the desired results and function of a drawing.

Disregard for or Poor Composition

Because of the many factors that must be considered in developing a strong composition, the ways in which a drawing may reflect poor composition are numerous. Typical compositional weaknesses in the work of beginning students are often grounded in a disregard for the most basic compositional "rules" or guidelines. Your work may show a lack of visual balance; awkward or overstated divisions in the picture plane; a lack of recurring similarities of line, shape, value, texture, or form necessary for compositional harmony; or a most fundamental disregard for the relationship between image and format.

This disregard is typically not intentional. It results instead from a narrow and singular focus on the individual forms or images that make up a drawing, eclipsing the need to pay attention, from the onset, to the relationship of forms or images to each other and to the format or picture plane that becomes their universe by defining the total space in which they exist. Key compositional concerns are discussed in Chapter One.

Intentions Versus Results

Discovering Disparity

On countless occasions I have witnessed the frustration of students who had very specific intentions for a drawing and thought they were clearly conveying these intentions only to discover that no one experienced their drawing in the way they intended, either formally or conceptually. The discovery of a disconnect between intentions and results is often revealed through the critique process, through a dialogue between viewer or audience and artist. Although it can be disconcerting to discover that you did not effectively communicate what you had intended to communicate, it is important to be receptive to feedback provided by peers and teachers. What they can provide you is a relatively unbiased perception of your work, free from all the internal dialogue and familiarity that you, as the artist, bring to the drawing. And you can provide others with the same unbiased perception of their work. This process of receiving and giving feedback does not work very well if you are conducting the exercise with a friend or classmate with whom you have discussed your drawing at length while in the process of creating it. The information you have shared about your ideas and your process tends to bias the feedback you receive. It works best when it is a "blind" process.

Descriptive Feedback

A few different methods can help highlight how your audience perceives your drawing. One method is to have fellow students describe your drawing to you and to the rest of the class as if they are speaking to someone who is visually impaired. This yields a very literal and thorough description of what the viewer is actually seeing in the work, which may or may not be as you intended. It is important when describing the various aspects of a drawing that you utilize the vocabulary of art and design as much as possible and that you make an effort to be very precise and accurate with the words you use in order to make yourself understood. If it is your work being described, it can be very difficult to listen quietly and to avoid the temptation to grow defensive about your work. But make the effort to do just that.

The process of description can be very informative in terms of understanding what others are perceiving visually as they examine your drawing. This initial description does not require judgment: It is not about quality but rather about visual perception—what is seen. Assuming a drawing of a still life as an example, the description can include objects or other information found in the drawing like drapery or ground plane or background (what is represented in the drawing), the placement and scale of objects on the page (where things are and how large or small they are), their relationship to other objects (e.g., things are near other things or distant from other things or are overlapping), whether or

not any information moves toward or off the edges of the format (e.g., objects are contained by the drawing surface or objects move off the drawing surface), the character of line work (e.g., line work is uniform in thickness or not, line work has value variation or not), the character of light source and value structure (e.g., there is a clear light source or not, value range is full or value range is limited), textural variations of various forms or objects (e.g., an object has a smooth surface or a rough surface), the kind of space used in the drawing (e.g., space is shallow, space is deep), the relationship of negative space to positive space (e.g., there is a lot of positive space and not a lot of negative space or vice versa), how negative space is treated (e.g., the negative space is blank paper, the negative space has value added), the media used to make the drawing (e.g., the drawing includes charcoal and conte, the drawing is done with graphite only), the character of the paper or other substrate (e.g., the paper is smooth without much texture, the paper is bright white or cream colored)...in other words, a description of the elements of the drawing and their organization or composition. The more in-depth the description, the better. It is beneficial to take notes during a discussion of your work so that you can recall feedback at a later time. A variation on this process is to conduct the exercise in writing so that your peers record their descriptions for you to refer back to after the fact.

Eventually this process of description can be expanded to include an analysis or judgment of quality. For example, line weight that is uniform in value and thickness may be discussed as working against a goal of volume and dimension. Variations in the size relationship of objects may be discussed as a positive factor in terms of creating variety and visual interest. The use of a highly dramatic light source and heavy value structure may undermine the delicate, fragile quality of the objects depicted. Your compositional choices or the arrangement of information may be wonderfully dynamic and interesting just as you intended.

Interpretive Feedback

Continuing with the example of a still life, if the drawing is intended to convey meaning as opposed to being concerned purely with observational drawing, the discussion and feedback can continue to include interpretations of what the still life represents symbolically or metaphorically. In this analysis, elements represented in the drawing can provoke different associations in terms of mood or meaning, both as individual elements and collectively as the various elements relate to each other. As author Gene Mittler states in his book *Art in Focus*, "Art objects are unique arrangements of

the obvious and the not so obvious. In order to understand any art object, you must be willing to go beyond the obvious and examine the not so obvious as well." All aspects of the literal description of the drawing can also be assessed in terms of meaning beyond the literal, and together these can reveal strengths and weaknesses, highlighting any disparities between your intentions and your results.

When thinking about objects or elements in a drawing in terms of their symbolic or associative possibilities, you may attach significance to something based on very personal associations, and this significance may not be accessible to or understood by your peers. For example, you may include something in a drawing because your grandfather gave it to you and he was a very important influence on you. Perhaps he helped to foster your interest in art. But unless the item he gave you conveys this association to a broader audience, the significance you attach to it will not be evident to others and the item may conjure up associations that are radically different from what you intended. There is always the potential for the viewer to experience aspects of a work of art differently than the artist intended. The main point here is to avoid the exclusive use of elements in your drawing whose significance or associative properties are too heavily coded or personal, known only to you.

It should be noted that it is not necessary that your drawing convey with absolute clarity your intentions. In fact it is generally more favorable to lead the viewer in the general direction of your intent while still leaving room for us to discover our own meaning based on our unique personal history that informs everything we experience. It is, in the opinion of many artists, far better to pose questions in your work and maintain some mystery than to provide all the answers. Ultimately the critique process, in whatever form it takes, is unequaled in revealing to you where you have succeeded in terms of your technical, formal, and conceptual goals for a particular drawing and where you have not.

Written Feedback as an Alternative to Spoken Feedback

Another method for highlighting how your peers perceive your work (intentions vs. results) is writing-based rather than speech-based, resulting in a written record of feedback for you to refer to at a later time. This exercise can be qualitatively focused so that it extends beyond description to include perceived strengths and weaknesses. Half of your classmates write down only positive comments (strengths or successes) about your work, considering technical, formal, and conceptual issues. The other half writes down only critical comments (weaknesses or problems), again considering

technical, formal, and conceptual issues. This approach offers a few distinct advantages. As mentioned, you have a record of everyone's comments for later reference. Additionally, your peers will tend to be more honest in written feedback (especially concerning problems) and will formulate their own ideas about your work rather than simply agreeing with what others are saying or not responding at all.

Clearly these techniques for helping you discover the relationship between your intentions for a drawing and what you actually achieve are closely connected to the critique process. Critiques have the potential to take you on a roller coaster of emotion from exhilaration to despair and everything in between. But a good critique is an invaluable part of an education in the visual arts. We make art and want others to see and appreciate the art we make. In the public arena, our art is subject to all kinds of judgment whether we like it or not. Why not learn as much as possible about this inescapable reality of the art world in the relative safety of the classroom?

The Importance of Critiques

It is not enough for a student to use a critique for advice on how to improve a piece, or a body of work. The whole process must somehow be internalized, lest the artist simply start to believe, to take at face value what his or her teacher, friends, and critics say, instead of engaging them in a dialogue. Whether the work comes from heart-wrenching pain and passion, or cynically cool media manipulation, the artist has to acquire the ability to see it from the outside, lest one's vision cloud one's vision.

Michael Bulka, artist

It is often through our "mistakes" that we learn the most. Ideally you will grow more comfortable over time with the notion that a critique is not simply a forum for praise and admiration, but more importantly an opportunity to learn about how to make your work stronger, how to make your work the best that it can be.

If you are entering college right out of high school, you may find yourself to suddenly be a little fish in a big pond after leaving a situation where you were comfortably established as a big fish in a little pond. This can be most disquieting, particularly if you were accustomed to receiving frequent praise from friends

and family and high school teachers and now find yourself in a different situation, one in which your work is subjected to more careful scrutiny and more evaluative processes. Remember that if you cannot currently accomplish certain things that are expected of you, with focus and hard work you will in time be able to accomplish these things.

Consider how it is that you define success. You may define success purely in terms of the "finished product" and in terms of the grade you receive for your work. Consider some different ways of looking at success. Even if your end result is not as effective or as strong as you would like it to be, think about what you learned during the process and whether or not you think it will help you in your subsequent work. To have learned something that you can take with you and use in the future is certainly an indication of at least some degree of success. Consider additional ways you can think of success in terms other than those to which you may be accustomed.

Group Critiques

A group critique provides some distinct advantages over individual critiques. Time constraints and practicality often do not allow for an instructor to meet individually with each of you to discuss the strengths and weaknesses of your work. Your instructor can convey the most information to the greatest number of students through the group critique format. While you may receive more individual attention in a one-on-one critique, at the same time you are missing out on the opportunity to learn by viewing the work of your classmates, offering feedback, and hearing what feedback others offer them regarding their work.

In a group critique, you are learning to think critically and to deal with differing viewpoints. You are also given an ideal opportunity to develop verbal literacy concerning the visual arts, offering your own responses to others' work and developing those responses beyond the most basic "I like it" or "I don't like it." The group critique can begin the process of learning discernment, of learning to distinguish fact from opinion, of learning to use the language of art and design, and of learning to give and receive praise and criticism with integrity and grace.

A few different methods for organizing group critiques are discussed in the previous section, "Intentions Versus Results." Remember that critiques are not just useful in response to a

finished drawing. It is also very helpful to receive feedback about a drawing while it is in progress. In this way concerns are addressed early on and you have an opportunity to make changes and adjustments. This is exactly what happens in the classroom on a day-to-day basis when you are working on an in-class drawing and the instructor is moving around the room and providing feedback as you work. For work that is done primarily outside of class, in-progress critiques function in the same way and can also reveal any misunderstanding or misinterpretation on your part regarding instructions or parameters for a project. If your instructor does not schedule in-progress critiques for drawing projects (either individually or as a class), then perhaps you can meet during his or her office hours to request comments and suggestions while your drawing is in process.

Individual Critiques

There are a variety of reasons for one-on-one critiques as an alternative or compliment to group critiques. Individual critiques may be the result of working with a teacher on an independent study basis, although this would be quite unusual for a foundation level student. Individual critiques may be held at the midpoint of the term or semester or at the end of the term or semester. Individual critiques may be something you arrange with an instructor if you feel that you are clearly struggling more than is necessary and would benefit from some private and individual attention. And of course there are those brief individual critiques that are an integral part of any working class session as your instructor moves around the room and provides individual guidance, encouragement, assistance, and feedback.

Students are generally happy to receive an instructor's individual attention and focus, even if only for a relatively brief amount of time. But it may also make you a bit nervous, particularly if you know that you are not doing very well and would like to be doing better in order to make a positive impression on your instructor.

Individual critiques that are conducted in complete privacy (in an office space or an unoccupied classroom, for example) provide both you and the instructor with an opportunity to address relevant issues in greater depth. You may feel more comfortable expressing confusion or uncertainty in private or may be more willing to ask questions that you fear are "stupid" if other students are not around. Take advantage of an instructor's office hours if you feel that you would benefit from an individual critique or meeting. Remember that your instructors are there to help you.

Key Questions for Critiquing Work

The following questions are helpful in directing your thinking during a critique. While there is some assumption that your work is dealing with recognizable imagery and/or objects, the questions can also serve to critique work that is rooted in abstraction or is nonobjective. Reference to "objects" in the questions suggests the presence of tangible and recognizable forms. By substituting the word "shapes" or "elements," the emphasis can shift to work that is more abstract in nature. Consequently, these questions could effectively address drawings dealing with a still life in which the objective is to record the information accurately and realistically, or these questions could effectively address a project that explores the elements of art and their arrangement in an abstract or nonobjective fashion. The focus of these critique questions is a broad-based analysis of your work. You may use these questions to facilitate your participation in a class critique, or you may use them to evaluate your work privately, both in progress and after it is completed.

Some of the questions imply that there is a "correct" and an "incorrect" way to approach your work. Other questions are intended to encourage you to think about variables in your work, what choices you have made, and why. Some questions may have no relevance to a particular project on which you are working. Use the questions that are most relevant to your work, and take into consideration any requirements or restrictions that may be in place if you are working on an assignment given to you by your instructor. If color is introduced through the use of chalk pastels or colored pencil or some other drawing medium, then you should also ask yourself questions that directly address the use of color in the drawing.

Questions Regarding Composition

- What kind of balance has been used in the composition? Has unintentional centralized or symmetrical balance been avoided? Has a more dynamic asymmetrical balance been used instead?
- Does the composition contain activity in different spatial planes? Have foreground, middle ground, and background been addressed?

- Do objects or elements in your composition occupy the foreground, the middle ground, and the background?
- Has attention been given to both positive and negative space? Has the arrangement of objects and/or positive space resulted in some interesting negative spaces?
- Have the objects in your composition been grouped in varied and interesting ways? Are there smaller compositions within the larger composition?
- Has overlapping been used in your composition? If not, why not? What does overlapping indicate?
- Are there objects of varying size and character, or are all objects roughly the same size? Are there both regular and irregular shapes or objects represented in your composition?
- Is there a combination of both open and closed shapes used to help integrate positive and negative space, or figure and ground?
- Is the entire composition developed equally, or are there primary and secondary focal points? Are there areas where the visual emphasis is greater and areas where the visual emphasis is lesser?
- Where are the literal or implied divisions in the picture plane located? Are dynamic divisions based on the Golden Section or the Fibonacci Series in evidence (2/3 to 1/3; 3/5 to 2/5...), or is the picture plane routinely divided into halves and/or quarters?
- Is the overall composition excessively crowded or excessively empty? Does this serve any significant purpose?
- Is there evidence of harmony (recurring similarities of line, shape, texture, value, and/or color)? At the same time, is there evidence of variety (recurring differences of line, shape, texture, value, and/or color)?
- Do the primary elements used in the composition deny the picture plane, or do they serve to reinforce and reflect the picture plane?
- Do directional forces and visual paths of movement direct the viewer's eye throughout the composition? Are there "dead" spaces in the composition?
- Are all forms fully contained by the picture plane, or has some cropping been used? If so, is the cropping occurring in a way that reinforces unequal divisions of forms, or are forms cropped in half?
- Has tonal structure or value structure been used in the composition? If so, is the general direction of the light source clearly identifiable?
- Are the values or tones in the composition well distributed and well balanced?
- Has value been used in both the positive spaces and the negative spaces, or just in the positive spaces?

 If tangible objects are being drawn, have cast shadows been used to help anchor the forms to a ground plane?
 Do objects appear to be floating?

Questions Regarding Drawing

- What is the subject being drawn? Does it involve representation, abstraction, simplification, distortion, or transformation?
- What media are used and on what kind of surface?
- What is the organizational element in the drawing?
 Is it a curve, a diagonal, a horizontal, a vertical, or a combination?
- What kind of line is used, if any—contour, mechanical, gestural, calligraphic, broken or implied, and so on. Where is line concentrated? Does it create mass? Does it create value? Does it define edges?
- Note the distribution of different types of line in a drawing. Are all the lines the same, or do they vary throughout the drawing?
- Is there line variation utilized in the drawing? Does the line variation reinforce volume and weight and directional light source? Is the variation random, or does it address specific concerns in relation to the forms or objects it depicts?
- What kinds of shapes predominate? Organic/curvilinear? Geometric/rectilinear? Do the shapes exist all in the positive space, all in the negative space, or in both? Are the shapes large, medium, or small, or a combination of all three? Are they the same size? Are there repeated shapes?
- How have shapes been defined? By line? By value? By texture? By a combination of these three?
- Are shapes flat, two-dimensional, and decorative, or are they volumetric, three-dimensional, and plastic?
- Is there value structure or tonality in the drawing? Can you divide value into three groups—lightest light, darkest dark, and middle gray? Can you identify in your value structure the six divisions of light and dark—highlight, light, shadow, core shadow, reflected light, and cast shadow?
- How are your values distributed throughout the drawing? Is value in the positive spaces only? In the negative spaces only? In both? Do the values cross over objects or shapes, or are they contained within the objects or shapes?
- Is value used to indicate a single light source or multiple light sources? Does value define planes? Does it define space? Does it define mass or weight?

- Does the value structure create a mood? Is it high key value, low key value, or a complete value range?
- Is invented, simulated, or actual texture used in the drawing? Is there only one kind of texture used, or are many textures used? Are textures repeated throughout the drawing?
- Have you used more than one medium? If so, does each medium remain separate from the other media, or are they integrated?
- What kind of space is utilized? Is it flat or two-dimensional or decorative space? Is it shallow space? Is it a deep or infinite space? Is atmospheric perspective used to indicate space? Is it an ambiguous space or a combination of different kinds of space?
- Are spatial indicators used? Is there evidence of diminishing size, variety in positions or base lines, overlapping, sharp and diminishing detail, sharp and diminishing contrast, linear perspective, or converging parallels?
- How is the composition related to the page or drawing format? Is it a small drawing on a large format? Is it a large drawing on a small format? Is there a lot of negative space? Does the image fill the format, or is there a lot of extra or unused space around the edges of the format? Do the negative shapes seem to have equal importance to the positive shapes? Are other compositional devices employed?

Questions Regarding Figure Drawing

Some of the issues that warrant attention in a critique of figure drawings are addressed in the critique questions concerning composition and drawing. But there are also some aspects of figure drawing that are specific to figure drawing and important to address in a critique that strives for thoroughness and specificity.

- Is the figure represented proportionately? Does the head relate to the torso, the torso to the limbs, the limbs to the extremities (hands and feet) correctly in terms of size? In other words, do the parts relate to each other in terms of size, and do the parts relate to the whole in terms of size? Is the width of forms considered in relation to the length of forms? Has the tendency to make the hands and feet too small been avoided? Is the process of sighting being employed to help determine accurate proportional relationships? Are the angles and axis lines of the figure accurate? Are the features of the face positioned correctly in relation to the head?
- Are the contours of the figure being addressed thoroughly?
 Is contour activity being overstated or understated or stylized? Do the contours of the figure accurately represent

the presence of anatomical elements and their influence on the appearance of the figure? Is attention being given to interior contours as well as exterior contours? Is the representation of contours taking into account instances of overlapping? Are contour lines reserved for actual edges in the figure, or is contour line being used to draw the edges of shadow?

- Is line work uniform in value and width and sharpness, or is there variation and sensitivity in the line? Are changes in value and width and sharpness in response to observed changes in contours, or does the variation in line work appear to be somewhat random? Does the line variation take into consideration the light source, the speed of contours, surface tension, and weight or mass? Does the line work convey a sense of volume in the figure, independently of shading or tonality? Do the quality and character of the line shift in describing the difference between delicate interior contours and firm exterior contours? Is there delicate line work underlying the more established line to convey a sense of process and search, or does the line appear stiff and rigid? Have appropriate medium and surface been used to build line quality and variation?
- Is composition being carefully considered? What is the scale of the figure in relation to the drawing format? Is the figure small on a large format or large on a smaller format? Is the entire figure represented, or are parts of the figure cropped? If there is cropping, is it planned and intentional or the result of poor planning? Does the placement of the figure on the page feel comfortable and balanced, or does it feel crowded to one side or to the top or bottom of the format? Does the scale of the figure on the format activate the negative space areas?
- Has value structure/tonality been addressed in a generalized manner in the initial stages, without premature attention to details? Is value structure distributed uniformly throughout the figure, or have focal points been developed? Does the treatment of value reinforce a clear light source, or does it create confusion regarding the light source? Can you identify the six divisions of light and dark in the drawing of the figure? Are details defined through value at the expense of the larger, simpler planes of value upon which detail is based? Does value cross over edges of the figure, or is value contained by edges of the figure? Does tonal structure help to identify anatomical structure? Has the relationship between shapes of shadow and shapes of light been accurately recorded? Are there abrupt value transitions, or gradual value transitions, or both?

Questions Regarding Perspective

The way in which perspective is being explored can vary. While these questions are generally addressing work that focuses purely on perspective and the cubic form as the basic geometric solid from which many other forms are derived, it is also possible to apply many of these questions to work that incorporates elements of perspective without being specifically focused on perspective.

- Is weighted line used effectively in the composition? Is line quality used to define the foreground, middle ground, and deep space? Lines should be darker and thicker in the foreground, growing progressively lighter as they move toward the vanishing point. Is there a gradation from darker to lighter line in the drawing?
- Is value/tonality used in the perspective study? Does the use of value help create a sense of spatial depth? Is the gradation from darker to lighter effective in describing planes and volumes? Is there a sense of consistency in the use of value in relation to light source?
- Has the placement of forms on the picture plane been carefully considered? Is the composition varied and interesting, employing principles of composition such as balance, harmony, and variety?
- Are the cubes drawn in correct proportion on their foreshortened sides? Cubes should look as though they are equal-sided. Do the cubes look more like rectangular solids than like forms that have six equal sides?
- Has the scale determined for the drawing been adhered to? Are the VPL and VPR or the SVPL and SVPR located in the correct position in relation to the station point? Is the eye-level line or horizon line the correct distance from the ground line according to established scale?
- Are the forms below the horizon line sitting firmly on the ground plane, or do they appear to float?
- Is overlapping used correctly, ensuring that the mass of one form or cube does not trespass into the mass of another? This error occurs when two cubes or forms appear to be occupying the same space. Have cubes or forms derived from cubes been drawn transparently in order to identify if trespassing is occurring?
- Are the sizes of the forms consistent with their position on the picture plane? Forms that are lowest on the page should generally be the largest. Forms that are higher in relation to the horizon line should generally be smaller. This relationship is reversed for forms located above the eye level.
- Is there a gradation from large to small on the picture plane? Is the diminution too extreme, or does it need to

- be more pronounced? Is the progression from large to small smooth and consistent?
- Is the convergence of the forms executed correctly?
 Do lines and surfaces on forms appear to come together as they recede from the viewer toward vanishing points?
- If the subject is in one-point perspective, are the lines of convergence meeting at the same vanishing point? If the subject is in two-point perspective, are the lines of convergence meeting at the proper vanishing points?
- Are the sides, tops, and bottoms of forms properly foreshortened as their angle to the picture plane increases or decreases? Often cubic forms are not foreshortened enough.
- Has the cone of vision been established? Is the cone of vision too constricted? Is distortion present in any of the cubes or forms near the edges of the picture plane? Has the cone of vision been adhered to?
- If construction lines are to be present in the final presentation, are they appropriately light and delicate, or do they interfere with the reading of the drawing?
- Is the presentation of the drawing strong? Is the drawing clear and clean and readable? Are points of intersection and points of convergence precisely drawn? Are all vertical lines drawn parallel to each other and drawn as true verticals? Is the drawing crumpled, creased, or otherwise disheveled?

CHAPTER 5

Drawing Materials and Processes

Media and Materials for Drawing

Traditionally, drawing was understood to utilize certain materials, such as charcoal, chalk, conte, or ink applied to paper. While these traditional materials remain vital elements in the language of contemporary drawing, the materials available to artists today have expanded tremendously, providing drawers with a multitude of options. The materials used to make a drawing may be chosen for practical purposes, or the materials may play a significant role in the content or meaning of a drawing. As a student of drawing, it is important to familiarize yourself with these materials and to begin to understand the advantages and disadvantages, the potential and the limitations, and the characteristics of different materials, both traditional and nontraditional. While it is helpful to be familiar with the information provided here, it should be noted that direct hands-on experience is the best teacher.

Following is a list of both traditional and nontraditional materials utilized in drawing and information regarding the different materials. This list reflects a broad definition of drawing as reflected in the work of contemporary artists who continue to expand and redefine drawing while acknowledging the fluidity of the discipline.

Traditional and Nontraditional Drawing Surfaces and Substrates

- Drawing papers (sheets or rolls)
- Watercolor papers
- Printmaking papers
- Commercially tinted papers
- Illustration boards
- Prepared paper surfaces (gesso, blackboard spray, etc.)
- · Photographs and photocopies
- Frosted mylar and acetate sheets
- Canvas and other fabrics

- Glass and Plexiglas
- Acrylic medium sheets (handmade, not available commercially)
- Metal
- · Raw and prepared wood
- · Wall surfaces and found surfaces

Traditional Paper

There are so many different kinds of paper available for drawing that it is difficult to sort through all the possibilities and impossible to list them all here. But paper choice is important and does affect the final results when drawing. It is generally not necessary for beginning drawing students to work on expensive sheets of paper, as there are a number of options that are more affordable and provide sufficient quality. Newsprint is good for gesture drawing, for larger sketches, and for initial investigations of line and value when using dry media. It is available in pads, both 18"×24" and 24"×36", and comes in both a rough (more versatile) and smooth finish. Affordable sketchbooks using inexpensive bond paper are more than suitable for smaller studies and daily sketching.

As you become more confident with your drawings and begin to explore more developed drawings, you should consider other higher quality papers as an option. A number of factors and variables determine the quality of a specific paper and what materials and processes work best with that paper. These include texture or finish, sizing, weight, acidity, ply, and size or dimension.

Texture or Finish

Texture or finish refers to how rough or smooth the surface of the paper is. Some papers, like Stonehenge or charcoal paper, are available in one texture or finish only, resulting from how the paper is made. Other papers offer options such as **rough finish** (a heavily textured surface), **cold press** (a mild or moderately textured surface created by pressing the paper through unheated rollers), or **hot press** (a smooth surface created by pressing the paper through heated rollers). Fabriano Artistico, for example, is available in either hot press or cold press or rough finish. Other terms that refer to the texture or finish include **vellum finish** (a slightly textured finish) and **plate finish** (a smooth finish). Strathmore Bristol, for example, is available in either vellum finish or plate finish.

Be aware that some papers are fairly uniform on both sides, and you can use either side of the paper with fairly consistent results. Other papers have a finish or texture that is different on both sides, with one side considered to be the "front" of the paper and one side considered to be the "back." When describing the paper's texture or finish, the manufacturer will be describing the front side of the paper. This is not to say that you cannot use either side, but you may find that some of the properties of the paper are different on the back side. For example, Canson Mi-Teintes paper, made for charcoal and chalk pastel drawing, has a very different texture on the back side of the paper than it does on the front side. In order to see any differences between the front or primary side of a piece of paper and the back or secondary side, hold the paper so that light rakes across the surface at an angle. This will more clearly reveal texture and surface characteristics, and you can make an informed comparison between the two sides.

Sizing

Sizing, such as gelatin, glue, rosin, or starch, is added to the paper to provide resistance to liquid penetration or to control absorption of wet media. Internal sizing is sizing that is added to the raw material before the sheet of paper is made. Most western papers are sized internally. Surface sizing is sizing that is applied to the paper after it has been formed, but before it dries. Surface sizing can be used in combination with internal sizing. If just one side of the paper is surface-sized, it is best to work on that side to control absorption and buckling. Tub sizing is sizing that is applied to both sides of formed and dried paper by passing it through a tub. This process results in a more thoroughly and uniformly sized paper. Watercolor paper is generally tub sized. Waterleaf refers to a paper with little or no sizing. The most significant aspects of sizing are how well it controls absorption or "bleeding" of water-based media and how well it controls buckling or rippling of the paper when waterbased media is used.

Weight

The weight of paper involves a rather complicated system used by the paper industry that is inconsistent at best, especially when you consider the differences in sheet size between commercial paper and artist's paper. Traditionally, paper is measured by the weight in pounds of one ream, which equals approximately 500 sheets. Because paper comes in a variety of sizes, the weight will vary even though the actual thickness remains the same. Each different type of paper establishes a certain size as its standard for determining weight. This is called the "basis weight." For example, a 140-lb paper tells us that 500 sheets (a ream) of this paper at its standard size of 22"×30" weighs 140 pounds.

A more consistent measure of a paper's weight is the metric measure, which is being used more frequently by suppliers

of paper for artists. This system standardizes the weight in grams of a square meter of paper, without regard for the individual dimensions of the sheet of paper. In the metric system, the 140-lb paper mentioned just (based on the basis weight) would be 300 gsm (grams per square meter). The bottom line is this: A heavier (thicker) paper will be indicated by a higher number using either system. In general, a heavier paper is more durable.

Acidity

Acidity refers to the amount of acid present in a paper. A paper that is acid free has a pH of 6.5 or higher, indicating alkalinity. A paper with a pH below 6.5 is considered acidic. Acidic paper is more prone to deterioration over time, while acid-free paper resists deterioration over time. Paper can be acidic because of the ingredients used in making it or because of inferior storage methods, how it is used, and uncontrolled environmental conditions. In general, a higher quality paper will be referred to as acid free, archival, or 100% or high rag content.

Ply

Ply refers to one sheet of paper that is bonded or laminated to another sheet of paper of the same kind; 1 ply is thinnest, 2 ply is twice as thick, and so on. For example, Strathmore Bristol 500 series paper is available in 1, 2, 3, or 4 ply. The 1 ply paper is very thin and flexible and can be rolled, whereas 4 ply is quite thick and boardlike and would crease or bend if you attempted to roll it.

Size or Dimension

Paper comes in a variety of sizes and dimensions and is sold either in pads (multiple sheets backed by fiberboard and a cover sheet and glue bound or spiral bound on one edge), blocks (pads of watercolor paper bound on all four sides to help control buckling), individual sheets, or rolls. Paper comes in a variety of sizes, with most pads ranging from sketchbook size (4"×6" up to 11"×14") to larger pads (18"×24" up to 24"×36"). Individual sheets come in a variety of sizes, depending on the manufacturer–19"x24", 23"×29", 22"×30", 26"×40", 30"×44", 36"×48", 38"×50", 40"×60", and more. Rolls of paper, available only for certain papers, range in size from 32"x10 yards, 42"×10 yards, and 52"×10 yards to 80"×20 yards and up to 150-yard rolls! Larger paper can be cut or torn to any desired size.

Paper Recommendations

Clearly there are numerous options in terms of paper, and the choices can be a bit overwhelming, even for an artist who is familiar with various papers and their characteristics. While there are some papers that are made specifically for drawing (as opposed to printmaking or watercolor), many papers offered today provide characteristics that are suitable for drawing and printmaking or drawing and watercolor (which will also accommodate ink washes). While by no means an exhaustive list, the following information addresses higher quality papers available in individual sheets and recommended for use with a variety of drawing materials and processes.

White Papers and Neutral Tinted Papers

Stonehenge: 100% cotton, acid free, moderately sized, vellum surface, 250 gsm, comes in various sizes and neutral colors (including black), also available in rolls. It has a smooth surface and works well with a variety of media, including pen and ink, pencil, charcoal, pastel, washes, and colored pencil. Holds up well to repeated erasure and reworking.

Folio: 100% cotton, neutral pH, vellum finish, moderate texture, comes in two sizes and two neutral colors. It is a good, durable paper for dry drawing media (pencil, charcoal, and pastel) and will accept washes but with some buckling depending upon how much water is used.

Strathmore Bristol 500 series: 100% cotton, acid free, moderately sized, comes in one size (23"×29"), one color (white), various weights or plies, and vellum (also called medium or kid) and plate surface. The vellum surface is excellent for dry drawing media, and the plate surface is receptive to fine pencil and pen work and washes.

Lenox 100: 100% cotton, acid free, vellum surface, 250 gsm, comes in three sizes, also available in oversize rolls (60" and 80"×20 yards). It is a good all-purpose white paper for drawing and printmaking. Not generally recommended for washes.

Rives BFK: 100% cotton or rag, acid free, vellum finish, moderate internal sizing, comes in various sizes, neutral colors, and weights (180 gsm, 250 gsm, 270 gsm, 280 gsm, and 300 gsm). Rives BFK white is also available in rolls. It has a smooth and absorbent surface, good for drawing (pencil and charcoal) and printmaking.

Fabriano Artistico (formerly sold as Fabriano Uno): 100% cotton, acid free, internally and externally sized, comes in one size (22"×30"), various weights, and cold press, hot press, and rough finishes. Excellent for ink and ink washes.

Arches Cover: 100% cotton, acid free, lightly sized, cold press surface, comes in various sizes, weights (160 gsm, 200 gsm, 250 gsm, 270 gsm, and 300 gsm) and neutral colors (including black); white also available in rolls. A versatile,

soft paper, good for printmaking and dry drawing media, does not hold up well to repeated erasure or reworking. Not recommended for washes.

Coventry: 100% cotton, internally sized, comes in various sizes (up to 46"×63"), various weights (130 gsm, 135 gsm, and 270 gsm), and both smooth and vellum finish. Good for dry drawing media, including pencil, charcoal, and pastel.

Copperplate (by Hahnemühle): Neutral pH, moderate internal sizing, vellum finish, comes in two sizes and two versions of white. It is good for both drawing and printmaking.

Vellum: A cotton paper, usually translucent, externally sized, often used when tracing is required, comes in a variety of sizes and weights. The surface lacks significant tooth but will accommodate a variety of dry drawing media and is especially nice for pen and ink and marker work.

Illustration board and bristol board: Although not technically considered paper, both illustration board and bristol board provide a good working surface for a variety of drawing materials and processes. Bristol board provides a working surface on both the front and back side, while illustration board is finished only on one side. Bristol board is typically intended for longer-term use and preservation, while illustration board is not. Both are available in both student grade and professional grade.

Depending on the manufacturer and whether or not it is student grade or professional grade, bristol board is generally acid free and comes in a variety of sizes, weights, and both plate surface (smooth) and kid surface (slightly textured). Some manufacturers provide bristol board in a variety of colors, but generally it is white or off-white.

Illustration board, like bristol board, varies in properties depending upon whether it is intended for student use or professional use. It is generally available with high rag content and comes in a variety of sizes, weights, and both hot press and cold press surfaces. The color is usually white or off-white. Because the backing of illustration board is different than the working surface, it can curl or warp when subjected to moisture or wet media. To remedy this, you can simply apply gesso to the back side with a brush, either "X"ing the back surface from top right to lower left and top left to lower right, or you can coat the entire back lightly with gesso. This usually counteracts any warping or curling of the illustration board.

Charcoal and Pastel Papers-White and Color

Both white and colored charcoal and pastel papers are made with special consideration for dry drawing media and generally have a very identifiable texture that reveals itself when the charcoal or pastel is stroked across the surface. A "laid" surface or finish, typical of many charcoal and pastel papers, is the result of a wire grid against the surface of the paper when it is made. Although it is not the only surface found on charcoal and pastel papers, it is a popular finish. Ultimately, personal preference will determine which paper(s) you most prefer when working with charcoal or chalk pastel.

Colored pastel paper provides two important benefits for working with chalk pastels—a tinted surface that emphasizes color interaction and a textured surface to grab and hold the chalk pastel and allow for the application of multiple layers of color. Charcoal paper is often white or neutral in color because it generally does not require concern for color interaction. Because both charcoal and chalk pastel benefit from some degree of texture to hold the dry media, many papers are made with both materials in mind. While not an exhaustive list, the following information discusses higher quality papers available in individual sheets and recommended for working specifically with charcoal or chalk pastels.

Strathmore 500 Series charcoal paper: 100% cotton, acid free, 95 gsm with a traditional laid finish. Comes in pads (a variety of sizes) and individual sheets (25"×19") of black, white, and eight different tints. A great paper for charcoal and chalk pastel.

Fabriano Ingres: A handmade paper, acid free, watermarked, with a traditional laid finish. Comes in two weights (90 gsm and 160 gsm), various sizes, and multiple colors including black and white. A beautiful paper for charcoal and chalk pastel.

Hahnemühle Ingres: acid free, watermarked, with a traditional laid finish, 95 gsm, 19"×25", comes in fifteen colors including black and white. A good paper for charcoal and chalk pastel.

Canson Mi-Teintes: 67% cotton, acid free, 160 gsm, 19½" × 25½", comes in a wide variety of colors that are not lightfast, also available in rolls. The front side has a heavy woven texture and the back side has a smoother texture. Good for charcoal and chalk pastel.

Art Spectrum Colourfix™: Acid free, lightfast, 340 gsm, fine tooth surface similar to fine sandpaper, made by coating smooth watercolor paper with a special primer. Durable surface withstands vigorous reworking and holds multiple layers of color. Comes in small and large sheets in a variety of colors surrounded by a thin white border.

Pastelbord™: Acid free, nonyellowing, granular finish, ¹/₈" rigid panel coated with clay and marble dust. Comes in various sizes and a few different colors.

Figure 5-1. Student work. Laura Gajewski. This large drawing that merges both interior and exterior views of an abandoned house was done with charcoal on paper prepared with several coats of gesso.

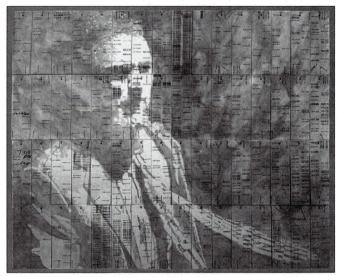

Figure 5-2. Student work. Rian Morgan. This drawing, one in a series of works that explores the structure and limitations of the 9-to-5 working world, uses a grid of time cards as the substrate. Viewers were able to remove the cards at will and insert them into a nearby time clock device often used by hourly workers to punch in and out. Once punched, the cards were then rehung, creating a piece that changed based on viewer interaction.

Figure 5-3. Student work. Lauren Taylor. This is one in a series of drawings done on pages taken from a child's coloring book and remounted. The drawn images are combined with the coloring book drawings and text to transform the original meaning.

Nontraditional Surfaces and Substrates for Drawing

- Prepared paper surfaces—gesso, blackboard spray, and so on. (Figure 5-1)
- Nontraditional or found paper surfaces (Figures 5-2 and 5-3)
- Photographs and photocopies (Figure 5-4)
- Frosted mylar and acetate (Figure 5-5)

- Canvas and other fabrics (Figures 5-6 and 5-7)
- Glass and Plexiglas (Figures 5-8 and 5-9)
- Acrylic medium sheets—handmade, not available commercially (Figure 5-10)
- Metal (Figure 5-11)
- Raw and prepared wood (Figures 5-12 and 5-13)
- Wall surfaces and found surfaces (Figure 5-14)

Figure 5-4. Student work. Michael Bobenmoyer. This series of reworked photocopies is based on an iconic journalistic photograph from the Vietnam War that was published around the world. Each photocopy of the original photograph is reworked and manipulated through a variety of drawing processes to shift the meaning.

Figure 5-5. Student work. Kendra Kennedy. This layered drawing combines ink drawings of wolves on paper (bottom layer) with body prints and graphite on frosted mylar (top layer).

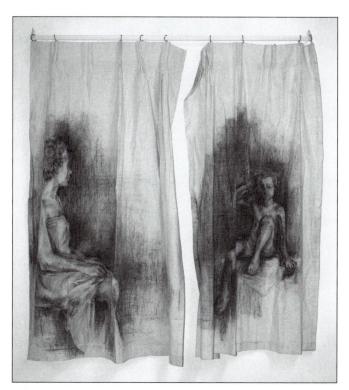

Figure 5-7. Student work. Alison Simmons. Curtains purchased from a secondhand store are drawn on with charcoal in this exploration of the experience of looking back on our youth from the perspective of adulthood.

Figure 5-6. Student work. Lauren Taylor. This drawing is done on a fabric substrate mounted on masonite. Oil pastel is the drawing medium.

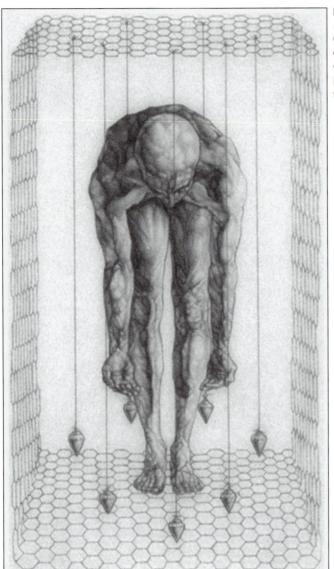

Figure 5-8. Leah Gregoire Prucka, American, *Ladder Series #14: Caged Pendulum*, 1997. Graphite on prepared glass, 4×7 inches. Courtesy of the artist. This drawing, which explores Christian concepts of the relationship between suffering and grace, is drawn with graphite on glass. The glass has been specially prepared to provide a surface that will receive and hold the graphite.

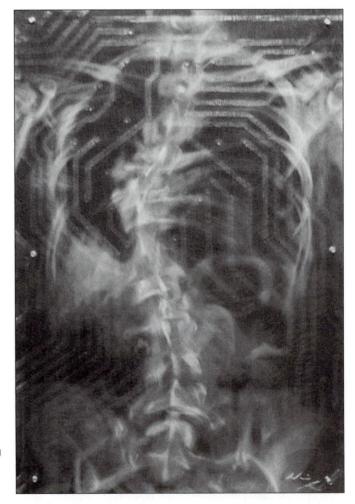

Figure 5-9. Student work. Naomi Fish. This mixed-media drawing includes Plexiglas as the top layer of the piece. The Plexiglas has been sanded with sandpaper and drawn on with white conte to create the misshapen spinal column, rib cage, and pelvis.

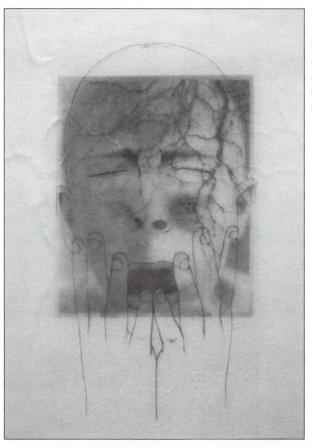

Figure 5-10. Deborah Rockman, Untitled FBML from Losing Sleep, 2003. Digital Lazertran transfers on handmade acrylic medium sheet, 32 × 21 inches. Collection of Jeff Meeuwsen and Steve Samson. Photobased and hand-drawn imagery were combined to create this image. The image was then digitally printed on Lazertran transfer paper and transferred to a handmade sheet of acrylic medium. The irregular areas visible on the surface of the acrylic medium are fissures that result from shrinkage (also known as crazing) when the acrylic medium is drying.

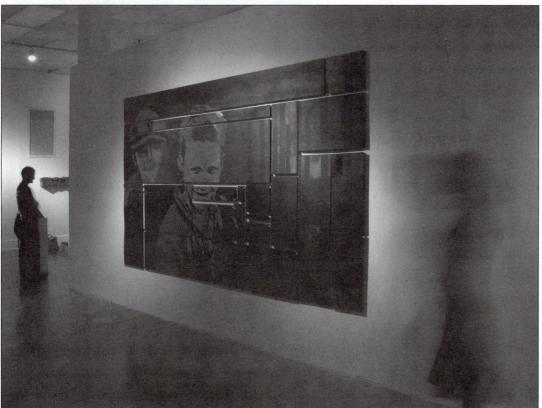

Figure 5-11. Dustan Julius Creech, American, The Breaker Boys, 2004. Steel, coal, and oil, 136 x 71 inches. Courtesy of the artist. Creech uses the raw materials of bluecollar industrial laborers to comment on the hardships suffered by the iron, steel, and coal workers of the United States. This massive drawing is executed on scrap panels of steel arranged in a gridlike structure.

Figure 5-12. Student work. Alison Simmons. The small headboard of a child's bed, found at a secondhand store, provides a surface for this ink drawing that subtly explores the abuse of a young girl.

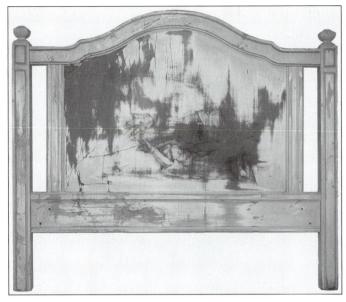

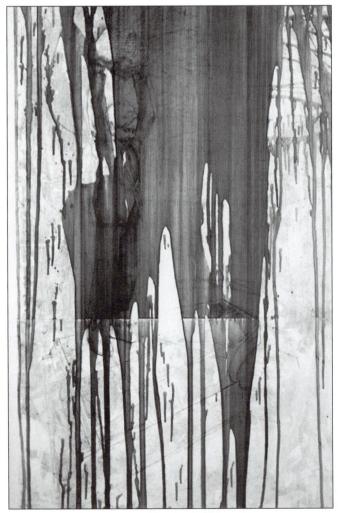

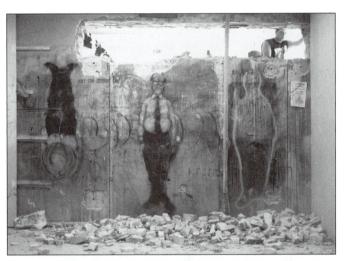

Figure 5-14. Student work. Harry Williams. This drawing, which measures 10×12 feet, was done on a drywall surface that was slated for demolition as part of a renovation project. Using a variety of dry drawing materials, the drawing progressed over a period of a few weeks and was documented throughout the process. This photograph of the piece shows a construction worker breaking through the wall from the other side as he begins tearing the wall down.

Figure 5-13. Student work. Alison Simmons. A wood panel prepared with sanded gesso is the substrate for this ink drawing with tinted galkyd poured onto the completed drawing.

Traditional and Nontraditional **Drawing Media**

- Drawing pencils or graphite pencils
- Graphite sticks
- Graphite powder
- Silverpoint
- Charcoal pencils
- Carbon pencils
- Vine or willow charcoal sticks
- Compressed charcoal sticks
- Powdered charcoal
- Conte or drawing crayons
- Conte pencils
- Colored pencils
- Colored pencil sticks
- Chalk pastels
- Chalk pastel pencils
- Oil pastels
- Ink
- Ink wash
- Ink pens
- Watercolor
- China markers
- Litho pencils
- Litho crayons
- Acrylics/acrylic washes
- Gouache
- Mixed media
- Oil paint washes
- Wax
- Coffee and tea washes
- Dirt, mud, and clay
- Smoke and/or soot
- Photocopy toner
- Rust
- Body fluids

Dry Media-Black/White and Monochromatic

Drawing Pencils or Graphite Pencils

Graphite is actually soft carbon and, when mixed with clay as a binder, becomes the "lead" in pencils. Drawing pencils are made of sticks of graphite encased in wood or, in the case of woodless pencils, wrapped in a lacquer sheath. There are also raw sticks or leads of graphite that can be slipped into a mechanical lead holder. Drawing pencils are available in a range from hard to medium to soft, denoted as 10H (the hardest), 9H, 8H, 7H, 6H, 5H, 4H, 3H, 2H, H, F, HB (these last three are mid-range), B, 2B, 3B, 4B, 5B, 6B, 7B, and 8B (the softest). Harder graphite yields lighter, more delicate lines and tones; softer graphite yields darker, richer lines and tones. Graphite can also be erased, rubbed, smeared, or dissolved with an oil-based solvent. Water-soluble graphite pencils are also available. Be aware that an excessive build-up of graphite can lead to an undesirable shiny surface (Figure 5-15).

Ebony pencils and carpenter's pencils are variations of graphite pencils. Ebony pencils feature a very black, thick lead that is soft, smooth, and strong and yields a more matte finish than other graphite pencils. A carpenter's pencil has a soft medium lead and is flattened rather than round so it will not roll. The larger, flattened lead is capable of larger, broader marks.

Graphite Sticks

Graphite sticks are a blend of powdered graphite and clay. Graphite is available in stick form, both square and rectangular, approximately 3" or 4" long. It is also available in larger blocks or chunks of irregular shape. Like graphite pencils, graphite sticks come in a range of hard, medium, and soft, with the amount of clay determining the degree of hardness. The advantages of graphite over charcoal are that it is less dusty and generally more durable than charcoal in terms of how well it adheres to a surface and its greater resistance to smearing.

Graphite Powder

Powdered graphite (finely ground graphite) is available from art supply sources and from hardware stores (it is used as a lubricant). Because it is in a raw form, you can apply it with a variety of materials-cloths, tissues, your fingers, or a soft brush. Although graphite is not considered toxic, it is not advisable to breathe any significant amount of graphite dust.

Silverpoint

Silverpoint is a specific form of metalpoint drawing in which a wire length of metal (in this case, silver) is used like a pencil lead to create delicate lines and marks on a prepared surface. The stylus used to hold the silver wire is similar to an X-acto blade holder and tightens around the wire, holding it securely in place. The metal wire should be sharpened to a point, using a sharpening stone. The drawing surface for silverpoint must be prepared in a way that will accept the metal. There are some commercial papers available for silverpoint, but otherwise you can prepare your own surface using Chinese white ground, a white pigment made from zinc oxide. Silverpoint cannot be erased or changed, and so requires time and patience with which to build up subtle strokes that, when clustered together, create subtle tone. Over time silverpoint will oxidize, causing it to darken slightly and take on a subtle brownish hue. Similar metalpoint processes include drawing with a copper wire, which is called copperpoint, and drawing with a brass wire, which is called brasspoint (Figure 5-16).

Figure 5-15. Kiel Johnson, American, Work in Progress, 2006. Graphite and ink on paper, 72 × 48 inches. Courtesy of Hyperbolestudios.com. This very large and highly imaginative drawing of a waterfront structure in progress and surrounded by scaffolding is drawn with graphite and ink. Careful application of the graphite eliminates excessive glare.

Figure 5-16. Ben Polsky, American, Site 21.04, 2005. Graphite and brasspoint on rabbit skin glue gessoed panel, 12 × 15 inches. Courtesy of the artist. Polsky uses graphite and brasspoint (a form of metalpoint) to investigate the beauty and mystery of abandoned and demolished buildings and sites. The rabbit skin glue gesso used to prepare the panel is necessary to create a surface that is receptive to brasspoint.

Charcoal Pencils

Charcoal is made by heating wood in the absence of oxygen until only pure carbon remains. Charcoal pencils are made from compressed charcoal. There are also white "charcoal" pencils that have properties similar to black charcoal pencils (Figure 5-17). Like graphite pencils, charcoal pencils come in a full range from hard to medium to soft. Some charcoal pencils utilize the same system as graphite pencils (4H, 2H, HB, 2B, 4B, etc.), and some use the designations of S (soft), M (medium), and H (hard). Charcoal pencils come in a couple of different forms. Some are lengths of charcoal encased in wood just like a regular pencil; these can be sharpened in a pencil sharpener. Others are lengths of charcoal wrapped in a coil of paper with a small string running along the length. The string is used to tear down the paper coil that is then removed to expose the desired length of charcoal. These pencils cannot be sharpened in a pencil sharpener, but must be sharpened using a sandpaper pad (Figure 5-18).

Carbon Pencils

Carbon pencils are made from lampblack (obtained by collecting the soot from the burning of oil) and combine the best qualities of graphite and charcoal together. They yield a soft, rich, and velvety tone without shine. They are available in B, 2B, 4B, and 6B.

Vine Charcoal or Willow Charcoal

Vine charcoal is made by burning sticks or twigs of wood in the absence of oxygen. In an unaltered form, the sticks will be a bit crooked or curved, but some manufacturers shape them into a more uniform stick. Vine charcoal comes in soft, medium, and

Figure 5-17. Student work. Mike Hetu. Shiny and reflective surfaces, which exhibit a different response to a light source, are drawn using white charcoal on black paper.

hard and in different diameters (very thin to very thick). It is easily erased and very flexible, so it is particularly good for the early stages of a drawing. It is not capable of producing rich, dark black tones and is very fragile on the surface of a drawing, smearing and rubbing off very easily either by accident or intentionally. Vine charcoal is light and airy and can be easily pulverized between two fingers (Figure 5-19).

Compressed Charcoal

Compressed charcoal is made by mixing charcoal powder with a binder and then compressing it into sticks. The amount of binder used determines the hardness of the compressed charcoal. It is available in both square and round sticks that generally range from 2H, HB, B, 2B, up to 6B. Sticks of compressed charcoal are stronger and denser than vine charcoal and can be used to lay in a broad stroke of charcoal by using the side of the stick. Compressed charcoal cannot be pulverized between your fingers (Figure 5-20).

Figure 5-18. Student work. Barb Helmer. Charcoal pencil is used very effectively in this drawing to describe a variety of different textures and values. The contrast between decay and new growth is emphasized through the use of the potted plants, which are being nourished and cared for, and the neglected interior space.

Figure 5-19. Student work. Vine charcoal, which responds well to rubbing, smearing, and eraser work, is an effective medium for this drawing of a tricycle. While the drawing is done from direct observation, the goal was to focus more on the *feeling* of a tricycle rather than the *appearance* of a tricycle.

Figure 5-20. Student work. Naomi Fish. Compressed charcoal sticks are an excellent choice for addressing the strong tonal contrast in this drawing of an abject body.

Powdered Charcoal

Powdered charcoal is finely ground charcoal with no binder. Like graphite powder, it is in a raw form and you can apply it with a variety of materials—cloths, tissues, your fingers, or a soft brush. Although charcoal is not considered toxic, it is considered a nuisance dust; it is not advisable to breathe any significant amount of charcoal dust.

Conte Crayons or Drawing Crayons

Conte crayons are made with a chalk base. They are formed into small square sticks and are available in a range of hardness and softness. They are available in black, white, gray, and several shades of sanguine (reddish-brown). They are capable of a beautiful range of tones but are somewhat difficult to erase (Figure 5-21).

Conte Pencils

Conte is also available in a pencil form, with a lead of conte encased in wood. Conte pencils come in the same shades as

conte crayons. They can be sharpened in a pencil sharpener and are good for detail work that complements the use of conte crayons.

Dry media-color

Colored Pencils

Colored pencils are colored leads encased in wood; they come in a wide range of colors. They are available in both a wax base and, more recently, a water base. The wax-based colored pencils can be blended by working the pencils together or by blending them with a solvent, but they are difficult to erase. The water-based pencils can be blended with water. Colored pencils can be sharpened to a fine point for great detail (Figure 5-22). They have a tendency to develop a waxy, whitish layer on the surface called "wax bloom." This can be remedied by wiping the surface gently until the wax bloom is diminished and then applying a layer or two of spray fixative. Depending upon the brand you select, some colors may or may not be lightfast. Check with the manufacturer.

Figure 5-21. Joseph Stashkevetch, American, *Blossoms*, 2005. Conte crayon on paper, 60×48 inches. Courtesy of Von Lintel Gallery. Stashkevetch works with conte crayon on paper that has been sanded to create a very soft, lush surface. This allows for a very broad and rich tonal range in his highly realistic drawings.

Colored Pencil Sticks

Colored pencils are available in a slender, square stick form. Colored pencil sticks have the same properties as colored pencils and are also available in a wide range of colors. They can be sharpened by hand to a point and can also be used to block in large areas of color more quickly than a colored pencil. Again, you should check the manufacturer's information regarding lightfastness.

Chalk Pastels

Chalk pastels are made of color pigment mixed with chalk and a binder. This mixture is then shaped into round or square sticks in a broad range of colors. Chalk pastels are sold as both hard pastels (usually square or rectangular in shape) and soft pastels (usually round in shape), with hard pastels typically having more chalk and binder and less pigment and soft pastels typically having less chalk and binder and more pigment. Hard chalk pastels are less crumbly and produce less dust, while soft chalk pastels are more crumbly and produce more dust. Whether hard or soft, high quality pastels provide rich and beautiful color. Their disadvantage is that they are very easily damaged and hard to protect since spray fixatives can darken, dull, and/or spot the color. Be aware that breathing chalk pastel dust is not safe, so take appropriate precautions (Figure 5-23).

Chalk Pastel Pencils

Chalk pastel pencils (usually called pastel pencils) are chalk pastel leads encased in wood. Like other pencils encased in wood, they can be sharpened for detail work and used in combination with chalk pastel sticks. They are also known as colored charcoal pencils because their texture and consistency resemble those of charcoal pencils. They come in a

Figure 5-22. Student work. Jessica Serfass. Although this sensitive investigation of light and shadow has been translated into black and white for reproduction, it was executed using a full range of colored pencils on neutral-toned paper.

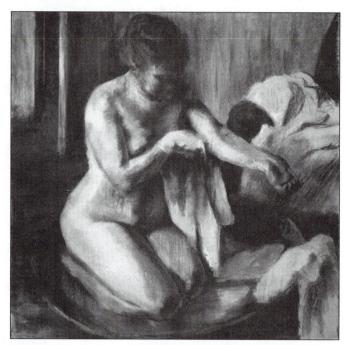

Figure 5-23. Student work (after Edgar Degas). Alison Simmons. A broad range of chalk pastels on brown tinted paper was used to create this full-color study of a drawing by Degas.

wide range of colors that coordinate with the manufacturer's range of chalk pastel sticks.

Oil Pastels

Oil pastels are color pigment (the same pure pigment used in oil paints) mixed with a binder of wax and mineral oil and shaped into square or round sticks. Unlike oil paint and paint sticks, oil pastels do not require drying time. They will harden to a degree after application, but they never completely dry so they resist cracking. Oil pastels are acid free and non yellowing, and they adhere well to a variety of surfaces. They come in a wide range of colors and can be manipulated in a variety of ways. They are soluble with traditional oil paint mediums, but this works best with professional grade oil pastels because they contain less wax. Lightfastness should be tested by applying patches of color to a paper surface. Cover half of each color patch with a thick piece of paper, expose the paper to direct sunlight for a week or two, and check for color shifts between the covered and exposed

color. Higher quality oil pastels are generally more lightfast than inexpensive oil pastels (Figure 5-24).

Wet Media-Black/White and Color Ink

Although ink can come in a solid form known as cakes or sticks (often called Chinese ink or Sumi ink), you may be most familiar with the liquid form of ink. Black drawing ink, often called India ink, is made from lampblack pigment suspended (in high concentration) in water with a binder. It can be used full strength with a variety of different pens (quill pens, reed pens, metal nib pens) to create line work, or it can be applied with soft brushes. Waterproof ink will not respond to water or redissolve once it has dried. Nonwaterproof ink will run or bleed if exposed to water after it has dried (Figure 5-25).

Ink is also available in a variety of different colors (including white), with pigment suspended in water with a binder. Do not confuse pigment-based colored inks with

Figure 5-24. Deborah Rockman, Port Huron Fog, 1992. Oil pastel on gessoed paper, 8 x 10 inches. Collection of Kathleen Taylor. This study of fog over the shoreline of Lake Huron shows the subtlety that is possible with oil pastel. The surface of the drawing also reveals some of the different textures possible with oil pastel. The sky area is done using solvents and soft brushes to dissolve and move the oil pastel around. The water area is done using multiple layers of oil pastel and a process called scumbling that involves dragging the oil pastel stick on its side across the surface of the paper.

dye-based colored inks, which are not lightfast (they will fade significantly over time). Like black ink, colored ink can be applied as line with a variety of different pens or can be applied with a brush.

Ink Washes

Ink, both black ink and colored inks, can be diluted to varying degrees to create a full range of tints and tones applied as a wash. Again, make sure you use pigment-based, lightfast colored inks rather than dye-based colored inks. Use distilled water to dilute your inks, as tap water can cause the inks to separate (Figures 5-26 and 5-27).

Ink Pens

Ink pens come in a wide variety of forms, including technical pens, rollerball pens, felt-tip pens, and ballpoint pens. In general, ballpoint pens, which come in a variety of colors, will fade over time and are not advised for archival work. However, many artists enjoy using them for sketching and other exploratory drawing processes (Figure 5-28).

Technical pens are valued for their ability to produce uniform line widths and because they contain their own replaceable ink. They are available with a variety of tips, each providing a different line width. They must be carefully cleaned and maintained in order to prevent clogging. The most well known technical pen is the Rapidograph® (Figure 5-29).

Felt- or fiber-tip pens and rollerball pens (often called *markers*) are widely available and come in a variety of colors. Many are not lightfast, while some are. They are available in very wide tips (felt- or fiber-tip pens), very fine tips, and everything in between. They are disposable because they cannot be refilled with ink. Some are permanent, meaning they will not bleed when water is introduced to the dry ink, and some are not. Two especially popular brands that many artists are using for fine line work are Pigma Micron® and Sharpie® Micro. The Pigma Microns use archival ink, come in six point sizes, will not smear when dry, and are offered in a variety of colors. The Sharpie Micros do not use archival

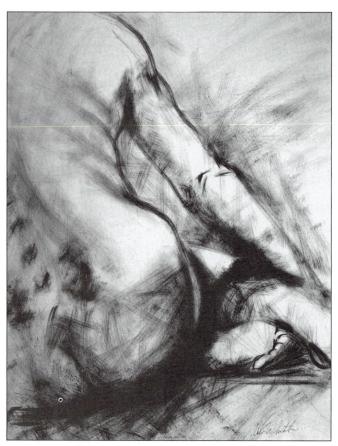

Figure 5-25. Student work. Alex Whitehead. A broad tonal range was achieved using full strength ink applied with various brushes both fully charged and dry brushed.

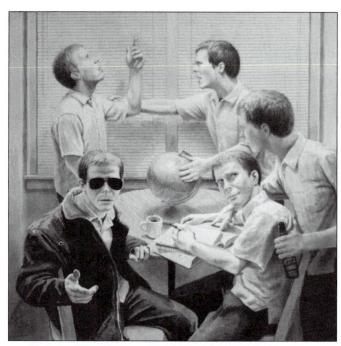

Figure 5-26. Student work. Collin Regimbal. This beautifully composed and rendered self-portrait, showing the artist engaged in a lively debate with himself, was done exclusively with ink washes.

Figure 5-27. Student work. Rian Morgan. Dramatic light and a somewhat graphic treatment of tonal structure characterize this drawing of a figure gesturing in frustration.

Figure 5-28. Student work. Matt Maxwell. This large drawing, done exclusively with ballpoint pen on a gessoed surface, presents a rather surreal investigation of two-point perspective, interior and exterior space, and the self confronting the self.

Figure 5-29. Student work (detail). Nicholas Longenecker. This beautifully detailed linear drawing highlights this student's interest in the figure and all manners of clothing and serves to emphasize the precise nature of technical pens.

ink, but they will mark on a wide variety of surfaces, including film, glass, plastic, and other smooth surfaces (Figures 5-30 and 5-31).

Nontraditional Drawing Media

Many of the following materials are considered traditional materials in disciplines other than drawing, such as painting (watercolor, acrylic or acrylic washes, gouache, oil paint washes) or printmaking (litho pencils and litho crayons). So while they are not strictly nontraditional, they are not first and foremost considered to be drawing materials. However, just as traditional drawing materials can be incorporated into works that are primarily paintings or prints, drawing can incorporate materials that are often associated with other disciplines. Additionally, drawing is a vital element in mixed-media work that defies any narrow or specific classification through its use of a variety of media and/or surfaces.

Figure 5-30. Rian Morgan, American, Drawing from "Routine," 2006. Grayscale markers on paper, 4 × 6 inches. Courtesy of the artist. This drawing, one of nearly a thousand drawings based on video stills, shows the translation of full value into limited value through the use of a set of twelve grayscale markers.

A few of the materials listed here are not generally considered to be media used in the creation of art, but some artists have used these materials inventively and effectively.

- · China markers
- · Litho pencils
- Litho crayons
- Watercolor washes (Figures 5-32 and 5-33)
- Acrylics/acrylic washes (Figure 5-34)
- Gouache (Figure 5-35)

- Mixed media (Figures 5-36-5-38)
- Oil paint washes (Figure 5-39)
- Wax (Figure 5-40)
- · Coffee and tea washes
- · Dirt, mud, and clay
- Smoke and/or soot (Figures 5-41 and 5-42)
- · Photocopy toner
- Rust (Figure 5-43)
- Body fluids

Figure 5-31. Student work. Doug Stahl. Drawn on location, this black marker drawing utilizes a variety of strokes to address this view of a cityscape.

Figure 5-32. Kristopher Jones, American, *Bib*, 2006. Ink and watercolor washes on paper, 50×38 inches. Courtesy of the artist. Jones' primary medium is ink line, but here he incorporates a watercolor wash as an understructure for a complex network of lines that respond to the more ethereal nature of the wash.

Figure 5-34. Jon Rappleye, American, *Enchanted Wood*, 2005. Acrylic on paper, 41 × 38% inches. Private Collection. Courtesy of Jeff Bailey Gallery, New York. Rappleye's skillful use of acrylic yields both bold and graphic lines as well as remarkably fine tonal structure resulting from the use of very fine brushes that are stroked across the surface of the paper. The results, especially in the birds and animals, more closely resemble fine graphite rendering and attest to Rappleye's skill and sensitivity.

Figure 5-33. Student work. Sarah Miller. Watercolor washes provide delicate color and atmosphere for this graphite pencil drawing that uses nesting birds as a metaphor for humans.

Figure 5-35. Kelly Allen, American, *Basil Friends*, 2006. Mixed media on paper, 22 × 30 inches. Courtesy of the artist. This playful drawing on paper is executed primarily with gouache while also incorporating woodblock printing and graphite pencil.

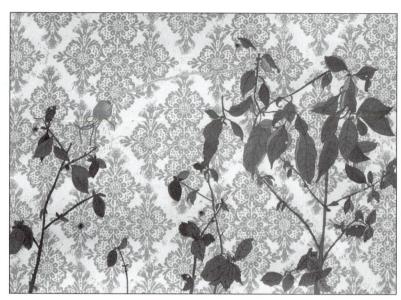

Figure 5-36. Student work. Joe Houston. This mixed-media drawing on paper combines charcoal, watercolor, and vegetable oil.

Figure 5-37. Student work. Jason Roda. This mixed-media drawing on paper combines charcoal, graphite pencil, and an ink transfer of torn netting.

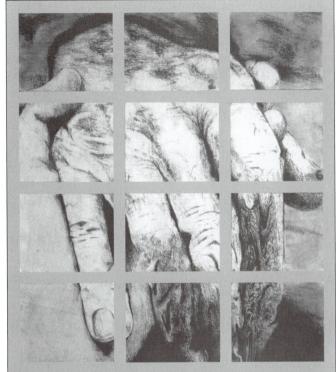

Figure 5-38. Student work. Elizabeth I. Clare. This twelve-panel mixed-media drawing combines ink wash, charcoal, and digital manipulation of four of the scanned panels.

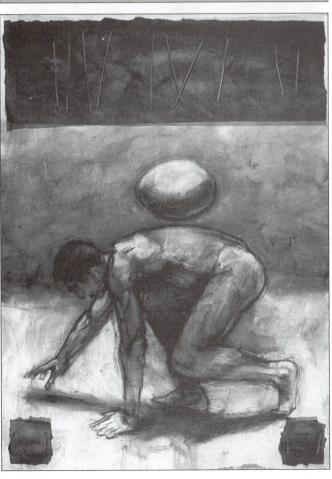

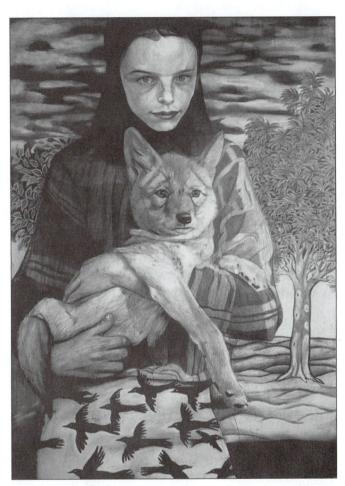

Figure 5-40. Jenny Scobel, American, *Girl With Wolf (Untitled)*, 2003. Graphite and wax on gessoed wooden panel, 32×24 inches. Private collection. Scobel draws with graphite on a gesso-coated wooden panel. When the drawing is completed, she seals it under a coat of poured wax.

Figure 5-39. Student work. Jody Williams. Oil paint washes on gessoed paper establish the ground for this charcoal and collage drawing.

Figure 5-41. Steven Spazuk, Canadian, *Codres*, 2001. Soot on paper, 7×5 inches. Courtesy of the artist. This drawing was done using soot deposited on the paper. The tracks or trails of lighter marks are made by placing an insect (in this case, a millipede) on the soot surface and allowing it to crawl around, lifting up the soot as it moves across the paper.

Figure 5-42. Steven Spazuk, Canadian, *Charancon*, 2003. Soot on paper, $14 \times 21 \frac{1}{2}$ inches. Courtesy of the artist. This gridded piece was done using numerous fragments from other soot drawings in which a variety of insects explored the surface. All of the different traces were cut up into half-inch squares (a total of 1,204) and arranged to create this image of a weevil. The traces were made by butterflies, caterpillars, ants, millipedes, and other insects.

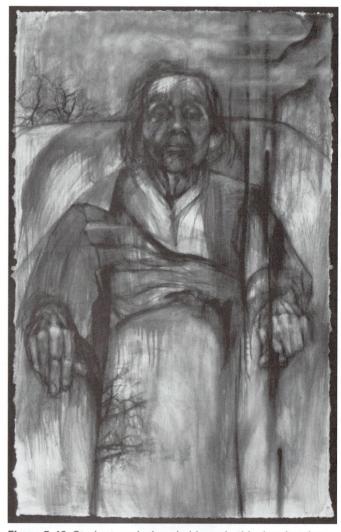

Figure 5-43. Student work. Jane Lubbers. In this drawing that addresses old age and our cultural attitude toward the elderly, rust was used as one of the drawing mediums for both its beautiful color and its association with decline and aging.

Additional Materials for Drawing and Related Processes

- Erasers—Pink Pearl, kneaded, plastic, and tube erasers for subtractive drawing, removal of media, repair of a drawing, or manipulation of media
- Assorted grades of sandpaper for subtractive drawing and for sanding gessoed surfaces
- · Assorted grades of steel wool for subtractive drawing
- Odorless solvents such as Turpenoid, Permtine, and Mineral Spirits for dissolving or thinning oil-based media
- Chartpak brand Ad Marker colorless blender P-O #201 for image transfers and blending of markers and colored pencils
- Eberhard-Faber brand Design Art Marker colorless blender #311 for image transfers and blending of markers and colored pencils
- Other appropriate solvents for image transfers, such as Citrasolve, acetone, lacquer thinner, and so on

Transfer Techniques Combined with Drawing

Drawing is capable of conveying a wealth of ideas and information, whether in its pure, traditional form, in a more experimental form, or when combined with other materials or processes that are not specific to drawing. Drawing is also very versatile, and it can be creatively combined with a variety of materials and processes. Many contemporary artists utilize transfer processes in combination with drawing, achieving results that expand upon drawing and incorporate aspects of technology that were unavailable to artists of the past. One of these transfer processes, closely aligned with printmaking and the idea of multiples, utilizes photocopies or black-and-white laser printer images.

Photocopy and Laser Print Transfers

Materials Needed

You will need some basic materials to explore the process of photocopy or laser print transfer.

 An image to be transferred—a black-and-white photocopy or a computer-generated image that is printed on a black-and-white laser printer

- A solvent for transferring the image
- A metal spoon, bone folder, or other smooth burnishing tool for applying pressure to the transfer
- Small pieces of cotton fabric, cotton balls, webril wipes, or makeup remover pads for applying solvents
- · A surface on which image is to be transferred
- Drafting tape for holding your transfer in place when you are burnishing it
- Scissors or X-acto blade for trimming your transfer if desired
- · Gloves and safety glasses for your protection
- · Drawing materials for working back into the transfers

Images for Transfer

Because of a tremendous number of variables regarding the source of printed color images for transfer, we are only addressing here the transfer of images that are black and white. It should be noted, however, that any color image can be made into a black-and-white image through photocopying or digital scanning in grayscale mode.

Any image that is in the form of a black-and-white photocopy or a black-and-white laser printed image (printed on a black-and-white laser printer) can be transferred to a receptive surface. Inkjet images do not work as a source for solvent transfers because the ink is water soluble. This is not to say that there are not ways to transfer an image generated by an inkjet printer (both black and white and color), but we are not addressing inkjet transfers here. In the case of both photocopies and laser prints, it is the toner that is transferred from the source image to the receiving surface. The toner is made up of very fine particles of carbon or another dry pigment, and during the photocopy or printing process, powdery pigment is transferred to paper and fused in place using heat. When making a transfer, the solvent used for the transfer releases the toner from the source image and deposits it on the receiving surface through applied pressure. In most cases, a laser print transfers more cleanly and effectively than a photocopy does.

If desired, images that are in color can be translated into black and white by photocopying them in black and white or by digitally scanning them, translating them into gray-scale mode, and printing them on a laser printer. These can then be transferred. Original images (drawings, collages, photographs, etc.) can also be transferred by first photocopying them in black and white or by scanning them and laser printing them as a digital image in black and white. Color can be added by hand after the transfer is complete.

The photocopying or digital scanning process can also be used to enlarge or reduce an image, darken or lighten an image, or otherwise distort or manipulate an image. Photocopied images can be altered by moving or sliding the image while the photocopy is in progress. You can also make a photomontage by combining a variety of images, and this photomontage can be unified and made ready for transfer by photocopying it or digitally scanning it. Scanned images can be manipulated in a variety of ways on the computer by utilizing PhotoShop. Some photocopy centers have the technology to enlarge and print images up to "poster" size (approximately 24"×36"), and these can then be transferred by hand or by using an etching press to make the transfer. If enlarging a small image to poster size for transfer, be aware that the tonal structure will "open up" after enlargement, meaning that tones that were rich and dark in the original image will be considerably less rich and dark after enlargement, and this will impact the character of the transfer. Note that some photocopies transfer more easily than others based on slightly different technologies in different photocopy machines. In general, both photocopies and laser prints will transfer best when they are fresh (Figures 5-44 and 5-45).

Since a transferred image is reversed from its original form (left is right and right is left), images that include text or are exclusively text, or images that you don't want to be reversed must first be reversed or flipped during the photocopying process if the transferred text is to be readable or if the image is to retain its original orientation. Most new photocopy

Figure 5-45. Student work. Elizabeth Tjoelker. This drawing results from the same process described in Figure 5-44. Both drawings reflect an interest in World War II and the related phenomena of cultural guilt, selective memory, collective denial, and the layering of truth and falsehood.

machines now allow for reversing an image, and digital images can be reversed in PhotoShop. Another alternative for reversing an image is to apply cooking oil to a photocopy or laser print, which makes it transparent, and then photocopy it again from the back or digitally scan it from the back.

Solvents for Transferring Images

A variety of solvents can be used successfully for making transfers. Some of the solvents suggested for transfers have harmful vapors, are skin irritants, and/or are flammable. So please exercise caution, read the labels for information on safe use, and work in a properly ventilated space.

Figure 5-44. Student work. Elizabeth Tjoelker. Photocopies and laser printer transfers form the basis for this drawing. An image or combination of images is chosen and appropriated based on conceptual interests. The image or collage of images is photocopied at its original size and then reworked via drawing, sanding, scraping, cutting areas out, and so on. The altered photocopy is then enlarged to poster size and, if desired, altered some more. Finally, the large photocopy is transferred to rag paper using Citrasolve and an etching press. The transferred image on rag paper continues to be reworked and altered until the desired result is achieved.

Acetone is an ingredient found in nail polish and nail polish remover. It works very well for transfers and can be used full strength (most recommended) or as an ingredient in nail polish remover (use a nonoily polish remover and check the ingredients to make sure it contains acetone). Acetone can be applied with any of the recommended absorbent pads or fabrics. Acetone evaporates rather quickly, depending on whether or not it is full strength or suspended in nail polish remover. Because of this it is recommended that you work on small areas at a time and continue to apply acetone as needed. Acetone is *not* nontoxic and should be used with appropriate precautions.

Colorless blender markers work well for transfers, but only a relatively small area can be transferred at a time because of the evaporation rate of xylene, the primary solvent used in many blender markers. In the past, any number of colorless blender markers could be used for transfers, but many companies changed their chemical formulas in response to toxicity and "recreational" sniffing. As a result, not all blender markers are now capable of transferring. Design Art Marker brand colorless blenders (#311) by Eberhard-Faber work well, as do Ad Marker brand colorless blenders (P-O 201) by Chartpak. Again, these are only appropriate for doing hand transfers as opposed to press transfers, and the blenders tend to be depleted rather quickly. Xylene is *not* nontoxic and should be used with appropriate precautions.

Citrasolve, a slightly oily, nontoxic cleaning agent available at major grocery stores where cleaning agents are sold, has a pleasant citrus scent and works well for transfers. It allows a larger area to be transferred more easily because it evaporates more slowly than other solvents do. If working with large transfers on a print press bed, Citrasolve allows you to transfer larger areas in a single pass on the press bed because of the slower evaporation rate. Citrasolve can easily be used for hand transfers as well. It can be applied with any of the recommended absorbent pads or fabrics, depending on the size of the area you wish to cover. Sometimes Citrasolve does not transfer quite as thoroughly or richly as other solvents. There is a product called Citra-Strip that is similar to Citrasolve but is thicker and works very well for transfers. It is recommended that with either Citrasolve or Citra-Strip, allow the solvent to sit for a little while on the back of the image to be transferred before burnishing or applying pressure. This helps to loosen up the toner and results in a higher quality transfer.

Lacquer thinner will work, but it has the distinct disadvantage of being highly toxic. Like acetone and xylene, lacquer thinner evaporates very quickly and thus is not a good choice for doing a large transfer on a printmaking

press. If lacquer thinner is the solvent of choice, it should be used in a well-ventilated area away from any open flames, and skin and eyes should be protected.

Concentrated wintergreen oil, although sometimes recommended as a solvent for transfer processes, should not be used as it is toxic and can be extremely irritating to skin, eyes, and all mucous membranes. Make sure you test the surface you are transferring to with the solvent you want to use. Some of the stronger solvents may not react positively to some surfaces, altering them or breaking them down.

Procedure for Transferring Images

When transferring by hand, place the image to be transferred face down on the receiving surface. You can transfer to a variety of surfaces, including paper, drafting vellum, glass, mirror, metal, frosted mylar, smooth wood, and other porous and nonporous surfaces. You can use drafting tape to hold the image in place while you transfer it. The tape will also hold the image in place when you lift up a corner to check the progress and quality of the transfer.

Using a small piece of cotton fabric or other material listed under "Materials Needed," apply a small amount of your chosen solvent to the back of the photocopy or laser print. This makes the copy or laser print nearly transparent until the solvent evaporates. Using a burnishing tool, rub the back of the image to be transferred in firm, circular motions, applying uniform pressure. This transfers the loosened toner to the receiving surface. Be careful not to move the transfer while burnishing it. If you are transferring a large image, work in small sections at a time and lift a corner to check the progress of the transfer. If an area has not transferred well and your solvent has evaporated, you can apply more solvent and rework the area to strengthen the transfer. If your copy or laser print sticks to the receiving surface (which sometimes happens as the solvent dries or evaporates), slightly dampen the copy with water from the back to release it.

Keep in mind that using too much solvent will blur or smudge the transferred image (although this can create some interesting effects), while not enough solvent will result in a weak or incomplete transfer. Depending upon the solvent you are using, it is wise to experiment first to get a sense of how much solvent is appropriate, the rate of evaporation, and your sensitivity to the different solvents. Remember to dispose of solvent soaked materials safely, in a certified safe metal wastecan with a lid.

As mentioned, transfers can also be made on an intaglio press in a printmaking lab using one of the oil-based solvents

that will not evaporate quickly. You can also use Naz-Dar transparent base (used to thin oil based screen printing inks) to make a press transfer by applying a thin layer to the back of the copy, positioning the copy on the receiving surface, and running it through the press with firm pressure in the traditional manner. Do not attempt to use a press for making a transfer unless you have received instruction regarding the correct use of an intaglio press.

If transferring to a nonabsorbent or less absorbent surface, you need to be especially attentive to how much solvent you use in order to prevent the transferred image from blurring or bleeding, unless you desire this effect. For example, if you are transferring to a gessoed paper surface or a piece of frosted mylar, any excess solvent that reaches the gesso or mylar will not be readily absorbed and will tend to blur the toner being transferred. So test your solvent and your surface first, and keep in mind that you will need less solvent when transferring to a nonporous surface.

Other Materials Used in the Transfer Process

A burnisher works well as a burnisher! Other options include wooden or metal spoons (my preference) or any tools that can be used to vigorously rub the back of the image to be transferred without tearing the paper. You want to be able to press hard and get good contact with your burnishing tool. The manner in which you burnish can also be manipulated to achieve various results.

Drafting tape can be used to mask off areas of the image to be transferred or to mask off areas on the receiving surface where you do not want the transfer to go. Drafting tape is also used to hold your transfer in place while you are burnishing and checking the progress of the transfer. If your transfer accidentally shifts while you are working on it, it is nearly impossible to realign the image with what you have already transferred. Intentionally shifting the registration can create an interesting "double image."

Additional Considerations

The quality of the photocopy or laser print affects the quality of the transfer. The richer the image, the richer the transfer. Delicate information, particularly in photocopy form, does not generally transfer well. An image that is high in contrast will generally maintain more integrity after being transferred. The best way to determine the potential quality of the transfer is to first experiment on scrap surfaces with an extra photocopy or laser print. The amount of pressure applied, either in a hand transfer or on a press bed, also affects the quality of the transfer. More pressure yields a more complete transfer.

Note that different photocopy machines and laser printers yield slightly different results and use different amounts of ink or toner that can affect the quality of the transfer. While all the solvents listed here work to facilitate a transfer, the stronger solvents (acetone, lacquer thinner, xylene in colorless blenders) generally yield a richer transfer. Again, a little extra time spent in experimentation will help you to avoid unnecessary frustration.

The surface to which you are transferring has an impact on the quality of the transfer. The smoother the surface, the more crisp and complete the transfer will be. If you are transferring to a rougher, more textured surface, this will be reflected in the transfer because the carbon or pigment particles will sit on the highest areas of the textured surface but not on the lower areas of the textured surface. The more pressure you apply to the transfer, the more likely that the transferred image will find its way into the textured surface.

By photocopying or scanning original art, you can utilize a drawing, painting, collage, or other image in a variety of different ways without altering the original. You can repeat an image (in various sizes) as much as you want without having to draw it over and over again, which can save a lot of time. You can draw back into transfers with a variety of materials, and once an image is transferred it will withstand erasure and will not bleed if exposed to water-based materials like watercolor or ink wash. You can take a photocopied or laser printed image and alter it by scraping or sanding, taping or stenciling areas out, cutting into the image, or otherwise manipulating it before you transfer it.

Transfers can also be layered one on top of another. Because only the toner is actually transferred, any areas of an image that are white or paper tone will effectively become transparent when you make the transfer. Transferred images can be combined in a variety of ways, limited only by your imagination and sense of experimentation.

Inkjet Transfers

Inkjet printers are capable of creating an image that can be transferred without the use of chemical solvents. An additional advantage of inkjet transfers is that colored inks can be transferred so that you are not limited to working in black and white. Be aware, however, that the specific process described here is unorthodox, experimental, and somewhat unpredictable, and you should experiment to acquaint yourself with the possibilities and the limitations.

Materials Needed

You will need some basic materials to explore the process of inkjet transfers.

- An image to be transferred. You can use any kind of image, generated through drawing or photography or collage or other processes. The only requirement is that the image must ultimately be in a digital format so that it can be printed on an inkjet printer.
- Digital inkjet glossy photo paper (various brands are available).
- Water for transferring the image.
- A metal spoon, a bone folder, or other smooth burnishing tool for applying pressure to the transfer.
- A paper surface on which the image is to be transferred.
 Stonehenge drawing/printmaking paper is especially effective, but any hot press, heavyweight paper will work.
- Drafting tape for holding your transfer in place when you are burnishing it.
- Scissors or X-acto blade for trimming your transfer if desired
- Drawing materials for working back into the transfers.

Procedure for Transferring Images

Print the image you want to transfer on an inkjet printer, using Digital Inkjet Glossy Photo Paper. The atypical aspect here is that you want to print the image on the *back* of the digital inkjet glossy photo paper so that it does not immediately fuse with the inkjet paper. Make sure you take into account that the image will be flipped or reversed when it is transferred. A high contrast image will transfer more effectively than a low contrast image. Also, be aware that this process works best if you make your transfer shortly after you have printed the image onto the back of the glossy photo paper, before the ink has dried.

Prepare your Stonehenge or other paper to receive the transfer by wetting the surface. You can run the paper under water and sponge off the excess water after the paper is uniformly wet. You can also soak the paper in a tub of water and then sponge off the excess water after the paper is thoroughly soaked.

Carefully place your inkjet print face down on your dampened paper (the image printed on the *back* of the inkjet paper will be face down). If you are concerned about the paper moving while you are transferring the image, you can tape it down using drafting tape. Rub the back of the inkjet print with a burnisher or a spoon or even your hand. Varying the pressure you use will create a weaker or stronger transfer. The inkjet image should transfer very easily once it makes contact with the damp paper. Make sure that your

paper is not too wet, with no standing water on the surface to avoid a blurry transfer. Remember that low contrast areas will not transfer as clearly as higher contrast areas. Once the paper with the transferred image has dried, you can work back into the image in any way you desire with any nonwater based materials that are compatible with the paper you are using.

Acrylic Medium Transfers

Although a bit different than a toner or inkjet transfer, you can also "transfer" images using liquid acrylic gloss medium and almost any image existing on paper, including color images (Figure 5-46).

Materials needed

You will need some basic materials to explore the process of acrylic medium transfers.

- An image to be transferred. You can use photographs or images from magazines, newspapers, photocopy machines, or laser printers—black and white or color. Photographs or coated magazine images should be photocopied first in order to transfer effectively.
- Liquid acrylic gloss medium.
- Small pieces of cotton fabric for removing paper backing.
- Drafting tape for keeping your image flat and holding it in place when you are coating it.
- Soft brush appropriately sized.
- · A pan of lukewarm water.

Procedure for Transferring Images

Take the image that you want to transfer and tape it (using drafting tape) to a firm surface, front side up, to minimize curling. Note that any area of the image that is taped will not transfer because it will not receive the necessary coats of acrylic medium. With a soft brush, apply a coat of acrylic gloss medium to the *front* side of the image, brushing in one direction only. Make sure you don't get any medium on the back of the image. After each coat dries, apply another coat, brushing in the opposite direction. Apply five to ten coats minimum, letting each coat dry and brushing in the opposite direction each time.

When you have finished this process, place the coated image in a pan of lukewarm water and let it soak for about fifteen minutes, no longer than twenty minutes. The acrylic medium may appear foggy or milky while wet, but it will turn clear again after it is dry. While still wet, peel or gently

Figure 5-46. Deborah Rockman, Scenario 7GRDR (version 2) from Losing Sleep, 2006. Acrylic medium transfer on gessoed panel, 17 x 22 inches. Courtesy of the artist. Images from a variety of sources, including drawings, photographs, and digital drawings, are collaged together digitally, printed, and transferred onto clear acrylic medium. The sheet of acrylic medium that holds the images is then adhered to a gessoed birch panel using more acrylic medium as the adhesive.

rub the paper backing off with a piece of soft cotton fabric. You may have to gently rub the wet paper backing a few times to completely remove all of it from the sheet of acrylic medium. The end result is your image suspended in a thin, transparent, flexible sheet of acrylic medium. This can be applied to any surface that accepts acrylic using acrylic medium as an adhesive. The suspended image can also be stretched and distorted slightly, but be aware that too much stretching will tear the sheet.

Lazertran Transfers

Lazertran transfer processes allow you to apply images to all sorts of different surfaces, including porous and nonporous, flat and three-dimensional, smooth and rough. There are a wide variety of Lazertran papers available for different uses, including Lazertran Inkjet (for use with inkjet printers), Lazertran Silk (for transfers to silk that will not stiffen the fabric), and original Lazertran (for transfers to a variety of surfaces), which is what we will be discussing here.

For purposes of clarification, please note that the terms Lazertran, Lazertran paper, transfer, transfer paper, decal, transfer decal, and decal membrane are all various ways of referring to the Lazertran waterslide decal transfer paper used for making your transfers (Figures 5-47 and 5-48).

Lazertran is a waterslide decal transfer paper (currently available in both 8½"×11" and 11"×17" sheets) that was originally developed for use in black-and-white and color photocopy machines. In its earlier form, it allowed you to photocopy any image (in black and white, monochrome, or full color) onto Lazertran paper for transfer to another surface via a clear, thin, decal-like membrane. The original paper was relatively heat sensitive, but older photocopiers operated at a temperature that was compatible with the product. Several years ago, the Lazertran paper was reformulated to tolerate higher temperatures without melting, which allowed for its use in a variety of black-and-white laser printers as well.

With the introduction of multifunction printers, many current photocopiers are integrated into digital printers that

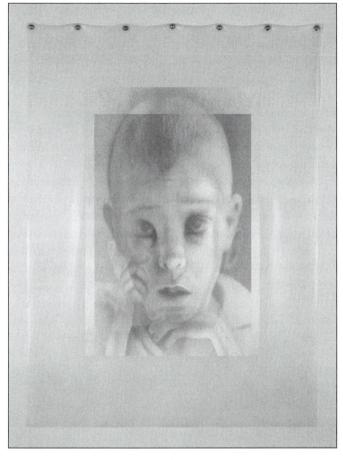

Figure 5-47. Deborah Rockman, *Untitled LBbF from Losing Sleep*, 2004. Digital Lazertran transfer on acrylic medium, 37×28 inches. Courtesy of the artist. A scanned drawing and a found photograph were digitally merged and then printed (using a black-and-white laser printer) on Lazertran. The Lazertran was then transferred onto a handmade sheet of acrylic medium.

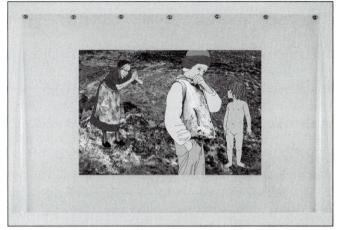

Figure 5-48. Deborah Rockman, Scenario 1GRDR from Losing Sleep, 2005. Digital Lazertran transfer on acrylic medium, 23 × 34 inches. Collection of Regina Salmi. Found photographs were scanned and digitally manipulated. The figures were then digitally drawn using a mouse and merged with the photographic background. The finished image was printed on Lazertran using a black-and-white laser printer and then transferred onto a handmade sheet of acrylic medium.

use a different technology and operate at a higher temperature, rendering them incompatible with current Lazertran transfer paper. But Lazertran continues to work very well with older color and black-and-white photocopiers that use a dry toner and silicon release oil as well as a variety of black-and-white laser printers and some color laser printers. Lazertran transfers do not reverse when they are transferred, so there is no need for concern about this. A comprehensive list of compatible printers, supplied by customers who use Lazertran, is provided on the Lazertran website at www. lazertran.com.

Materials Needed

You will need some basic materials to explore the Lazertran transfer process.

- Lazertran paper created for use with color photocopiers.
- An image to be transferred. You can use any kind of image or combination of images that is capable of being

- printed on Lazertran using a compatible photocopier or laser printer.
- A shallow pan with warm water for soaking the Lazertran paper.
- A plastic or rubber squeegee to assist with the transfer.
- A surface on which the image is to be transferred, including paper, canvas, glass, ceramic, shiny sheet metal, wood, stone, plaster, leather, PVC, and other "difficult" surfaces.
- A soft brush.
- Scissors or X-acto blade for trimming your transfer if desired.
- Acrylic medium (matte or gloss) for transferring onto paper or canvas.
- Denatured alcohol for use when transferring to nonabsorbent shiny surfaces.
- Turpentine for transferring to paper, wood, stone, plaster, leather, PVC, and other "difficult" surfaces without using acrylic medium.

Procedure for Transferring Images to Nonabsorbent, Shiny Surfaces

For this process, you don't need any special adhesive other than the gum that is on the back of the transfer paper. Trim your transfer to size if you do not require the entire sheet. Place the Lazertran into a shallow pan of warm water, inserting the wide end first. The paper will roll up. Make sure it is entirely covered with water and soak for a minute or two.

Remove the transfer from the water, at which time the transfer should be releasing from the backing. Carefully unroll it, and position it on the receiving surface. Slowly slide the backing out from beneath the transfer without lifting it too much, which can create excessive air bubbles or wrinkling. Use a soft brush to begin brushing out any air bubbles. Brush carefully from the center and toward the edges, avoiding excessive pressure that could tear the delicate film. When you have brushed out any large air bubbles, you can then use the squeegee to remove any remaining smaller air bubbles. Allow the transfer to dry for twenty four hours. To protect it, you can varnish the image with either acrylic or oil-based varnish.

If you are interested in stretching the transfer decal around a surface that is not flat you can apply a very small drop of denatured alcohol to the receiving surface and apply the wet decal to this. This makes the transfer decal more flexible so that you can stretch it around a variety of shapes. Remember that once the decal is separated from the backing, it is very thin and must be handled carefully to prevent tearing.

Procedure for Transferring Images to Paper or Canvas

Attach your paper or canvas to a flat board. Paper surfaces should be sealed with clear acrylic medium (gloss or matte or a blend of the two) to help avoid buckling and to increase the mobility of the transfer, making it easier to move it around into the position you want. Canvas should be primed with acrylic medium or another acrylic primer. You can dilute the acrylic medium with up to 25 percent water.

Trim your transfer to size if you do not require the entire sheet. Place the Lazertran into a shallow pan of warm water, inserting the wide end first. The paper will roll up. Make sure it is entirely covered with water and soak for a minute or two.

While the transfer is soaking, recoat your paper or canvas with acrylic medium or acrylic primer (use a soft brush or a short haired roller) so that it is wet when you apply your transfer. Remove the transfer from the water, at which time it should be releasing from the backing. Carefully unroll the transfer, and position it on the receiving surface. Slowly slide

the backing out from beneath the transfer without lifting it too much, which can create excessive air bubbles or wrinkling. Use a soft brush to begin brushing out any air bubbles. Brush carefully from the center and toward the edges, avoiding excessive pressure that could tear the delicate film. When you have brushed out any large air bubbles, you can then use the squeegee to remove any remaining smaller air bubbles. Allow the transfer to dry flat for several hours, after which you can apply an additional coat of matte medium for a flat finish or gloss medium for a shiny finish.

When using water or acrylic medium to facilitate your transfer, Lazertran leaves a decal-like surface in place after the transfer process is complete, and this surface is somewhat plastic-like in character. Whether the surface is left open or is coated with acrylic medium, it is not very receptive to most traditional drawing media, especially dry drawing media. As

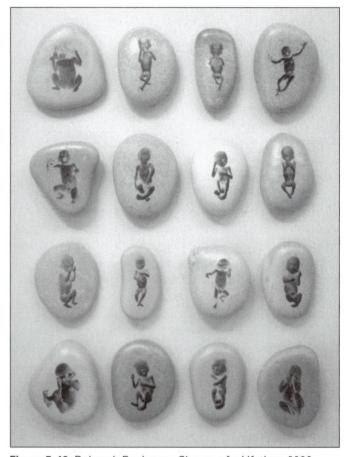

Figure 5-49. Deborah Rockman, *Chance of a Lifetime*, 2000. Digital Lazertran transfer on stones, 20 × 16 inches. Courtesy of the artist. Digitally scanned images were printed on Lazertran using a black-and-white laser printer. The images were then transferred onto the surface of stones using a turpentine transfer method.

Figure 5-50. Student work. Michele Bosak. Digital Lazertran was applied to the surface of the three prepared wood panels using turpentine. Lazertran was also applied to the glass that covers the recessed areas of the wood panels. When transferring Lazertran to glass, no solvent or additional wet medium is necessary.

a result, you will typically not be able to work back into the surface in the same way that you can if working with, for example, a solvent transfer. So make note that if you want to combine drawing processes with images derived from other sources, you should integrate these media prior to printing the image on Lazertran via photocopying or laser printing.

Procedure for Transferring Images to a Variety of Porous Surfaces Using Turpentine

Trim your transfer to size if you do not require the entire sheet. Place the Lazertran into a shallow pan of warm water, inserting the wide end first. The paper will roll up. Make sure it is entirely covered with water and soak for a minute or two.

While the transfer is soaking, coat your receiving surface with pure turpentine. Remove the transfer from the

water, at which time the transfer should be releasing from the backing. Carefully unroll it, and blot off as much excess water as possible. Position your transfer on the receiving surface. Slowly slide the backing out from beneath the transfer without lifting it too much, which can create excessive air bubbles or wrinkling. Using a soft brush, apply some more turpentine to the surface of the transfer, which begins to dissolve the decal membrane. If you use too much turpentine or brush too long or too vigorously, you risk breaking the transfer down, so exercise caution. Allow the image to set for several hours until the turpentine has evaporated and the surface is dry. Be aware that use of pure turpentine requires adequate ventilation and other safety precautions. Turpentine substitutes will not work with this process (Figures 5-49 and 5-50).

APPENDIX

Contemporary Art A Gallery of Drawings

As the title clearly states, this book is a guide to drawing from observation. It focuses primarily on the development of increased sensitivity to visual stimuli, to drawing materials and surfaces, to the skills that form a solid framework for exploring drawing and the myriad possibilities it offers at an advanced and independent level. Throughout the text, the examples offered reflect an approach to drawing that is not limited to observation exclusively. Some abstract drawings serve as examples for the use of various materials, some drawings combine traditional drawing with digital techniques, some drawings incorporate nontraditional practices such as transfers and collage, and some drawings clearly utilize a blend of observation and invention.

As stated in the Preface, the duality of tradition (based on historical notions of drawing) and innovation (based on contemporary notions of drawing) is, in my experience, one of the hallmarks of a successful drawing program. Initial course work at the foundation

level provides students with strong fundamental skills and experiences rooted in tradition, while intermediate and advanced course work progresses toward a broad working definition of drawing that supports students whose emphasis is more traditional as well as students who wish to expand upon or work outside of a traditional definition of drawing.

In these final pages is a sampling of the work of a number of contemporary artists who work exclusively in drawing or whose studio practice incorporates drawing as a significant component in their body of work. When possible, the artist's own words are used to describe his or her work and intentions. In the absence of this, a discussion of the artist's intentions or process is provided based on available information. Some of the work is clearly more rooted in tradition (Mary Borgman's charcoal on mylar portraits, Joseph Stashkevetch's highly realistic drawings, or Robert Schultz's graphite renderings of the figure), while other work extends beyond the scope of observation

or engages nontraditional processes and materials (Jon Rappleye's fantastical worlds populated by the familiar and the unfamiliar, Dustan Creech's drawings on steel, Leah Gregoire's drawings on prepared glass, or Jennifer Purdum's cut newspaper drawings).

Although these works represent only a small fraction of contemporary drawing practices, the intention is to highlight possibilities in terms of subject matter, content or idea, formal concerns, materials, and processes. All of the artists represented here graciously granted permission to reproduce their work.

Joe Biel (Figures App.-1-App.-4)

Joe Biel, who lives in Los Angeles, says about his work, "I am most interested in charged human situations. This interest is reflected through various means in particular works; sometimes by portraying a particular moment or event, but more often by showing the moment before or after an action that is not named or specified. I'm more interested in the suggestion of narrative possibilities than in clearly resolved linear narratives, though it seems important that certain details (e.g., gestures, expressions, clothing, object types) remain quite specific. For me it is in the possibility of the more general metaphor meeting the peculiarly specific that images

Figure App.-1. Joe Biel, American, *Jumper*, 2005. Watercolor, pastel, prismacolor, and graphite on paper, 72×60 inches. Courtesy of Greg Kucera Gallery, Seattle, WA.

Figure App.-2. Joe Biel, American, *Dancers*, 2005. Graphite on paper, 30×22 inches. Courtesy of Greg Kucera Gallery, Seattle, WA.

start to realize a greater, more layered potential." While Biel is interested in narrative, he doesn't think of himself as a storyteller. "Not that I wouldn't want to be, but if I try to look at the work from a distance, as much as that is possible, I realize that what I'm really interested in is charging images with narrative possibilities."

Biel's process is elegant yet pared down, excluding everything that is not immediately significant to the central figure. Most often male, the subjects find themselves in strange, unsettling, surreal situations and predicaments. "I realized that what really interested me was not the story that was being told, but the strangeness of the world these figures and their often stranger environments created. It was all in the details, the strange distortion of a head or a hand, the way a gesture seemed forced when compared with photographic naturalism. Or the fact that the rider was too big for the horse so that a sort of toylike quality invaded the whole scene, or that the artist set the scene partially in his own time and place and partially in a place with some biblical or historical reality so that the combination created an almost surrealistic quality."

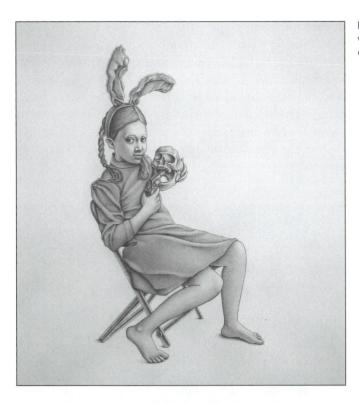

Figure App.-3. Joe Biel, American, *Pistol*, 2006. Graphite, watercolor, and prismacolor on paper, 64×53 inches. Courtesy of Goff and Rosenthal Gallery, New York.

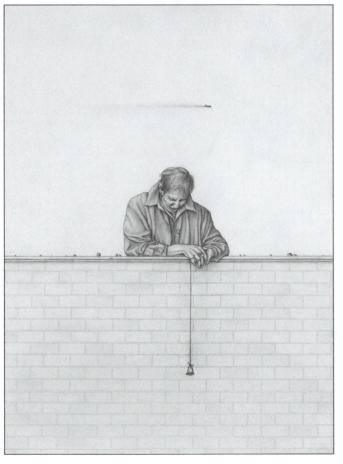

Figure App.-4. Joe Biel, American, *Bell*, 2006. Graphite on paper, 30×22 inches. Courtesy of Greg Kucera Gallery, Seattle, WA.

Mary Borgman (Figures App.-5-App.-8)

Mary Borgman works in the tradition of representational portraiture and uses the traditional drawing medium of charcoal. But her drawings, executed on large sheets of frosted mylar, rise above the conservative associations we often ascribe to traditional portraiture.

Her subjects are usually depicted slightly larger than life, gazing out from the surface directly into the eyes of the viewer. Regardless of who her subjects are, they capture

our attention and exude intelligence, pride, and self-awareness, inviting a response of curiosity and a desire to know these people better. Borgman's facility and sensitivity with her medium and process are nothing less than impressive. And her selection of subjects is broadly diverse in terms of age, gender, and ethnicity. Borgman's drawings are as compelling for their surface of marks and smudges as they are for the character of her subjects that is so expertly revealed.

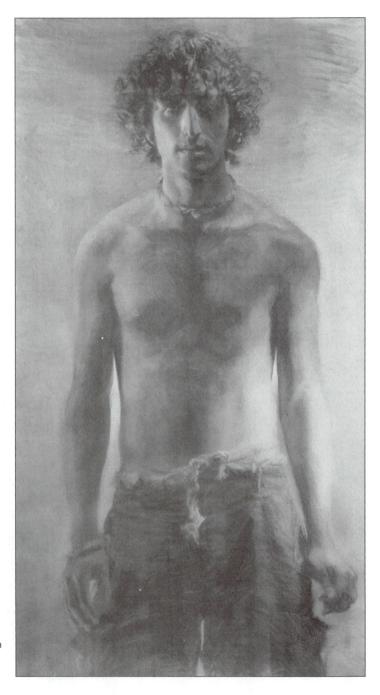

Figure App.-5. Mary Borgman, American, *Nati Zohar* (*standing*), 2004. Charcoal on mylar, 76×42 inches. Collection of Rick Shoemaker and Jim Ruud, Chicago; courtesy of Ann Nathan Gallery, Chicago.

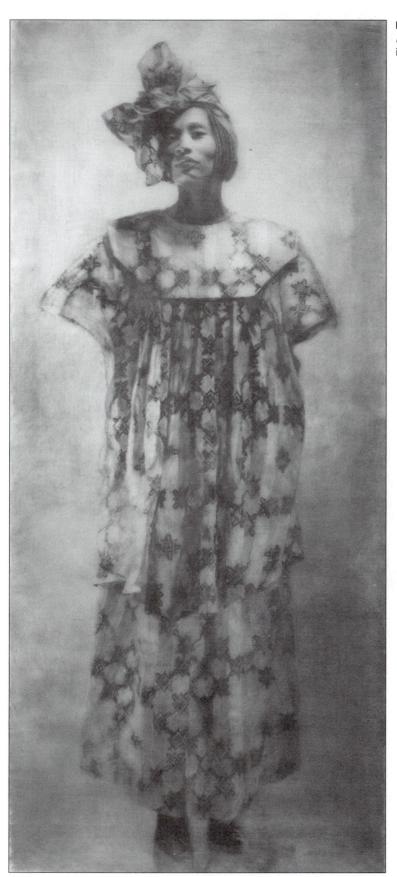

Figure App.-6. Mary Borgman, American, *Dr. Kopano Mpuang (standing)*, 2002. Charcoal on mylar, 96×43 inches. Courtesy of Ann Nathan Gallery, Chicago.

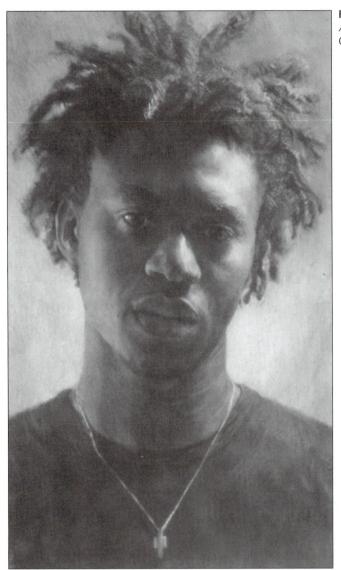

Figure App.-7. Mary Borgman, American, Portrait of Tomiwa Alabi, 2004. Charcoal on mylar, 69×42 inches. Private Collection, Chicago; courtesy of Ann Nathan Gallery, Chicago.

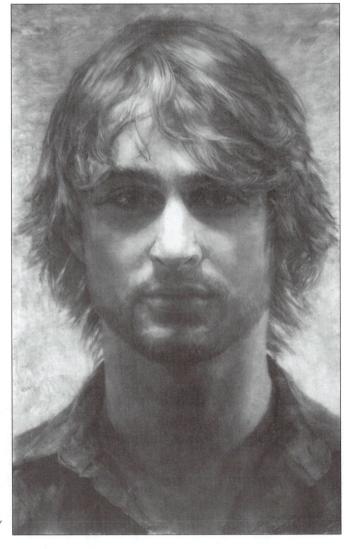

Figure App.-8. Mary Borgman, American, *Portrait of Kevin Croker*, 2006. Charcoal on mylar, 68×44 inches. Collection of David Pence, Los Angeles; courtesy of Ann Nathan Gallery, Chicago.

Dustan Creech (Figures App.-9-App.-11)

"I create work that encapsulates the lives of the socially insignificant. I am from Harlan County, a poverty stricken coal area in southeastern Kentucky. My father has been a coal miner for thirty five years and he is still underground at the age of fifty seven. He has sacrificed his life for his profession and our nation's energy. I've watched his health slowly decline due to his work environment as the demand for his job grows. This has fueled the fires for my work in which I relate industry, labor rights and America's energy

consumption. From the victims of Hurricane Katrina to the blue-collar worker in our factories, these are the lives I focus on.

"The 'steel drawings' are a portrayal of the lives of the blue-collar workers who slave to build the backbone of America through iron, steel, and coal. I gather scrap panels from steel factories and arrange them like puzzle pieces to create the background for the work. I only use tools and materials indigenous to the professions of the workers included in my imagery, such as metal grinders, metal sheers, coal dust, oil and steel." See more of Dustan Creech's work in Chapter Five.

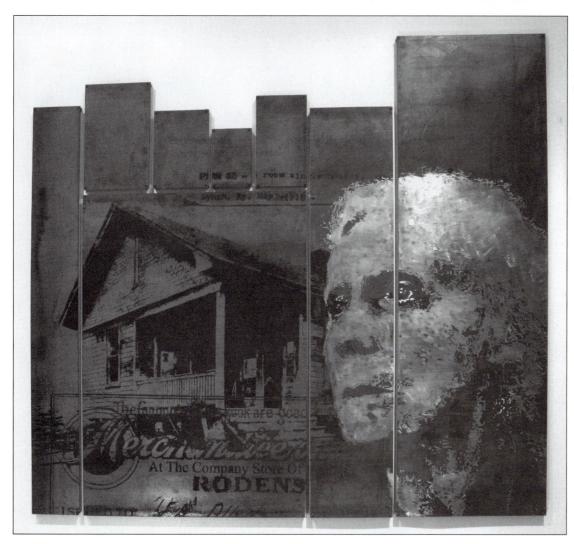

Figure App.-9.
Dustan Julius Creech,
American, Deeper in
Debt, 2005. Steel, coal,
and oil, 73×60 inches.
Courtesy of the artist.

Figure App.-10. Dustan Julius Creech, American, The Breaker Boys, 2004. Steel, coal, and oil, 136×71 inches. Courtesy of the artist.

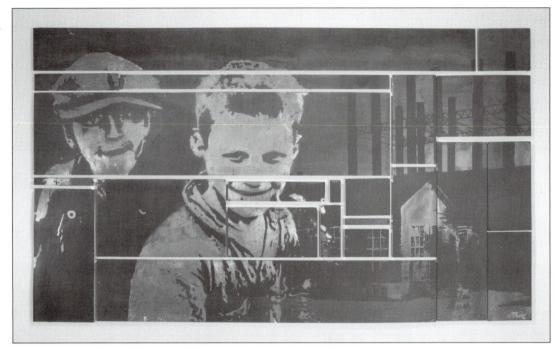

Figure App.-11. Dustan Julius Creech, American, Another Day Older, 2005. Steel, coal, and oil, 60×48 inches. Courtesy of the artist.

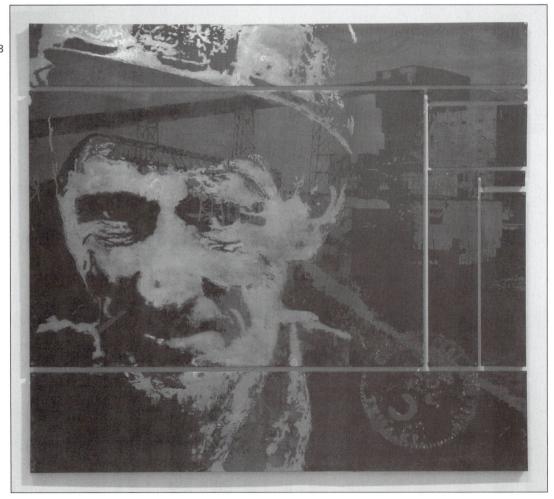

Susan D'Amato (Figures App.-12—App.-14)

"The navel is a symbol of origin and myth, a form and space at once that embodyes our identity, vulnerability and mortality. Intrigued with the symbol, form, and idea of the navel, these drawings explore the relationships between identity, the body, nature, and origin. Often regarded as sexual, hidden, attractive, or repulsive, the navel signifies our primal beginning to birth and our primary connection to maternal nurturing. Seen as a wound or scar, it is the evidence of our separation, dependence, and need, embodying the dualities of attachment and detachment, dependence and independence, loss and growth. The interplay between the mystery of creation and the body comes together in a single landscape to evoke a contemplative awareness of the interdependence of life."

Figure App.-12. Susan D'Amato, American, *Paragon*, 2005. Charcoal on paper, 60×42 inches. Courtesy of the artist.

Figure App.-13. Susan D'Amato, American, Reflection, 2005. Charcoal on paper, 60×42 inches. Private collection, The Minister of Foreign Affairs, Belgium.

Figure App.-14. Susan D'Amato, American, *Dad*, 2000. Pastel and charcoal on paper, 60×42 inches. Courtesy of the artist.

Bailey Doogan (Figures App.-15-App.-17)

"For the past fifteen years, my drawing and painting has focused on the human body, the mutable body where flesh moves, changes, and has infinite variety. Our bodies are full of stories. They are detailed maps of our experiences. This corporeal topography of hair patterns, veins, scars, calluses, wrinkles, and flesh (both smooth and crenulated) speaks of a life lived.

"Representations of the aging body, with some notable exceptions, have been largely excluded from the art canon. For the most part, the history of the body as naked subject has been the history of the body as seamless object. In addition to visuals, since language carries the weight of intellectual authority, text is often used to 'explain' the body. Much of my work explores that charged relationship between the world of discourse and the palpable world: the body and the words surrounding it.

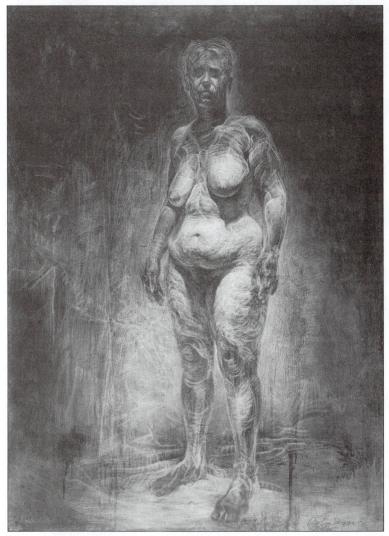

Figure App.-15. Bailey Doogan, American, A Front, 2002. Charcoal on primed paper, 72×53 inches. Courtesy of Etherton Gallery, Tucson, AZ.

"Because of the highly articulated physical presence that I have wanted in my work, over the past fifteen years I have had to reteach myself to draw. That learning process is ongoing. The drawing process is subtractive. I initially apply many layers of gesso to the paper, then blacken the entire primed surface with charcoal. I draw with sandpaper to pull light areas from the dark, so that the bodies become luminous in the space: both receivers and emitters of light. As my visual acuity diminishes (detaching retinas, cataracts, etc.), my representation of the body has become more haptic or felt. While working, I feel that I'm literally crawling over the surface of the body—familiarity breeds redemption."

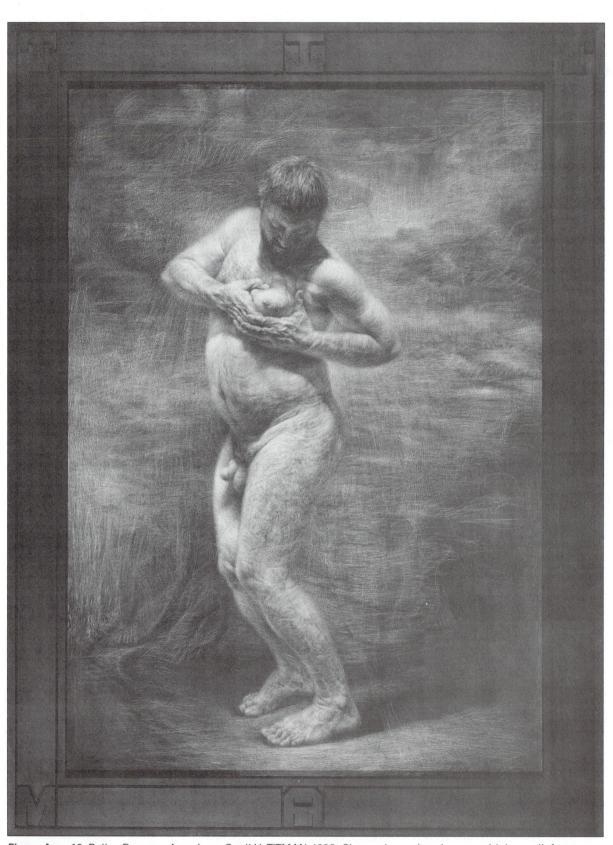

Figure App.-16. Bailey Doogan, American, *Spell V, TITMAN,* 1998. Charcoal on primed paper with bas-relief text frame, 84×62 inches. Collection of Ted G. Decker.

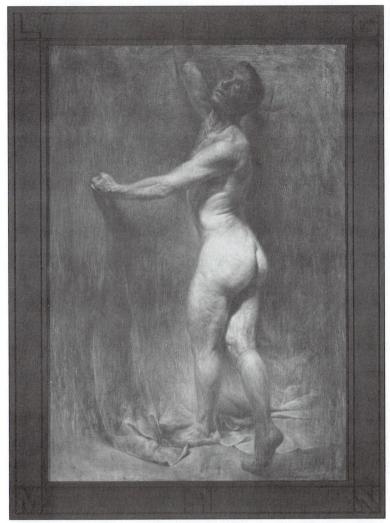

Figure App.-17. Bailey Doogan, American, *Spell III, LEGMAN,* 1997. Charcoal on primed paper with bas-relief text frame, 84×62 inches. Courtesy of Etherton Gallery, Tucson, AZ.

Rob Evans (Figures App.-18—App.-21)

For the past twenty years, Rob Evans work has focused almost exclusively on the farm and surrounding landscape in rural Pennsylvania where he lives with his wife and his children. His earlier work from the late eighties through the late nineties explores various aspects of rural life and the inevitable forces of nature. Through his astute observations and exquisite draftsmanship, his exterior spaces focus on the passage of time, the cycles of life and death, growth and decay, changes of season and weather, and the mysteries of light. In many cases they are about seemingly insignificant events, perhaps

an insect metamorphosing or a distant storm approaching, or provide discreet evidence of distant neighbors via specks of light or trails of smoke. His intricate interior spaces, orderly and geometric, provide tiny glimpses of the surrounding landscape and are eerily devoid of the human form for which they are intended, conveying instead a profound stillness and isolation.

It is his hope to present these commonplace objects, spaces, or events in such a way that they become unconventional metaphors for the human experience and specifically his own experiences as an artist, father, husband, and participant in life at this particular time in history.

Figure App.-18. Rob Evans, American, Study for "Predator," 1996. Graphite on paper, 12×21 inches. Courtesy of the artist.

Figure App.-19. Rob Evans, American, Study for "Refuge," 1997. Graphite on board, 12×13 inches. Courtesy of the artist.

Figure App.-20. Rob Evans, American, Metamorphosis (Study for "Cicada"), 1996. Charcoal and conte on paper, 40×30 inches. Courtesy of the artist.

Figure App.-21. Rob Evans, American, *Power Lines 1*, 1986. Graphite on paper, 21×25 inches. Courtesy of the artist.

Dan Fischer (Figures App.-22–App.-24)

Dan Fischer, who works with only a mechanical pencil and an eraser, continues to explore his self-appointed task of drawing familiar photographs of renowned artists with great detail and precision. The artists he chooses to represent in his drawings are artists who have influenced him in some way, although the influence may not be readily apparent to the viewer. Upon encountering these drawings, they initially appear to be photographs, revealing their true identity only upon close inspection.

Fischer uses a grid when transferring his drawings to the paper surface and allows the grid to remain visible in the end result. The grid fades in and out of view, depending upon the tonal structure through which it passes. The grid is most poignant when juxtaposed with images of artists who worked in the modernist era, and serves to remind us that we are in fact not looking at a photograph, but at a drawing of a photograph intended to pay homage to artists, both past and present, whom this artist admires.

Figure App.-22. Dan Fischer, American, *Philip Guston*, 2004. Graphite on paper, image: 8.125×11.375 inches, paper: 17.125×22.125 inches. Image courtesy of the artist and Derek Eller Gallery, New York. Private collection.

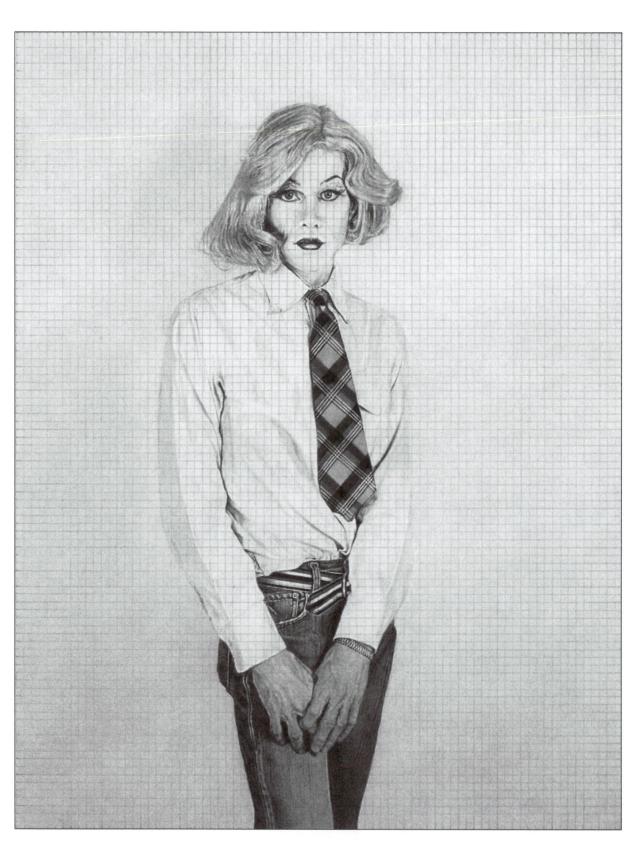

Figure App.-23. Dan Fischer, American, *Andy Warhol*, 2003. Graphite on paper, image: 12.625×9.625 inches, paper: 22.25×17.875 inches. Image courtesy of the artist and Derek Eller Gallery, New York. Collection of Graham Schneider.

Figure App.-24. Dan Fischer, American, *Dave Wojnarowicz*, 2003. Graphite on paper, image: 6.125×5.25 inches, paper: 15×11.25 inches. Image courtesy of the artist and Derek Eller Gallery, New York. Collection of Mark Pollack.

Leah Gregoire Prucka (Figures App.-25–App.-28)

"The idea of drawing onto glass stems from a much older process known as lithography. In lithography, a special limestone surface is prepared for the acceptance of oil-based drawing materials by graining the surface to an even texture. I love the stone surface, but also wished to engage my love of graphite as a drawing tool. This led me to experiment with glass as a drawing surface.

"I begin the process by grinding a sheet of glass to create a surface similar to limestone, but which accepts pencil.

Using carborundum grit and a careful amount of water, I begin to grind the glass using a levigator (a weighted device used to prepare the surface of litho stones). This continues either until the glass cracks and is discarded or until I achieve an evenly ground surface to draw upon. Like lithography, the process of drawing on glass is not very forgiving, and erasure is not possible. If a mistake is made or I change my mind about the progression of an image, the glass must be reground until the entire image is removed. I then begin to draw the image again." See more of Leah Gregoire Prucka's work in Chapter One and Chapter Five.

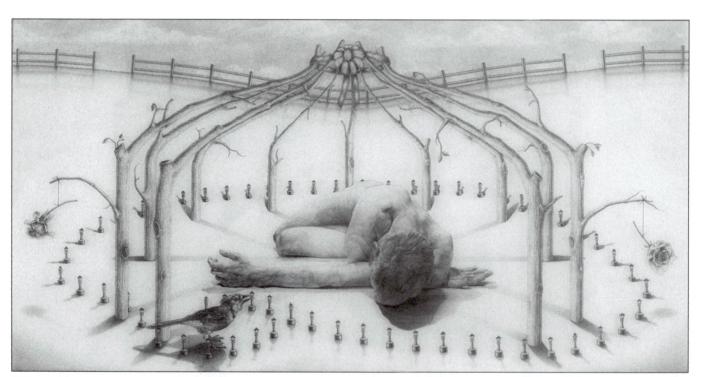

Figure App.-25. Leah Gregoire Prucka, American, *Mirari: Venerable*, 2001. Graphite on prepared glass, 6.625×12.875 inches. Courtesy of the artist.

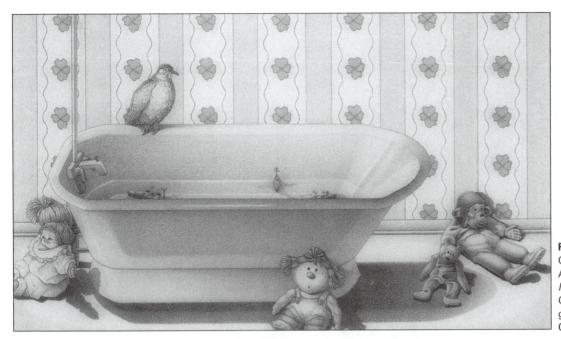

Figure App.-26. Leah Gregoire Prucka, American, Mirari: Missionary Sisters, 2002. Graphite on prepared glass, 3.25×5.5 inches. Courtesy of the artist.

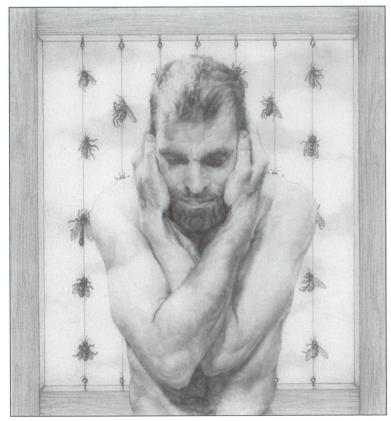

Figure App.-27. Leah Gregoire Prucka, American, *Mirari: Ephphatha*, 2001. Graphite on prepared glass, 5.5×6 inches. Courtesy of the artist.

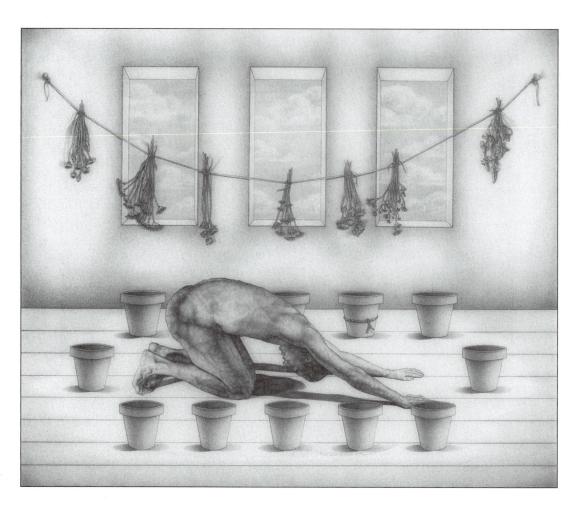

Figure App.-28. Leah Gregoire Prucka, American, Garden Series: Prelude, 2000. Graphite on prepared glass, 9×10.625 inches. Courtesy of the artist.

Sol Kjøk (Figures App.-29-App.-31)

"My drawings and paintings are the visual terminus of a much longer method, and their surplus, or extravisual, meaning may be found in the archeology of their making: My process starts with performances staged in my studio, where my co-swirlers and I carry out potentially painful acrobatic exercises, such as walking the tight rope, climbing ropes or juggling, dribbling, or balancing on balls.

"This initial physical experience, driven by a desire to first experience as manifest reality the symbolic content of my images, is documented with a camera and subsequently mediated by cutting out the naked figures from these source shots and reassembling them into collages. Like lost wax, the photo collages gradually disappear while serving as visual documentation for drawings and paintings.

"The optimal viewing experience for this series requires ropes suspended from the gallery ceiling. These are intended as expansions into three-dimensional space of this series' central recurring pictorial element: the string of beads. Their presence in the exhibition venue brings the creative journey full circle, that is, back to the initial physical experience occurring in my studio. The gallery-goers willing to step into the circus ring to swing on the rope for a minute can see the images unfold from a participant's perspective. And because my pictorial epic is partially a comment on being fully present in one's body, I want the viewers to feel the strain in their own limbs as they slowly glide through the air."

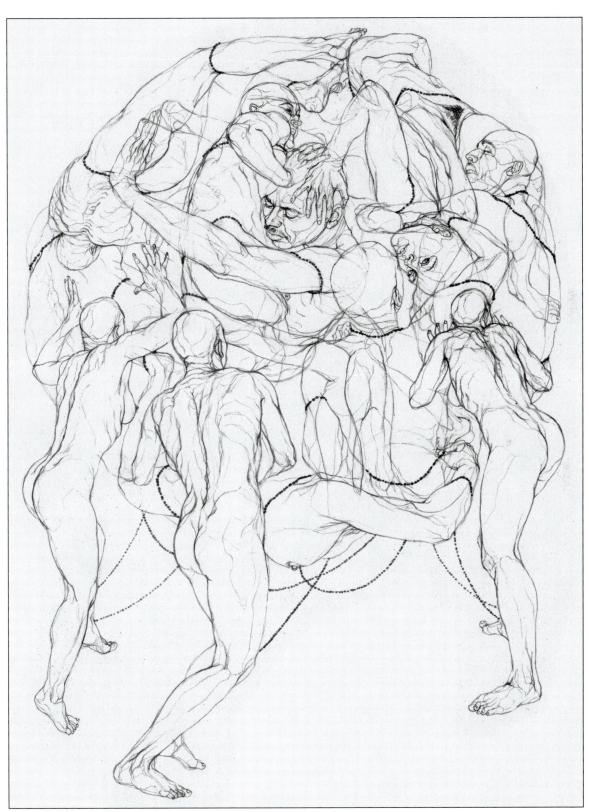

Figure App.-29. Sol Kjøk, Norwegian, String of Beads 38, 2003. Pencil and colored pencil on paper, $13^3/4 \times 11^3/6$ inches. Courtesy of the artist.

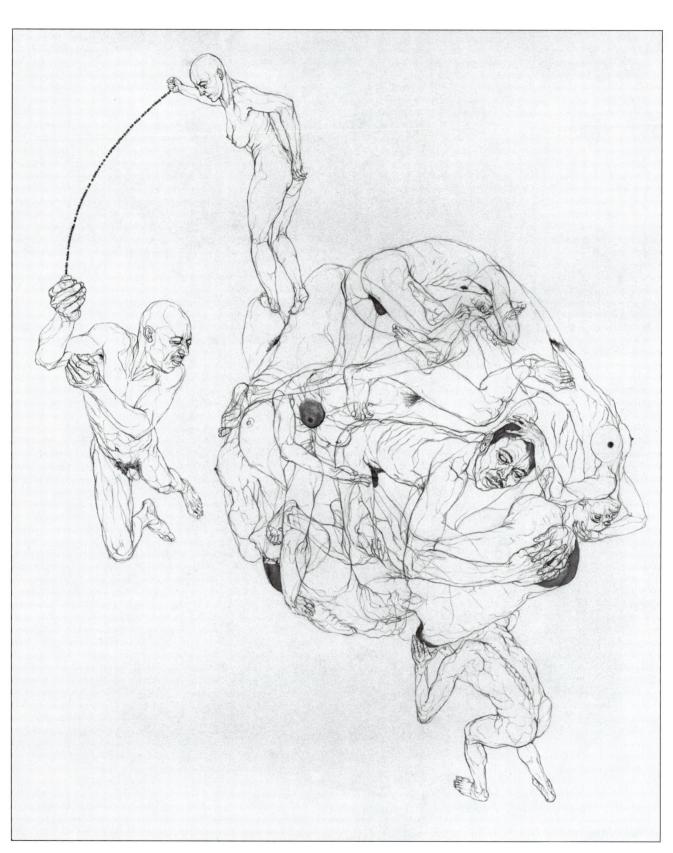

Figure App.-30. Sol Kjøk, Norwegian, String of Beads 28, 2003. Pencil and colored pencil on paper, $14^{1}/2 \times 11^{5}/8$ inches. Courtesy of the artist.

Figure App.-31. Sol Kjøk, Norwegian, *String of Beads 37* (Panel A of triptych), 2003. Pencil and colored pencil on paper, 14×14 inches. Collection of Gösta Peterson, New York.

Sangram Majumdar (Figures App.-32—App.-36)

Sangram Majumdar is a witness to the beautiful in the ordinary, to the casual interplay of strangers encountering each other in crowded public places. They pass by one another in a bus station, on an escalator, in an airport, on a sidewalk at night. They move in different directions, some looking down, some looking straight ahead, some sneaking sidelong glances at passersby. The interaction is almost exclusively physical as they jostle past one another on their

way to their destination, moving off all four sides of the picture plane.

Majumdar views his subjects from above and washes them in rich, beautiful charcoal and graphite tones. Their contours shift between distinct and indistinct as they both merge and separate in their movement through space. We are frequently drawn to one or more specific figures through his careful manipulation of value and light. As viewers, we scan the scene looking for a familiar face and are just a step or two away from slipping into the crowd and joining the others as they hurry on their way.

Figure App.-32. Sangram Majumdar, American, Darkening Rain, 2006. Graphite and charcoal on paper, 30×41.5 inches. Courtesy of Ann Nathan Gallery, Chicago.

Figure App.-33. Sangram Majumdar, American, Time Flowing in the Middle of the Night, 2006. Graphite and charcoal on paper, 38×57 inches. Courtesy of Ann Nathan Gallery, Chicago.

Figure App.-34. Sangram Majumdar, American, Held Back, 2005. Graphite and charcoal on paper, $30 \times 41^{1}/2$ inches. Courtesy of Ann Nathan Gallery, Chicago.

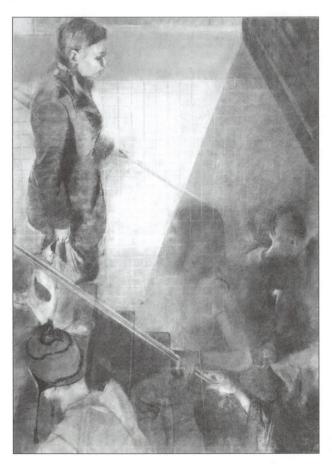

Figure App.-35. Sangram Majumdar, American, *Recurrence*, 2005. Graphite and charcoal on paper, 50×72 inches. Collection of Susan and Steve Scholl, Glencoe, IL; courtesy of Ann Nathan Gallery, Chicago.

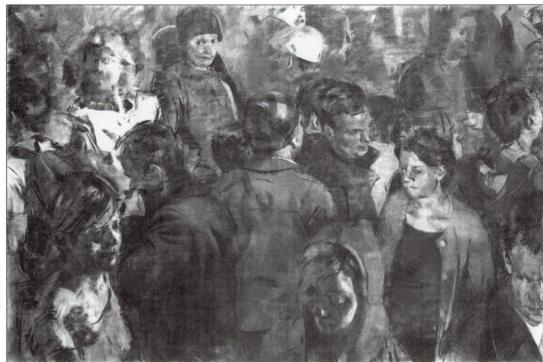

Figure App.-36. Sangram Majumdar, American, *The Maze*, 2006. Graphite and charcoal on paper, 38×57 inches. Courtesy of Ann Nathan Gallery, Chicago.

Antony Micallef (Figures App.-37–App.-39)

Antony Micallef is a British artist who grew up with a great interest in fashion, graphic design, music, and pop culture. His current influences range from classical masters such as Caravaggio and Velazquez to Japanese cartoon characters. The human figure plays a significant and central role in his

work, driven by an attraction to something he sees or senses in others. His Baconesque portraits and figure drawings, executed in both charcoal and black oil paint, are both beautiful and raw in their simplicity and directness, displaying the angst that lies beneath the inescapable consumer-driven, brand name pop culture that permeates the twenty-first century.

Figure App.-37. Antony Micallef, *English, Becoming Animal*, 2003. Charcoal on paper, 35×45 cm. Courtesy of the artist.

Figure App.-38. Antony Micallef, English, $Study\ of\ a\ Boy\ 1$, 2004. Charcoal on paper, 100 × 141 cm. Courtesy of the artist.

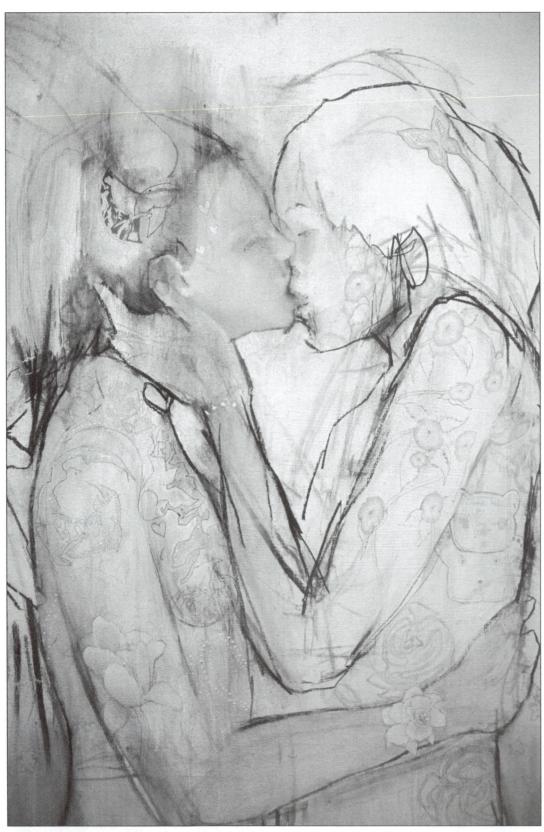

Figure App.-39. Antony Micallef, English, *Study for the Suck Lovers 2*, 2002. Oil, charcoal, pencil, pen on canvas, 160×170 cm. Courtesy of the artist.

Chloe Piene (Figures App.-40-App.-42)

Chloe Piene's charcoal drawings on paper and vellum are at once sensitive and disturbing, examining notions of sexuality, gender, eroticism, and the fine line between anguish and ecstasy. She works primarily from photographs and most often uses herself as a model. The inspiration for her subject matter often draws from a variety of sources, including

primitive rituals, biblical stories, and the history of art. Her naked figures are translucent, often providing a glimpse of the skeletal framework that holds these fragile yet forceful forms together. Piene describes the abject bodies in her work as straddling "the erotic and the forensic." The line work, reminiscent of Egon Schiele, exudes energy and anxiety and reflects the rapid execution of these single-session works.

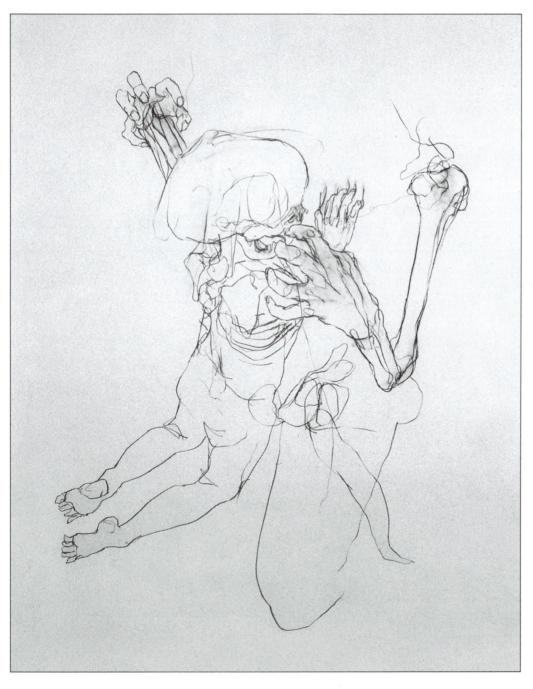

Figure App.-40. Chloe Piene, American, *Mismatched Pair* (Aino & Vaino) (detail), 2001. Charcoal on paper, 45¹/₄×40 inches (114.9×101.6 cm). Courtesy of the artist.

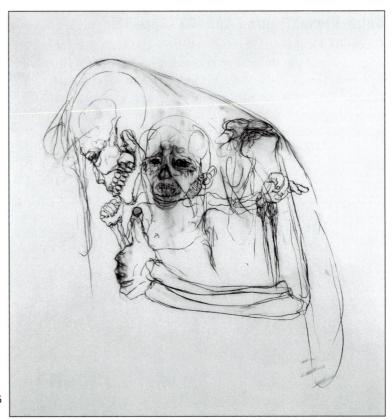

Figure App.-41. Chloe Piene, American, *Death Carrying Her Brood* (detail), 2002. Charcoal on vellum, 36.125×49.5 inches (91.8×125.7 cm). Courtesy of the artist.

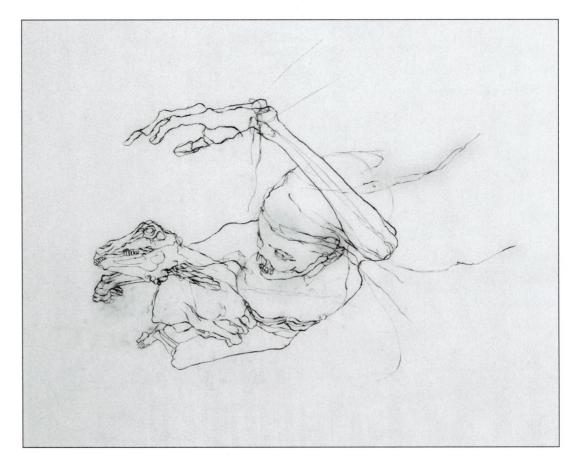

Figure App.-42. Chloe Piene, American, Girl with Dead Goat, 2002 (detail). Charcoal on vellum, 44.09×30.31 inches (112×77 cm). Courtesy of the artist.

Ben Polsky (Figures App.-43-App.-46)

"I take digital photographs to make drawings. My drawings are guided by these photographs. I have little interest in the kind of free form usually associated with drawing as it too often degrades into self-conscious mark making. The drawing that I do is a mechanical act intended to function in a specific way. The use of a predetermined layout enables me to have a clear start and end to the picture. In contrast to the *feeling* of being finished with something, I am done when I reach the other side of the page. Although this may seem cold, it is actually an intimate situation as much interpretation of the visible image takes place.

"My objective is to transport the experience that I have had — locating sites, hopping fences, walking in black puddles and breathing in mysterious dusts — taking in the wholeness of the complex and contemplating how particular

views will transfer to the paper. The photos are a temporary reference for the purpose of transferring my experience to the viewer of a drawing.

"To me these sites are organic and to convey that is my primary goal. Art is essentially a construct — in direct opposition to destruction, and these pictures exemplify this point. These sites are not devastation. My subject is beautiful. First, I revere the places I find and I elevate them from that source. An archeologist searches for answers from the past in order to articulate an exact order to things but my locations are not significant in this manner. They simply reach back throughout our century and functioned at one time in average ways. It is the way they exit that seems to me to be so mysteriously organic and universal. These drawings are documents, not myths. The testament to the sites lies in innovation, not folklore." See more of Ben Polsky's work in Chapter Five.

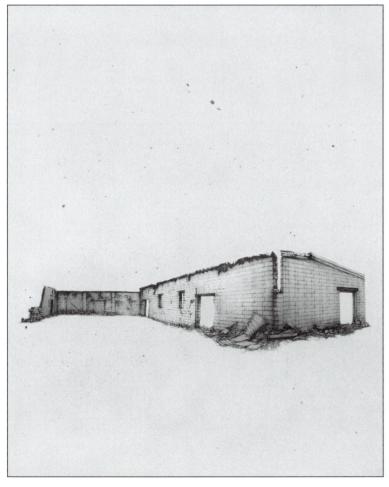

Figure App.-43. Ben Polsky, American, *Cinderblock Remnant*, 2002–2007. Carbon transfer on rag paper, 100×80 inches. Courtesy of the artist.

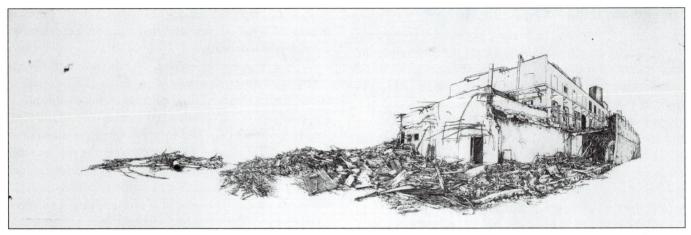

Figure App.-44. Ben Polsky, American, *Ink Plant—Building 2*, 2002. Carbon transfer on rag paper, 20×60 inches. Collection of Michael Straus, Birmingham, AL.

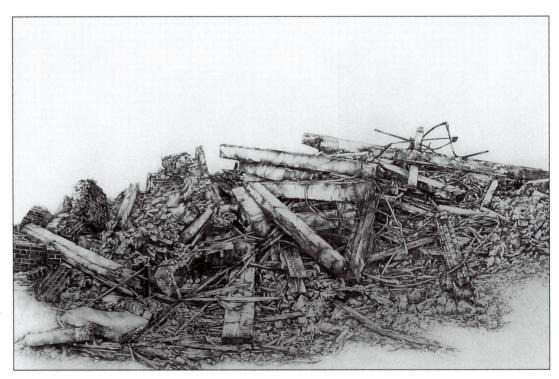

Figure App.-45. Ben Polsky, American. *Oliver* Street Survey—Pile 01 (detail), 2005, Graphite on mylar, 22×34 inches. Courtesy of the artist.

Figure App.-46. Ben Polsky, American, *Site* 21.01, 2005. Graphite and brasspoint on rabbit skin glue gessoed panel, 7.5×12 inches. Courtesy of the artist.

Jennifer Purdum (Figures App.-47–App.-50)

Jennifer Purdum makes her art from everyday objects and materials that many of us would consider discardable. In some of her work she uses newspaper that is cut up or shredded and formed into unexpected and innovative shapes. Through her transformation of the material, the newspaper takes on an entirely new identity and references our contemporary culture's insatiable consumption and regurgitation of information, which her own process parallels. In order to provide her viewers with her transformative vision, she

must first consume or destroy the information that is the newspaper.

Works from her *Heap* series, which share some of the same concerns and interests as her *Newspaper* series, include drawings, transfers, stamps, and other materials meandering across a surface of paper and mylar. The resulting images, notably absent of human figures, are heavily populated by abandoned structures, chairs, beds, sofas, and trash and are linked by vague tubular forms that ultimately suggest a cosmic space station of discarded domestic debris passing through a cloud of dust.

Figure App.-47. Jennifer Purdum, American, *Picayune Heap*, 2005. Newspaper on paper, 40×32 inches. Courtesy of the artist.

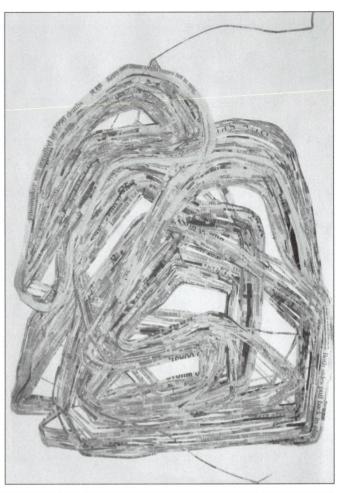

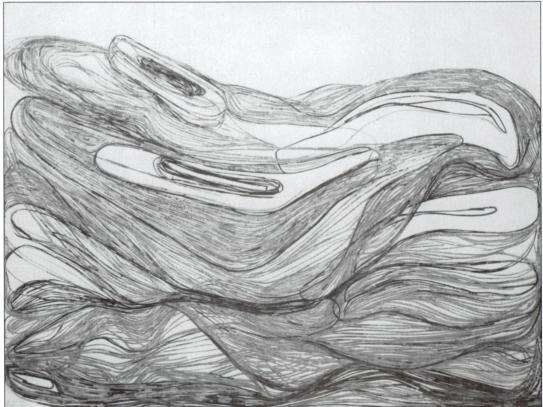

Figure App.-48. Jennifer Purdum, American, Sediment, 2005.
Newspaper on paper, 32×40 inches. Courtesy of the artist.

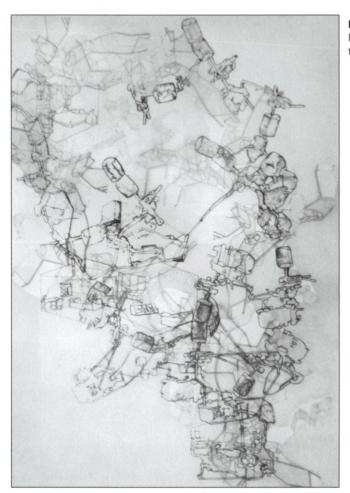

Figure App.-49. Jennifer Purdum, American, *Soft Cities*, 2004. Mixed media on paper and mylar, 36 x 24 inches. Courtesy of the artist.

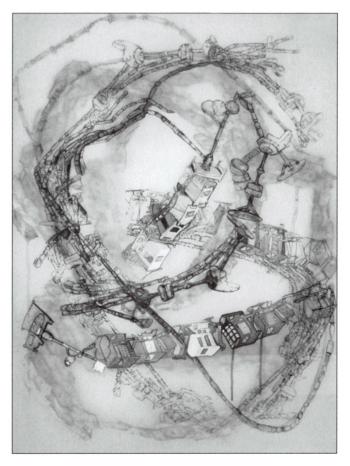

Figure App.-50. Jennifer Purdum, American, *Soft Cities 2*, 2004. Mixed media on paper and mylar, 36×24 inches. Courtesy of the artist.

Jon Rappleye (Figures App.-51-App.-54)

Jon Rappleye's drawings depict fantastical worlds populated by familiar animals, exotic creatures, and strange hybrid phenomena. They are homespun fairy tales, explorations of cultural folklore and his own personal mythology. Within these environments are layered references to the human body. Biological structures and functions are reanimated, exploring ecological issues, technology, and the dream world landscape.

Owls, deer, rabbits, and various birds inhabit unfamiliar terrains that appear to have been barren yet are coming back to life in freakish ways. Clouds, stars, and volcanic smoke curl and drift in skies that range in color from yellow to orange to blue to green to gray. What has happened naturally and man's effect on the environment are blurred and left open to question. Using nature as a blueprint, he explores the boundaries of reality versus artifice.

Through the utopian ideal that inspires all of Rappleye's work, he convinces us that, in these dreamlike worlds, peaceful coexistence is much more than just an unattainable desire. See more of Jon Rappleye's work in Chapter Five.

Figure App.-51. Jon Rappleye, American, *Beast of Fowl*, 2005. Acrylic on paper, 30×22 inches. Private collection; courtesy of Jeff Bailey Gallery, New York.

Figure App.-52. Jon Rappleye, American, Wherein Creature Both Great and Small Doth Dwell, 2005. Acrylic on paper, 30×22 inches. Collection of Ryan Wallace; courtesy of Jeff Bailey Gallery, New York.

Figure App.-53. Jon Rappleye, American, *Warble Over Thessalian Hills*, 2005. Acrylic on paper, 30×21³/₄ inches. Private collection; courtesy of Jeff Bailey Gallery, New York.

Figure App.-54. Jon Rappleye, American, *Our Old Feuillage That Shadows My Likeness*, 2005. Acrylic on paper, 30×22 inches. Private collection; courtesy of Jeff Bailey Gallery, New York.

Robert Schultz (Figures App.-55-App.-57)

"My work is narrative and thought provoking. In all my drawings, the human form is the main compositional element. It provides movement for the piece. Because I work in graphite, the page is designed with shapes of value (light to dark) that create strong positive and negative shapes. This brings

an abstract quality to each drawing. An additional element in my work is the lost edge, where the light skips across the edge of forms and dissolves into the white of the paper. Titles are sometimes simply descriptive, and other times serve to suggest the meaning or intention behind the drawing." See more of Robert Shultz's work in Chapter One.

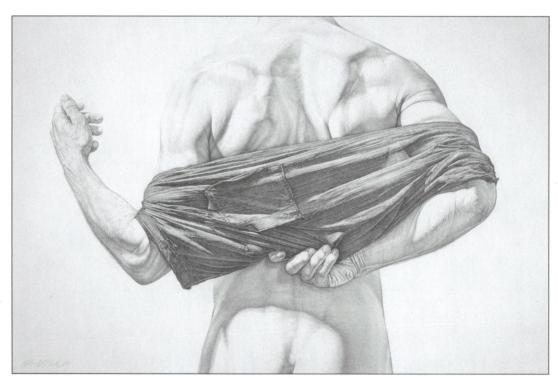

Figure App.-55. Robert Schultz, American, Black Shirt and Torso—Back, 2006. Graphite on paper, 8½×12½ inches. Collection of Dr. Norman E. Masters, Jr.

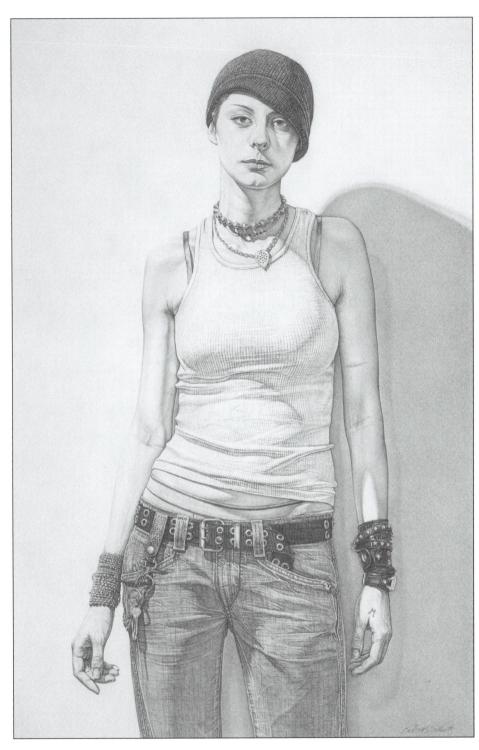

Figure App.-56. Robert Schultz, American, M, 2005. Graphite on paper, $17^{1}/4 \times 10^{1}/2$ inches. Collection of Graham and Louise Rowe.

Figure App.-57. Robert Schultz, American, *Descend*, 2005. Graphite on paper, $22^1/2 \times 10^3/4$ inches. Collection of Brett Barrett.

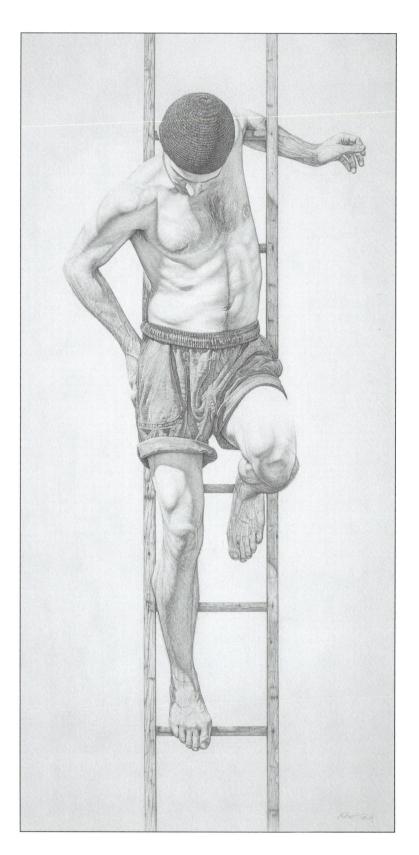

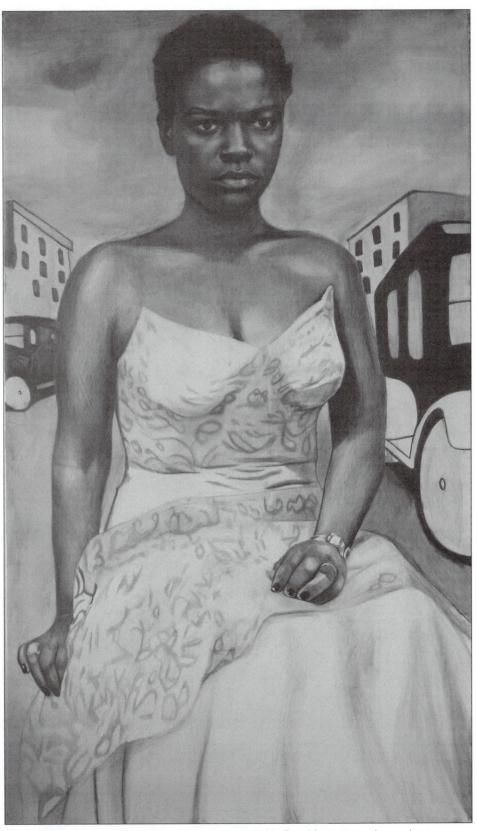

Figure App.-58. Jenny Scobel, American, *Cars*, 2006. Graphite, watercolor, and wax on gessoed wooden panel, 42×24 inches. Private collection.

Jenny Scobel (Figures App.-58-App.-61)

Jenny Scobel's portraits are done with a combination of graphite, wax, and sometimes oil on gessoed wooden panels. Scobel uses the heads of both well-known personalities (including Virginia Wolf, Michelle Pfeiffer, Jacqueline Kennedy, and Audrey Hepburn) and anonymous people that she culls from vintage found photographs or print media. These heads are then merged with iconic torsos that make nostalgic reference to an era long past. There are often subtle (and intentional) disproportionate relationships between the head and the body.

Scobel repeatedly uses the same faces and torsos in various combinations, positioned centrally against Walt Disney– and Betty Boop–inspired cartoon backgrounds or wallpaper motifs from the 1930s and, 1940s. There is an unsettling relationship between the disparate elements, and the backgrounds often allude, metaphorically, to death and/or family happiness. Atmospheric perspective is absent, compressing the space between the figurative foreground and the background. The finished images are sealed under a layer of wax, alluding to memory and recalling black-and-white television. See more of Jenny Scobel's work in Chapter Two and Chapter Five.

Figure App.-59. Jenny Scobel, American, Whispers, 1999. Graphite, oil, and wax on gessoed wooden panel, 32×24 inches. Private collection.

Figure App.-60. Jenny Scobel, American, *Outrun Memory*, 2002–2003. Graphite on gessoed wooden panel, 34×48 inches. Private collection.

Figure App.-61. Jenny Scobel, American, *Dancing With No Shoes*, 2003. Graphite, oil, and wax on gessoed wooden panel, 32×24 inches. Private collection.

Joseph Stashkevetch (Figures App.-62—App.-64)

Joseph Stashkevetch is a realist whose work is often characterized by an all-over composition that flirts with abstraction via patterns of shape, tone, and texture. His monochromatic work is executed with conte crayon on large sheets of thick paper that are sanded to soften the surface. There is a distinct duality in the subjects that he chooses to represent, shifting from natural forms to human-made forms both celebrated and discarded. In those images that recede into

space, he often calls attention to the effects of photography by exaggerating the tension between focused form and outof-focus form.

These larger-than-life drawings, when viewed from afar, at first appear photographic in terms of their precision. But upon closer inspection, they reveal a beautifully rich surface and evidence of the artist's patient and meticulous hand, rewarding us in a way that realist work often does not when examined closely. See more of Joseph Stashkevetch's work in Chapter One and Chapter Five.

Figure App.-62. Joseph Stashkevetch, American, *Rocks*, 2005. Conte crayon on paper, 60×40 inches. Courtesy of Von Lintel Gallery.

Figure App.-63. Joseph Stashkevetch, American, *Clouds* #6 (*Hunter's Point*), 2000. Conte crayon and watercolor wash on paper, 30×40 inches Courtesy of Von Lintel Gallery.

Figure App.-64. Joseph Stashkevetch, American, The End of the Road, 2000. Conte crayon and watercolor wash on paper, 50×60 inches. Courtesy of Von Lintel Gallery.

Richard Talbot (Figures App.-65–App.-67)

"I use drawing as a way of thinking and a way of bringing together apparently disparate ideas and images. Through drawing I can start with a gut feeling, a vague thought, a hunch, or an idle observation and can distill and combine these into something concrete.

"Drawing has become the major part of my studio practice, but I think of myself as a sculptor. Within the drawings, I develop forms associated with architecture, maps, landscape, water, vessels, and containers using a process (geometric linear perspective) that involves producing a

complex and almost transparent matrix. This web of lines acts as scaffolding in which the images are created and then held. Importantly, and possibly paradoxically, a strict geometric drawing system such as perspective allows me to have an almost purely intuitive response to ideas and images.

"My approach to making a drawing is comparable to that of building a medieval/gothic cathedral, where a relatively rigid two-dimensional ground-plan was put in place, and the ensuing structure then developed organically, its form being the result of varying amounts of intention, pragmatism, accident, and ambition."

Figure App.-65. Richard Talbot, British, *Vertical Shells* (detail), 1986. Pencil and ink on paper, 1.2×1.2 m. Courtesy of the artist.

Figure App.-66. Richard Talbot, British, *Floating* (detail), 1989. Pencil and ink on paper, 1.2×1.2 m. Courtesy of the artist.

Figure App.-67. Richard Talbot, British, *Random Moves* (detail), 1989. Pencil and ink on paper, 1.2×1.2 m. Courtesy of the artist.

Bibliography

- Barcsay, Jeno. *Anatomy for the Artist*. New York: Little, Brown & Company, 2004.
- Bartel, Marvin. *The Secrets of Generating Art Ideas*. May 3, 2006. Goshen College, Goshen, IN. June 5, 2007 http://www.bartelart.com/arted/ideas.html.
- Berry, William A. Drawing the Human Form: Methods, Sources, Concepts. 2nd ed. Englewood Cliffs, New Jersey: Prentice Hall, 1994.
- D'Amelio, Joseph. *Perspective Drawing Handbook*. New ed. Mineola, NY: Dover Publications, 2004.
- Doblin, Jay. *Perspective: A New System for Designers*. New York: Whitney Library of Design, 1970.
- Doczi, Gyorgy. *The Power of Limits: Proportional Harmonies in Nature, Art and Architecture.* New ed. Boston: Shambhala, 2005.
- Edwards, Betty. *The New Drawing on the Right Side of the Brain.* 3rd rev. ed. New York: HarperCollins Publishers, 2001.
- Fletcher, Rachel. *Harmony by Design: The Golden Mean as a Design Tool.* New Paltz, NY: Beverly Russell Enterprises, 1995.
- Goldstein, Nathan. Figure Drawing: The Structure, Anatomy and Expressive Design of the Human Form. 6th ed. Englewood Cliffs, NJ: Prentice Hall, 2003.
- Mendelowitz, Daniel M., David L. Faber, and Duane A. Wakeham. *A Guide to Drawing.* 7th ed. Belmont, CA: Wadsworth Publishing, 2006.
- Miller, Drew Allen. *Mastering the Art of Creative Leadership*. December 6, 2004. Board Report Publishing Company, Inc., Kansas City, MO. June 5, 2007 http://www.aacsb.edu/handouts/WCPT04/A4-Miller.doc.
- Osborne, Harold, ed. *The Oxford Companion to Art.* New York: Oxford University Press, 1993.

Supplemental Reading

The books listed in this section are recommended for general reading and for additional information about technical, formal, and conceptual issues as they relate to drawing, figure drawing, artistic anatomy, perspective, and design principles. This list does not include books listed in the preceding bibliography.

Supplemental Reading for Drawing

- Betti, Claudia, and Teel Sale. *Drawing: A Contemporary Approach*. 6th ed. Belmont, CA: Wadsworth Publishing, 2007.
- Calle, Paul. *The Pencil*. Cincinnati: Writer's Digest Books, 1985.
- Chaet, Bernard. *An Artist's Notebook: Techniques and Materials.* New York: Holt, Rinehart and Winston, 1979.
- —. The Art of Drawing. 2nd ed. New York: Henry Holt & Company, 1988.
- Curtis, Brian. *Drawing from Observation*. New York: McGraw-Hill Publishing, 2002.
- Dexter, Emma. Vitamin D: New Perspectives in Drawing. New York: Phaidon Press, 2005.
- Enstice, Wayne, and Melody Peters. *Drawing: Space, Form, Expression.* 3rd ed. Englewood Cliffs, NJ: Prentice Hall, 2003.
- Goldstein, Nathan. *The Art of Responsive Drawing*. 6th ed. Englewood Cliffs, NJ: Prentice Hall, 2005.
- Hoptman, Laura. *Drawing Now: Eight Propositions*. New York: Museum of Modern Art, 2002.
- Kaupelis, Robert. *Experimental Drawing*. New York: Watson-Guptill, 1992.
- —. Learning to Draw: A Creative Approach. Mineola, NY: Dover Publications, 2006.
- Mendelowitz, Daniel M. *Drawing*. New York: Henry Holt & Company, 2000.
- Rawson, Philip. *The Art of Drawing: An Instructional Guide.* 2nd ed. Philadelphia: University of Pennsylvania Press, 1987.
- Smagula, Howard J. *Creative Drawing*. 2nd rev. ed. London: Laurence King Publishing, 2002.

Supplemental Reading for Figure Drawing

Brodatz, Phil. *The Human Form in Action and Repose*. New York: Reinhold Publishing, 1966.

- Brown, Clint, and Cheryl McLean. *Drawing from Life*. 3rd ed. Belmont, CA: Wadsworth Publishing, 2003.
- Gordon, Louise. How to Draw the Human Figure: An Anatomical Approach. New York: Penguin Books, 1987.
- Hale, Robert Beverly. *Drawing Lessons from the Great Masters*. New York: Watson-Guptill, 1989.

Supplemental Reading for Artistic Anatomy

- Farris, John Edmond. *Art Student's Anatomy*. 2nd ed. New York: Dover, 1961.
- Goldfinger, Eliot. Human Anatomy for Artists: The Elements of Form. New York: Oxford University Press, 1997.
- Kramer, Jack. Human Anatomy and Figure Drawing: The Integration of Structure and Form. New York: Van Nostrand Reinhold, 1972.
- Oliver, Charles. Anatomy and Perspective: The Fundamentals of Figure Drawing. Mineola, NY: Dover Publications, 2004.
- Peck, Stephen. *Atlas of Human Anatomy for the Artist*. New York: Oxford University Press, 1982.
- Raynes, John. *Human Anatomy for the Artist*. London: Crescent Books, 1988.
- Schider, Fritz. An Atlas of Anatomy for Artists. 3rd ed. New York: Dover, 1957.
- Sheppard, Joseph. *Anatomy: A Complete Guide for Artists*. New ed. Mineola, NY: Dover Publications, 1992.

Supplemental Reading for Perspective

- Auvil, Kenneth W. *Perspective Drawing*. 2nd ed. New York: McGraw-Hill, 1996.
- Bartschi, Willy A. *Linear Perspective*. New York: Van Nostrand Reinhold, 1981.
- Coulin, Claudius. Step-by-Step Perspective Drawing for Architects, Draftsmen, and Designers. New York: Van Nostrand Reinhold, 1982.

- Gerds, Donald A. *Perspective: The Grid System*. Santa Monica, CA: DAG Design, 1989.
- James, Jane H. *Perspective Drawing: A Point of View*. Englewood Cliffs, NJ: Prentice Hall, 1988.
- Montague, John. *Basic Perspective Drawing: A Visual Guide*. 4th ed. Hoboken, NJ: Wiley Publishing, 2004.
- White, Gwen. Perspective: A Guide for Artists, Architects and Designers. Washington, DC: Batsford, 2004.

Supplemental Reading for Design Principles

- Bouleau, Charles. *The Painter's Secret Geometry.* New York: Hacker Art Books, 1980.
- Cheatham, Frank R., Jane Hart Cheatham, and Sheryl Haler Owens. *Design Concepts and Applications*. 2nd ed. Englewood Cliffs, NJ: Prentice Hall College Division, 1987.
- Cook, T. A. *The Curves of Life*. New ed. Mineola, NY: Dover Publications, 1979.
- Elam, Kimberly. Geometry of Design: Studies in Proportion and Composition. New York: Princeton Architectural Press, 2001.
- Ghyka, Matila. A Practical Handbook of Geometrical Composition and Design. London: A. Tiranti, 1964.
- Hambidge, J. *The Elements of Dynamic Symmetry*. Mineola, NY: Dover Publications, 1967.
- Kappraff, J. Connections: The Geometric Bridge Between Art and Science. 2nd ed. Hackensack, NJ: World Scientific Publishing Company, 2002.
- Lund, F. M. Ad Quadratum. London: B.T. Batsford, 1921.
- Myers, Jack Fredrick. *The Language of Visual Art: Perception as a Basis for Design.* New York: Holt, Rinehart and Winston, 1989.
- Ocvirk, Otto G., Robert E. Stinson, Philip R. Wigg, Robert O. Bone, and David L. Cayton. *Art Fundamentals: Theory and Practice.* 9th rev. ed. New York: McGraw-Hill Publishing, 2001.

Index

definition of, 9 Note: Page numbers set in italics refer to illustrations. major, 9 minor, 9 A sighting for, 9-10, 10, 11 acetone, 227 acrylic medium transfers, 229-230, 230 actual texture, 71, 72. see also texture acute angles, 149. see also angles A Ballet Dancer in Position Facing Three-Quarters Front (Degas), 96 Adams, Aaron, 107 Barkhouse, Donald, III, 21 additive drawing, 76, 76-76 agitated lines, 61, 64, 65. see also lines Barnes, Jennie, 5, 54 baseline Alberti, Leon Battista, 42 definition of, 21, 148 alignment space and, 46, 47 diagonal, 12 Basil Friends (Allen), 222 in human figure drawing, 92, 94, 94, 95 Bath (Heuer), 141 of landmarks, 11-12, 12, 13 Beast of Fowl (Rappleye), 272 Allen, Kelly, 222 Becoming Animal (Micallef), 263 Allison, Amy, 56, 108 Bell (Biel), 237 Allured, Ralph, 177, 178 Bib (Jones), 220 Aloft II (Schultz), 74 Biel, Joe, 235-236, 235-237 altered lines, 61, 64. see also lines Bierens, Kirk, 7, 56, 66 ambiguous space, 50, 51, 194. see also space binocular vision, 142 anatomical lines, 60, 60. see also lines Bitch (Rockman), 73 anatomical terminology, 139 Black, Jane, 53 anatomy black and white media, 211-214. see also media artistic vs. medical, 123-124, 124-126 Black Shirt and Torso-Back (Schultz), 276 revelation of, 126, 126, 129, 131 blender markers, 227 Andy Warhol (Fischer), 252 Blossoms (Stashkevetch), 215 angles Boat Studies in Three-Point Perspective (Allured), 178 acute, 149 Bobenmoyer, Michael, 207 observed, 9, 11 bones right, 149 of arm, 135 sighting for, 9-10, 10, 11 as landmarks, 127, 129 sighting stick and, 9-10 of leg, 135 angry lines, 61, 64, 65. see also lines major, 132-135, 134 angular lines, 61, 62, 63, 63. see also lines of torso, 135 Another Day Older (Creech), 242 Bonnard, Pierre, 61 Antonio, Lea (Momi), 6, 7, 55, 82, 184 Borgman, Mary, 238, 238-240, 240 Arches Cover paper, 204-205 Borton, Douglas, 65 bones of, 134, 135 Bosak, Michele, 233 Bradley, Abbey, 123 muscles of, 137, 138 brainstorming, 189-190 Brandt, Paul, 186 diagnosing problems in, 190-194 brasspoint, 211, 212 ideation and, 188-190 The Breaker Boys (Creech), 209, 242 Art Spectrum Colourfix paper, 205 atmospheric perspective, 141, 142, 143. Bristling Rocks (Stashkevetch), 70 bristol board, 205 see also perspective broken lines, 61, 64. see also lines Augustine, Deborah, 186 Brunelleschi, 140 axis lines, 10, 11. see also lines

D. H. A.C. I. 140/	
Bulka, Michael, 196	conte, 77, 214, <i>215</i>
burnishing, 228	continuous tone, 76. see also tone
	contour hatching, 75, 76
C	contours. see also lines
	cross, 59, 60
calligraphic lines, 61. see also lines	definition of, 59, 59
Cannarile-Pulte, Susan, 100	dips in, 54, 55, 56
canvas, Lazertran transfer to, 232-233	modified, 59
carbon pencils, 213. see also pencils	outermost, 34, 35
Carlson, Erik, 33, 91	speed of, 54, 55
Cars (Scobel), 279	contrast, 31, 48, 49
Castaneda, Jennifer Rocco, 182	convergence, 148
central axis, 106, 107	converging diagonals, <i>156</i> , 157–158
chalk pastels, 215, 216	converging parallels, 48, 49
Chance of a Lifetime (Rockman), 232	Copperplate paper, 205
Charancon (Spazuk), 224	corridor of convergence, 14, 16, 17, 18, 19, 20
charcoal	Cossolini, Stacy, 12, 49
compressed, 213, 214	Coventry paper, 205
powdered, 214	creativity, 188–190
tone and, 77	Creech, Dustan Julius, 209, 241, 241–242
vine, 213, <i>214</i>	critiques, 196-201. see also feedback
charcoal paper, 205. see also paper	cropping, 32, 34, 35
charcoal pencils, 213, 213. see also pencils	cross hatching, 75
chiaroscuro, 68, 69	cross-contour lines, 59, 60. see also contours; lines
Christo, 61	Crucigerous (Stashkevetch), 69
Cinderblock Remnant (Polsky), 267	cubes. see also forms
Citrasolve, 227	depth of, 152–153
Citra-Strip, 227	division of, 161, 161–162
Clare, Elizabeth I., 223	as fundamental form, 175–178, <i>176–178</i>
classical lines, 60, 60. see also lines	key, 151
Clouds #6 (Stashkevetch), 283	mathematically precise, 162–166, 163–165
Codres (Spazuk), 224	multiplication of, 158–161, 159–160
cold press, 203	in two-point perspective, 151–153, 152
color	cubic forms, 83, 83
intensity, 51	Cummings, Yvette, 71
space and, 50–52	
temperature of, 51	D
value of, 50	1 77 1 7 1 10
color media, 214–216. see also media	da Vinci, Leonardo, 42
colored pencil sticks, 215	Dad (D'Amato), 244
colored pencils, 214, 216. see also pencils	D'Amato, Susan, 243, 243–244
colorless blender markers, 227	Dancers (Biel), 235
Combs, Jamie, 76, 102	Dancing With No Shoes (Scobel), 281
common errors, 190–194	Dark Horse No. 1 (Rockman), 79
composition 108 100	Dark Horse No. 5 (Rockman), 32
critique questions, 198–199	Darkening Rain (Majumdar), 260
definition of, 24	Dave Wojnarowicz (Fischer), 253
Golden Section and, 41–45, 41–46	Davidson, Maryann, 82
guidelines for, 34	Davis, Stuart, 61
importance of, 22–23	Death Carrying Her Brood (Piene), 266
problems with, 194	decorative lines, 61. see also lines
thumbnail studies and, 37, 39, 40	decorative space, 50. see also space
variable elements, 26–28	deep space, 50, 51. see also space
visual principles of, 24–28	Deeper in Debt (Creech), 241
compressed charcoal, 213, 214. see also charcoal	Degas, Hilaire-Germain-Edgar, 96, 96, 117
cone of vision, 147, 153	Delmonico Building (Sheeler), 179
Conn, David, 129 Constantine, Jay, 103	depth
Constantine, Jay, 100	of cubes, 152–153

illusion of, 46-50	Erlebacher, Martha Mayer, 125
indication of, 46-50, 47, 48, 49	Euclid, 42
Descend (Schultz), 278	Evans, Rob, 247, 248–250
descriptive feedback, 195	Evers, Mary, 65
detail	eye level height, 15, 15–16, 17, 18, 105, 119
in gesture drawing, 100	eye level perspective, 146, 147, 191
problems with, 192	eyes
space and, 48, <i>48</i>	distance between, 107, 109
diagnosing problems in work, 190-194	in portraiture, 109–110, 111
diagonal alignment, 12. see also alignment	
diagonal measuring line, 148	F
diagonal scaling, 18. see also scaling	•
Diebenkorn, Richard, 25, 29	Fabriano Artistico paper, 204
dimensional lines, 64, 65, 66. see also lines	Fabriano Ingres paper, 205
diminution, 148, 191	face
directional forces, 26	central axis line in, 106, 107
distortion	features of, 109-118
in cube multiplication, 160, 161	muscles of, 136, 137
in ellipses, 167–168, 166–169	proportions in, 105-106
divergent thinking, 188-190	Father and Child (Rockman), 78
division	feedback, 195-196. see also critiques
applications of, 170, 171	fencepost method, 155, 156–157,
of areas, 169–171	158–159, <i>159</i>
critique questions, 198	Fibonacci Series, 44–46, <i>45</i>
of cubes, 161, 161–162	Fischer, Dan, 251, <i>251–253</i>
Dr. Kopano Mpuang (standing)	Fish, Naomi, 110, 112, 208, 214
(Borgman), 239	Floating (Talbot), 285
Dog (Rockman), 69	Flutter in the Room (Scobel), 89
domination, 24–26	Folio paper, 204
Doogan, Bailey, 244–245, 245–247	foot
drafting tape, 228	bones of, <i>134</i> , 135
Drawing from "Routine" (Morgan), 219	muscles of, 137, 138–139
Drawing (Mendelowitz), 3	forehead, 105
dry media, 211–216. see also media	foreshortening
Dürer, Albrecht, 140	definition of, 148
Dyer DeNio, Jacquelin, 62, 121, 122	in ellipses, 166–169
Dyjak, Amy, 123	of human form, 91, 94, 191
27),, ,	problems with, 191–192
T.	sighting and, 8, 8–9
E	format, 24, 31, 34
O.A.W.	forms. see also cubes
in facial proportions, 108, 110	construction in three-point perspective,
in portraiture, 115, 115	179–181
	cubic, 83, 83
Ecce Homo (van Leyden), 22	division of, 169–171
economy, 26	geometrical composition of, 174
edges. see also lines	in human figure drawing, 103–104, 104
of nose, 107, 109, 110–111, 112	irregular, 82–83, 83
shared, 34	placement of, 33, 34, 35
speed of, 54, 55	problems with, 190–191, 192
strength of, 56, 56	
value and, 74, 75	regular, 82, 82
Edwards, Betty, 105	in still life, 82, 82–83, 83
Elsholz, John, 111, 132	Francis Deap 181 183
Embroidery: The Artist's Mother (Seurat), 30	Francis, Dean, 181, 183
emphasis, 24–26, <i>30</i>	freehand perspective, 140, 141.
Enchanted Wood (Rappleye), 221	see also perspective
The End of the Road (Stashkevetch), 284	A Front (Doogan), 245
erasers, 225	frottage, 72, 73

G	Hokusai, 61
Grissoli I 9 141 200	horizon line, 15, 15–16, 17, 147
Gajewski, Laura, 8, 141, 206 Garden Series: If Given Wings(Prucka), 9	Hossink, Andrea Helm, 39
Garden Series: If Green Wings(Flucka), 9 Garden Series: Prelude (Prucka), 256	Hossink, Jamie, 24, 31, 106, 113, 128
Garden Series: Fretade (Flucka), 256 Garden Series: Redemptive Sanctification (Prucka), 85	hot press, 203
geometric solids, 174–178, 175–178. see also cubes	Houston, Joe, 222
Germanicus, 98	human body. see also bones; musculature
gesture drawing	Golden Section in, 42, 90
of human figure, 98–101, <i>99</i> , <i>100</i>	male and female, 94–98
pace in, 100–101	human figure drawing. see also portraiture
as value exercise, 80–81, <i>81</i>	alignment in, 92, 94, 94, 95
gesture line, 59. see also lines	anatomy in, 123–129, <i>126</i> , <i>127</i>
Giacometti, Alberto, 60, 61	bones in, 132–135, <i>134</i>
Girl with Dead Goat (Piene), 266	challenge of, 90
Girl with Twig (Nerdrum), 27	critique questions, 199–200
Girl With Wolf (Scobel), 223	Doogan on, 244–245 etiquette, 90–91
Golden Section, 41–45, 41–46, 90	foreshortening in, 191
graduate teaching assistants, 1	gender and, 94–98
Grant, Sheila, 8	gesture drawing, 98–101, <i>99</i> , <i>100</i>
graphite, 78, 211, 212	Golden Section in, 90
Greenleaf, Ann Drysdale, 8	history, 88
grids	importance of, 88–90
in Fischer's work, 251, <i>251–253</i>	lines in, 101, 102
perspective, 153–158, 154–156	mapping, 120–123, <i>121</i> , <i>122</i>
Griffin, Michael, 130	medical vs. artistic anatomy in, 123–124, 124–126
Grindle, Matt, 182, 186	musculature in, 129, 135–139, <i>137</i>
Gris, Juan, 41	paths of movement in, 123, 123
Grosz, George, 64	poses in, 102–103
ground level, 15, 15-16, 21, 22, 144-145	relative proportions in, 91, 91, 92
ground line, 147	scaling in, 101–104, 103
ground plane, 147	sighting in, 91–93, 91–94
group critiques, 197	straight line construction in, 121, 122, 122
	value in, 103–104, <i>104</i>
Н	volume in, 101–104, 103
Hahnemühle Ingres paper, 205	I
Hale, John, 12, 53, 111, 122	
Hammar, Dave, 33	ideation, 188-190
hand	illustration board, 205
bones of, 134, 135	Imaginary Flying Machine in Two-Point Perspective
muscles of, 137, 138	(Allured), 177
Hand Studies (Constantine), 103	imaginative thinking, 188-190
harmony, 24, <i>27</i>	implied lines, 61, 64. see also lines
hatching, 75, 76	inclined planes, 171–174, 172–174
head	individual critiques, 197
bones of, 134	infinite space, 50, 51. see also space
errors in representation of, 105	Ingres, Jean-Auguste-Dominique, 97
muscles of, 136, 137	ink, 216–219, <i>218–219</i>
positioning of, 119, 119–120, 120	Ink Plant-Building 2 (Polsky), 268
as unit of measure, 5, 6, 96	inkjet transfers, 229–230
Held Back (Majumdar), 261	intaglio press, 228
Helmer, Barb, 213	intensity. see also value
Hemak, Sean, 124	space and, 51
Her Place #2: Study for Closed Ward Number 12 (Mazur), 38	volume and, 52
Hetu, Mike, 213	intentions vs. results, 194–196
Heuer, Nate, 141	interpretive feedback, 195–196
high key value, 69, 71. see also value	interval, 28

invented texture, 71. see also texture	altered, 61, 64
irregular forms, 82–83, 83. see also forms	anatomical, 60, 60
friegular forms, 62-63, 65. see also forms	angry, 61, 64, 65
J	angular, 61, <i>62</i> , 63
,	baseline, 21
Jackson, Peggy, 184	broken, 61, 64
Johnson, Chris, 193	calligraphic, 61
Johnson, Kiel, 143, 212	classical, 60, <i>60</i>
Jones, Kristopher, 220	contour, 59, <i>59</i>
Jumper (Biel), 235	cross-contour, 59, 60
jumper (Biel), 200	decorative, 61
	functions of, 59–65
K	gesture, 59
	Golden Section proportion of, 41–45, 41–46
Kennedy, Kendra, 207	horizon, 15, 15–16, 17, 147
key cube, 145, 151. see also cubes	in human figure drawing, 101, 102
Kilgore, Steve, 187	importance and, 57, 58
Kjøk, Sol, 256, 257–259	kinds of, 59-65
Kokoschka, Oskar, 61	light source and, 53, 53-54
Kolosowsky-Paulus, Lisa, 100	mechanical, 61, 62
Kowanko, Chris, 76, 101	medium and, 52
	modified contour, 59
	organizational, 60, 61
L	problems with, 192
T. D. W. T. 45 50	process, 64, 65
LaBue, Emily, 7, 35, 58	sensitive, 52–53, <i>53</i>
lacquer thinner, 227	structural, 60–61, <i>62</i>
Ladder Series #14: Caged Pendulum (Prucka), 208	
landmarks	surface and, 52
alignment of, 11–12, <i>12</i> , <i>13</i>	tension and, 54, <i>54</i>
"bony," <i>127</i> , 129	tonal, 64, 65, 66
in human face, 106–108, 109–111	variation and sensitivity, 52-65
in human form, 92, 94, 94, 95	weight and, 54, <i>54</i>
in sighting, 5–6	Lockwood, Cassandra, 72
laser print transfers, 225–228, 226	Longenecker, Nicholas, 219
Lazertran transfers, 230-233, 231-232	Lot's Daughter (Van Der Velde), 129
Lazzari, Margaret, 62	low-key value, 69, 70. see also value
Lebrun, Rico, 61	Lubbers, Jane, 224
leg	Luce, Scott, 10, 11, 144, 175
bones of, 134, 135	
muscles of, 137, 138–139	M
length	***
foreshortening and, 8	M (Schultz), 277
of nose, 106–107, <i>108</i>	Macaluso, Nik, 36
Lenox 100 paper, 204	Mahon, Dr. Eugene J., 42
Lewitt, Sol, 61	major axis line, 9. see also axis lines
light. see also value	Majumdar, Sangram, 259, 260–262
categories of, 66, 66	Male Back (Erlebacher), 125
raking, 70, <i>71</i> , 83–84	mapping, 120–123, <i>121</i> , <i>122</i>
shape and, 73, 74	mark making, 75
in still life, 83–84	Master of Fine Arts degree, 1
light source	materials. see also media
	additional, 225
lines and, 53, 53–54	
location, 34, 36	media, 211–220
nose and, 110–112	paper, 203–205
texture and, 69–71, 71	perspective and, 146
value structure and, 66	for photocopy transfer, 225–227
linear perspective, 50, 140–142, 141. see also perspective	tone and, 77
lines. see also axis lines; contours; edges; measuring lines	volume and, 193

mathematically precise cubes, 162-166, 163-165. see also cubes	movement, 26
Matisse, Henri, 59, 61	multiplication, of cubes, 158-161, 159-160.
Maturia, April, 184	see also cubes
Maxwell, Matt, 11, 70, 116, 218	musculature, 129, 135-139, 137
The Maze (Majumdar), 262	
Mazur, Michael, 38, 61	N
McCannell, Rebecca Marsh, 14	N
McKibbin, Alex, 60	Nati Zohar (standing) (Borgman), 238
measuring lines. see also lines	Naz-Dar base, 228
in cube multiplication, 160, 159–161	neck
definition of, 148	muscles of, 136, <i>137</i>
diagonal, 148	in portraiture, 115, <i>116</i>
for divisions of area, 169–171	width, 108, 110
perspective grids and, 155, 156	negative space, 24, 25, 31, 38, 38–39
vertical, 16	Nerdrum, Odd, 27
vertical measuring line, 16, 18, 21	Nichols, Greg, 60
mechanical lines, 61, 62. see also lines	nonliteral space, 37, 38. see also space
mechanical perspective, 140, 141. see also perspective	nontraditional media, 219–220, 220–224. see also media
media. see also materials	nose
black and white, 211-214	edges of, 107, 109, 110–111, 112
brasspoint, 211, 212	in portraiture, 110–112, 112, 113
chalk pastels, 215, 216	size of, 106–107, 108
charcoal, 213–214, <i>213–214</i> , <i>214</i>	Nowatzki, Steve, 142
color, 214–216	number, 26
conte, 214, 215	Nykamp, Kerre, <i>65</i> , <i>111</i> , <i>127</i>
dry, 211–216	Nykamp, Reffe, 65, 111, 127
graphite, 211, 212	
ink, 216–219, <i>218–219</i>	0
nontraditional, 219-220, 220-224	
oil pastels, 216, 217	oblique perspective, 147. see also perspective
pencils, 211–214, <i>216</i>	observed angles, 9, 11. see also angles
silverpoint, 211	oil pastels, 216, 217
wet, 216–219	Oliver Street Survey-Pile 01 (Polsky), 268
Mendelowitz, Daniel M., 3	Olson, Kevin, 39
Metamorphosis (Study for "Cicada") (Evans), 249	one-point perspective. see also perspective
M.F.A. see Master of Fine Arts degree	cubes in, 148, 149, 149–151
Micallef, Antony, 262, 263–264	definition of, 147
middle key value, 69, 70. see also value	perspective grids, 154, 153–154
Miller, James P., II, 124	Oosterink, Glenda Sue, 10, 94
Miller, Sarah, 221	organizational line, 60, 61. see also lines
Miltgen, B. A., 102	O'Rourke, Dennis M., 126, 131
minor axis line, 9. see also axis lines	Our Old Feuillage That Shadows My Likeness
Mirari: Ephphatha (Prucka), 255	(Rappleye), 275
Mirari: Missionary Sisters (Prucka), 255	outermost contours, 34, 35. see also contours
Mirari: Venerable (Prucka), 254	out-of-focus image exercise, 79–80
Mismatched Pair (Piene), 265	Outrun Memory (Scobel), 281
Mittler, Gene, 195–196	overlapping, 46–48, 48, 92, 94, 148
The Model Nizzavona (Toulouse-Lautrec), 63	
models, 90-91. see also human figure drawing; subjects	P
modified contour lines, 59. see also contours; lines	
monocular vision, 142	Palmer, Megan, 66
Moore, Michael, 35	paper, 203-205
Morgan, Rian, 206, 218, 219	Paragon (D'Amato), 243
"mother cube," 145, 151	parallel hatching, 75, 76
mouth	parallel perspective, 147. see also perspective
centerline of, 107, 108, 113, 113	Park, Chul Yeon, 121
corners of, 107–108, 109	pastel paper, 205
in portraiture, 112–114, 113, 114	Pastelbord, 205
	*

pastels	plastic space, 50, 51. see also space
chalk, 215, 216	plastic value, 68, 70. see also value
oil, 216, <i>217</i>	plate finish, 203
pattern, 24	point of reference, 5, 6-7, 7, 13, 14
Pavlin, Jennie, 6	point zero, 16
pencils	points of articulation, 5-6, 34, 35, 101
carbon, 213	Polsky, Ben, 267, 267–269
charcoal, 213, 213	Port Huron Fog (Rockman), 217
colored, 214, 216	Portrait of Kevin Croker (Borgman), 240
conte, 214	Portrait of Tomiwa Alabi (Borgman), 240
graphite, 211	portraiture
pastel, 215–216	ears in, 115, <i>115</i>
Pennington, Craig, 49	errors in, 105–106
perpendicular, 148	eyes in, 109–110, 111
perspective	facial features in, 109–118
atmospheric, 141, <i>142</i> , <i>143</i>	hair in, 116, 118, <i>118</i>
complexity in, 158–162	head position in, 119, 119–120, 120
critique questions, 200–201	landmarks in, 106–108, 109–111
cubes and, 149–150, 149–153, 152–153	mouth in, 112–114, 113, 114
definition of, 140	neck in, 115, 116
exercises, 181	nose in, 110–112, 112, 113
eye level, 147, 191	proportions in, 105
freehand, 140, 141	shoulders in, 116, 117
inclined planes in, 171–174, 172–174	value in, 118, 119
linear, 50, 140–141, 141, 141–142, 142–143	viewpoint in, 119, 119–120
materials for, 146	position
one-point (see one-point perspective)	as compositional element, 26
parallel, 147	definition of, 148
problems in, 192–193	space and, 46, 47
scale and, 144	positive space, 24, 25, 34. see also space
sequencing in comprehension of, 143–144	Potential for Disaster (Rockman), 71
sighting and, 142	powdered charcoal, 214
technical, 140, <i>141</i>	Power Lines 1 (Evans), 250
terminology for, 147–149	process lines, 64, 65. see also lines
three-point, 178–181, 179–180	proportion. see also scaling
two-point (see two-point perspective)	in composition, 26
types of, 140–141, <i>141–143</i>	in face, 105–106
variable elements in, 144–146, 145	Golden Section and, <i>41–45</i> , 41–46
perspective grids, 153–157, <i>154–156</i>	in male vs. female figures, 94-98
Peterson, James, 111	problems with, 190–191
Pfleghaar, Michael, 104	relative, 6–9, 7–9, 91, 91–92
Philip Guston (Fischer), 251	in thumbnail studies, 37, 39
photocopy transfers, 225–228, 226	in viewfinder, 28
photographic references, 86–87	proximity, 28
phrenology, 113	Prucka, Leah Gregoire, 9, 85, 208, 254, 254–256
phyllotaxis, 46	psychology, 188–190
Picasso, Pablo, 42, 59, 61	Purdum, Jennifer, 269, 270–271
Picayune Heap (Purdum), 270	
picture plane	
definition of, 147	R
perspective and, 142, 143, 145	
in three-point perspective, 178	raking light, 70, 71, 83-84. see also light; value
Piene, Chloe, 265, <i>265–266</i>	Random Moves (Talbot), 286
Pistol (Biel), 237	Rappleye, Jon, 221, 272, 272-275
placement	Recurrence (Majumdar), 261
of forms, 33, 34, 35	Reddig, Ralph, 36
of subjects, 84	reference points. see landmarks
planes of value, 67, 67-68, 68. see also value	Reflection (D'Amato), 243

Regimbal, Collin, 218	shallow space, 50, 50. see also space
regular forms, 82, 82. see also forms	shared edges, 34. see also edges
	Sheeler, Charles, 179
Reid, Elizabeth, 32	
relative proportions	Ship-Up or Shape-Out (Johnson), 143
in human form, 91, 91, 92	Shirey, Andrew, 112, 115, 118, 130
sighting for, 6–9, 7, 8, 9	sighting
repetition, 24, 29, 36	for alignments, 11–12, <i>12</i> , <i>13</i>
Reynolds, Vickie Marnich, 28, 76	for angles, 9–10, 10, 11
rhythm, 24	applications of, 6–12
right angles, 149	arm positioning, 5
Rivers, Larry, 61	for axis lines, 9–10, 10, 11
Rives BFK paper, 204	clock face method, 10, 11
Rockman, Deborah, 32, 47, 69, 71, 73, 78, 79, 118, 209,	component part visualization in, 7
217, 230, 231, 232	foreshortening and, 8, 8–9, 91
Rocks (Stashkevetch), 282	guidelines for, 5–6
Roda, Jason, <i>64, 127, 222</i>	height in, 7
Rogers, Rene Adrian, 55	of human form, <i>91–93</i> , 91–94
Rohm, Robert, 49	landmarks in, 5-6, 92, 94, 94, 95
Rossell, Aaron, 141	observation to drawing transfer, 13, 13-14
rough finish, 203	perspective and, 142
Rousseau, Laurie, 57	point of reference in, 5, 6-7, 7, 13, 14
Rupert-Rush, Liisa, 176	reasons for, 4
	for relative proportions, 6–9, 7, 8, 9
S	for scaling, 15
	viewfinder for, 28, 31
Sargent. John Singer, 93	width in, 7
scaling	sighting stick
definition of, 14, 15, 147	alignments and, 11
diagonal, 18	angles and, 9, 10
guidelines for, 18–22, 19–21	foreshortening and, 8–9
in human figure drawing, 101–104, 103	specifications, 5
in perspective drawing, 144	use of, 6-7
problems in, 190–191, 192–193	silverpoint, 211
process of, 16–18, 17, 18	similarity, 28, 31
sighting for, 15	Simmons, Alison, 210, 216
size and, 14–15	simulated texture, 71, 72. see also texture
in two dimensions, 14	Site 21.01 (Polsky), 269
vanishing points and, 16, 17, 18, 21, 22, 23	size
scaling key, 16, 18, 21	as compositional element, 26
Scally, Phil, 95, 116, 119, 126	of paper, 203
Scenario 1GRDR from Losing Sleep (Rockman), 231	scaling and, 14–15
Scenario 7GRDR (version 2) from Losing Sleep (Rockman), 230	
	space and, 46, 46
Schiele, Egon, 60, 61	skeletal structure, 132–135, 134
Schindler, Gypsy, 6, 26, 31, 36, 37, 94, 107, 108	Skyscape No. 2 (Rockman), 47
Schroeder, Chris, 57, 115, 119, 120	Smithson, Robert, 61
Schultz, Robert, 74, 276, 276–278	Snider, Jack, 35
Scobel, Jenny, 89, 223, 280, 280–281	Soft Cities 2 (Purdum), 271
Scream (Lazzari), 62	Soft Cities (Purdum), 271
searching lines, 64, 65. see also lines	Songer, Janelle, 60
Sediment (Purdum), 270	space
Seib, Sheila, 70	ambiguous, 50, <i>51</i> , 194
sensitive line, 52–53, 53	baseline and, 46, 47
Serfass, Jessica, 86, 216	color and, 50–52
Seurat, Georges, 30, 42	contrast and, 48, 49
shadow. see also value	converging parallels and, 48, 49
categories of, 66, 66	decorative, 50
shape and, 73, <i>74</i>	deep, 50, 51
Shahn, Ben, 64	detail and, 48, 48

establishment of, 34	surface (for drawing), 202-206
in human figure drawing, 101-104, 103	surface (in drawing)
illusion of, 46–50	lines and, 52
indication of, 46–50, <i>47</i> , <i>48</i> , <i>49</i>	in still life, 84
intensity and, 51	m om me, or
intervals, 28	T
kinds of, 50	T
linear perspective and, 50	Talbot, Richard, 284, 285-286
negative, 24, 25, 31, 34, 38–39	Taylor, Lauren, 206, 207
nonliteral, 38	technical perspective, 140, 141. see also perspective
overlapping and, 46–48, 48	tenebrism, 68, 69
plastic, 50, 50	tension, 54, <i>54</i>
positive, 24, 25, 34	texture
sequence and, 56–57, <i>57</i>	actual, 71, 72
shallow, 50, <i>50</i>	frottage and, 72, 73
size and, 46, 46	invented, 71
temperature and, 51	kinds of, 71–72, 72, 73
value and, 50	light source and, 69–71, 71
Spazuk, Steven, 224	of paper, 203
Spell III (Doogan), 247	simulated, 71, <i>72</i>
Spell V (Doogan), 246	uniform, 71, 72
spiral, Golden Section, 43–44, <i>44</i> , <i>45</i>	value and, 69–71, 71
spoken feedback, 196	volume and, 52
	Thiebaud, Wayne, 47
Stahl, Doug, <i>72, 220</i> Stashkevetch, Joseph, <i>69, 70, 215</i> , 282, <i>282–284</i>	Thorp, Clarkson, 10, 39, 55
station point, 15, 16, 145, 145, 147	three-point perspective, 178–181, 179–180
Still Life (Giacometti), 61	three-quarter view, 108, 110, 111, 115 Time Flowing in the Middle of the Night (Majumdar), 260
importance of, 81	Tjoelker, Elizabeth, 31, 226
light in, 83–84	tonal lines, 64, 65, 66. see also lines
meaning in, 84–85, 85	tone continuous, 75, 76
subject selection, 81–83, 82	
surface in, 84 Still-Life: Cigarette Butts and Glasses (Diebenkorn), 29	materials and, 77 subtractive drawing and, <i>77,</i> 77–78, <i>78</i>
rtippling, 75 Stonehenge paper, 204	toned paper, 78, 78, 79
Strathmore Bristol 500 series paper, 204, 205	torso bones of, <i>134</i> , 135
String of Beads 28 (Kjøk), 258	muscles of, 136, 137
String of Beads 37 (Kjøk), 259	Toulouse-Lautrec, Henri de, 58, 61, 63
String of Beads 38 (Kjøk), 259	Towell, Cliff, 54
	transfers
structural lines, 60–61, <i>62. see also</i> lines Studies of a Man and a Woman for "The Golden Age" (Ingres), 97	acrylic medium, 229–230, 230
Study for "Diego Martelli" (Degas), 117	images for, 225–226
Study for "Predator" (Evans), 248	inkjet, 229–230
Study for "Refuge" (Evans), 248	Lazertran, 230–233, 231–232
Study for the Suck Lovers 2 (Micallef), 264	photocopy, 225–228, 226
Study of a Boy (Micallef), 263	procedure for, 227–230, 232–233
Study of a Boy (Witchiel), 200 Study of a Nude Man (Sargent), 93	solvents for, 226–227
Study of Man's Head (Rockman), 118	transparent construction, 174–178, 175–178
Study of Neal Stream (ROCKHAII), 110 Study of Reclining Chairs in Two-Point and One-Point Perspective	turpentine, 233, <i>233</i>
	two dimensions
(Allured), 178 Study (Toulouse-Lautrec), 58	scaling in, 14
subjects. see also human figure drawing	vs. three dimensions, 4
etiquette with, 90–91	two-point perspective. <i>see also</i> perspective
placement of, 84	cubes in, 151–153, <i>152</i> definition of, 147
still life, 81–83, 82	
subtractive drawing, 75–76, 76, 77, 77–78, 78	mathematically precise cubes in, 162–166, 163–165
superficial muscles, 135–139, <i>137</i>	perspective grids, 155-157, 155-157

U	vertical measuring line, 16, 18, 21. see also measuring lines
uniform texture, 71, 72. see also texture	Vertical Shells (Talbot), 285
unit of measure, 5, 13, 14, 15	vertical trace, 172–174, 172–174
unity, 26	viewfinder, 28, 31, 36, 39
Untitled (Diebenkorn), 25	viewpoint, 34, 37, 38, 119–120, 142
Untitled FBML from Losing Sleep (Rockman), 209	vine charcoal, 213, 214. see also charcoal
Untitled LBbF from Losing Sleep (Rockman), 231	visual principles of composition, 24–28.
Untitled (Lipsticks) (Thiebaud), 47	see also composition
Untitled (Rohm), 49	Vitruvius, 42
	volume
\mathbf{v}	in human figure drawing, 101–104, <i>103</i> intensity and, 52
1	materials and, 193
value	problems with, 193
applying, 74–78	texture and, 52
chiaroscuro and, 68, 69	value and, 51
contrast, 48, 49	raide dira, 51
edges and, 74, 75	
for effect, 68–69, 69, 70	W
in eyeball, 109–110, 111	
gesture drawing exercise, 80–81, 81	Wadzinski, Kevin, 31
high key, 69, 71	Warble Over Thessalian Hills (Rappleye), 274
in human figure drawing, 103–104, 104	weight
low-key, 69, 70	of lines, 54, <i>54</i>
middle-key, 69, 70	of paper, 203–204
for mood, 68–69, 69, 70	Weldon, Roberta, 15
out-of-focus image exercise for, 79–80	Wen Yen Tseng, 73
planes of, 67, 67–68, 68	Westhoff, Regina M., 98
plastic, 68, 70	wet media, 216–219. see also media
in portraiture, 118, 119	Wherein Creature Both Great and Small Doth Dwell
problems with, 193	(Rappleye), 273
space and, 50	Whispers (Scobel), 280
structure, 66, 66, 67, 67–68, 73–74, 74	Whitehead, Alex, 218
subtractive drawing and, 77, 77–78, 78	Whitman, Gill, 183
tenebrism and, 68, 69	width
texture and, 69–71, <i>71</i> tone and, 75, <i>76</i>	foreshortening and, 8
variations of, 73–74, 74	in sighting, 7
volume and, 51	Williams, Harry, 210
Van Der Velde, Scott, 129	Williams, Jody, 35, 46, 55, 95, 102, 223
van Leyden, Lucas, 22	Williams, Michael, 109
VandenBerg, Jeff, 62, 78, 176, 182, 185	Willis, Theron J., 176
Vander Ark, Melissa, 114	willow charcoal, 213. see also charcoal
vanishing points, 179–181	wintergreen oil, 227
definitions, 148	Wissner-Tabaczka, Sharon, 68
multiple, 158, <i>158</i>	Work in Progress (Johnson), 212
perspective and, 142, 145	written feedback, 196
scaling and, 16, 17, 18, 21, 22, 23	
sliding, 158, <i>158</i>	X
in three-point perspective, 179–181	
vertical trace and, 172–174, 172–174	xylene, 227
variable compositional elements, 26–28	
variety, 24	7
Velez, Michelle, 58	Z
vellum finish, 203	zero point, 16
Vellum paper, 205	Zoerhof, Christina, 72
1 1	,,